PENGUIN BOOKS

PEOPLE

Alfred Eisenstaedt's photographic career spans more than fifty years, thirty-six of which were spent with the original *Life* magazine, where he worked as a staff photographer from the magazine's inception to its end. Through the years his work has been featured in almost every major photography magazine in the world and has been exhibited as well, most recently at the M. Knoedler Gallery in New York City. A recipient of numerous honors for his work, Eisenstaedt is also the author of *The Eye of Eisenstaedt*, *Martha's Vineyard* (coauthor, Henry Beetle Hough), *Witness to Nature*, *Wimbledon* (coauthor, John McPhee), *Eisenstaedt's Album: Fifty Years of Friends and Acquaintances*, and *Eisenstaedt's Guide to Photography*. He continues to travel extensively, both in this country and abroad, on free-lance photographic assignments.

ALFRED EISENSTAEDT

 PENGUIN BOOKS

PEOPLE

I am deeply indebted to Bryan Holme, Director of Studio Books, for his inspiration and his guidance in organizing, designing, and editing this book, and to Olga Zaferatos for her invaluable research, enthusiasm, and painstaking attention to the many details involved in bringing this project to completion.

Penguin Books Ltd, Harmondsworth,
Middlesex, England
Penguin Books, 625 Madison Avenue,
New York, New York 10022, U.S.A.
Penguin Books Australia Ltd, Ringwood,
Victoria, Australia
Penguin Books Canada Limited, 2801 John Street,
Markham, Ontario, Canada L3R 1B4
Penguin Books (N.Z.) Ltd, 182–190 Wairau Road,
Auckland 10, New Zealand

First published in the United States of America by The Viking Press 1973
First published in Canada by The Macmillan Company of Canada Limited 1973
Published in Penguin Books 1979
Reprinted 1979

Library of Congress Cataloging in Publication Data
Eisenstaedt, Alfred.
People.
1. Photography—Portraits. 2. Eisenstaedt,
Alfred. I. Title.
TR680.E33 · 1979 779′.2′0924 78–10683
ISBN 0 14 00.5073 6

Printed in the United States of America by
The Murray Printing Company, Westford, Massachusetts
Set in Times Roman

It has often been said that I have photographed more people than any other photographer. I doubt that this is true, but when this book was proposed and I started delving through the piles of boxes that contain literally thousands of my negatives and prints, I was in fact surprised at the number of stories I *have* covered over the past decades or so. The majority of these stories, nearly two thousand of them, involved people, and to a large extent famous personalities.

I have noticed that most people, while viewing collections of this kind, tend to be drawn most toward the earlier pictures for their nostalgic interest and toward the most recent photographs because of their news value. In photo-journalism—an art that blossomed with the advent of the picture magazine and suffered its severest blow from television—it was often said that an event had to be photographed almost *before* it happened, for once a story was a few days old the impact was gone. Nevertheless, from a photographer's point of view, the most important thing is the picture itself, not the subject matter or the year in which, by chance, it was made.

To younger readers, the first pictures may appear to have been taken at the time of the Ark, but possibly they will prove no less interesting because of their antiquity. Older readers may recollect what an earlier generation remarked about Richard Strauss (page 39), for instance, or Gerhart Hauptmann (pages 24–25), when names such as these still made the headlines. And a few senior citizens, recognizing the image of Max Reinhardt (page 40) or George Bernard Shaw (pages 28 and 29)—to cite at random two other personalities in this book—might possibly remember seeing *The Miracle* in Salzburg during the twenties or—*just*—the premiere of Shaw's *Pygmalion*, which, strangely enough, occurred in 1913 in Vienna before the play opened in London the following year.

My professional career started in Germany in the late 1920s, and as the photographs, with a few exceptions, follow roughly in chronological order, the earliest will be found to be of Europeans and visitors to the Continent or England at that time. I was frequently in Switzerland, where fashionable hotels like the Grand Hotel and Palace Hotel in St. Moritz (*the* skiing resort then) were happy hunting grounds for royalty, international society, and stage and film personalities—Gloria Swanson, for example (page 26), who happened to be there when I was in 1930.

When I photographed Marlene Dietrich in 1928 (the year she made her film debut in *The Blue Angel*), I had no idea that the actress was destined for Hollywood, let alone that she would become Paramount's answer to MGM's Garbo, or that my Berlin pictures would hold the fascination they now do. Fortunately I saved the glass negatives, and some of the prints on pages 22 and 23 have never been published before. The same is true of the photographs of Richard Strauss, Gerhart Hauptmann, and Charlie Chaplin (page 40). Chaplin was attending a performance of *Land Without Smiles*,

On the Galápagos Islands

the new operetta by Franz Lehár (page 111), sung by Fritzi Massary and Richard Tauber, two popular singers of the day.

I particularly remember England in 1932. It was then that I photographed George Bernard Shaw at Whitehall Court. It was well known how difficult it could be to arrange for an appointment with Shaw; he was touchy, I was told, and had lately refused many other photographers seeking an interview. After deciding to try my luck by sending him some samples of my work, I heard, quite by chance, that the noted vegetarian was especially fond of bananas. I hastened to the nearest fruit shop, purchased the best-looking bunch available, and sent the bananas along with my portfolio. The ruse worked, and I couldn't help thinking, once I had met the playwright, that he was much easier to get along with than his famous hero Henry Higgins would have been in real life. Shaw entertained me by playing his spinet, and showed me the angle from which he thought he photographed best. He fancied himself a photographer, but the quite extensive viewing of his "snaps" to which he first subjected me was, I considered, a trifling price to pay for getting him in such a relaxed frame of mind.

One of my most interesting assignments in the early thirties was the first meeting of Adolf Hitler and Benito Mussolini. This occurred in Venice in 1934. Two of the resulting pictures (pages 56 and 57) are among the "firsts" in this book. Although the meeting came about several months before Hitler was in full power (he remained Chancellor until President von Hindenburg died), one could not help sensing that the end of Europe as my generation had known it was at hand. Mussolini, strutting like a peacock, impressed Hitler to the point that the ex-corporal commented afterward: "People stared and bowed in humility before him, as before a Pope, and he strikes the Caesarian pose necessary for Italy." Mussolini was less impressed with the Chancellor: "Instead of speaking about current problems," he complained, "he recited me *Mein Kampf,* that boring book I have never been able to read." It was three years before the two leaders got together again, and by that time even darker pages of history were being written.

Because of Mussolini's threat to Ethiopia, which he claimed should belong to Italy, I was sent by the Associated Press to do a general story on

George Bernard Shaw looking at the author's photographs, 1932

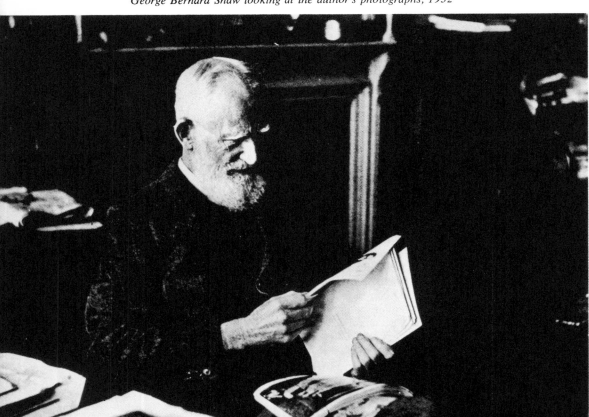

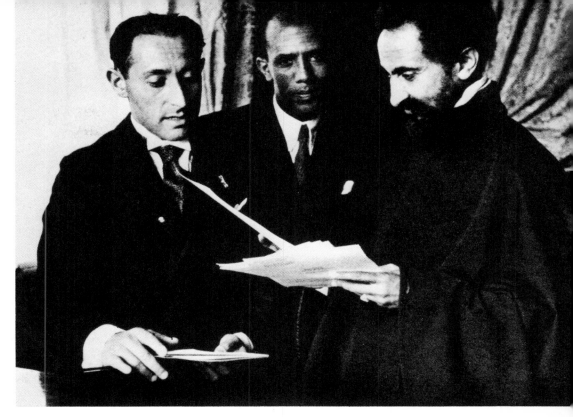

With Haile Selassie and interpreter, 1935

the country, with particular emphasis on Emperor Haile Selassie and the Ethiopian army (page 58). I was to return to Ethiopia again in 1955.

I love music, and one of my great pleasures has always been photographing conductors, musicians, and singers. I believe I was the first to do so during actual performances. The photographs of Igor Stravinsky, Alfred Cortot, Jascha Heifetz, and the others on pages 44 and 45, were made with the Ermanox, the first candid camera built. This new instrument, with a 1.8 opening (unheard of before) made it possible, with the aid of a tripod, to photograph indoors by available light and without flash. No film was manufactured for the Ermanox, only Ilford glass plates. The plates were heavy to carry around, and they were expensive—two reasons that kept reminding me not to be careless with my focusing and exposures. I find that one learns most in this life from necessity!

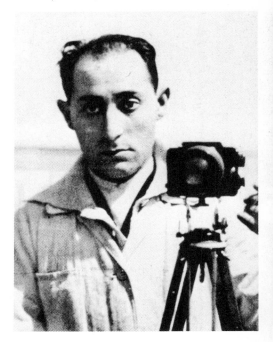

In 1928, with the Ermanox

There was a great deal of excitement when candid photographs (as opposed to formal studio portraits) were first used by the magazines, and I had no problem, armed with my friendly new "weapon," obtaining a center seat in the first row of practically any performance I wished to attend. I enjoyed listening to the soloists as much as I enjoyed photographing them, and either before or after recitals I usually had the opportunity of congratulating the stars and talking with them. It is interesting for me to compare the equipment I used in those days with today's improved cameras and films, which have made such assignments as the conductors on pages 44 and 45 much easier to fulfill.

Every photographer has his favorite pictures. The series of studies I made at the Paris Opera in 1931 are among those of my early period that I like best. I chose the one on pages 34–35 because it is less well known than other versions I took at the same time. Similarly, I selected the photograph of the white-tie premiere at La Scala (pages 42–43) because it shows the auditorium from a different angle from that seen in my most often reproduced early picture of the opera house—the one used in my first book, *Witness to Our Time*. Another of my early favorites is the photograph of a grandmother and grandson seated in the Rijksmuseum (pages 46–47).

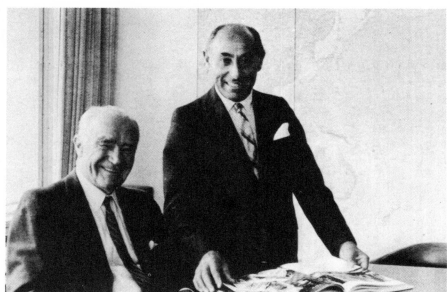

With Henry R. Luce, 1966

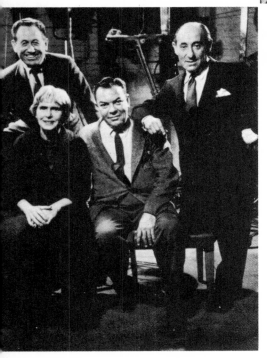

With (left to right): Peter Stackpole, Margaret Bourke-White, and Thomas McAvoy, 1960

As my work became known, more and more European magazines gave me assignments, but I realized that, quite apart from the political climate in Germany, my real opportunity lay in America. Finally I made up my mind to take the plunge, and I sailed for New York from Le Havre on the *Ile de France* at the end of 1935.

Around that time it so happened that the founder of *Time,* Henry R. Luce (page 208), was thinking of starting a "picture" magazine. Tentatively this project was designated "Magazine X." To help the project take shape, preliminary "dummies" complete with news, art, and photo essays were prepared and printed as try-outs. Luce knew of my work through Kurt Korff, former editor of the *Berliner Illustrierte Zeitung,* who was already in New York, and shortly afterward Luce hired me on a trial basis. After working for a few months, I was told that if "Magazine X" finally materialized, I would be taken on permanently as a staff photographer.

The miracle happened. The new *Life* hit the newsstands on November 21, 1936. I was proud to find my name on the masthead and to be among the elite company that included Margaret Bourke-White—Maggie, as we all called her—the greatest woman photographer of her day, perhaps of any day, as well as Thomas McAvoy and Peter Stackpole. The four of us created *Life*'s original photographic *esprit de corps.* I was equally proud when my West Point "hazing" cadet (page 63) appeared on the cover of the second issue. This was my first of over ninety *Life* covers—including the international editions—before the magazine finally ended its great career, to so many people's sorrow, in December 1972.

The America of the early thirties was the America of Franklin D. Roosevelt and his New Deal, which was designed to bring the country out of the deep depression following the Wall Street debacle of 1929. Shortly after the re-election of Roosevelt in 1936, I was sent to photograph the President on his way to a Good Neighbor Policy conference in South America. His son James, then acting as his secretary, was on board with him as the U.S.S. *Indianapolis* steamed out of Charleston, South Carolina (pages 64–65).

I did not meet or photograph Eleanor Roosevelt until the 1941 inaugural-day ball that celebrated the beginning of her husband's third term in office. The photograph of her on page 183, with Nikita S. Khrushchev, was taken at Hyde Park many years later. The former First Lady was one of the most charming women I have had the privilege to photograph, as were the two Queen Elizabeths, one now the Queen Mother (page 177), and the other Elizabeth II (pages 174 and 176).

A photographer usually has something between ten minutes and an hour to meet with a busy VIP, so the judgments of such personalities are, to say the least, superficial. One remembers the initial impression, as one always does when meeting anyone for the first time, and then one remembers the

Carole Lombard, 1938

degree of the subject's receptivity while being photographed. It is part of a photographer's job to make himself as engaging as possible without forgetting his technical responsibility to produce a good picture.

But there was nothing superficial about my impression of Carole Lombard, whom I photographed in 1938. She was so natural, sincere, and warm-hearted. In the thirties, Hollywood studios still supplied magazines and movie fans with idealized photographs of their stars—photographs taken with a diffusing disc over the lens, the purpose of which was to relieve a face of most of its lines and, as a consequence, most of its character. What a diffusing disc might not accomplish in minimizing crow's feet or the signs of a double chin, a retouched negative could. Every actress wanted to look like a young goddess, or like Garbo—one of the people I would have loved to have photographed had the opportunity come my way. Miss Lombard even allowed me to take the candid shot on page 77 while her face was still smothered with grease. She was making up to go before the cameras, and I consider this study to be one of the most interesting portraits I made of her.

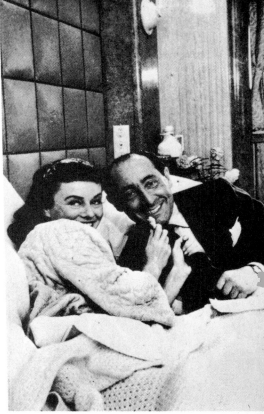

With Paulette Goddard on the S.S. Queen Elizabeth, *1948*

Candid photographs were the price film stars had to pay for appearing in *Life*. The new magazine, and similar ones in Europe, brought about a radical change in the public's attitude toward photography: readers now saw people in print as they really looked, not as the retouch artist tried to make them look. To put it another way, readers saw human beings, not dolls. Paulette Goddard summed this up most succinctly when she wrote in my autograph book, "Happiness is the absence of pain, retouching is the absence of beauty."

Pictures in *Life* often brought starlets to stardom and raised established stars higher still on the giddy rungs of success. In 1938, I photographed Bette Davis (page 76), who had recently won a coveted Oscar; Ronald Colman (page 74), idol of the silent screen and still as popular; Hedy Lamarr (page 80), then new to Hollywood; Jimmy Stewart (page 79); Walt Disney (page 78); Clark Gable (page 73), the reigning king of Hollywood; and others, some of whom also appear on these pages.

When I was assigned to the 1938 story on Hollywood, Wilson Hicks (one of *Life*'s great picture editors during the thirties and forties) gave me sound advice about moviedom's temperamental kings and queens. "Don't be in awe of them," he said, "you are a king in *your* profession." In Europe, when I photographed real emperors and kings, Haile Selassie, for instance (page 58), and Sweden's Gustaf V (page 48)—who was one of my easiest subjects, by the way—I learned that somehow one *must* be sure of oneself, both psychologically and technically, when facing a dignitary with a camera. Even if the subject tells you which side of his face he wants photographed, as Winston Churchill did (pages 138 and 139), you can oblige him by

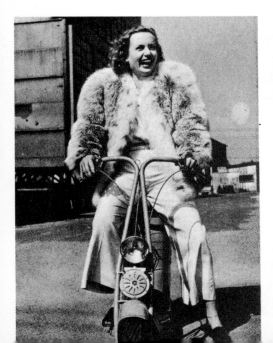

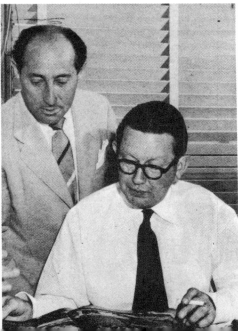

With Wilson Hicks, 1939

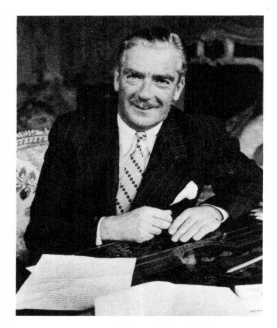

Anthony Eden, 1951

gracefully accepting the suggestion before moving on to take what you think will be a better picture.

The way a photographer *sees* characterizes his work. Normally people think of a photograph as just a photograph, but the work of different photographers can be as individual—or perhaps I should say *almost* as individual—as the work of different painters. One can recognize the distinguishing features of the work of Ernst Haas or Gordon Parks (photographs of whom appear on pages 242 and 243) or of Cartier-Bresson or Cecil Beaton (page 83), for instance. Each of us in the profession has his own particular "eye" and his own particular technique.

I have always made it a practice to be well informed about the news so that I have plenty to small-talk about with whomever it is I am to photograph, and the two of us begin to feel at ease with each other from the start. One has to be agreeable in order to become "a gentle executioner," as Sir Anthony Eden (page 54) once kindly called me. An erratic photographer usually fails to get the most out of his subject, as does a photographer who cannot prejudge the length of time he has before a subject starts asking how much longer the "suffering" will last.

The end of the thirties was grim. Everyone had been expecting Europe to go up in flames, and after Hitler's invasion of Poland, the explosion finally came. While other photographers covered the war, I was assigned to the home front. Those agonizing years witnessed an endless succession of good-byes. This image took hold of me and I decided to plant myself in the middle of New York's busy Pennsylvania Station, where I spent several successive days photographing soldiers waiting with wives or girl friends during those last few precious moments they had together (page 88). Being emotional myself, I found some of the farewells so touching that I had to wipe the mist from my view finder.

In 1945, four months after the atomic bomb was dropped on Hiroshima, I crossed the Pacific with the gifted writer Richard Lauterbach, who was also on *Life*'s staff. We were assigned to cover every aspect of postwar Japan that interested us and that we considered important.

We visited Hiroshima and Nagasaki, and we accompanied Emperor Hirohito on an inspection trip of war damage between Tokyo and Yokohama. The people treated the Emperor as if he were God. On the lighter side, we were invited to do a story on the Kabuki players at the Imperial Theater (pages 90–91), and another day to watch a production of John Drinkwater's *Abraham Lincoln* (page 96). Acted by Japanese in Japanese, the play was fascinating to my Western eyes and ears. In Kyoto, I photographed a day in the life of a geisha from the moment she put on her traditional attire and made herself up to look like a chalk doll at noontime (page 94), until she went to work in one of the fashionable restaurants that cater largely to

With Hirohito, 1946

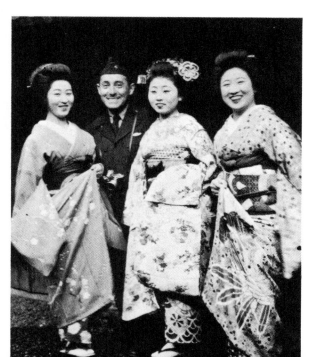

In Kyoto

Japanese businessmen according to the age-old and charming tradition of that country.

Very few people, and certainly no tourist, would run into a subject such as the one shown on page 95, which, with related pictures, also became a feature story in *Life*. The tattooed back is that of a former Japanese gambler. The custom developed from the practice of marking convicts with numbers that were later camouflaged with a design. Although the police have abandoned numbering in favor of fingerprinting, the patronage of gamblers and

With Kabuki player

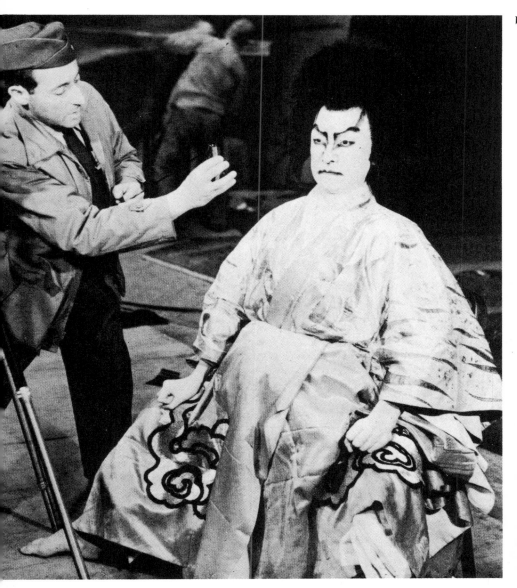

With Kōkichi Mikimoto

other members of the Japanese underworld has developed Japanese tattooing into this fanciful art. The photograph, incidentally, was taken in a house of prostitution to which Lauterbach and I were led by strange and devious means, including blind-folds and several changes of automobile, so that we could not possibly know where we were going—let alone ever get back there.

Before leaving Japan, we visited Mikimoto, the inventor of cultured pearls, and I also traveled to the island of Hokkaido on the Kuriles, where I made a photo essay on the "Hairy" Ainus (page 90). One of the world's racial curiosities, this primitive tribe (some also live on the Soviet island of

Sakhalin) had remained untouched by the recent war. The Ainus believe they will die if they take a bath, and, among other superstitions, they worship the bear as one of their gods. Before I left the chief and his companions, I had to be most diplomatic as I declined the supreme honor of drinking cold bear blood with them and eating the animal's raw testicles at a feast they were preparing for "Bear Festival" day.

The late forties brought me in touch with some of the world's great scientists, the people whom President Truman (page 190) acknowledged, indirectly, when he said that "the U.S. attempt to build an atomic bomb before Germany is the greatest scientific gamble in history." On August 6, 1945, when the story of Hiroshima broke in the newspapers, J. Robert Oppenheimer, then director of the technical laboratories in Los Alamos, New Mexico (where the first atomic bomb was produced), became world famous overnight. Between 1947 and 1963 I photographed many noted physicists (including Paul Dirac and Abraham Pais) at The Institute for Advanced Study in Princeton, and Oppenheimer, its director, five times. Oppenheimer's face, especially his eyes, fascinated me (page 140). Understandably, he felt the burden of his responsibilities and showed it through his nervous movements and chain smoking. The nuclear physicist complimented me on my attempts "to record men in their most difficult art—thinking."

Also in Princeton was Albert Einstein (page 108), who, casually dressed in an old sweater, struck me as the perfect example of the traditional absent-minded professor. "The world wants to be deceived," Einstein said, whereupon his mind ascended to a higher plane than mine could possibly be expected to reach. Regarding his New Jersey neighbors, Einstein had recently written Queen Elizabeth of Belgium: "Princeton is a wonderful little spot, a quaint and ceremonious village of puny demigods on stilts." But Princeton loved him just the same.

The great glamour days of Hollywood waned in the early fifties, but I was on the Coast again a few years before this happened. In 1949, when business was still booming, I photographed Lauren Bacall, Bob Hope, Lucille Ball, Loretta Young, and many others, some of whose familiar images appear on pages 114 to 121. When I returned to California in 1953, I met Marilyn Monroe for the first time. Everyone who knew the actress and has seen the photograph on page 151 seems to feel that this pensive portrait is the "real" Monroe. In any case, Miss Monroe was extremely beautiful. "Yes," said one of my colleagues on my return to the office, "she must have been . . . just look at all those photos you've overexposed." Once in a while this happens in the best of circles—*this* being a photographer using a camera loaded with black and white film, thinking it was color, and shooting at the wrong speed!

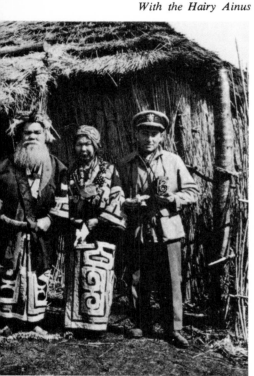

With the Hairy Ainus

In Naples, 1947

Of all the actresses I have met, Sophia Loren has always seemed to be the hardest-working and easiest to get along with. Her face, or a part of it, decorates the jacket of this book, and more of her is shown on pages 204 to 207. "Beauty is no handicap if you don't think about it," she told me one day as we were driving along to visit her birthplace in Pozzuoli, outside Naples. We were about to stop and pay the toll along the autostrada, when, with a twinkle in her eyes, she told me to watch the soldiers at the gate. "They are not really interested in my face," she insisted—and they weren't; the men looked only downward. When this was pointed out to them, everyone enjoyed a good laugh, and on we went to Pozzuoli.

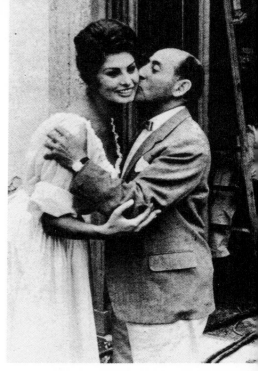

With Sophia Loren, 1961

Back in Europe again in the early fifties, one of my assignments for *Life* was "Distinguished Englishmen." High on my list was American-born T. S. Eliot, whose *Old Possum's Book of Practical Cats* I had particularly enjoyed reading years earlier. After I contacted Eliot's publishers, they phoned me back and said, "Why not come along over and photograph him here in his office." Faber and Faber's building was on Russell Square, and although the office they kept for Eliot was full of character—as most English publishers' offices are—it happened to be very small, very badly lit, and from just about every point of view as difficult a place to take a good photograph in as one could possibly imagine. After removing books, rearranging chairs, crawling on the floor, and squeezing my thin body into as advantageous a position as possible —facing away from the window—I finally succeeded in getting the photograph on page 124. Eliot was greatly amused by my antics, and later added to his autograph: "To the acrobatic photographer with apologies for giving him such a difficult time."

Often the most difficult photographs turn out to be among the best, especially if one has succeeded in being entertaining in a natural sort of way while working. It has always been a great asset that I like people, for in photography, as I have often been quoted as saying, it is not so much clicking the shutter that counts as clicking with the subject.

Among others on *Life*'s "distinguished" list were Christopher Fry (page 126), whose play *The Lady's Not for Burning* was a big hit in New York as well as London; the Very Reverend Martin Cyril D'Arcy (page 109), author of *The Mind and Heart of Love,* and possessor of one of the most ascetic faces I've ever seen; Alec Guinness (page 131) and Celia Johnson (page 130), both of whom were rehearsing for films; Augustus John (page 123); Benjamin Britten (page 110); W. H. Auden (page 156); Bertrand Russell (page 125); and David Low (page 122). While I was in Low's studio, I asked him about something I had often noticed in his cartoons; I was curious why none of his English subjects ever had a vicious expression. "We *English* are not vicious," Low declared. "Besides, I don't see any harm in human beings." "What about Hitler?" I inquired, glancing at one of the cartoons. "Well," said Low, "Hitler was no human being."

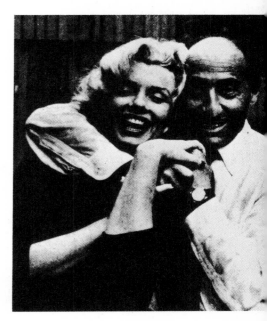

With Marilyn Monroe, 1956

I also photographed Lord Beaverbrook, the famous statesman and publisher, in London and then again later in the country of his birth—Canada (page 144). He was a reporter himself once, and we got along famously. I traveled around with his lordship quite a lot, and, by all standards, I found him a most enjoyable and entertaining companion. Somerset Maugham was on my list too; however, the photograph finally chosen for this book (page 87) was not taken in England but in South Carolina. The novelist was a guest of his publisher Nelson Doubleday during a week of duck shooting. "Wherever you go," Maugham said of me good-humoredly, "there he is with his camera, his tripod, and something he has forgotten at the last minute." I hadn't forgotten anything, but Maugham, not being a photographer, was unaware that sometimes one is obliged to change focus and re-adjust the opening of the camera's diaphragm!

Occasionally I have photographed at the theater, usually when plays are still in rehearsal stage, for example: Henry Fonda and Anne Bancroft rehearsing *Two for the Seesaw* (page 162); Margaret Leighton and Eric Portman in *Separate Tables* (page 163); and Cyril Ritchard, Charles Ruggles, and Dolores Hart in *The Pleasure of His Company* (pages 168 and 169). Katharine Hepburn (page 75) was on stage too, rehearsing for *The Phila-*

delphia Story, although the *Vogue*-like pose of her in a dress she wore in the Barry play looks more like a studio portrait than a candid shot.

Sometimes one runs into personalities quite by chance—at social gatherings, for instance, or at first nights. I was photographing the Bolshoi Ballet during the company's 1959 premiere at the old Metropolitan Opera House when, during the intermission, into Sherry's bar walked three people whose faces I quickly recognized as those of John Gielgud, Marlene Dietrich, and Noël Coward (pages 166–167). Not only is this another hitherto unpublished photograph, but quite possibly the only one ever taken of the three luminaries together. Among the many other celebrities at the opening were Sol Hurok, the impresario, Rudolf Bing, and, at a party afterward, Van Cliburn (page 164). On occasions such as these, one cannot wait more than a split second to take the picture; one must be neither startled nor excited—one doesn't think; with camera in hand, one simply acts as if by instinct. Obviously this is not one of my better photographs, but I was delighted to obtain it nevertheless.

I can say, in truth, that ninety-five per cent of the photographs I have taken of personalities owe their existence to *Life.* On the political scene, the only photographs I took prior to the year I became a *Life* staff photographer are those of Hitler and Mussolini, already mentioned, and those I took at The Hague, the League of Nations, and at Lausanne, where Ramsay MacDonald, Anthony Eden, Édouard Herriot, Eduard Beneš (pages 52 to 56), and so many others were struggling, not only over debts and reparations resulting from World War I but, desperately and fruitlessly, as it unfortunately turned out, to avert World War II. Will Rogers, whom I also photographed in Geneva, remarked, "There is a lot of nations here willing to throw away two spears and a shield for every battleship we sink." Some twenty-five years later, I again found myself amid politicians, diplomats, and statesmen at the United Nations in New York (pages 196 and 197).

Will Rogers, 1933

With Van Cliburn and Kyril Kondrashin, 1959

For *Life* I covered the Conservative Party's 1951 campaign in England. While recently checking my "takes," I discovered several strips of negatives showing Churchill stumping in Huddersfield that had never been printed— not even on a contact sheet. I chose the two on page 139 because I like them, because they are unknown, and because both show such typical Churchillian poses. I also photographed Churchill at home in Chartwell (page 138). The great war hero produced a cigar (he only smoked two a day but was always certain, I was told, to have one handy whenever a cameraman was in the offing) after which he told me most specifically how he wished to be photographed. "You have to do it from *there,* young man" (I was fifty), Churchill commanded, pointing to where I should stand, after which he introduced me first to some very good brandy—and then to his pet goldfish. He had three aquariums, and one of his well-known pastimes was watching his tropical fish mating.

While on location in England, I strayed into the opposing political camp and caught a weary Clement Attlee (page 193) cat-napping at a Labour Party meeting in London. Attlee was still Prime Minister (after six years), but a few weeks later he lost the election to Churchill.

Again due to *Life,* I have photographed all the American Presidents since Hoover: Franklin D. Roosevelt (pages 64–65), Harry Truman (pages 136 and 139), Dwight D. Eisenhower (with family, page 134), John F. Kennedy (with family, pages 186, 187, and 189), Lyndon B. Johnson (page 196), and Richard M. Nixon (page 253).

Looking at the many photographs I made of John F. Kennedy during his election campaign and as President, and reading the inscription he wrote for me on one of them, I sometimes wonder if perhaps in some strange way JFK had a premonition of what was to come: "To Alfred Eisenstaedt," the inscription reads, "who has caught us all on the edge of the New Frontier . . . what will the passage of the next four years show on his revealing

Nikita Khrushchev, 1960

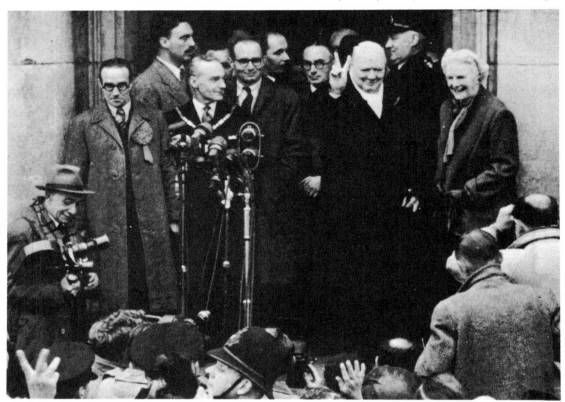

The Churchills, 1951 (author, back view, at extreme right)

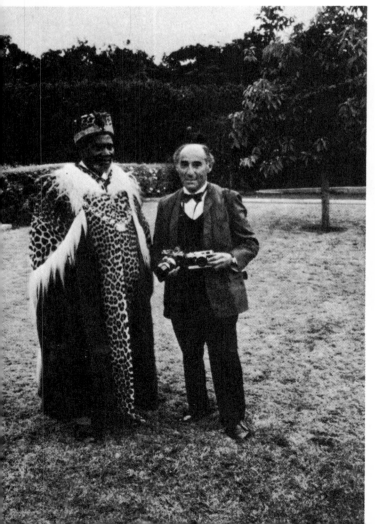

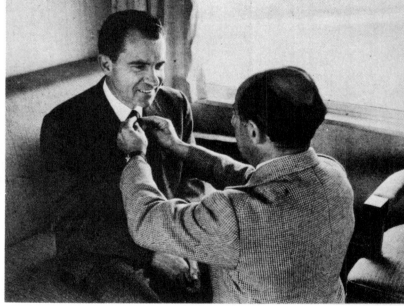

With Richard M. Nixon, 1960

With Jomo Kenyatta, 1966

plate?" Two other Americans who shared the same fate as the late President—his brother Robert Kennedy and Martin Luther King—are also seen on pages 190 and 191.

In trying to strike a happy balance in this book between people known and unknown, between people of different creeds and persuasions, living in different parts of the world, I have included a few favorite photographs I took in Paris in 1963: two typical elderly American tourists taking a "toes-up" amid the wonders of the Louvre (page 178), two Parisiennes arguing over the price of a chicken (page 227), and an eager young husband about to bestow a first married kiss on the lips of his bride (page 225). Also included for variety in mood and occupation: the poor and the devout in Ecuador and Mexico (pages 180 and 181); Henry Ford II in Detroit (page 143); a Jewish rabbi and an Indian scholar (pages 160 and 161); "Miss America" 1945 (page 104); artist Andrew Wyeth (page 233); Robert Graves as chef (page 211); an acrobatic Josephine Baker (page 101); singer Margaret Truman (page 147); a toothsome William F. Buckley (page 252); and the

With Jacqueline and Caroline Kennedy, 1960

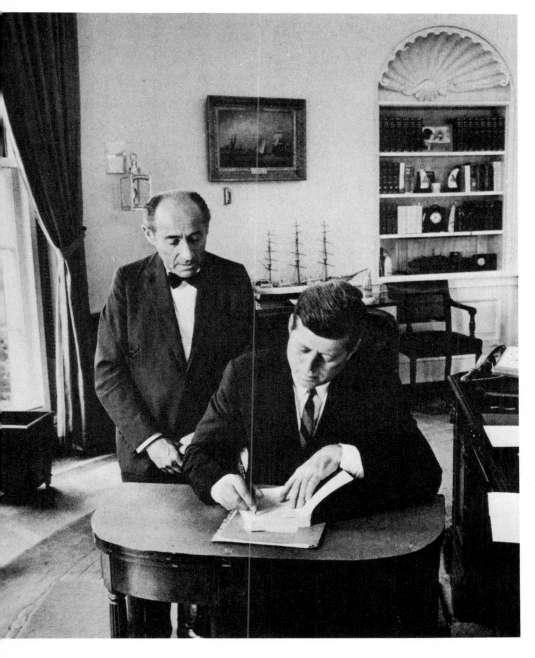

With John F. Kennedy, 1962

17

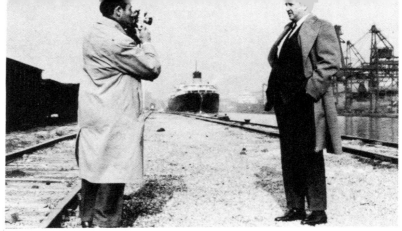

With Henry Ford II, 1955

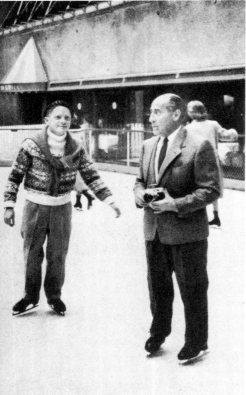

lively hippies on pages 248 to 251. I enjoyed photographing most of the hippies; however, for some reason the Roman ones became militant, threatening to call the police if I continued to aim my camera at them—so I left them on the Spanish Steps and went to enjoy the peace and quiet of Vatican City.

I am often asked how I manage to photograph people in such unaware poses (Angela Lansbury, for instance, page 147). The answer, of course, is that I make it a practice to be as unobtrusive as possible. If I didn't succeed in being invisible on the Spanish Steps, I did in Florida: the little girl on page 200 didn't notice me as she knelt down and peered into the mouth of a large, freshly caught fish. I wanted to capture the child's expression of wonderment, and would have failed had she known she was being photographed.

Agile though I am, I have never more than dabbled in sports, or photographed the subject much, but two separate assignments resulted in the pictures of baseball heroes Joe DiMaggio and Willie Mays (pages 152 and 153). Quite incidentally one day, I caught Truman Capote showing off his skatesmanship at Rockefeller Center (page 159). And while doing separate stories on the Kennedy family and Nelson Rockefeller, I trailed along in a boat on both occasions to photograph them sailing (pages 84–85 and 199) and managed to survive the swelling motion of the Hyannisport waters—and the choppier waves off the coast of Maine.

My biggest sport assignment came with my first visit to Wimbledon in 1971. My publisher had sent me to photograph the top players that summer for the book that was being written by John McPhee and that came out in 1972. Games were being played simultaneously on fifteen courts, and it was quite a challenge nipping back and forth to catch the players I wanted in

With Truman Capote, 1959

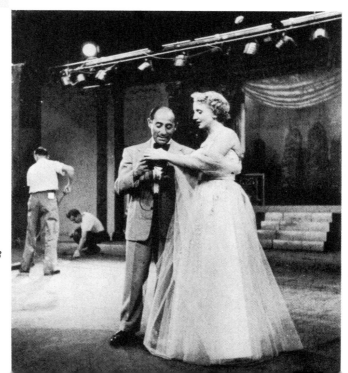

With Margaret Truman, 1953

18

action. On the Center court, particularly, I wished it had been possible to record the movement of the heads of the spectators turning in unison first left, then right, as their eyes followed the travels of a tennis ball from one end of the court to the other, but this, of course, could only have been accomplished in a movie. Some of the players I photographed are on pages 256 to 259.

People often ask me which cameras I use. I would like to say first that the choice of a camera must always be a personal one and that the make is of somewhat secondary importance. Most important is the art of seeing a good picture before one releases the shutter. Almost equally important is the art of being patient and growing to know the camera so well that you don't have to stop and think for a moment how to operate it. Once the technical operation becomes instinctive, one can always be ready to capture any interesting situation that might suddenly present itself. It so happens that I use Leicas and Nikons because I find the 35-mm cameras light to carry and easy to work with. I grew used to candid cameras at the very beginning.

Finally, I want to express my profound gratitude to the publishers of *Life*. Without the existence of that magazine, this book would never have been possible. A *Life* photographer in the early days and through the sixties had entry into the lives of people and events an average person could never have. And here I see my opportunity to thank the wonderful people—so many of them—who have allowed me to photograph them. I do so from the bottom of my heart.

In conclusion, I would like to share one of the most treasured so-called "autographs" that have been left in my album—a poem by Robert Frost,

With Nelson A. Rockefeller, 1960

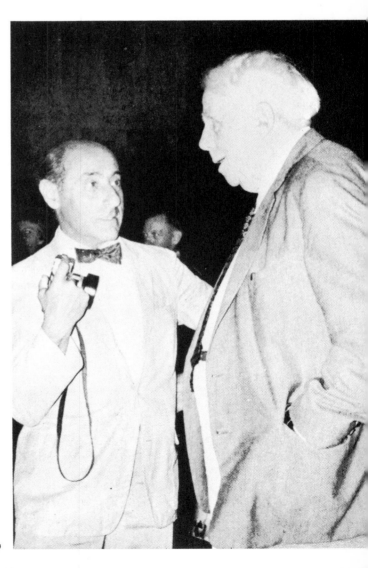

With Robert Frost, 1959

whom I also had the privilege of photographing in the Vermont he loved so well (page 150):

> Bound Away
>
> Now I out walking
> The world desert
> And my shoe and my stocking
> Do me no hurt.
>
> I leave behind
> Good friends in town
> Let them get well-wined
> And go lie down.
>
> I out think I leave
> For the outer dark
> Like Adam and Eve
> Put out of the Park.
>
> Forget the myth.
> There is none I
> Am put out with
> Or put out by.
>
> Unless you're wrong
> I but obey
> The words of a song
> "I'm bound away!"
>
> And I may return
> If dissatisfied
> With what I learn
> From having died.
>
> Robert Frost
>
> For my picture-taker Alfred Eisenstaedt
> Sept 15 1955

(A slightly revised version of this poem, under the title of *Away!*, appeared in *The Poetry of Robert Frost* in 1969.)

English boy.

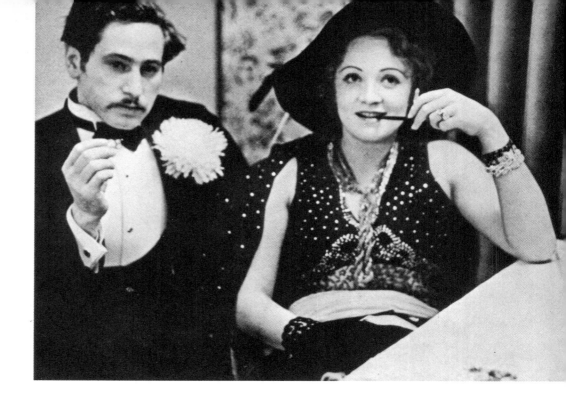

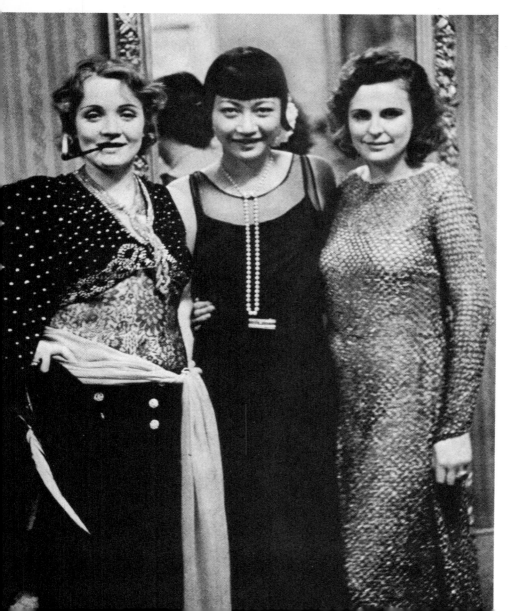

MARLENE DIETRICH in Berlin, 1928, the year her acting in *The Blue Angel* earned her a Hollywood contract. LEFT: With the director who "discovered" her—JOSEF VON STERNBERG. BOTTOM LEFT: At an artist's ball with ANNA MAY WONG (whose first film, *Crimson City*, had just been released) and LENI RIEFENSTAHL (who was to film the Olympics for Adolf Hitler in 1936 and to photograph the 1972 games for the London *Times*). BELOW: With husband, RUDOLF SIEBER. RIGHT: In an outfit she has made legendary with her name.

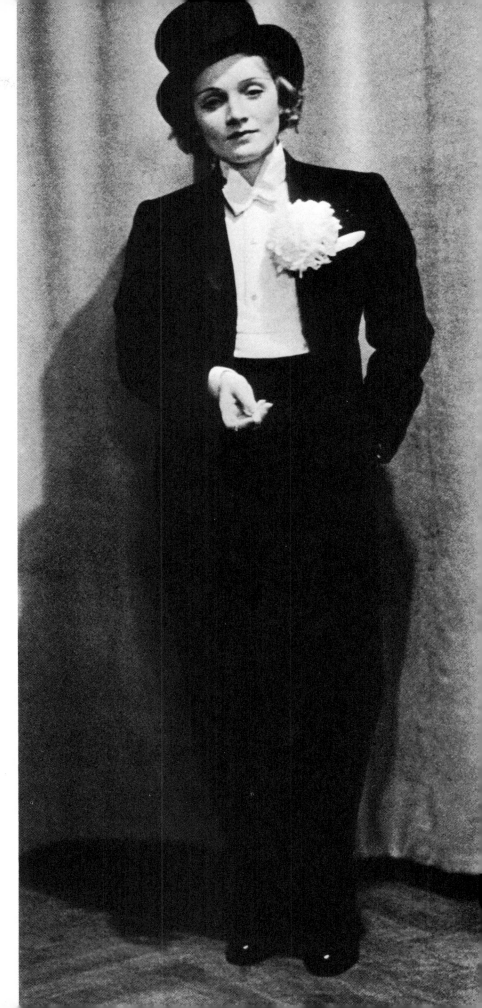

The Goethe-like figure of GERHART HAUPTMANN on a morning walk along the Baltic shore at Hiddensee, 1931. Hauptmann, a winner of the Nobel Prize for Literature, was completing his new (and last) play, *Before Sunset*, that year.

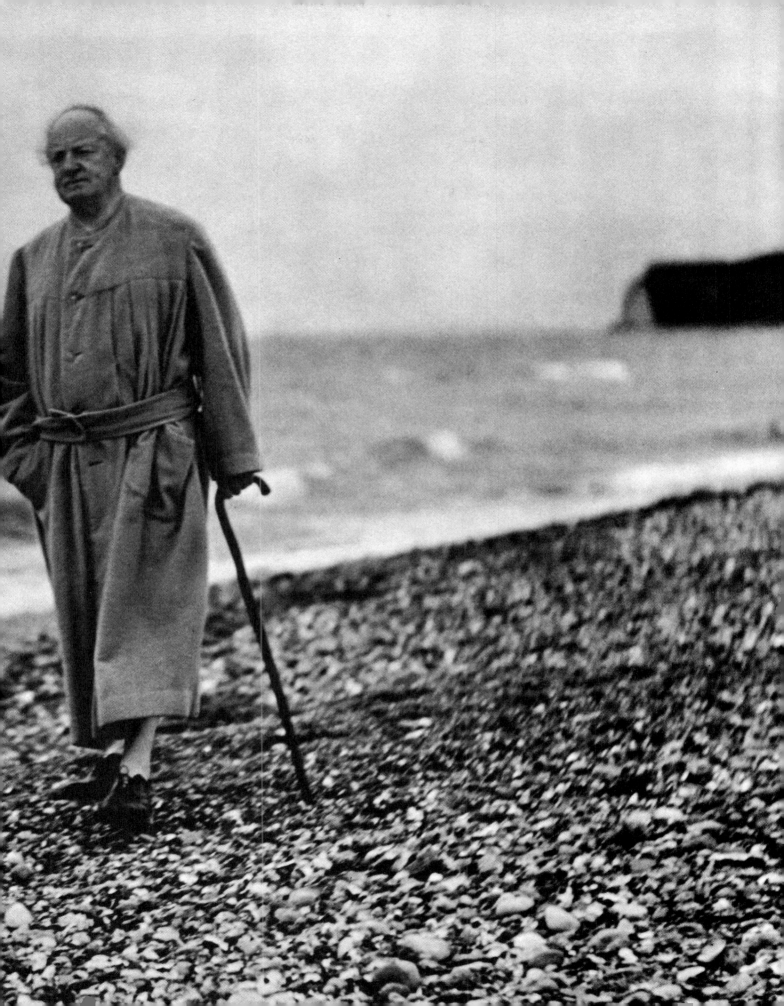

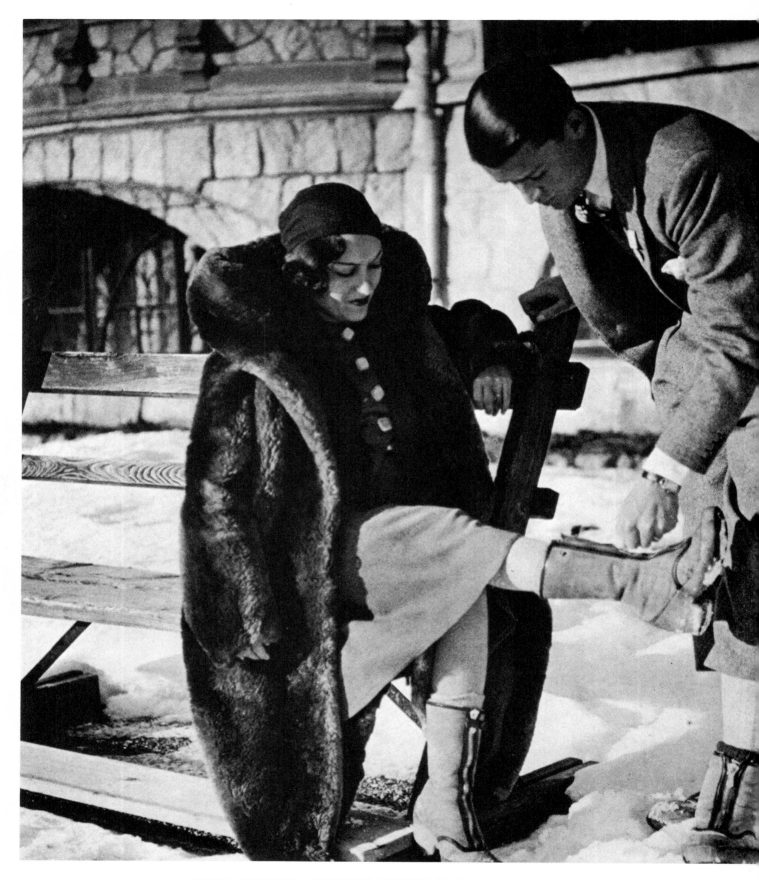

GLORIA SWANSON and MICHAEL FARMER (her fourth husband) holidaying in St. Moritz after the release of Miss Swanson's latest film, *What a Widow* (1930). TOP RIGHT: ETHEL RANDEM, Austrian skating champion, obliging an Arosa photographer. CENTER: ROBERT BREGUET of the Grand Hotel, St. Moritz, teaching apprentices how to serve cocktails on skates to Englishmen. BOTTOM: Italian officer "heading down" at Sestrière.

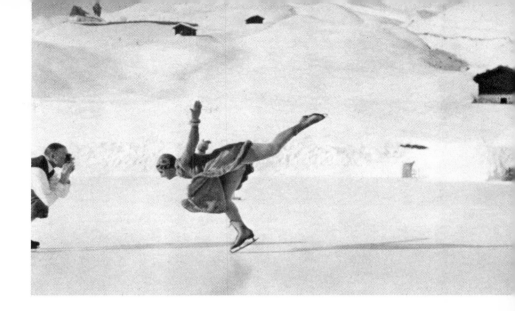
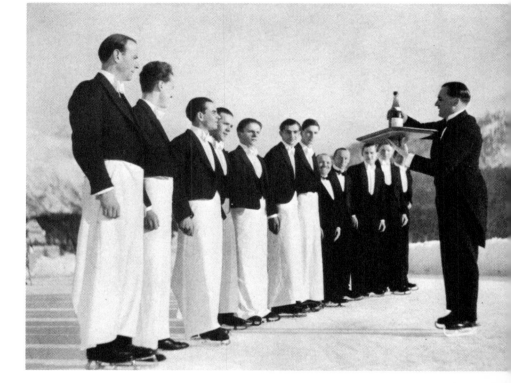
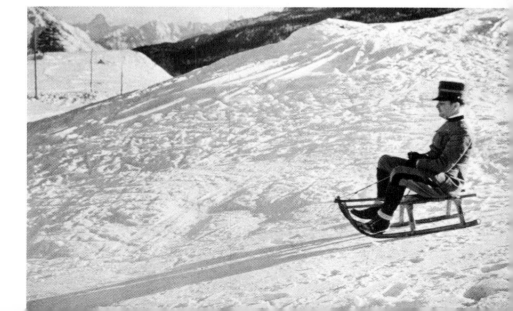

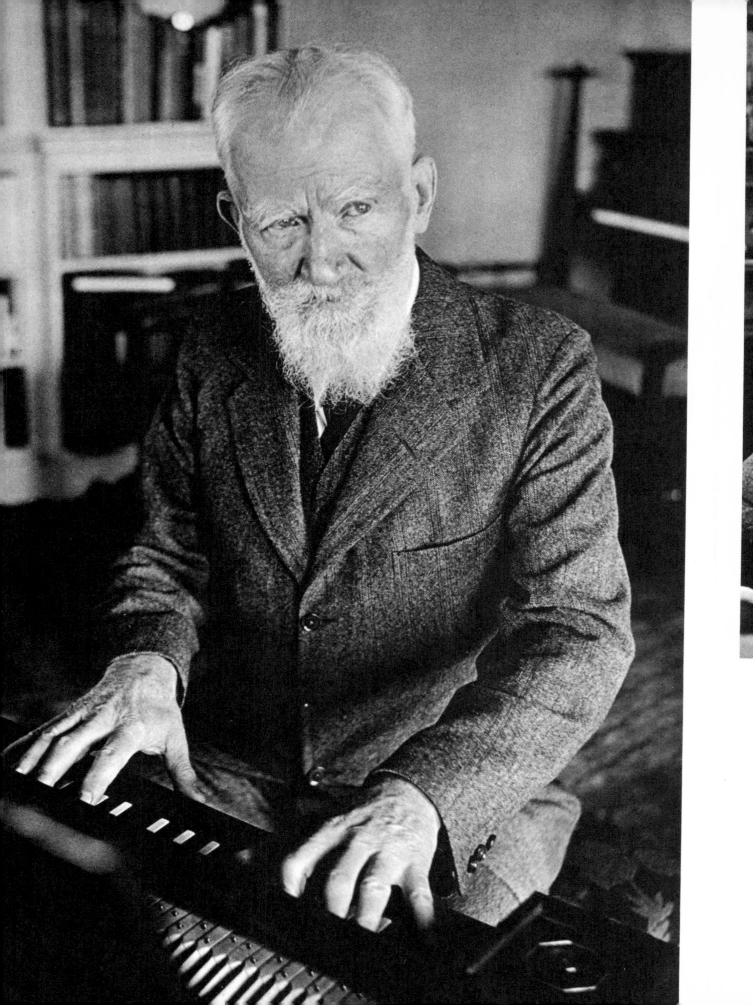

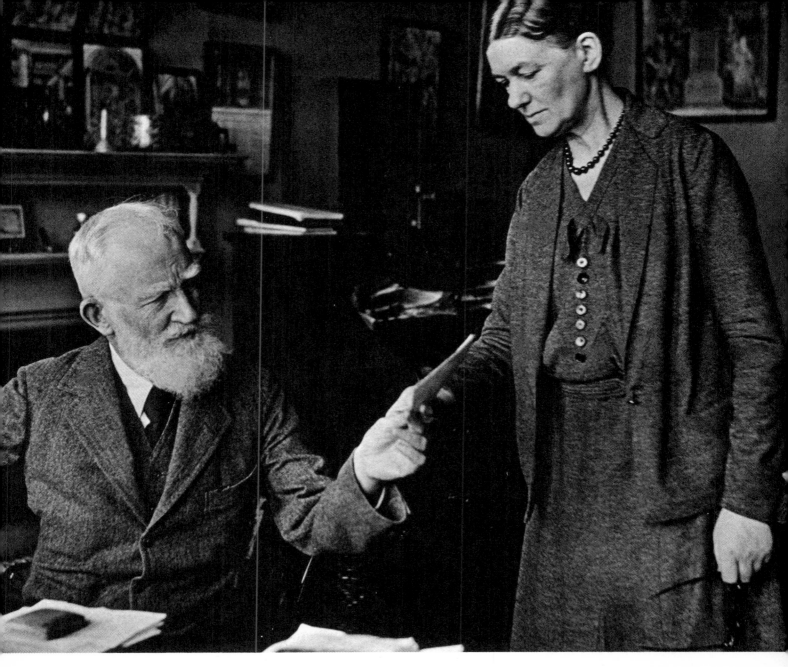

GEORGE BERNARD SHAW in his flat at Whitehall Court, 1932. OPPOSITE: The seventy-six-year-old playwright demonstrating his musical skill on a spinet. ABOVE: Shaw with his secretary. BELOW: Beside a caricature, and (RIGHT) going to work on his old *Premier*.

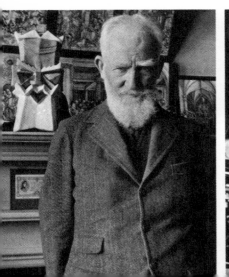

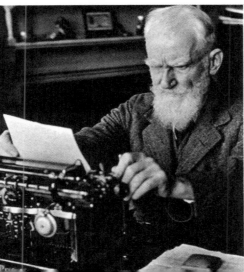

Over the next five years, Shaw's complete works were published in thirty volumes. He lived to see *Pygmalion* (1939) and other of his plays filmed. "Through the invention of the cinematograph," he wrote, "I lately received a further windfall of £29,000 on account of my film rights. The financial result was that I had to pay £50,000 to the Chancellor of the Exchequer within two years." What Shaw would have owed the Exchequer had *My Fair Lady* been produced in his lifetime is anyone's guess.

At the Truempy Ballet School, Berlin, 1929.

GOESTA EKMAN putting finishing touches to his makeup for the lead
in Friedrich Hebbel's *Herodes and Marianne* in Stockholm (1934).

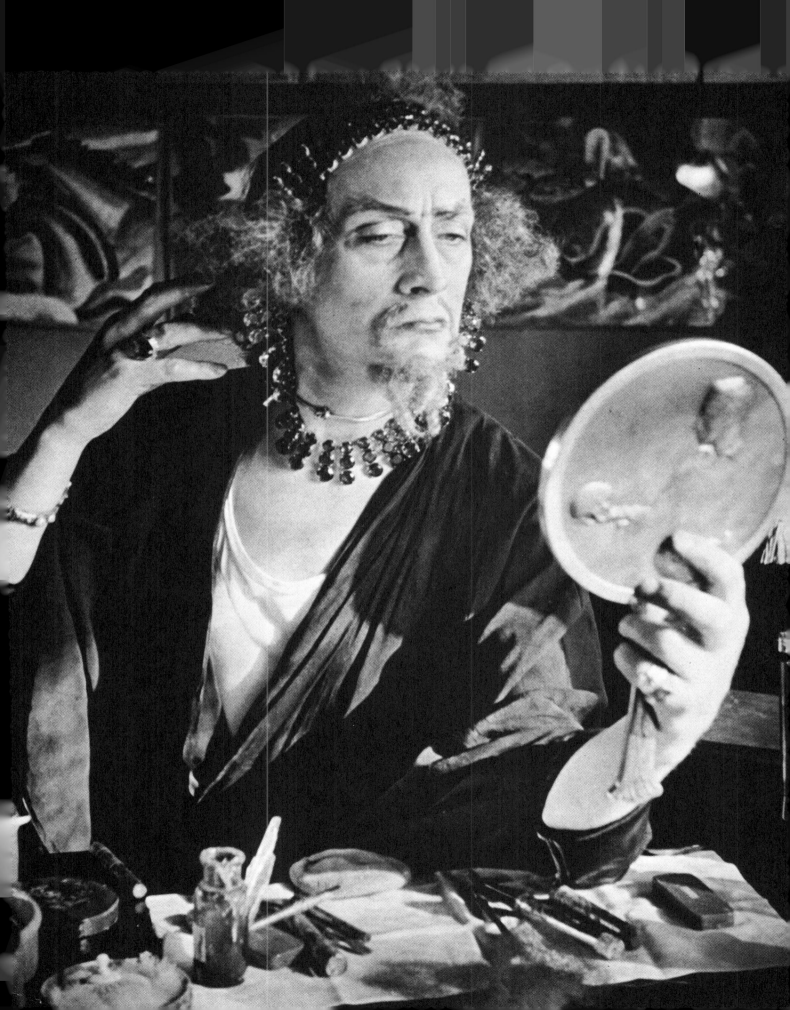

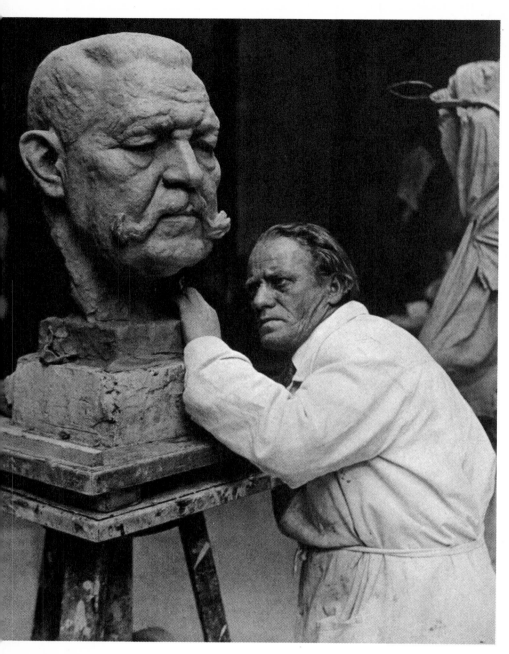

JOSEPH THORAK modeling the head
of President Paul von Hindenburg, Berlin.

RIGHT: Swedish-born Michigan resident
CARL MILLES in his studio at Cran-
brook (where he taught at the Academy)
a few months before the sculptor's second
major American work—the fountain *The
Wedding of the Mississippi and the Mis-
souri*—was unveiled in St. Louis (1932).

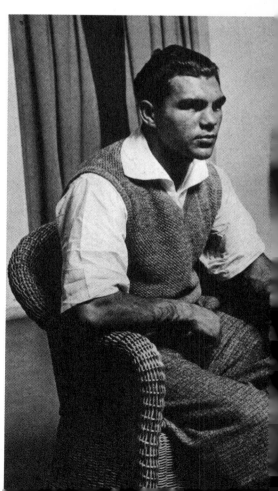

THORAK with boxer MAX SCHMELING, winner
of the World Heavyweight Championship in 1930,
photographed in 1932, the year he lost to the same
opponent—Jack Sharkey.

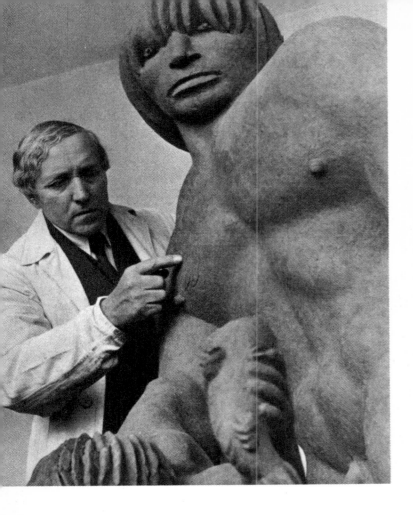

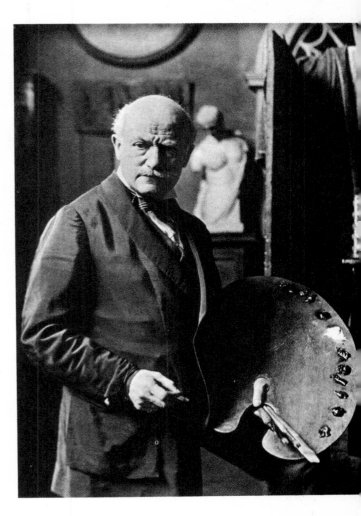

PHILIP DE LASZLO, highest paid painter of royalty and international society in the twenties and thirties, in his London studio, 1932. De Laszlo's "how I do it" opus, *Painting a Portrait,* was published by The Studio in 1934.

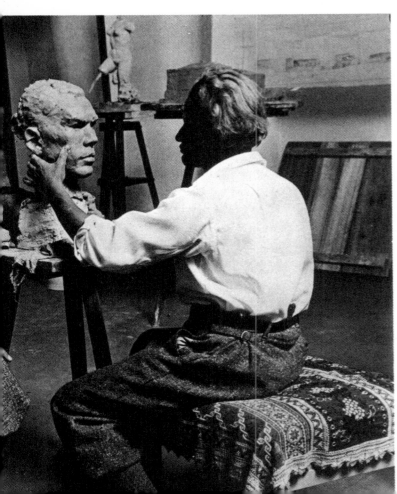

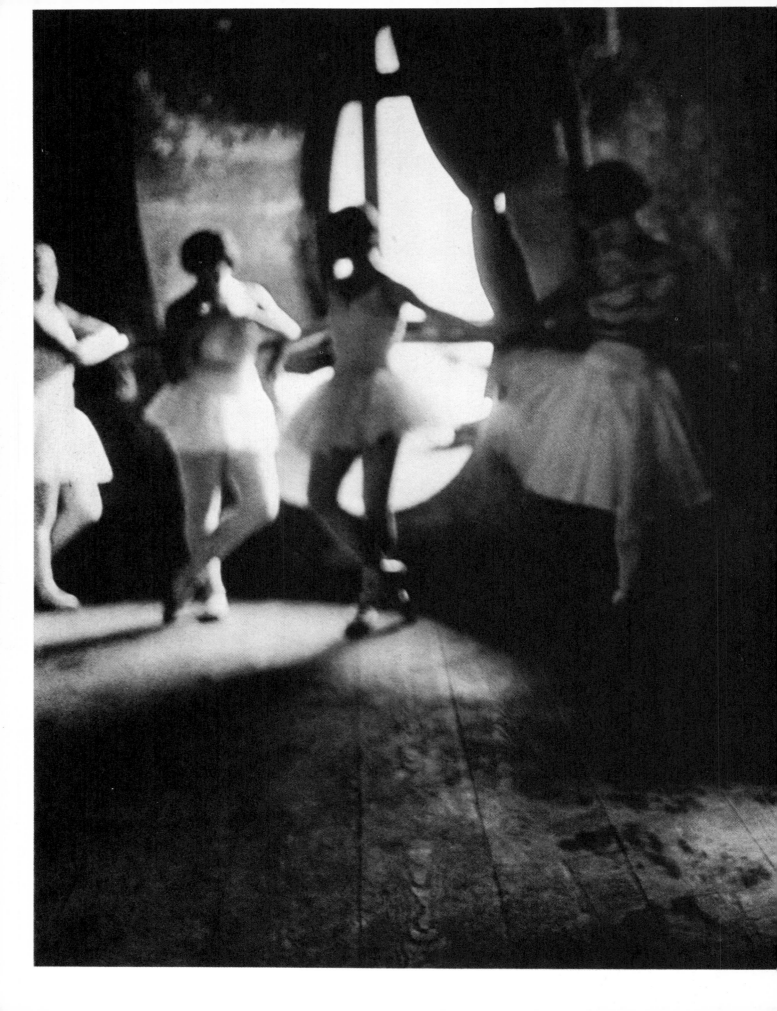

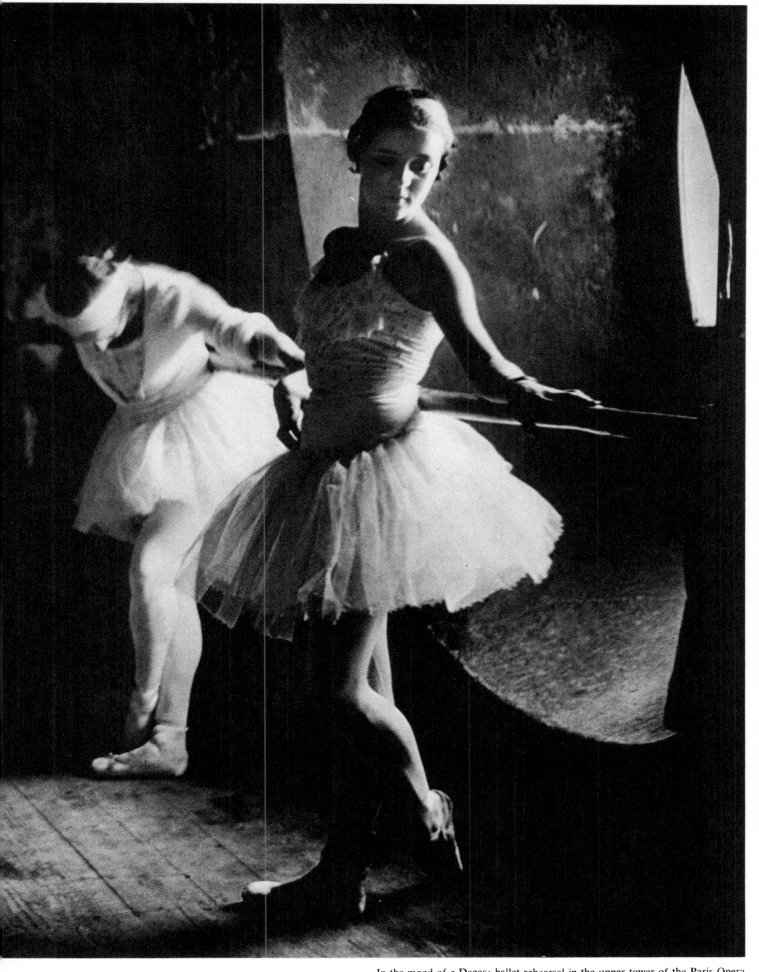

In the mood of a **Degas**: ballet rehearsal in the upper tower of the Paris Opera.

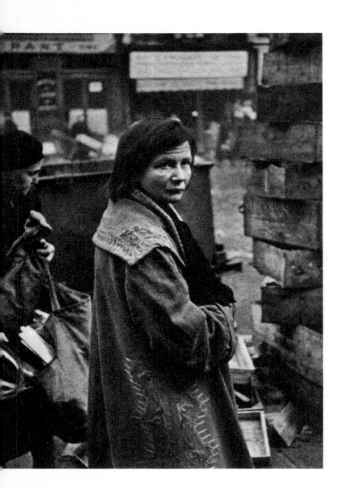

Paris, 1931. Ladies of the evening, Montmartre. LEFT AND BELOW: The poor, near Les Halles market. OPPOSITE: The eternal flame at the Arc de Triomphe.

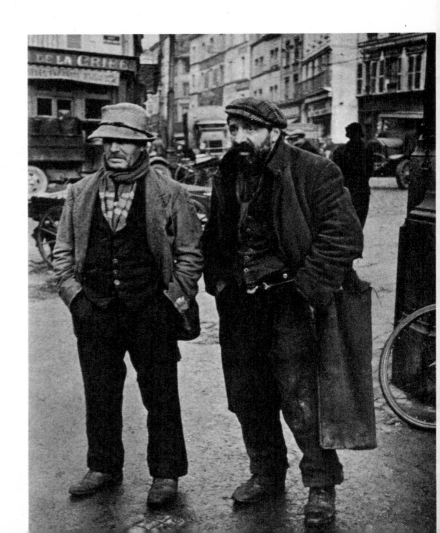

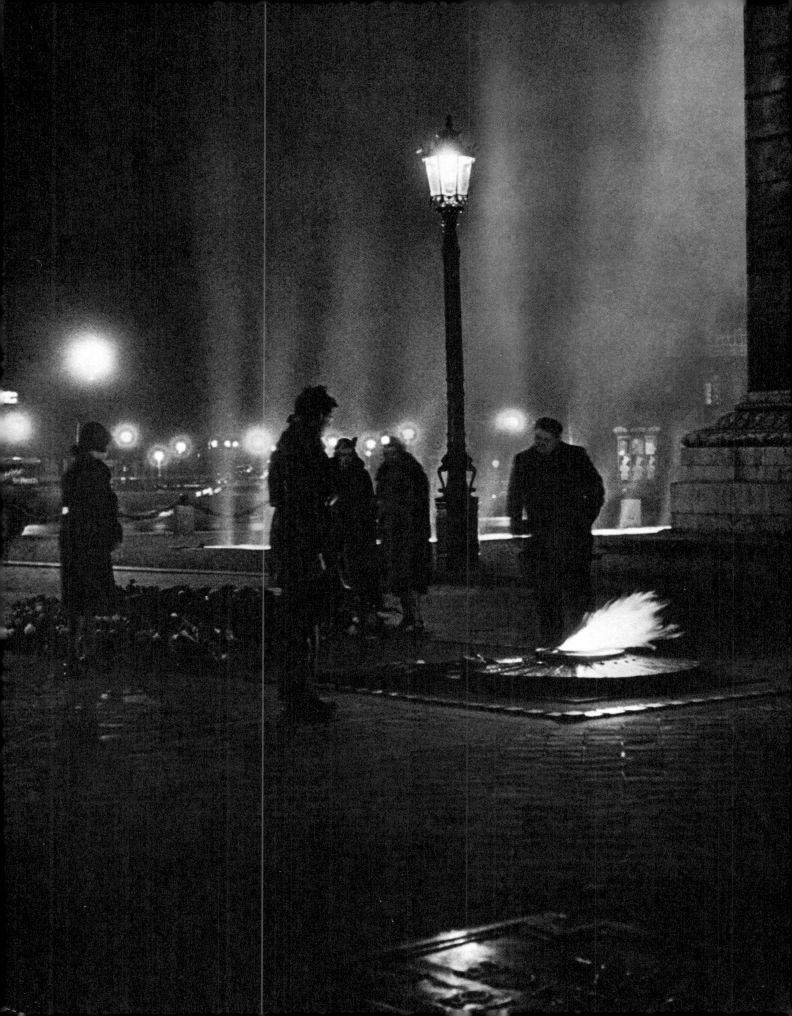

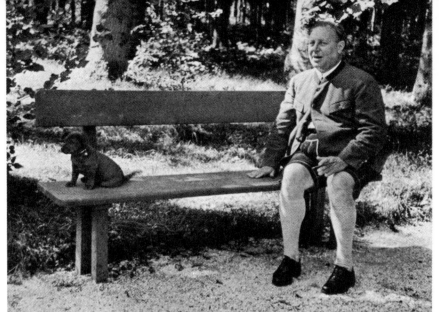

EMIL JANNINGS (*The Last Laugh, The Blue Angel*) with diminutive dachshund at his estate in Wolfgansee, 1930.

OPPOSITE: A rare glimpse of RICHARD STRAUSS. The composer was on his way to an outdoor performance of Hofmannsthal's *Everyman*, the spectacle produced by Max Reinhardt (page 40) during the Salzburg festival of 1931.

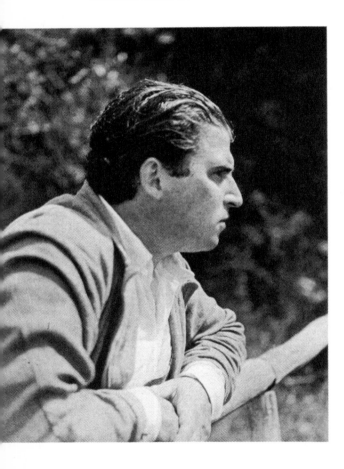

KARL ZUCKMAYER, who adapted novelist Heinrich Mann's *Professor Unrat* for the film *The Blue Angel*, also wrote *The Captain from Köpenick*, the satirical play ordered closed by Hitler in the thirties. *Köpenick* was filmed in Germany in 1958 and received an Old Vic stage production in London in 1971.

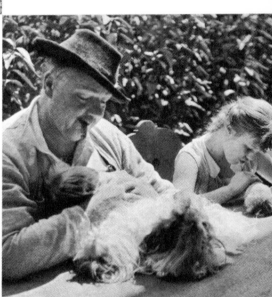

Actor LEO SLEZAK, with daughter, cocker spaniel, and rabbits, enjoying the Bavarian sunshine. Leo's son, Walter, became internationally famous, via Hollywood, in 1942.

ALBERT BASSERMANN, proud recipient of Germany's highest acting award—the Iffland ring—with his wife and co-star, ELSE BASSERMANN, in Arosa.

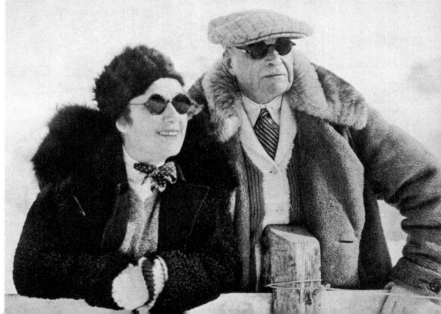
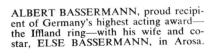

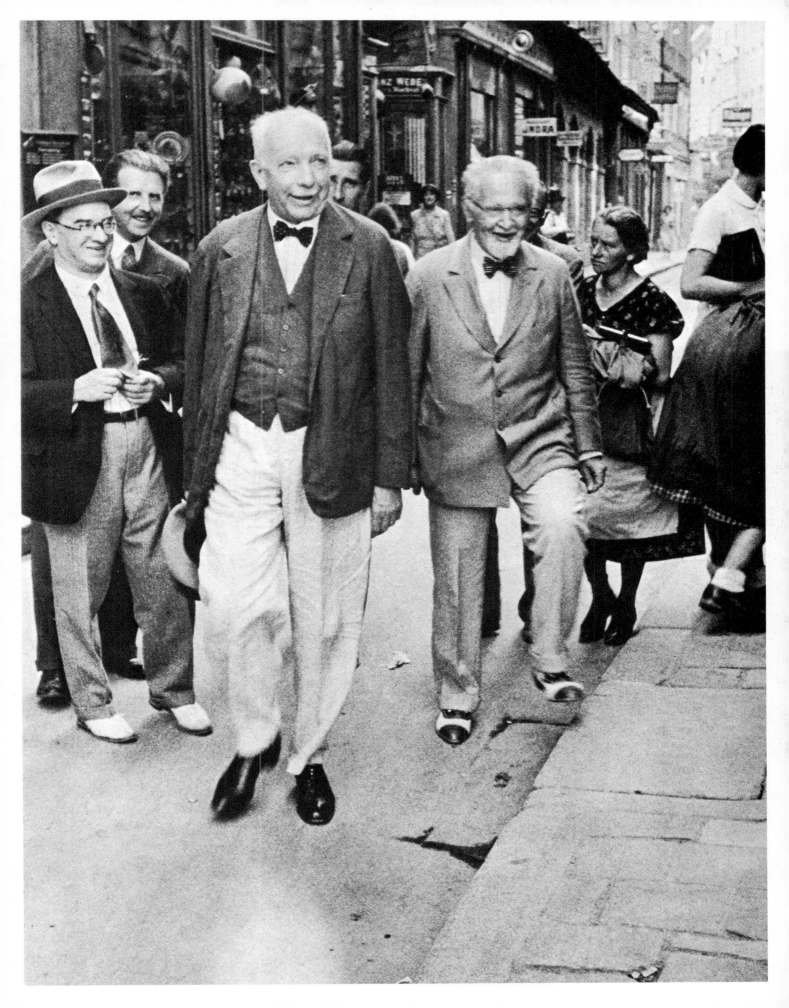

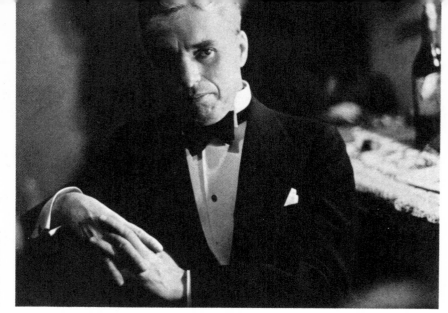

CHARLIE CHAPLIN in Berlin shortly before the release of the film he liked best, *City Lights,* in 1931. Chaplin went to London for the premiere, which was attended by many celebrities including George Bernard Shaw (pages 28–29).

MAX REINHARDT, master of super spectacles (*The Miracle, Everyman, A Midsummer Night's Dream*), at his desk in Berlin's Deutsches Theater, 1930. Three years later—after Hitler's rise to power—the impresario was forced to leave Germany.

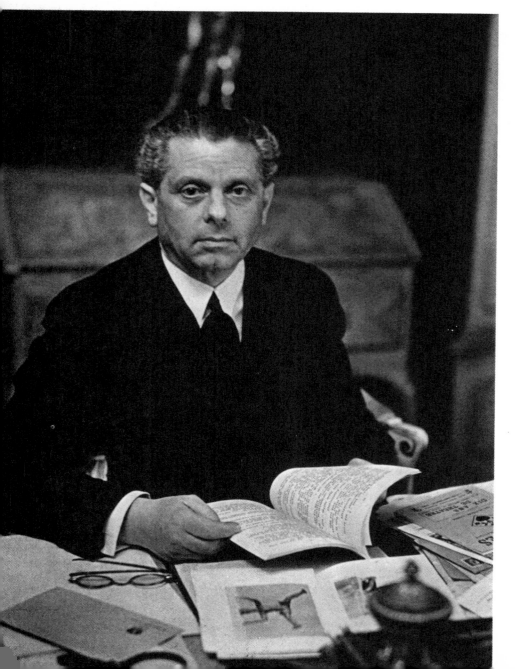

Basso PAUL ROBESON, of *Show Boat* and *Emperor Jones* fame, in Berlin, 1928.

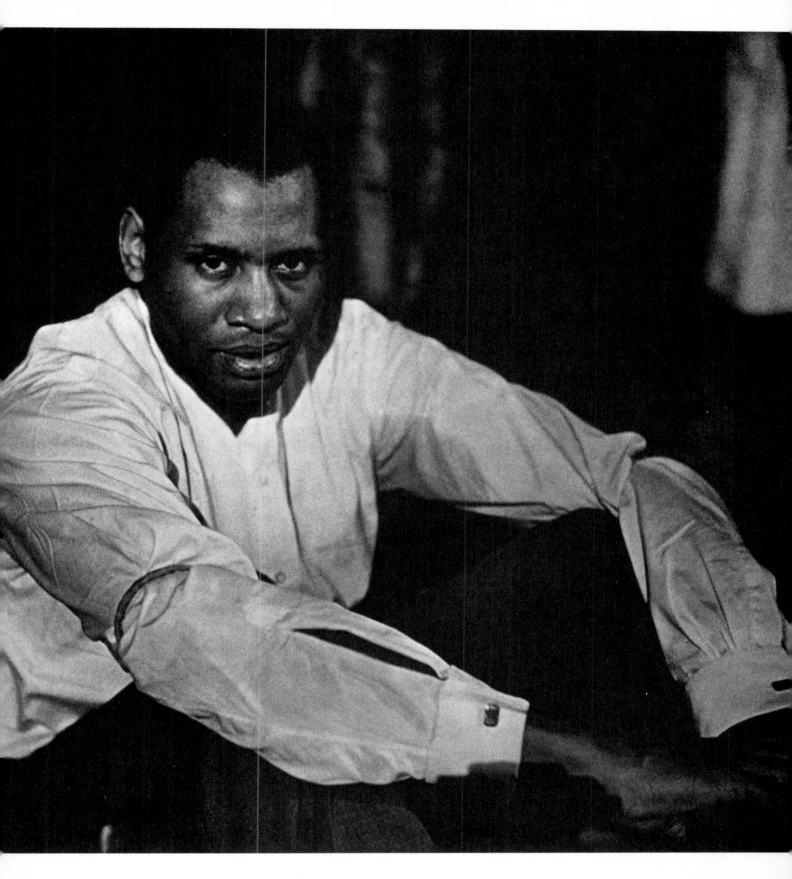

OVERLEAF: The auditorium of Milan's La Scala in 1933 during the season's full-dress premiere: Rimsky-Korsakov's *Legend of the Invisible City of Kitezh*.

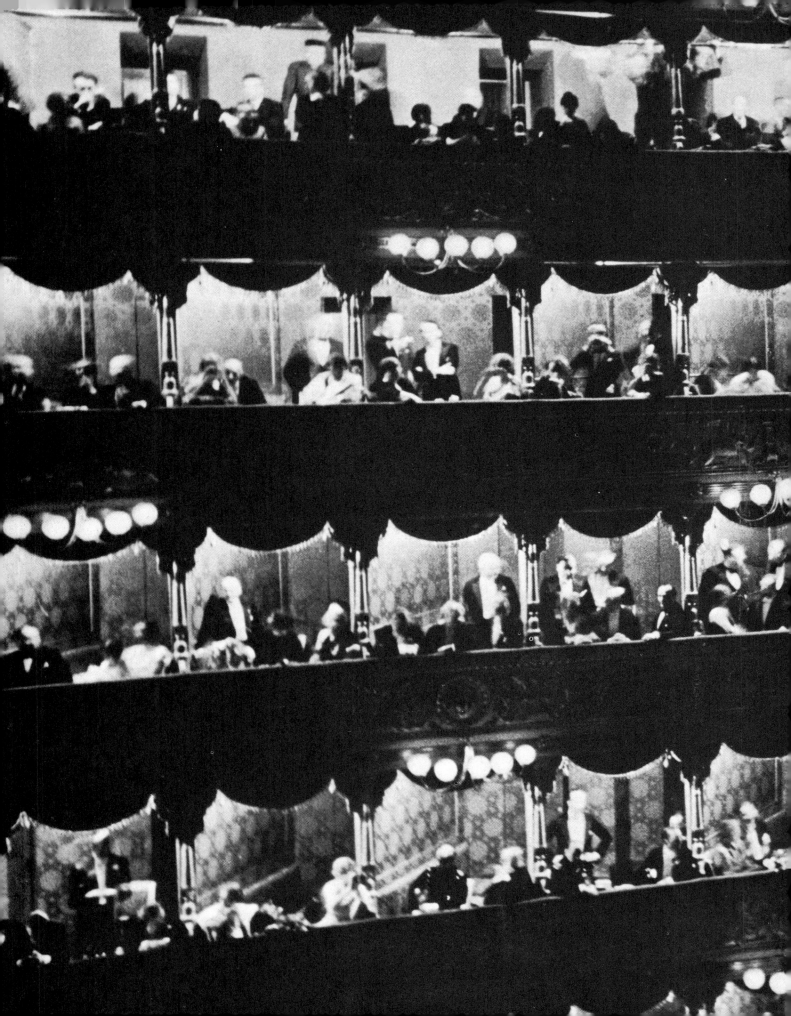

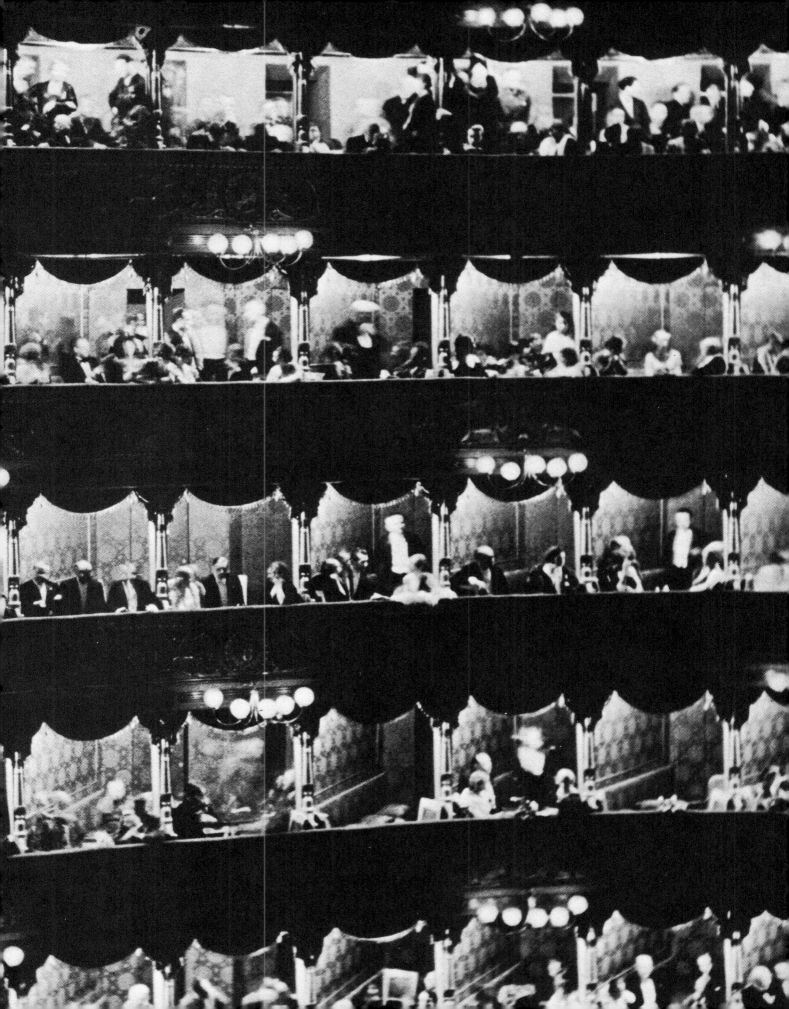

ABOVE: IGOR STRAVINSKY leading the Berlin Philharmonic
Orchestra in a program of his works in 1932. BOTTOM ROW,
LEFT TO RIGHT: WILLEM MENGELBERG conducting Brahms's
German Requiem in Amsterdam, 1932; Basso FEODOR
CHALIAPIN following a performance of Moussorgsky's *Boris
Godunov* (his best-known role) in Berlin, 1931; JASCHA
HEIFETZ before a performance of Beethoven's Violin Con-
certo, Berlin, 1932; and, the greatest interpreter of Chopin,
ALFRED CORTOT, on stage in Berlin. RIGHT: Prodigy violinist
RUGGIERO RICCI on stage for a Paganini recital at Berlin's
Philharmonic Hall in 1934.

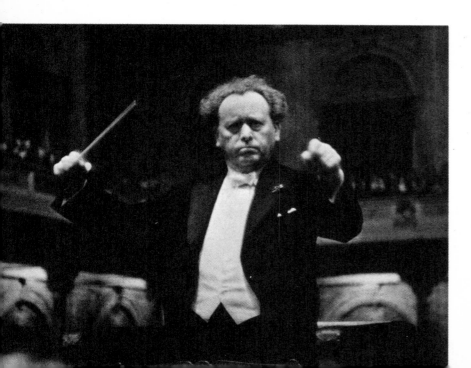

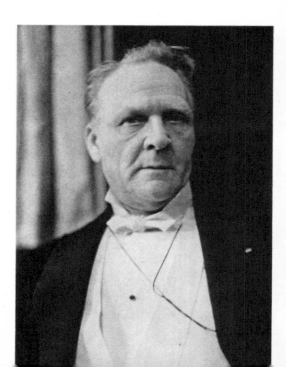

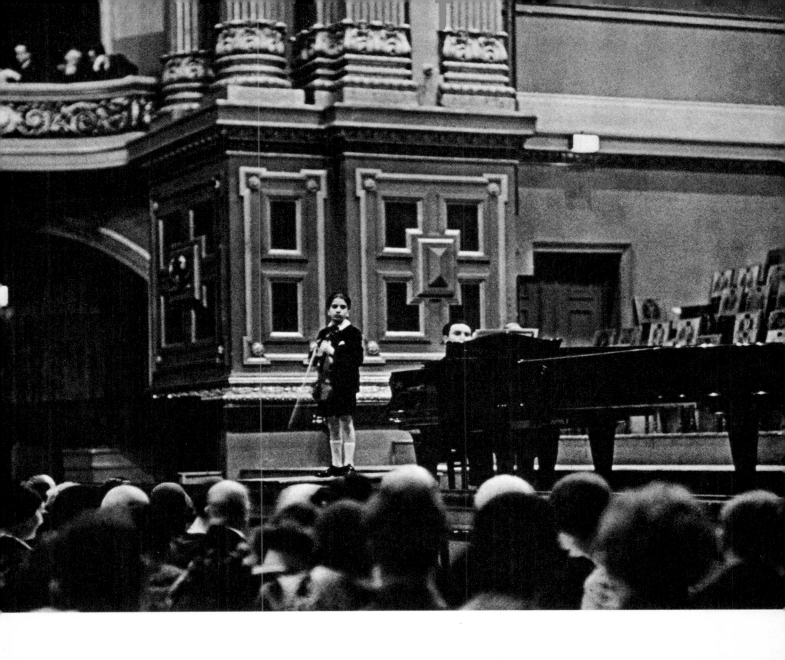

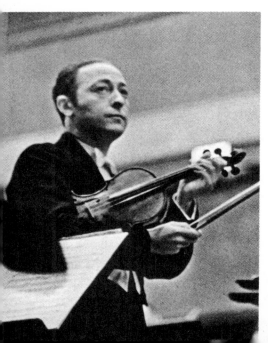

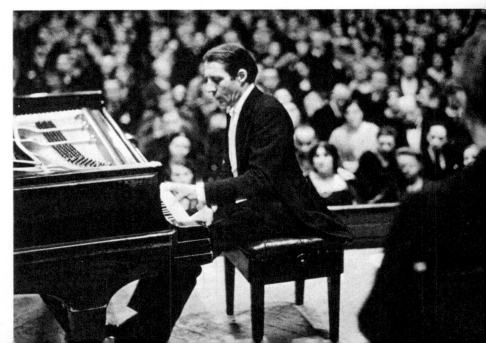

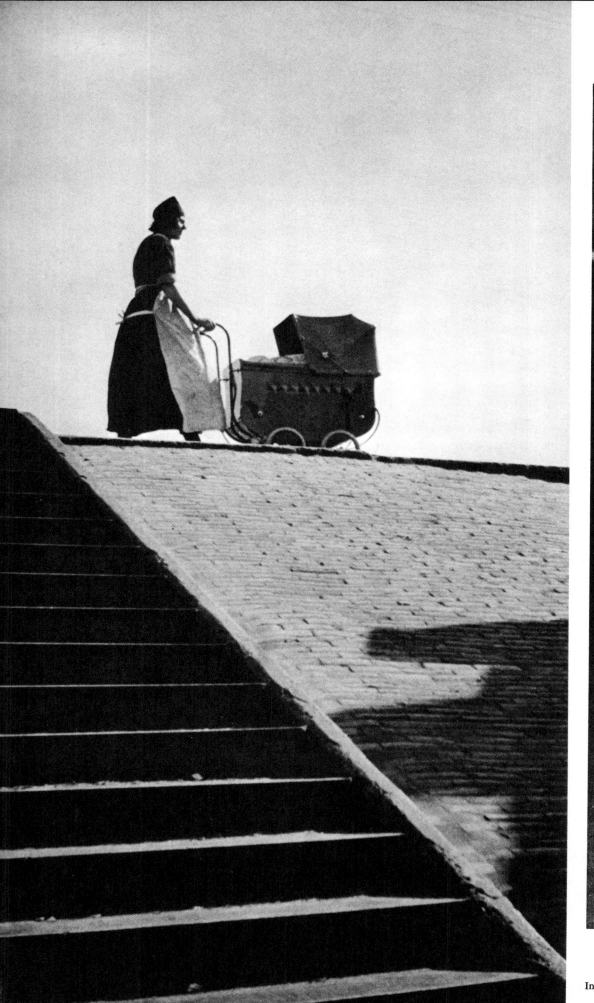

In Volendam.

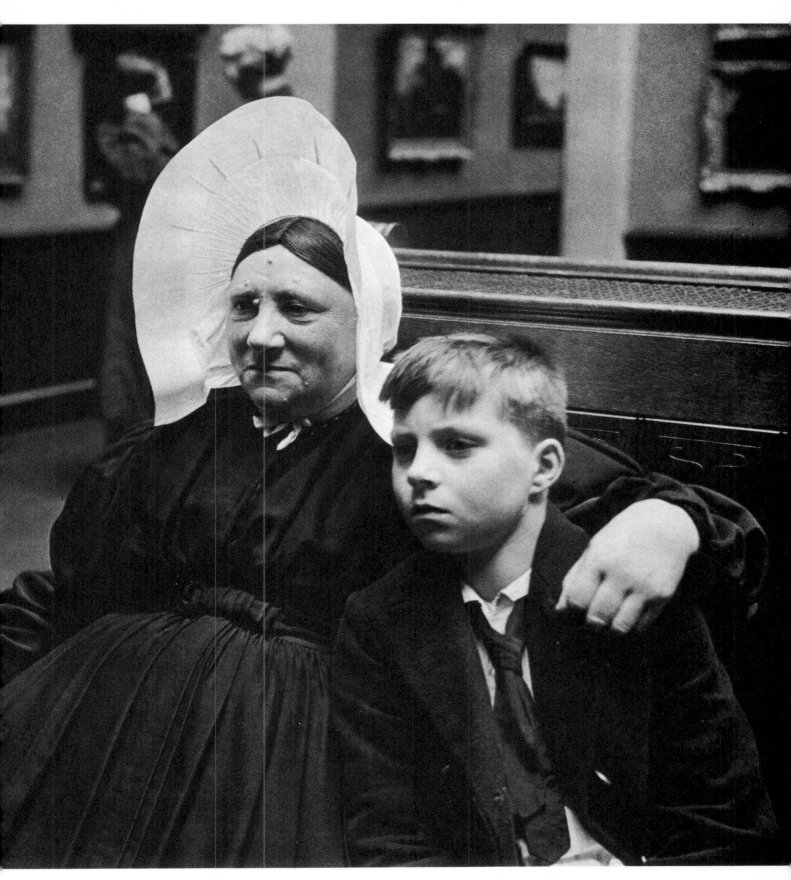

A grandmother and grandson viewing Rembrandt's *Night Watch* in Amsterdam's Rijksmuseum.

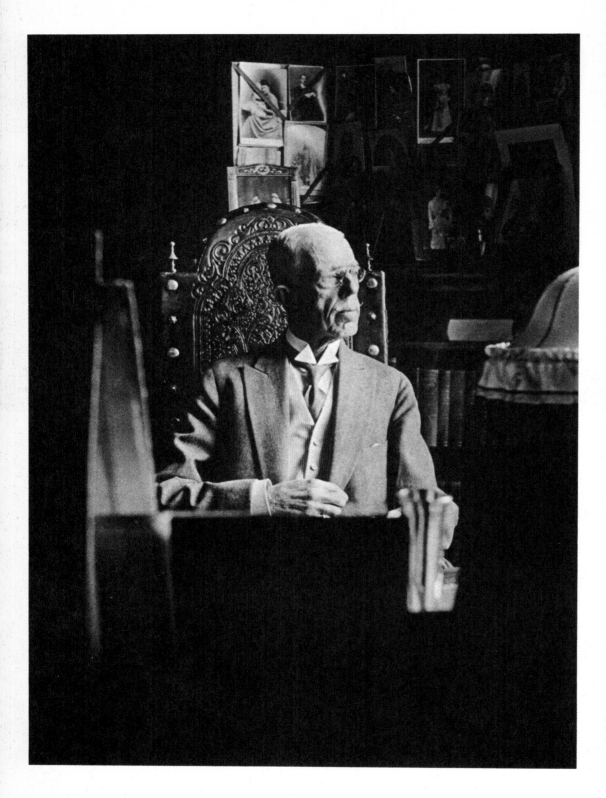

Sweden's GUSTAF V at his castle in Stockholm, 1934. The King was particularly proud of his silver collection. His other hobbies: tennis and knitting.

JOHN GALSWORTHY, author of *The Forsyte Saga,* with violinist FRITZ KREISLER in Lausanne in 1931. The following year, Galsworthy was awarded the Nobel Prize for Literature.

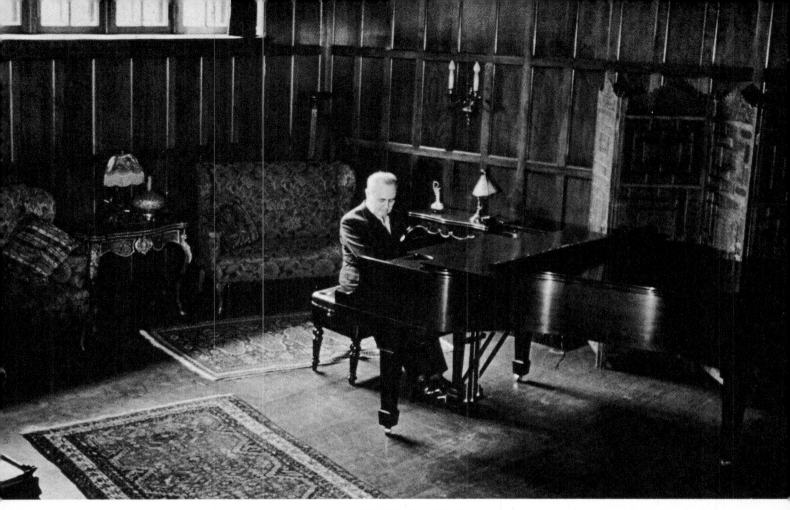

JOSEPH HOFMANN, Polish-American pianist and director of Philadelphia's Curtis Institute, photographed at home in the mid-thirties.

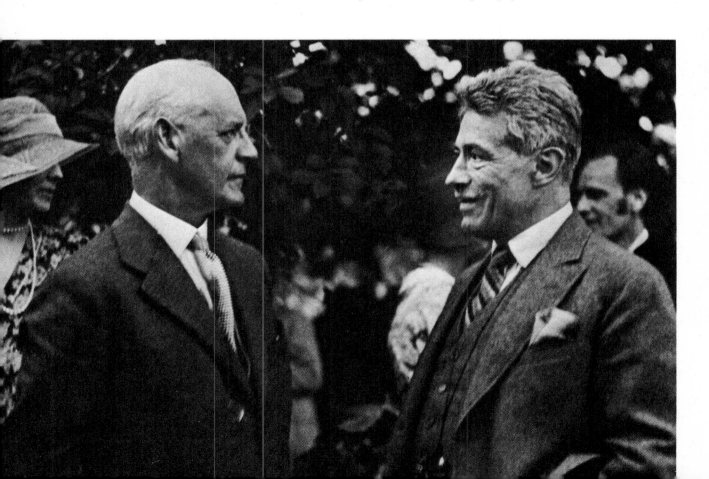

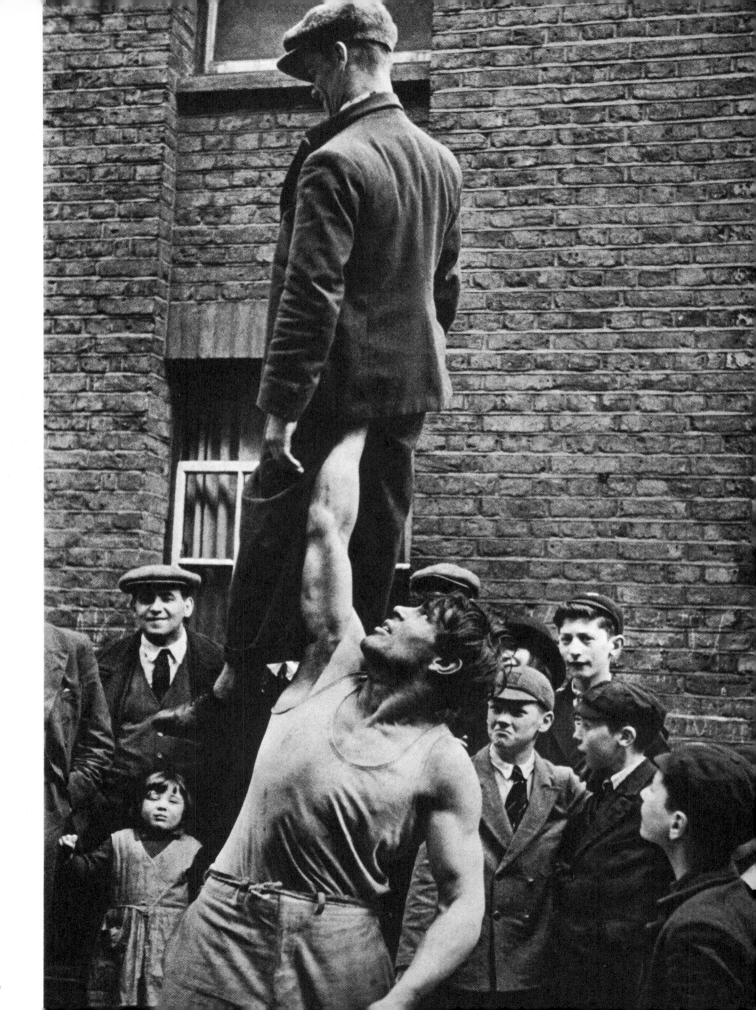

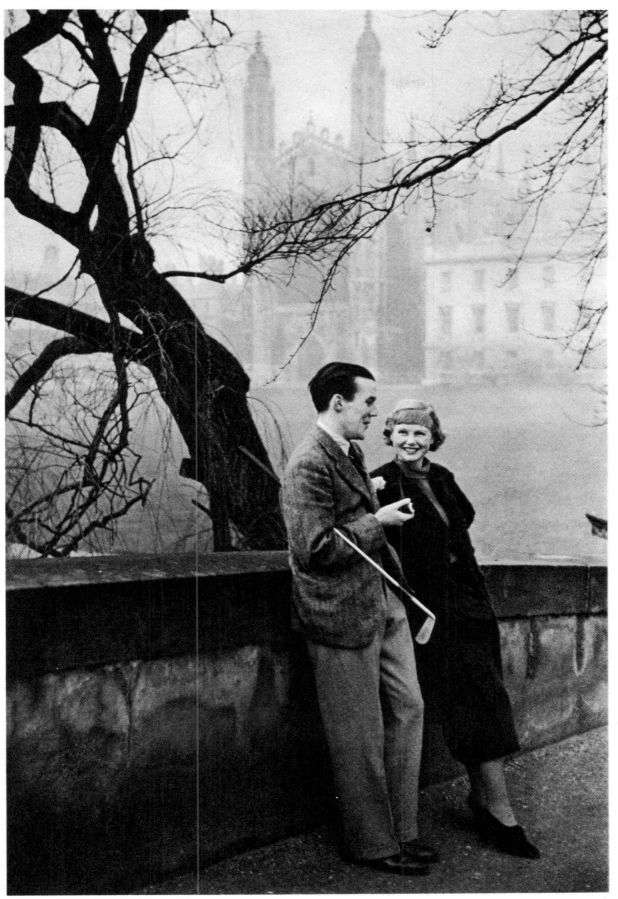

Abandoning golf in favor of a girl friend, a Cambridge student enjoys a foggy afternoon along "the backs."

Street performer in London's East End in the early thirties.

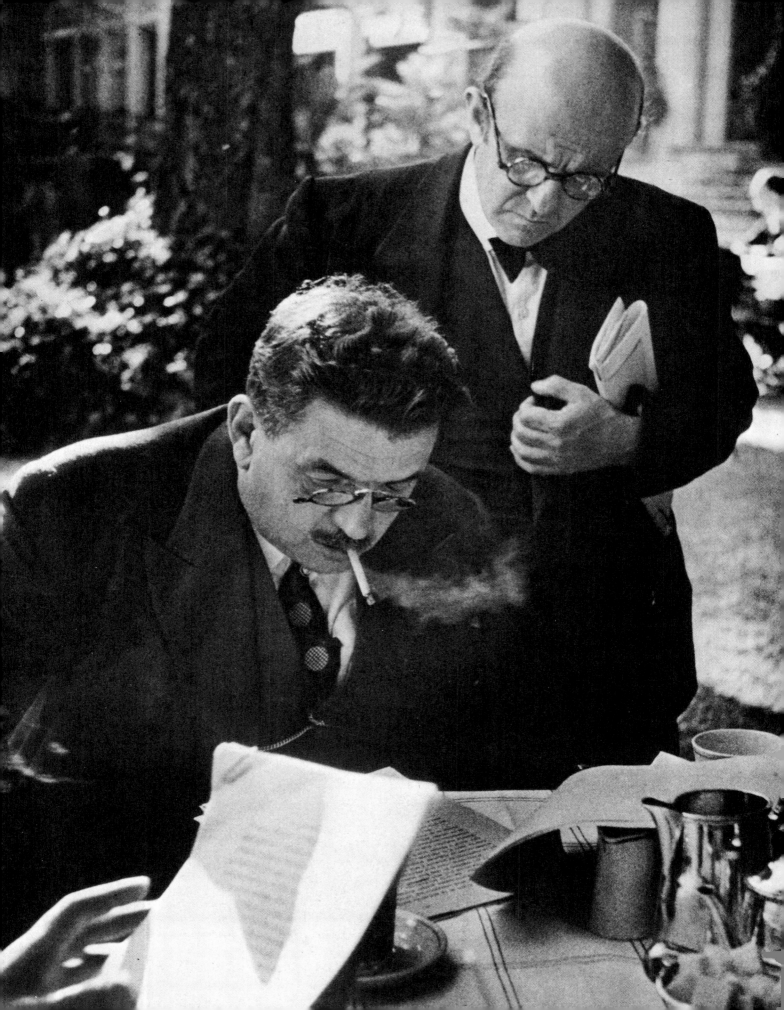

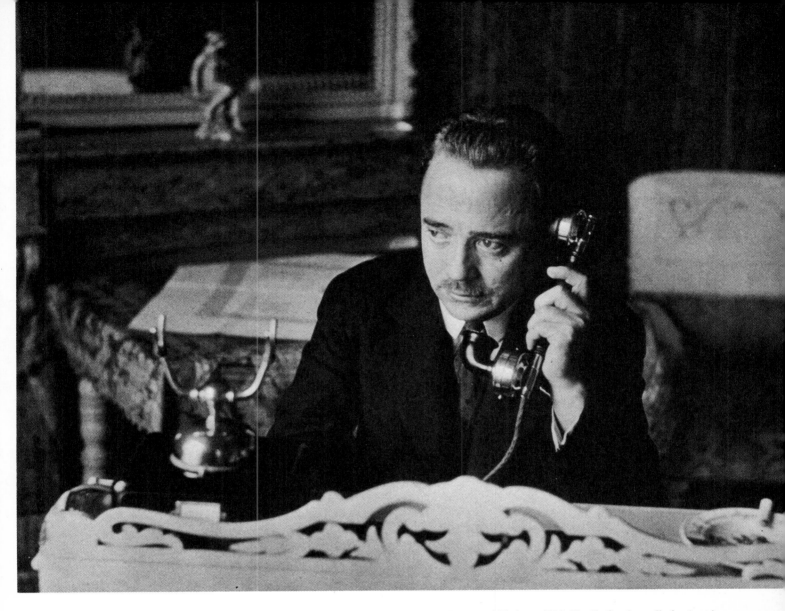

ENGELBERT DOLLFUSS in his hotel during the fifteenth session of the League of Nations, 1933. Hardly five feet tall, the Austrian Chancellor traveled with a small desk especially made to accommodate his size. In 1934, Dollfuss was assassinated by the Nazis.

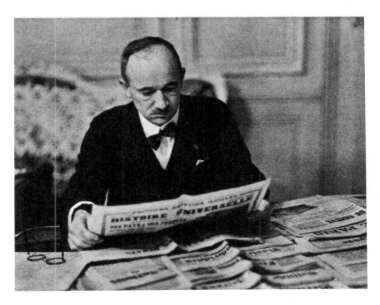

ÉDOUARD HERRIOT, Premier of France, during the Reparations Conference in Lausanne, 1932.

EDUARD BENEŠ, foreign minister of Czechoslovakia and later the country's President.

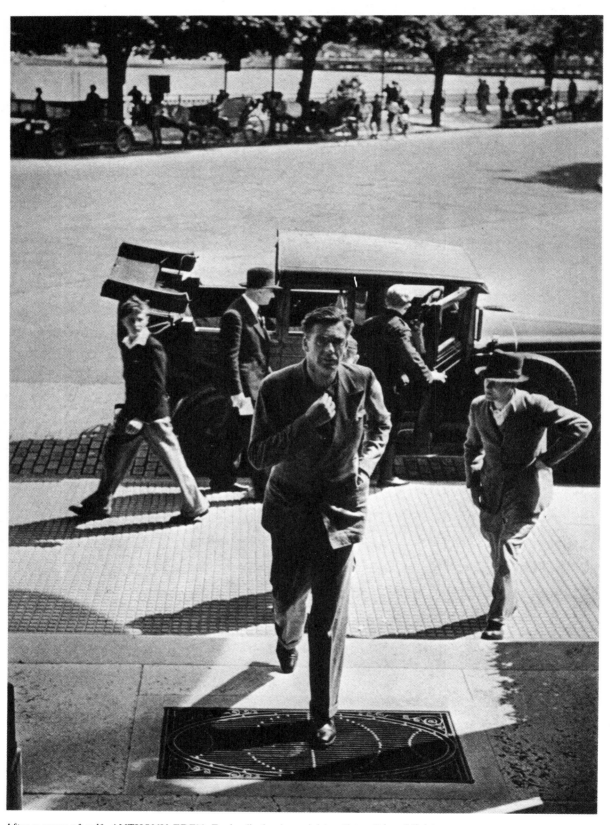

After a game of golf, ANTHONY EDEN, England's foreign minister (later Prime Minister, and Earl of Avon in 1961), hurries to attend a session at the League of Nations in 1934.

RAMSAY MacDONALD, Britain's Labour Prime Minister, delivering the opening speech at the Reparations Conference in Lausanne, 1932. ON HIS RIGHT: British Foreign Secretary JOHN SIMON and LORD RUNCIMAN.

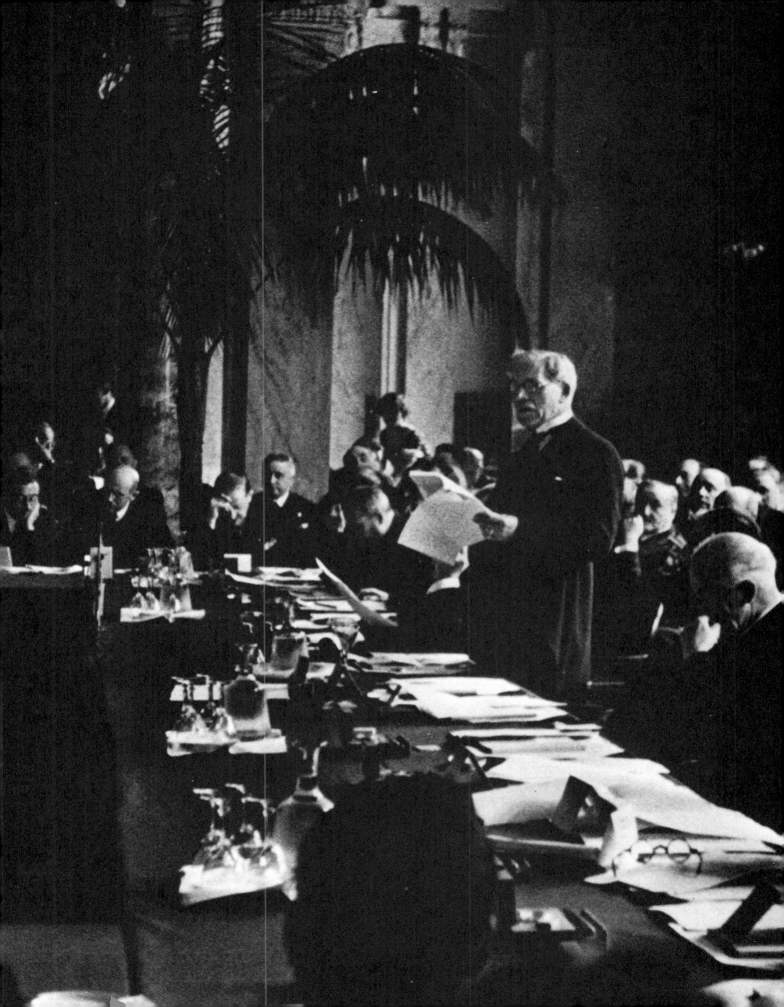

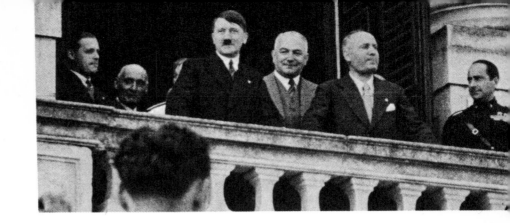

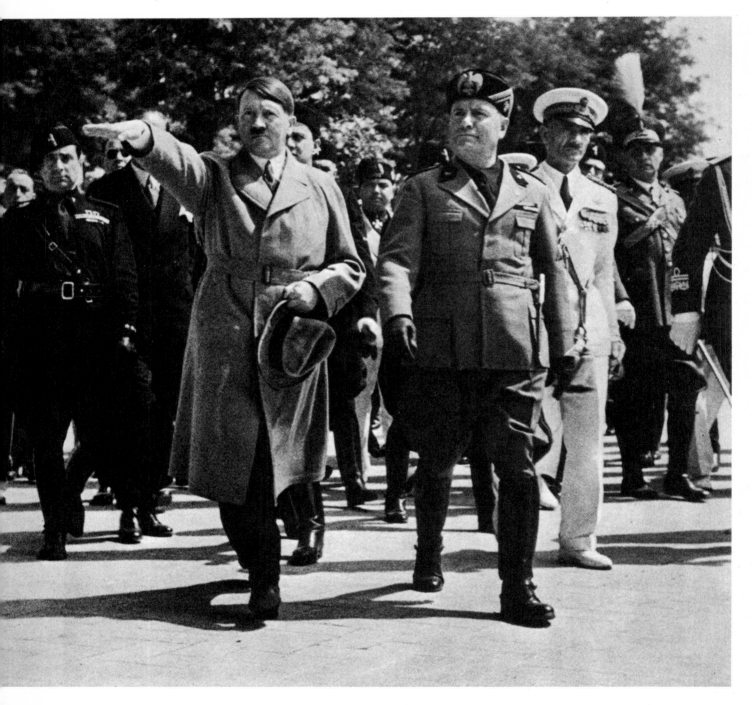

ADOLF HITLER with BENITO MUSSOLINI in Venice, June 13, 1934, shortly after the two had met for the first time. To Hitler's left: ACHILLE STARACE, leader of the Blackshirts (1931–39). Two months later, President von Hindenburg died and Hitler became Führer of the Reich. This was one of Hitler's last public appearances in civilian clothes.

HITLER and MUSSOLINI addressing a crowd of 50,000 from a balcony in the Piazza San Marco. Between the two: Germany's foreign secretary, KONSTANTIN VON NEURATH, and, at right, ACHILLE STARACE.

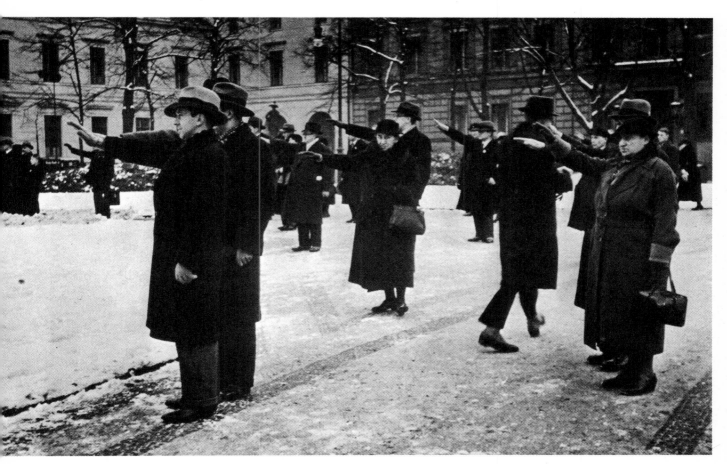

In front of Hitler's Berlin (Wilhelmstrasse) headquarters, citizens raise their arms in salute. The Führer had just announced Germany's victory in the Rhineland plebiscite.

JOSEF GOEBBELS in 1933, following his appointment as Germany's minister of culture and propaganda.

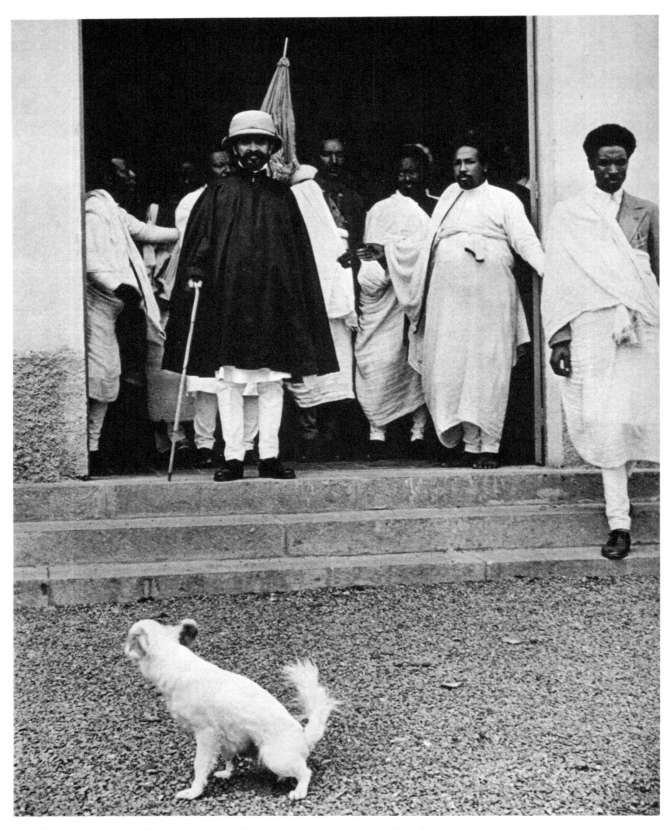

In 1935, following the official opening of Ethiopia's new Parliament Building in Addis Ababa, Emperor HAILE SELASSIE catches sight of his favorite Pekinese . . .

and a Moslem woman lifts her hands to her face.

OVERLEAF: Two priests of the Ten Commandments. Ethiopia.

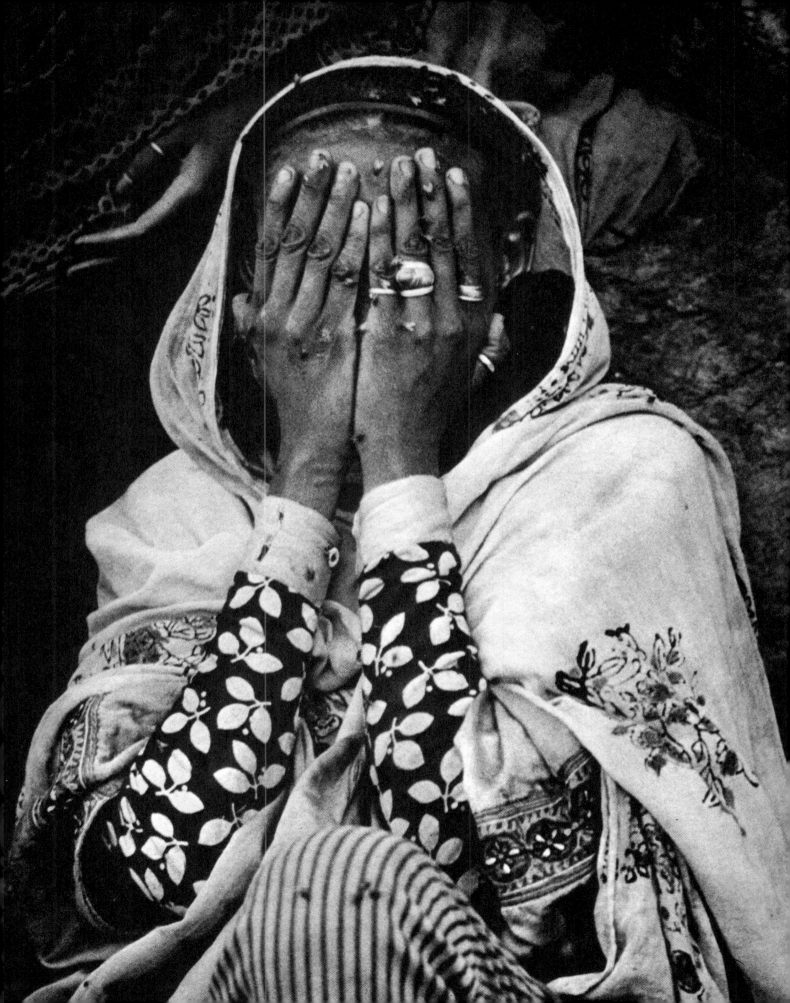

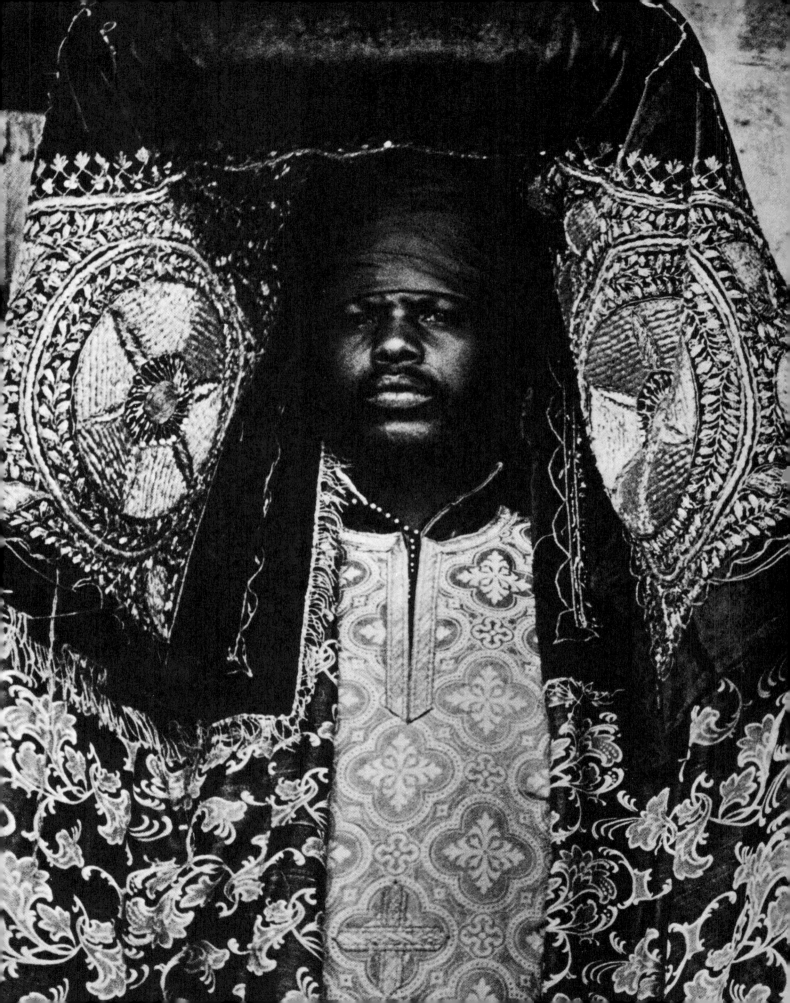

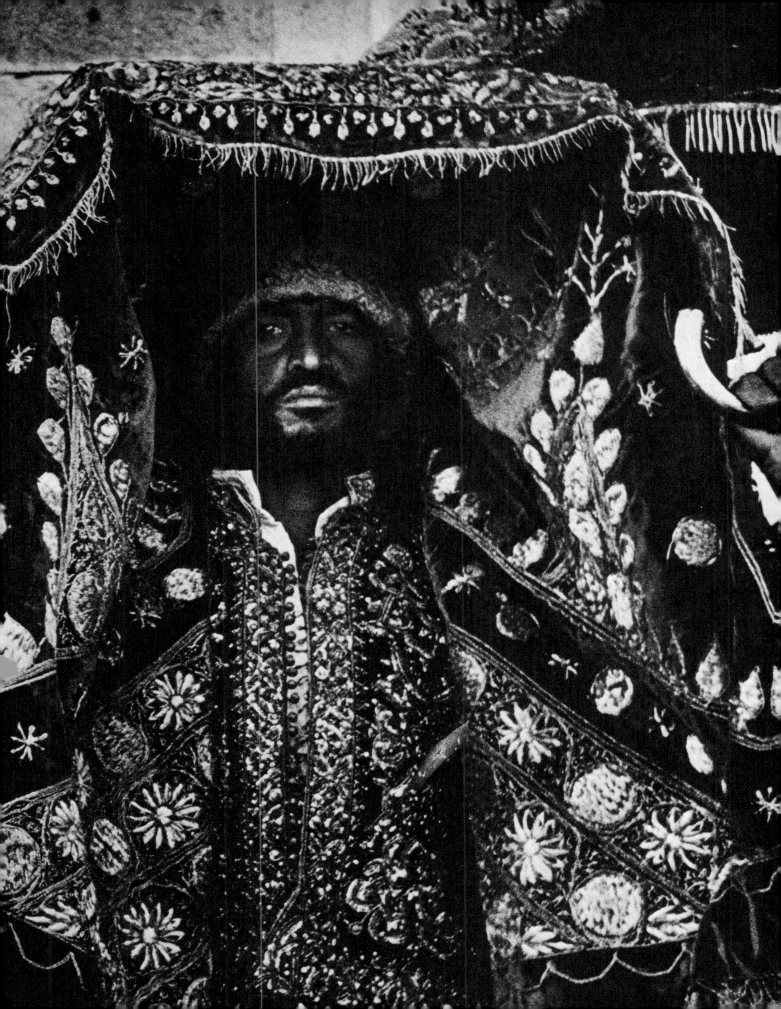

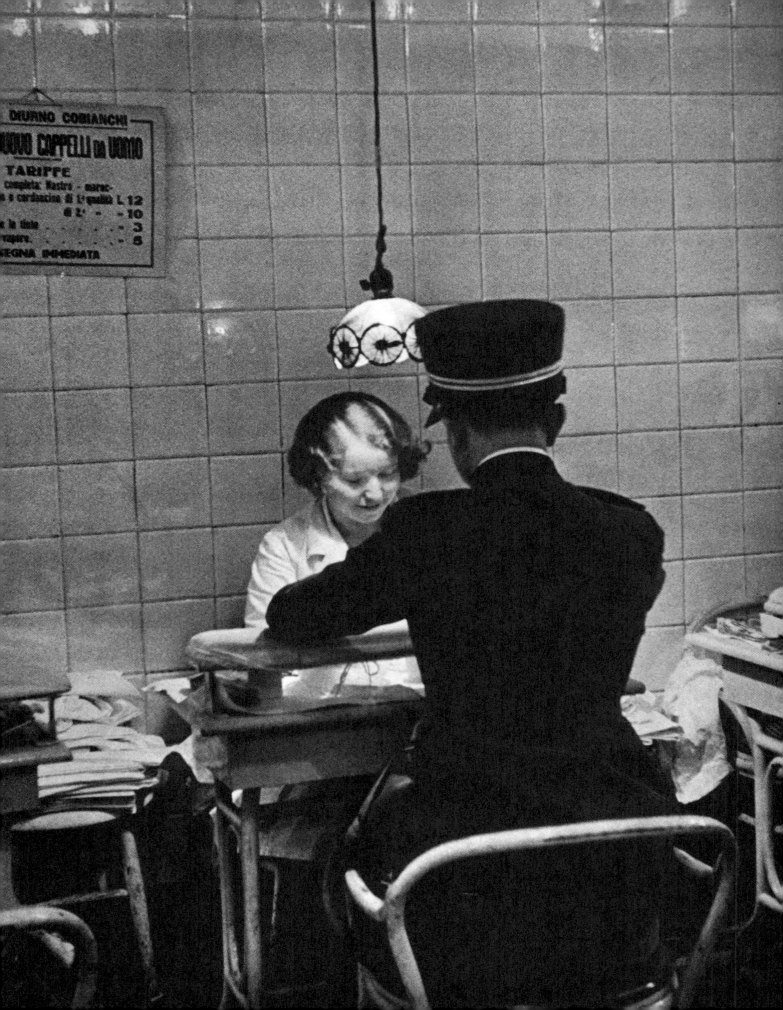

West Point cadet hazing.

Italian officer "relaxing" in a Milan manicure shop. After its publication in the German monthly *Die Dame*, the photograph came to the notice of Italian officials, who considered it an affront to their army. The issue was banned in Italy.

OVERLEAF: President FRANKLIN D. ROOSEVELT aboard the cruiser U.S.S. *Indianapolis* in 1936. Accompanied by son JAMES, he was off to Rio de Janeiro to attend a "Good Neighbor Policy" conference.

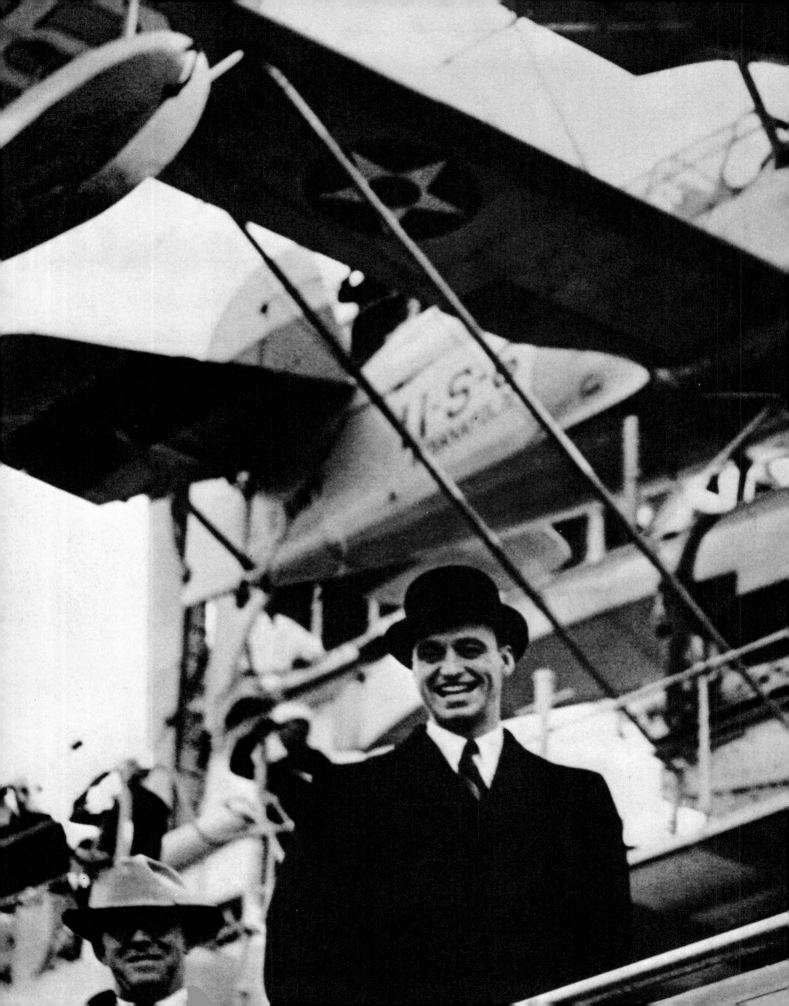

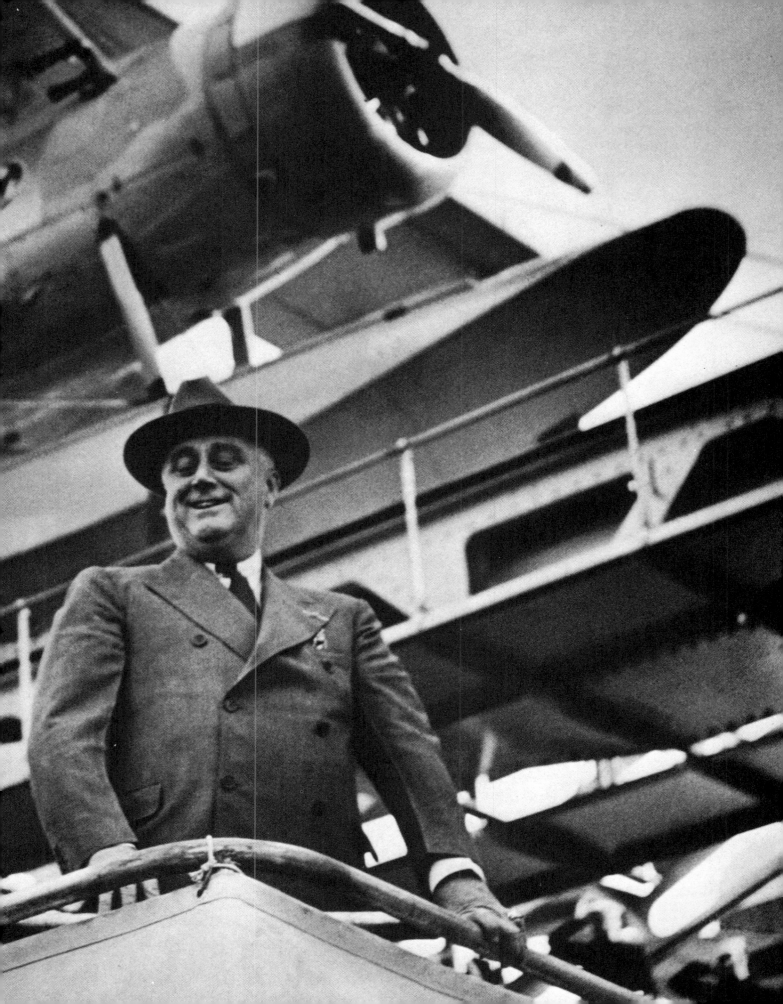

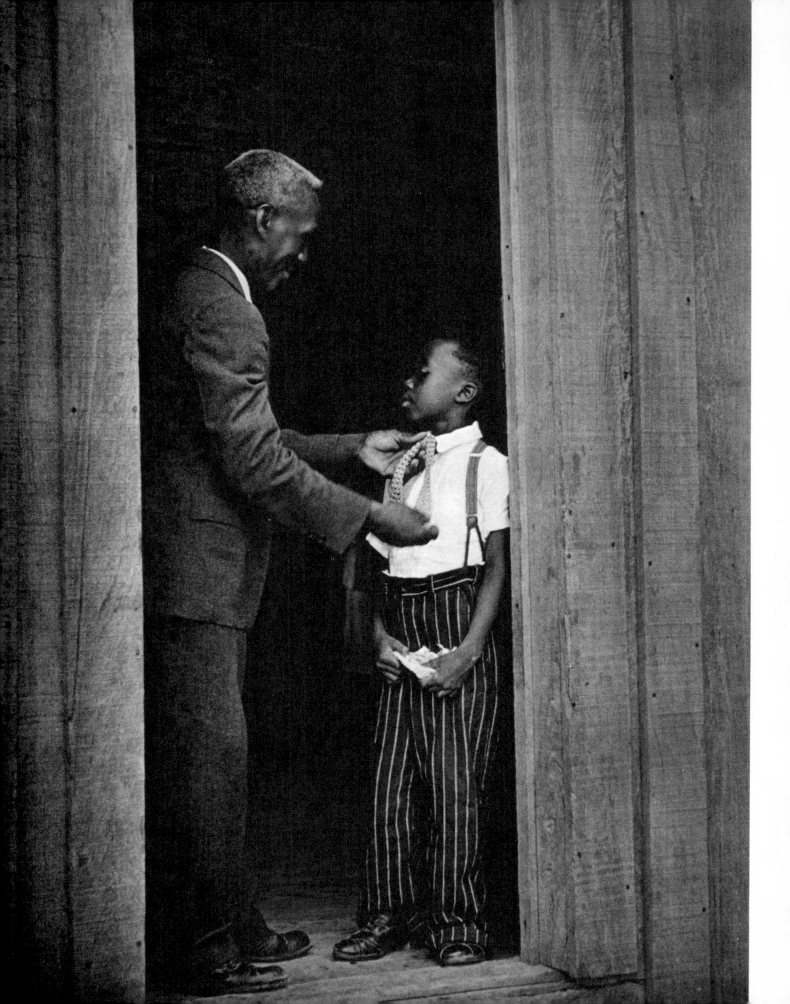

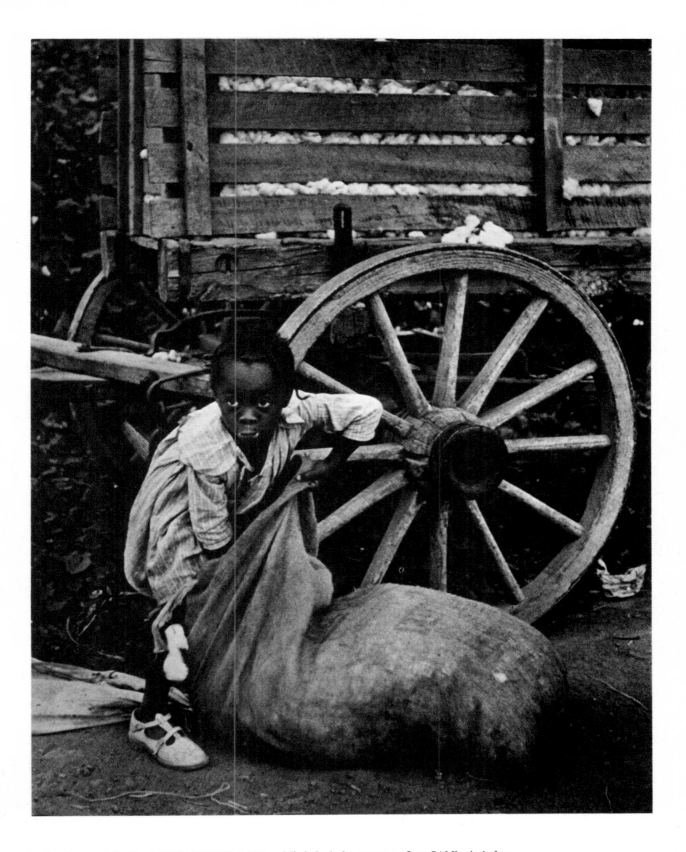

In the depressed South of 1936. LONNY FAIR, a Mississippi sharecropper, fixes SAM's tie before church while VIOLA (ABOVE) checks a sack of cotton destined for the local gin mill—when it's full.

En route to a deer-hunting party at the Lejendre Plantation, South Carolina.

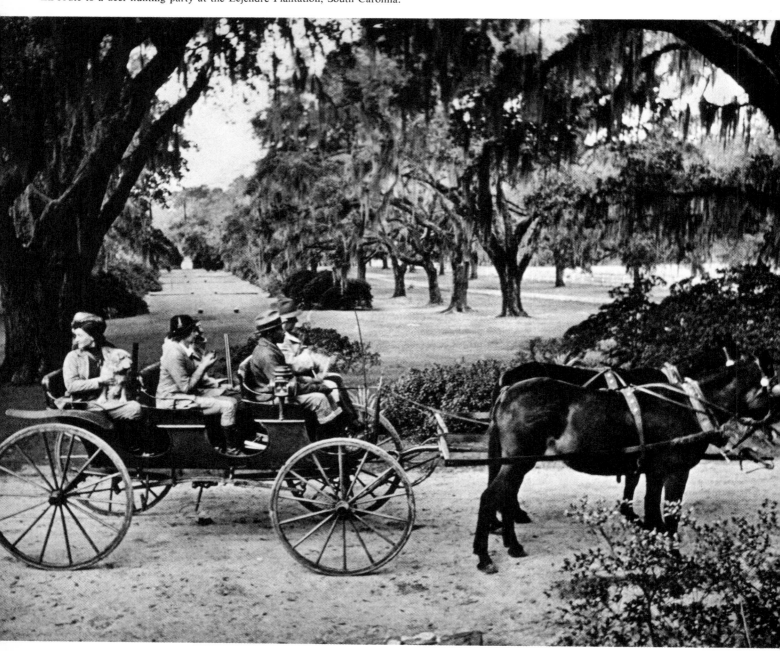

Tenement houses in New Haven, Connecticut, the locale of *The Ramparts We Watch*, a "March of Time" documentary filmed in 1937.

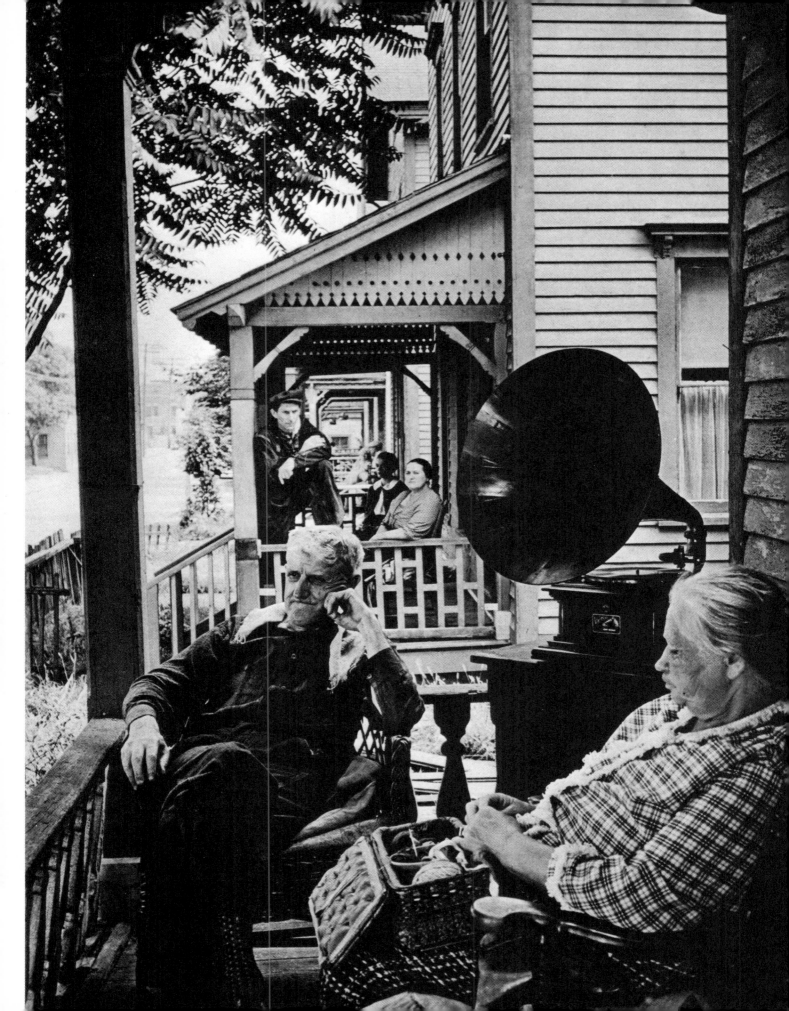

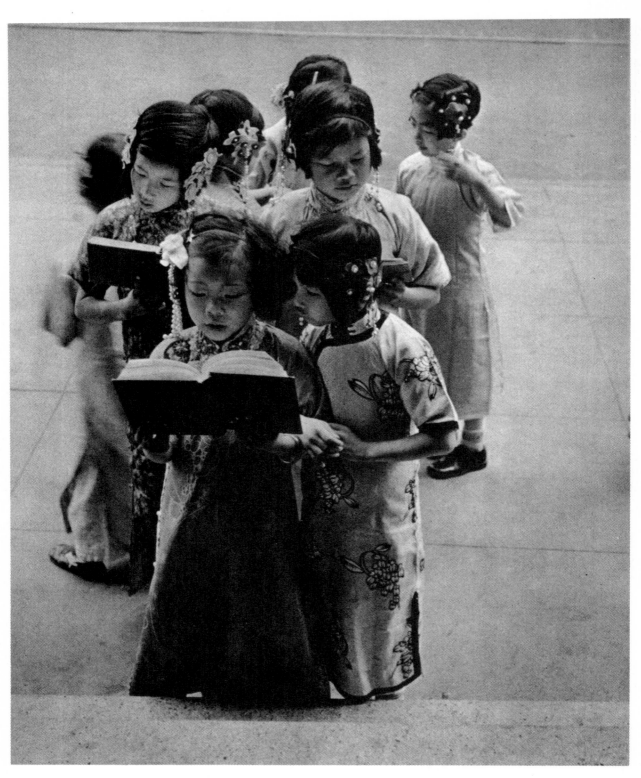

Girls at a Chinese mission school in San Francisco.

Two nuns with one of the students. The photograph appeared in the first issue of *Life* (November 21, 1936).

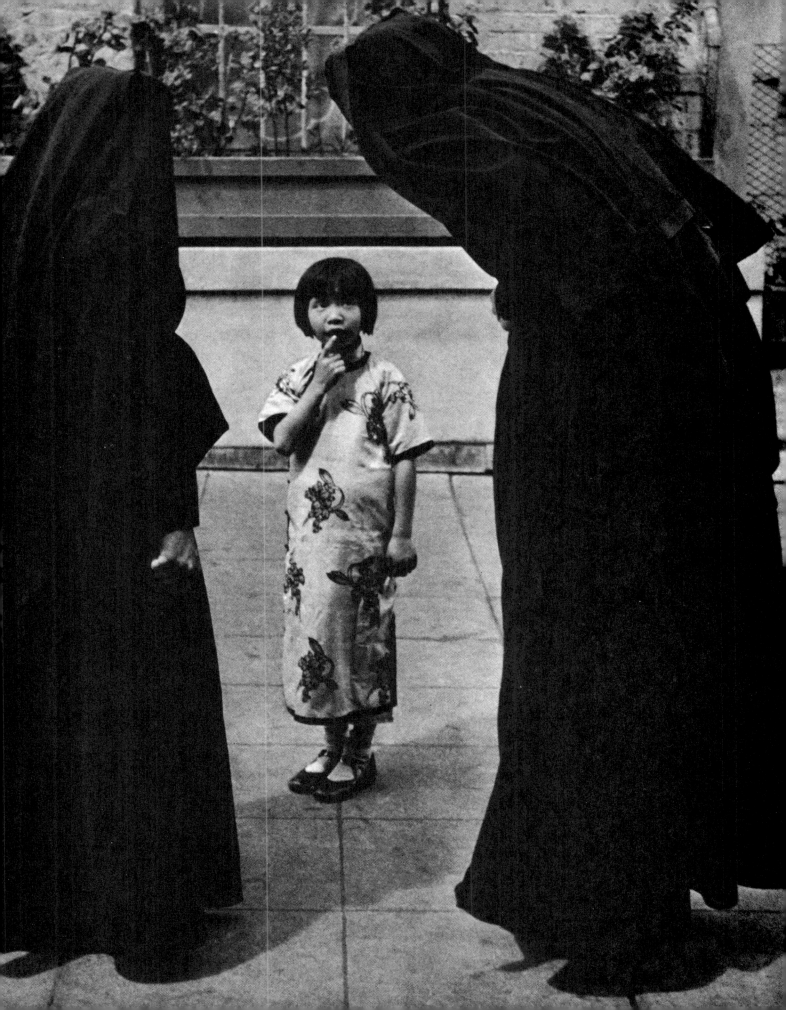

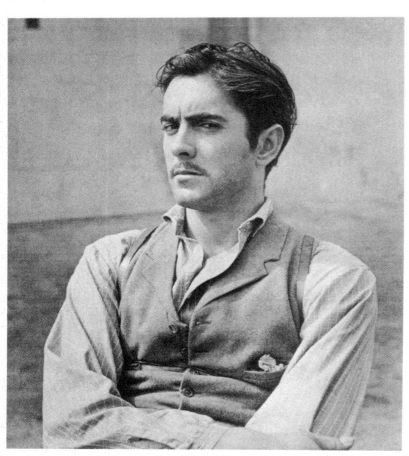

A solemn TYRONE POWER during the shooting of *Jesse James*. It was the actor's fourteenth feature film (1939).

CLARK GABLE, uncrowned king of Hollywood, enjoying a break with an extra during the filming of *San Francisco* on the MGM lot at Culver City, 1936. On screen Gable had already wooed Garbo, Norma Shearer, Marion Davies, Claudette Colbert (page 184), Jean Harlow, Jeanette MacDonald, Helen Hayes—and Carole Lombard (page 77), whom he was to marry in 1939.

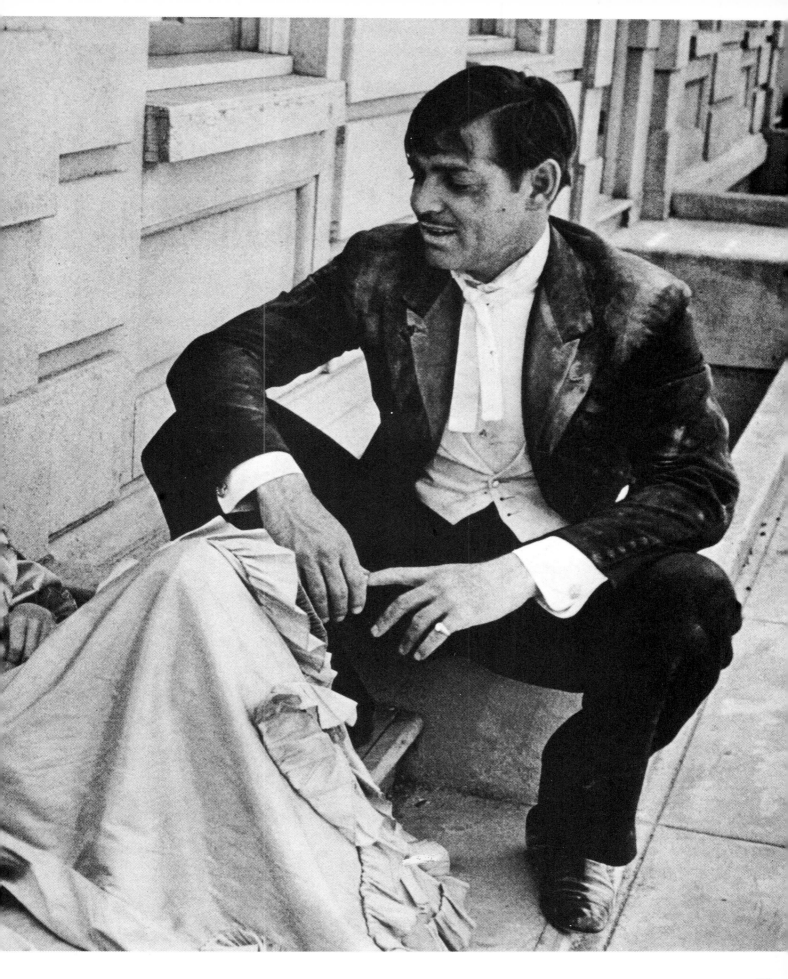

RONALD COLMAN, idol of the silent screen, made his first talkie, *Bulldog Drummond*, in 1929. Ten years and sixteen films later, Mr. Colman posed in Hollywood after completing Kipling's *The Light That Failed*.

KATHARINE HEPBURN dressed for *The Philadelphia Story*, the Philip Barry play that opened on Broadway in 1939. Miss Hepburn repeated her success in the film version a year later.

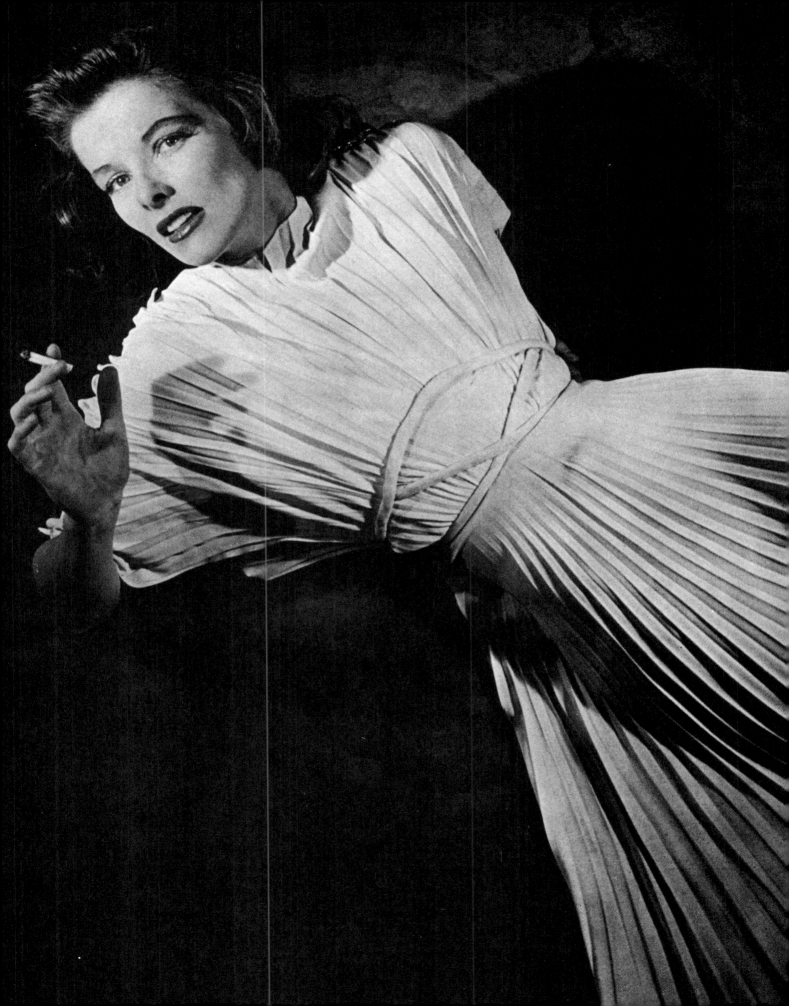

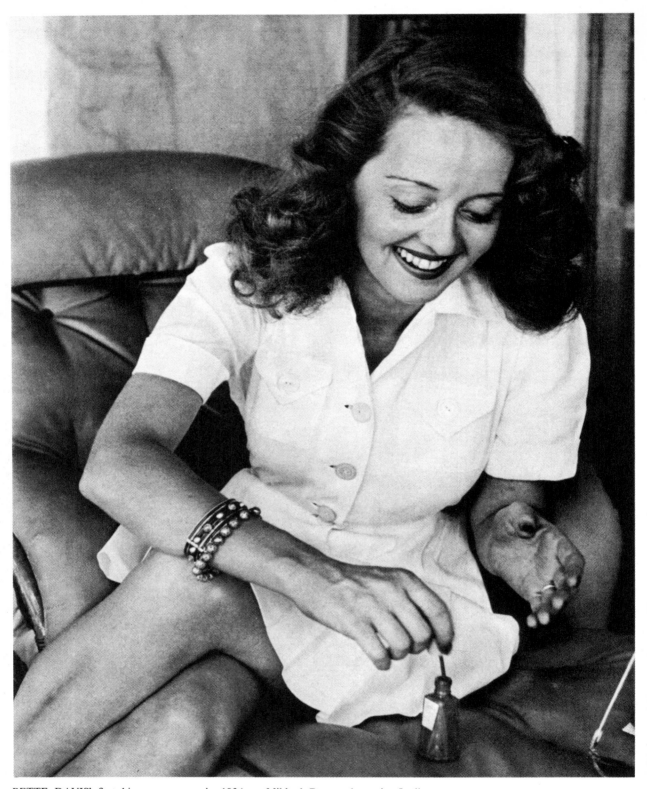

BETTE DAVIS' first big success was in 1934 as Mildred Rogers (opposite Leslie Howard) in *Of Human Bondage,* the film based on the novel by Somerset Maugham (page 87). Miss Davis won Academy awards for her performances in *Dangerous* (1935) and *Jezebel* in 1938, the year this photograph was taken.

In 1938, CAROLE LOMBARD (Jane Alice Peters) from Fort Wayne, Indiana, one of the screen's gayest and brightest comediennes, was filming *Made for Each Other.* "Very few actresses would allow themselves to be photographed with a face coated in heavy cream," she was pleased to point out. The following year, Miss Lombard married Clark Gable (page 73), then portraying Rhett Butler in *Gone with the Wind.* In 1942, she died in an airplane crash.

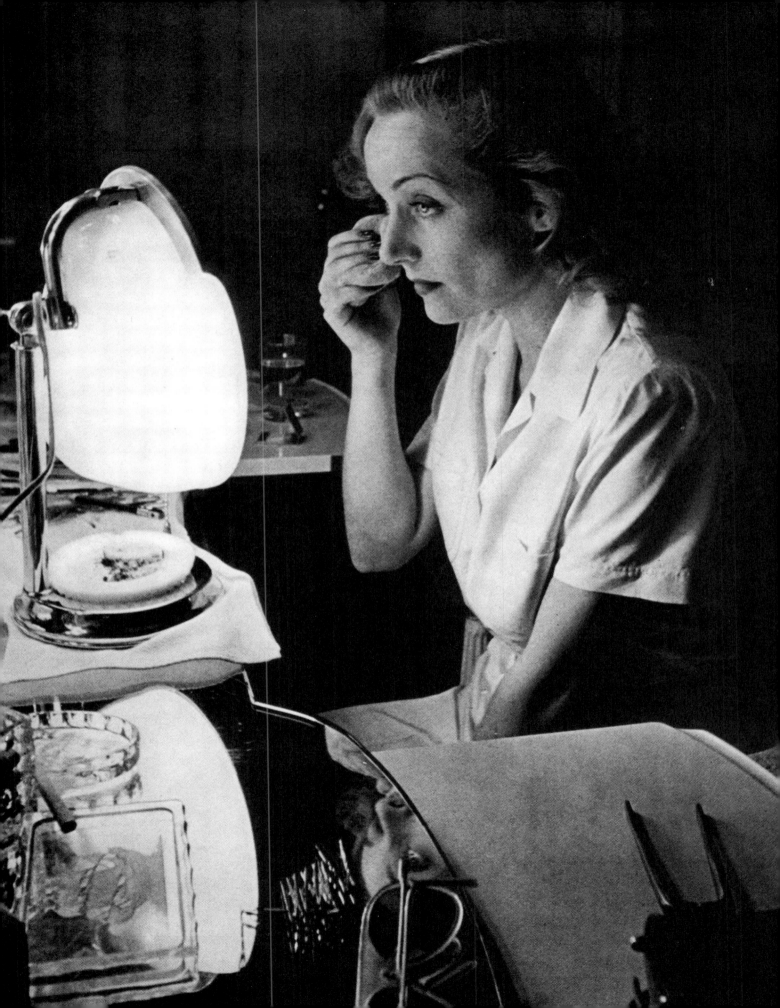

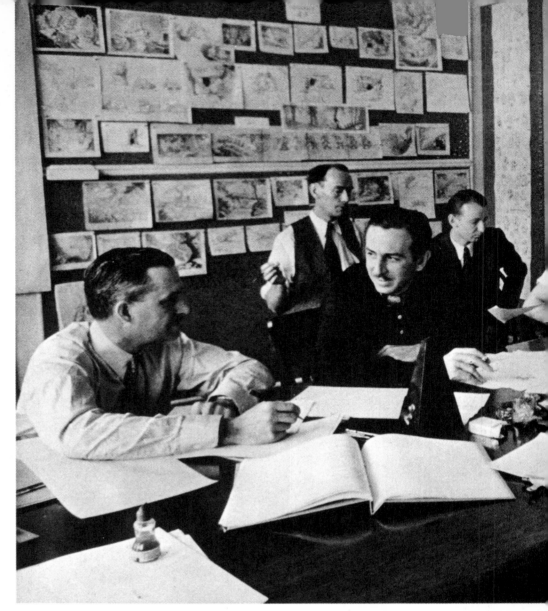

BELOW: SHIRLEY TEMPLE on her eighth birthday in April 1936. She made four films (including *Dimples*) that year. BELOW RIGHT: SINCLAIR LEWIS, author of *Main Street* and the first American to win the Nobel Prize for Literature (1930), photographed in New York a few years later.

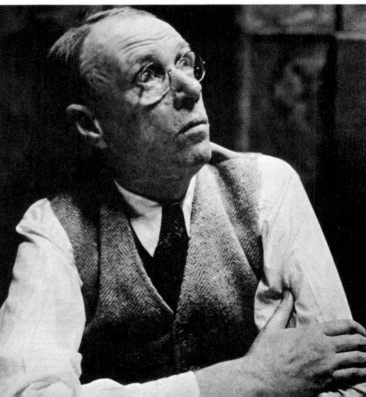

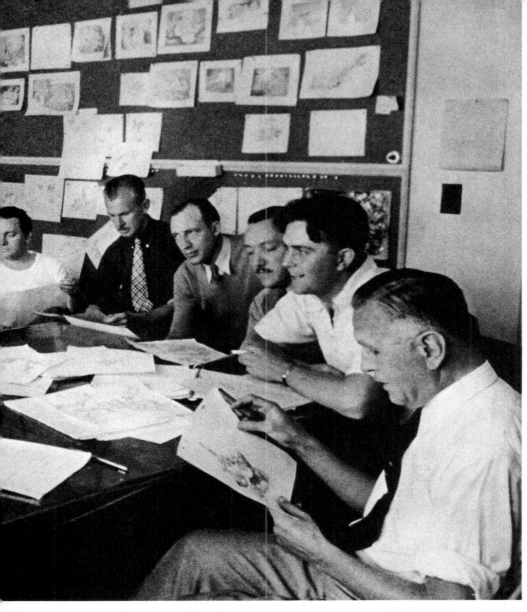

WALT DISNEY with animators at his Burbank studios in 1936. The camera equipment was primitive in those days: "Every frame," said Disney, "has to be sketched and painted."

BELOW LEFT: JAMES STEWART in 1938 on the set of *Made for Each Other*. The "other" was Carole Lombard (page 77). BELOW: Ventriloquist EDGAR BERGEN taking a rest from his talkative companion, Charlie McCarthy.

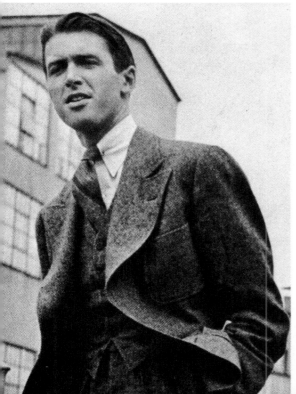

JOHN GARFIELD playing chess with his wife. The actor had just completed *Four Daughters* for Warner Bros.

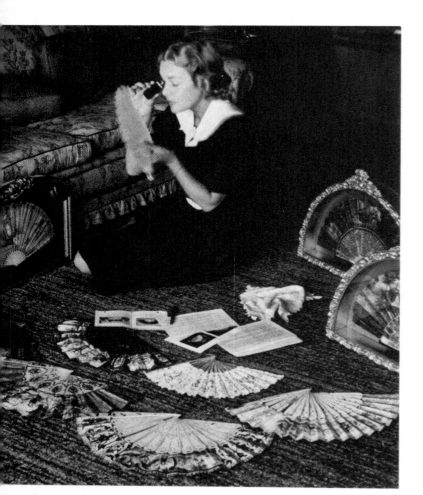

OPPOSITE: MARY MARTIN, the stagestruck girl from Weatherford, Texas, burlesqued and sang *My Heart Belongs to Daddy* in Cole Porter's *Leave It to Me* in 1938. Later she reached full stardom, by way of Hollywood, in *One Touch of Venus* and the Rodgers and Hammerstein milestones *South Pacific* and *The Sound of Music*.

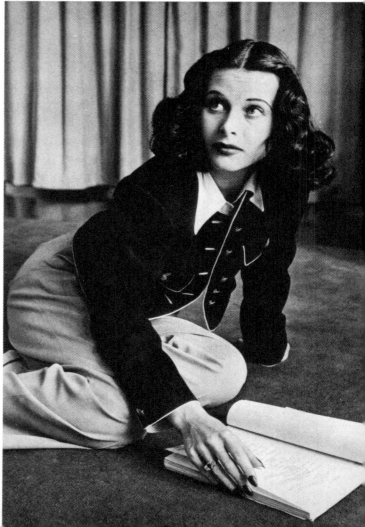

MADELEINE CARROLL (co-starred with Robert Donat in Alfred Hitchcock's *The Thirty-Nine Steps* in 1935) enjoys her fan collection in Hollywood in 1938. Among her American films at that time: *Lloyds of London* and *The Prisoner of Zenda*, opposite Ronald Colman (page 74). RIGHT: Vienna-born HEDY LAMARR studying lines in Hollywood. Her first English-language feature film, *Algiers*, was released in 1938.

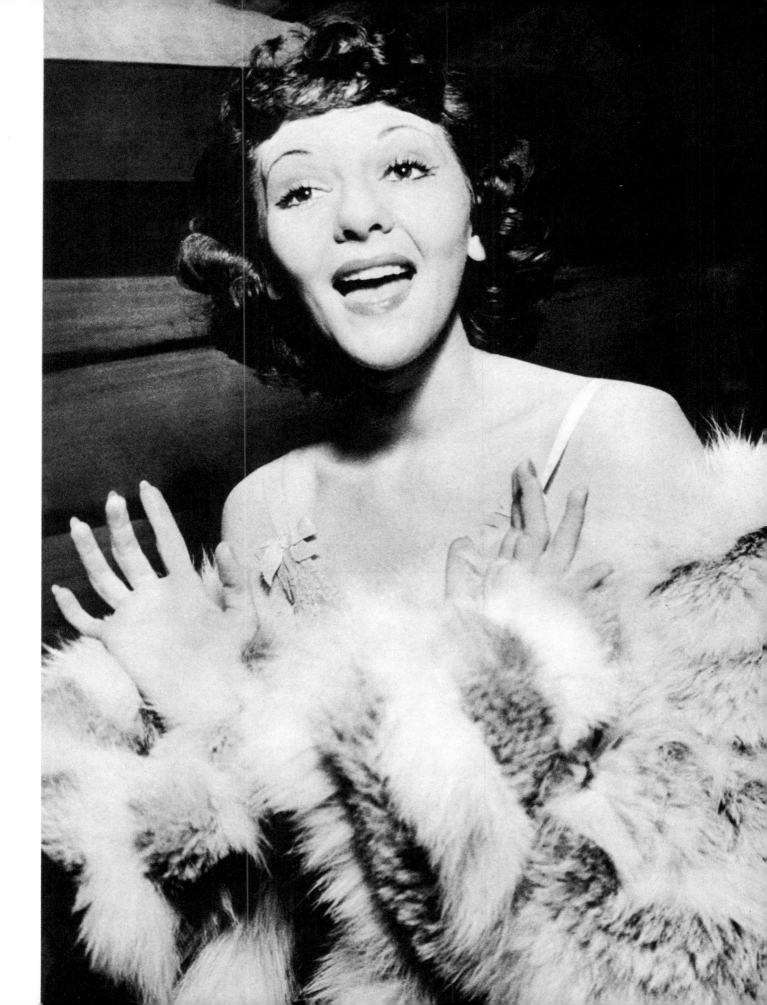

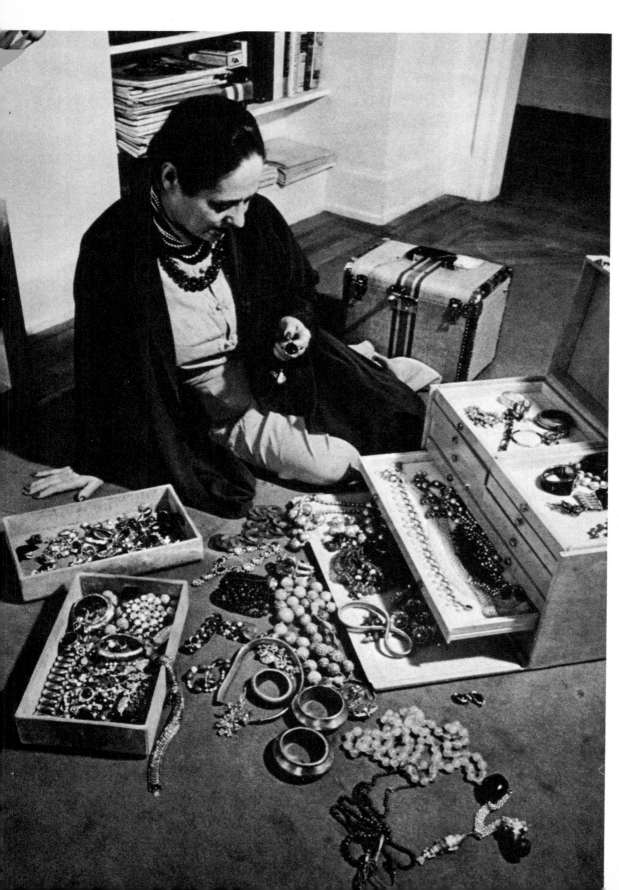

HELENA RUBINSTEIN, the Cracow-born founder of a cosmetics empire. In private life, Helena Rubinstein was Princess Gourielli-Tchkonia, and, in print, the star of Patrick O'Higgins' *Madame* (1972). She is seen here in the late thirties, relishing her jewelry collection in her Park Avenue apartment.

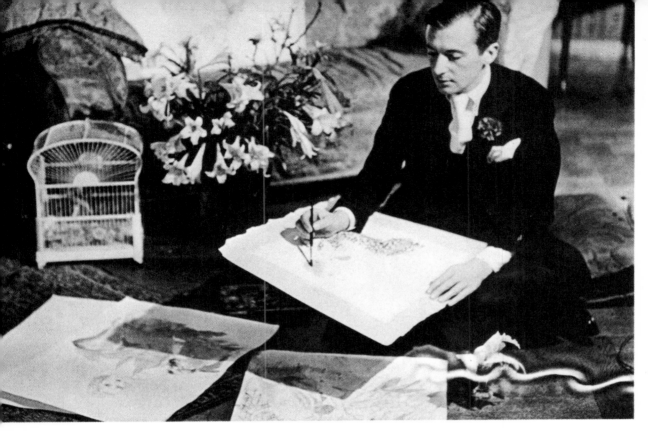

Young CECIL BEATON, photographer and designer, sketching fashions in the early thirties. Beaton's pet birds—gratefully freed from their cage—were enjoying the full compass of his London studio.

ELIZABETH ARDEN, whose real name was Florence Nightingale Graham, in the vestibule of her Fifth Avenue apartment in the late thirties. "After Rubinstein does the face," said Miss Arden, "*I* do the rest."

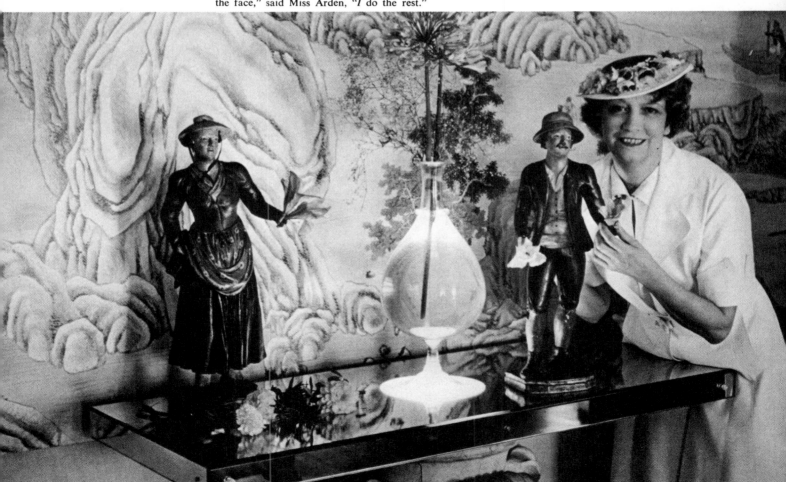

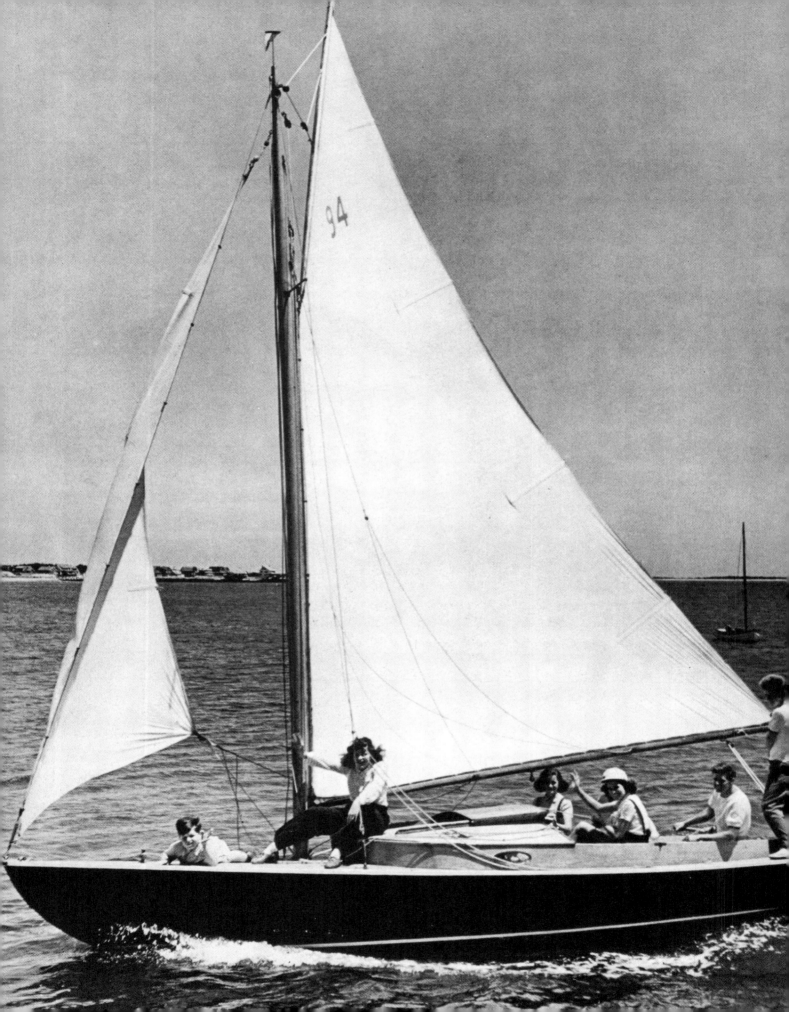

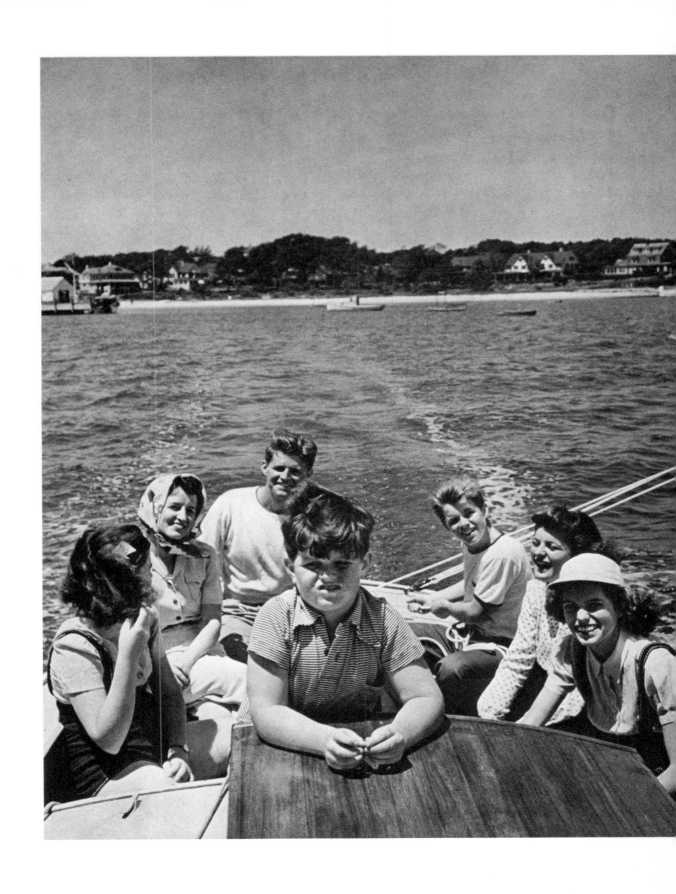

The **KENNEDY** family off Hyannisport. Clearly identifiable ABOVE: PATRICIA, MRS. ROSE KENNEDY, JOSEPH, EDWARD, ROBERT, KATHLEEN, and EUNICE. The photograph was taken in 1940 when John was away—in the navy—and father, Joseph Kennedy (U.S. Ambassador to the Court of St. James's), was in London.

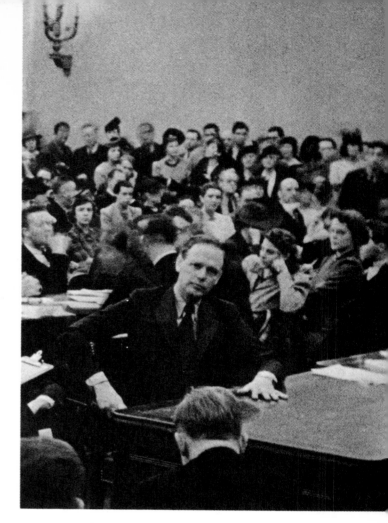

CHARLES LINDBERGH, first man to fly the Atlantic solo nonstop from New York to Paris (in 1927), arguing against President Roosevelt's Lend-Lease Bill at the Senate Foreign Relations Committee hearings in February 1941.

MARGARET BOURKE-WHITE, wife of playwright Erskine Caldwell (*Tobacco Road*) and one of *Life* magazine's first four staff photographers. The first *Life* cover was hers.

W. SOMERSET MAUGHAM. After studying to be a doctor, he switched to writing and became one of England's most prolific creators of novels and plays. Between 1915, when his best-known early novel, *Of Human Bondage,* was published, and 1949, when this photograph was taken, Maugham had averaged a book or play a year.

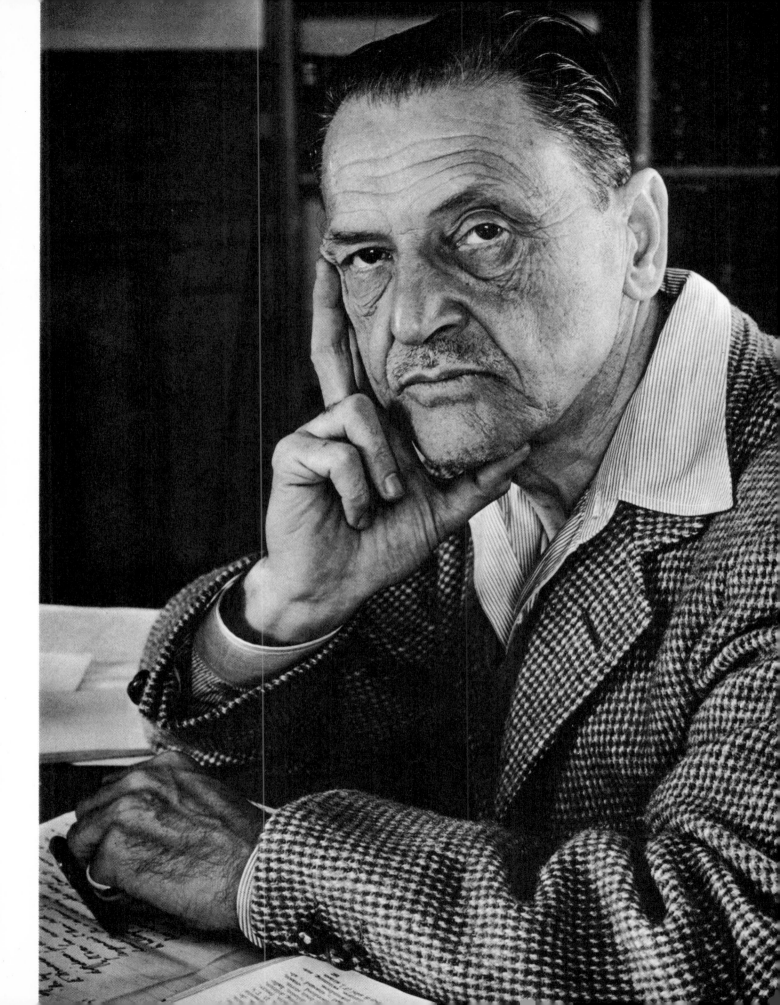

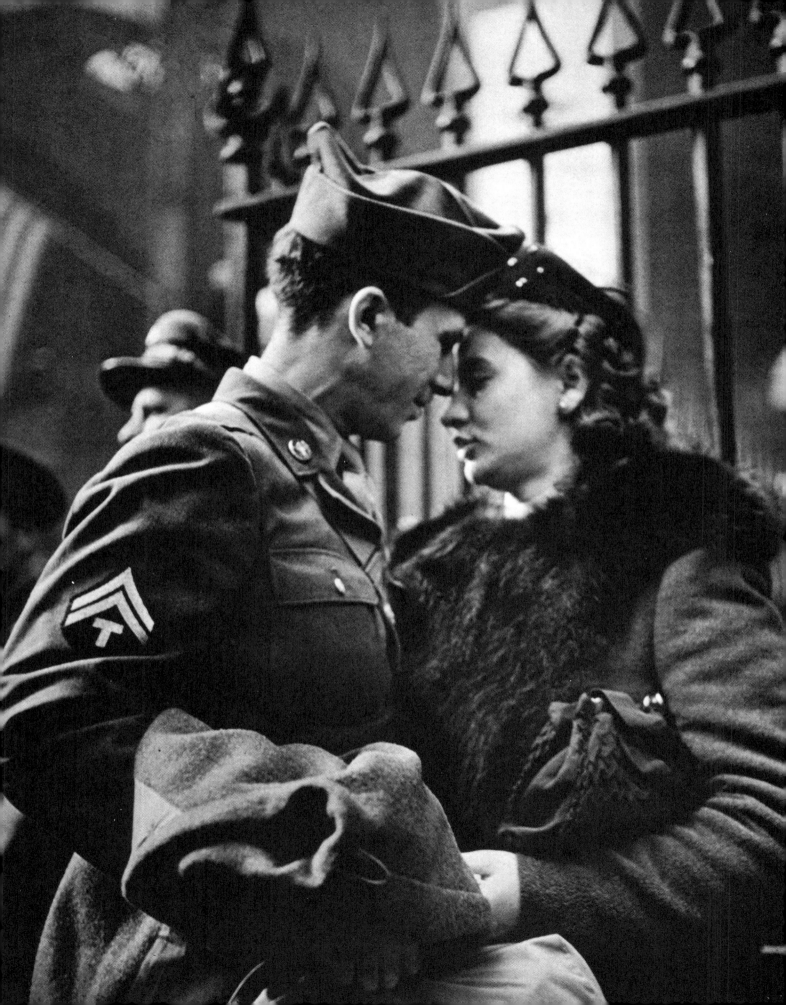

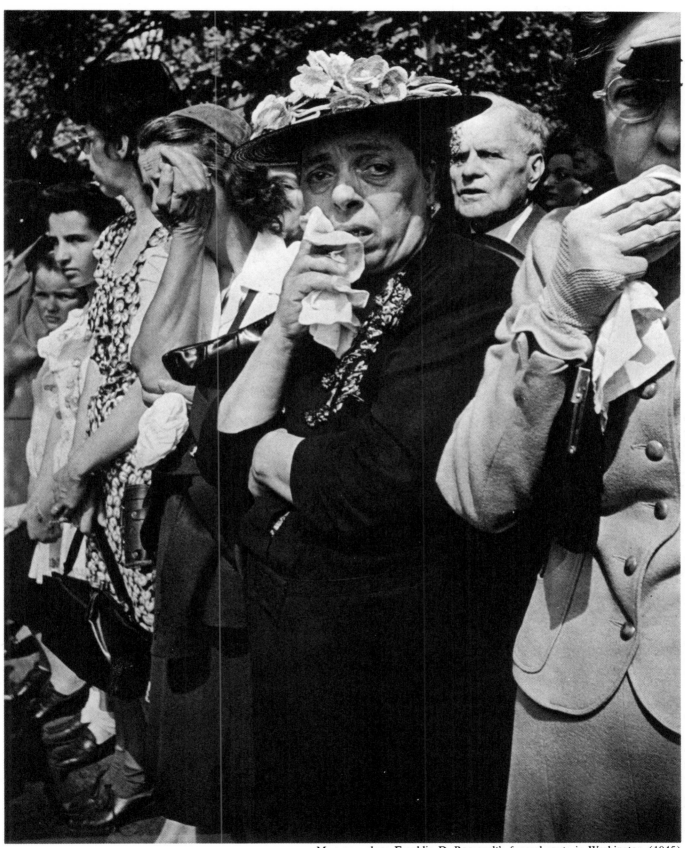

Mourners along Franklin D. Roosevelt's funeral route in Washington (1945).

His furlough over, a soldier bids his wife a tender farewell (1943).

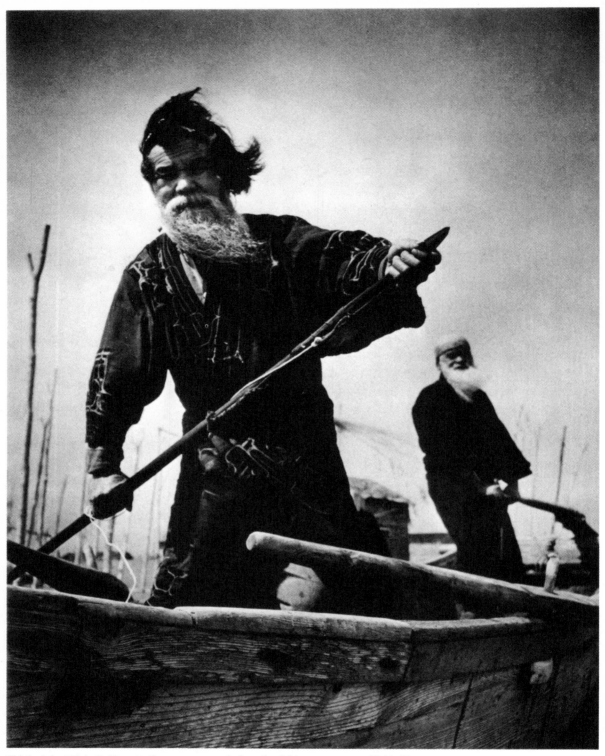

Chief of the "Hairy" Ainus testing a new oar—before the fishing season—on Hokkaido.

Kabuki players in Tokyo.

OVERLEAF: In January 1946, six months after Japan's surrender, men, women, and children arriving at Sasebo after a long trek back to their native land from Manchukuo.

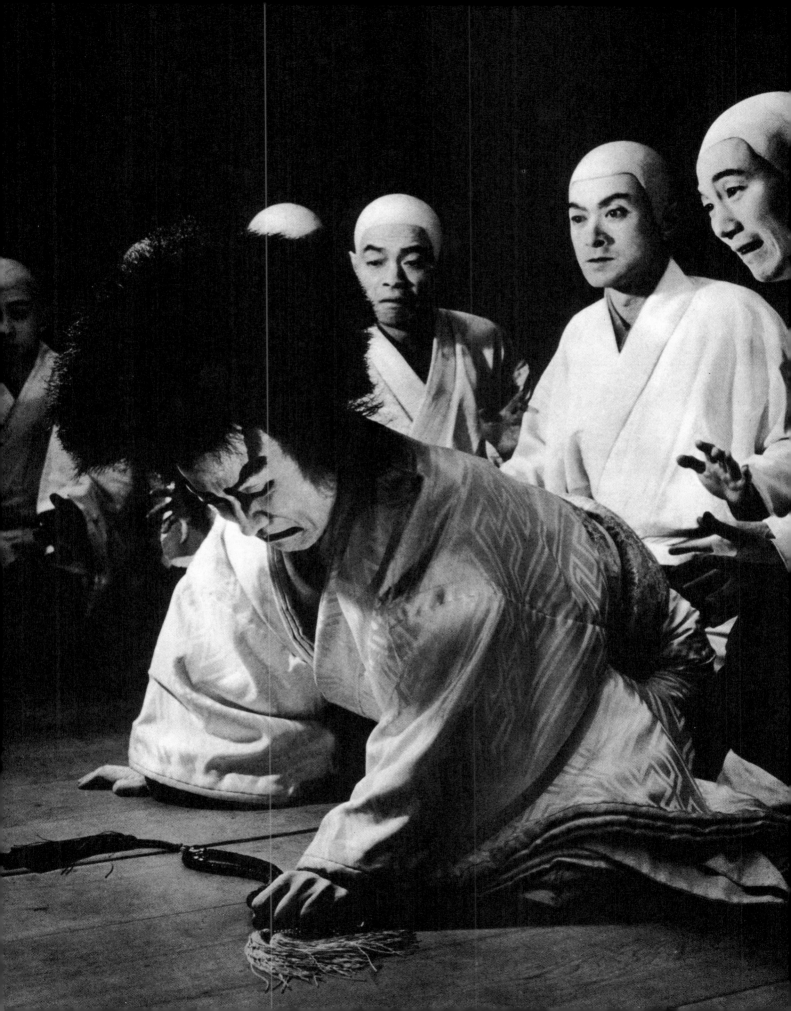

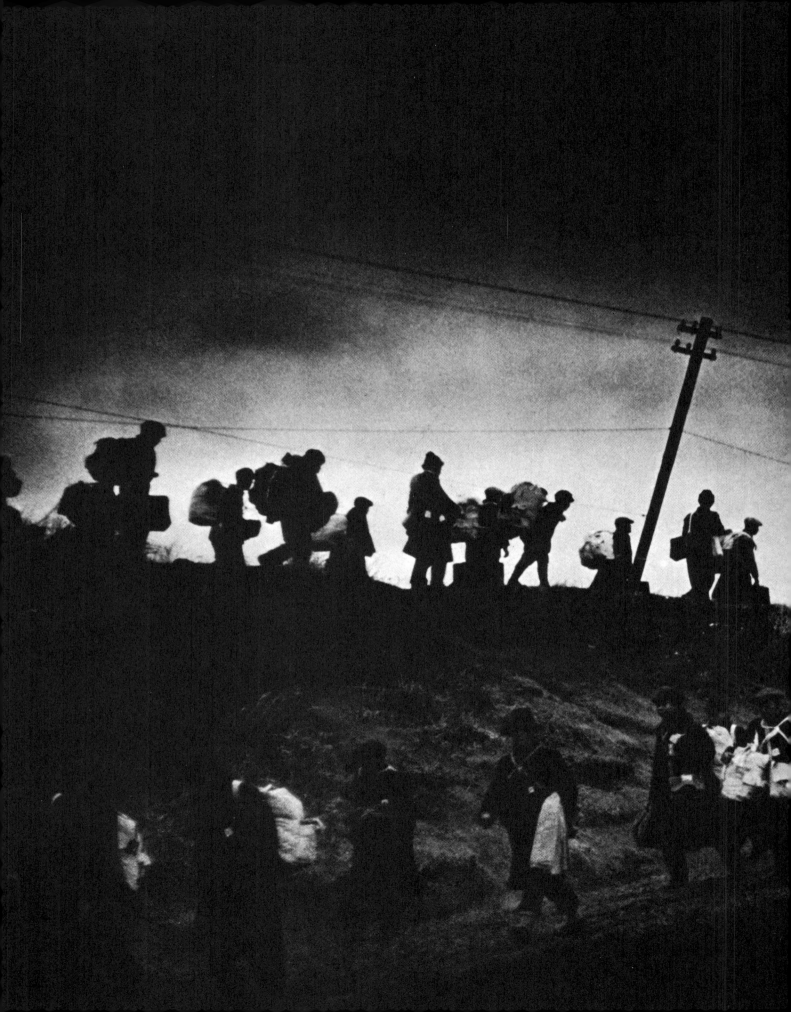

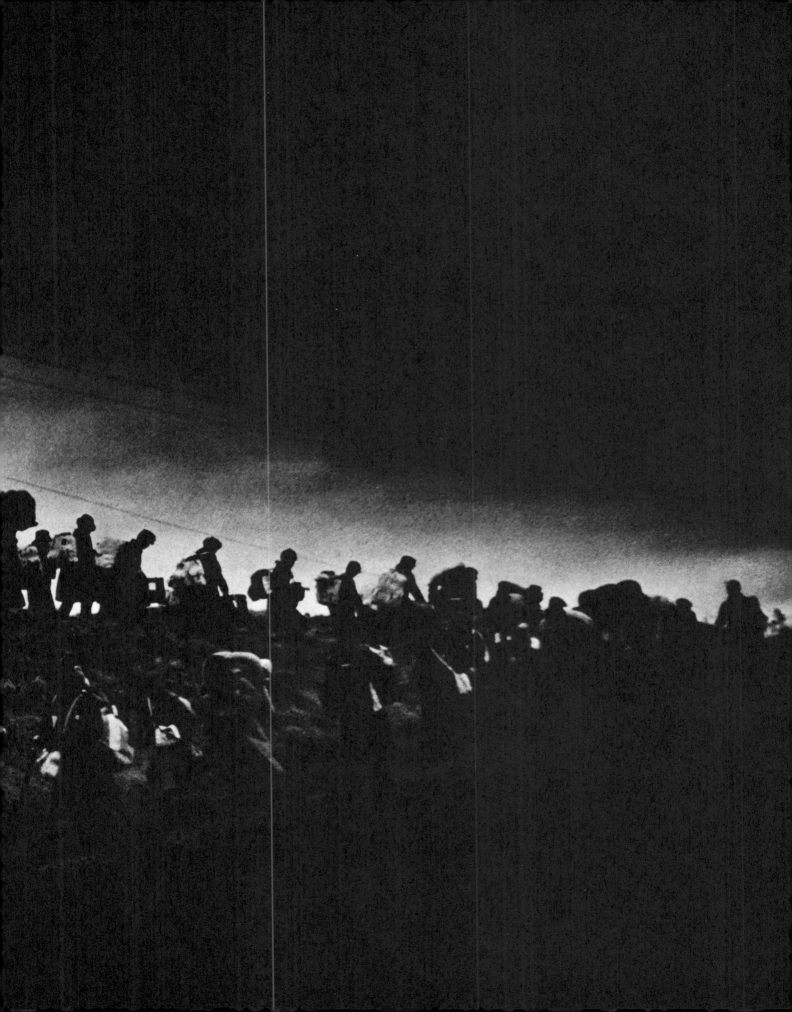

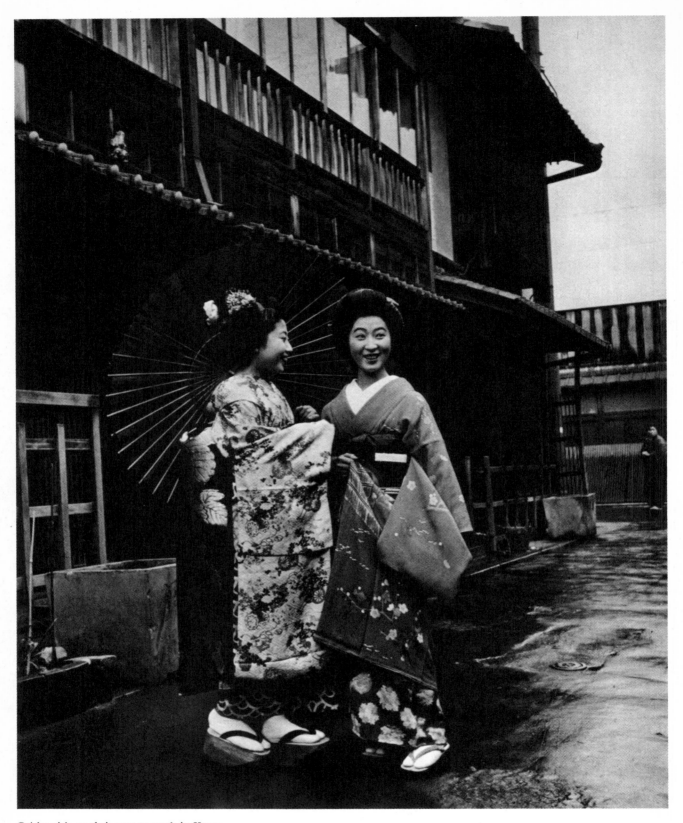

Geisha girls on their way to work in Kyoto.

Man with tattooed figures of the Samurai—a Japanese tradition of camouflaging criminal identification dating back nearly three hundred years.

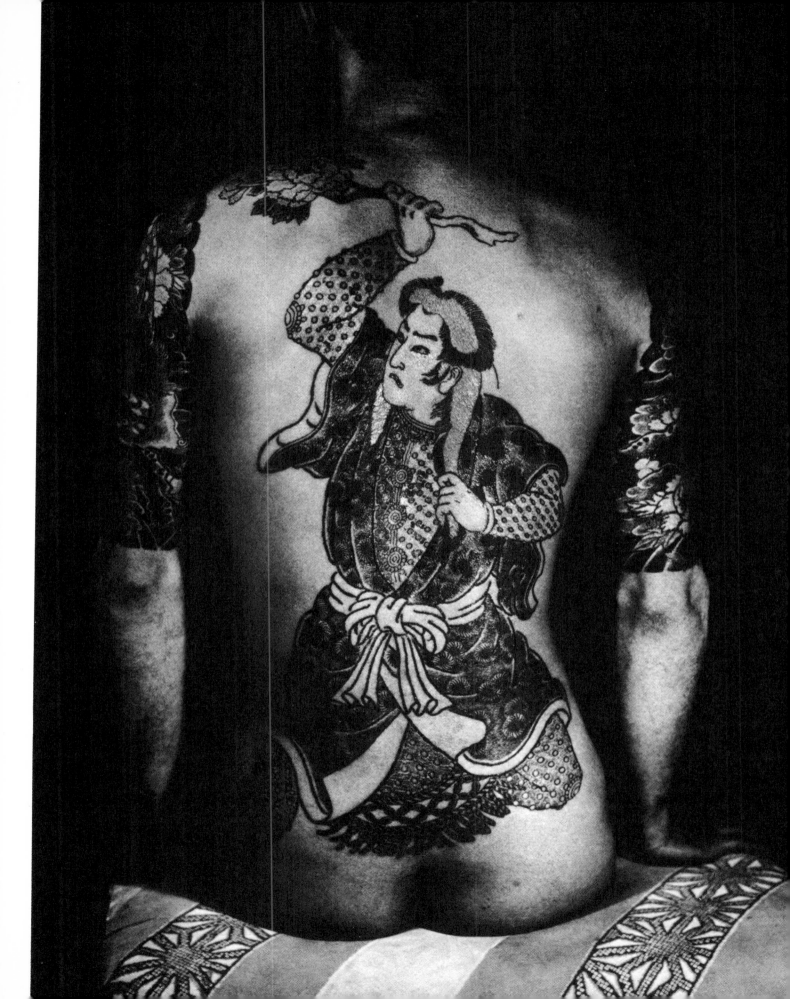

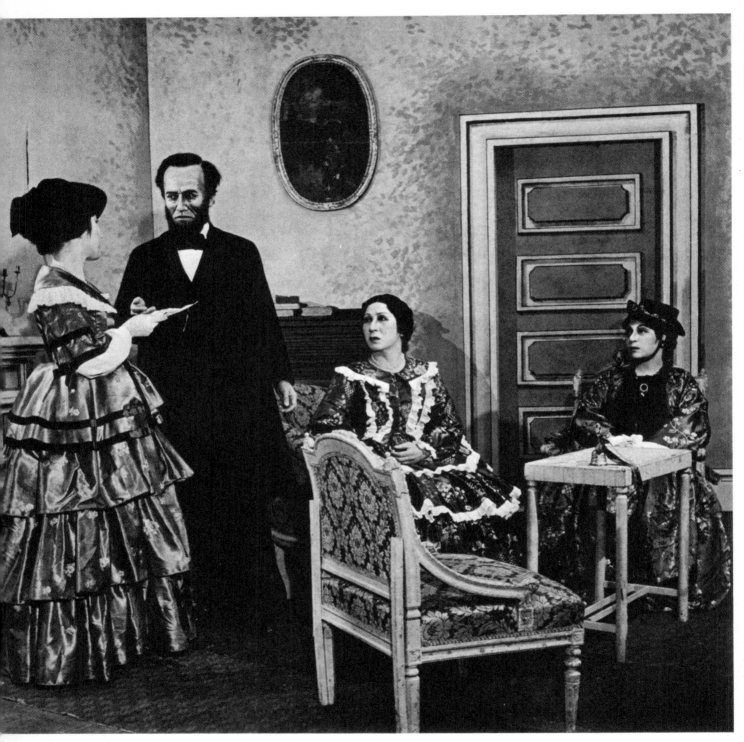

In a production of John Drinkwater's *Abraham Lincoln* at Tokyo's Imperial Theater, CHOJURO KAWARASAKI wore lifts and spike heels in a worthy effort to get his five feet seven inches up to Lincoln's six feet four.

A portrait of Abraham Lincoln finds a new owner at an Oklahoma auction. The Franklin D. Roosevelt bust had also been claimed by the highest bidder.

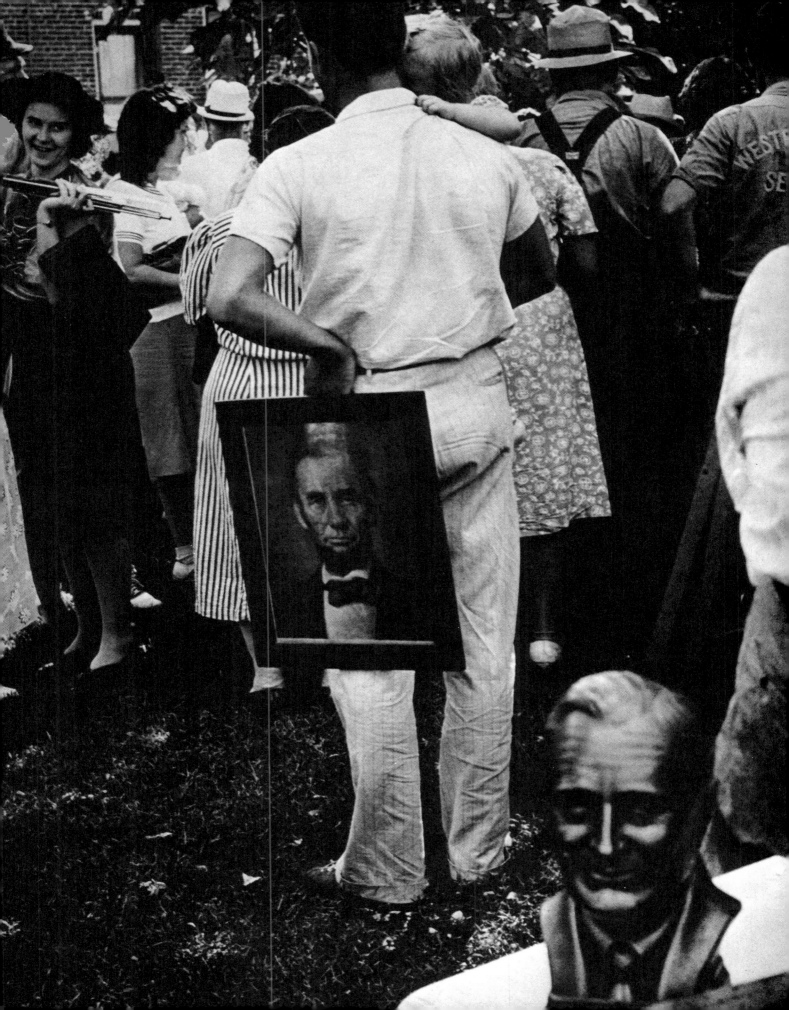

ALAN LADD in 1949. The popular actor was seen that year in both *The Great Gatsby* and *Chicago Deadline*.

Inseparable in real life as in the Westerns: ROY ROGERS and his palamino, TRIGGER.

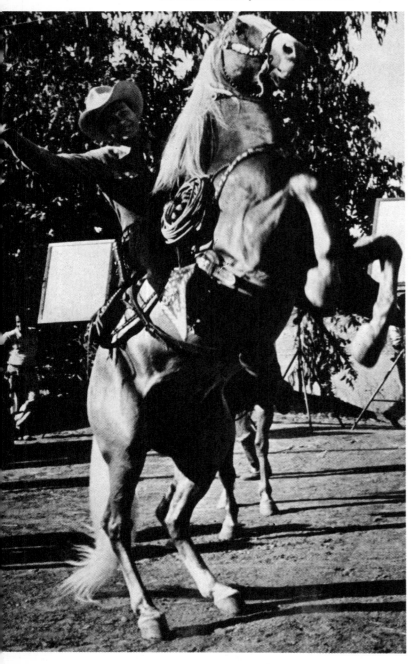

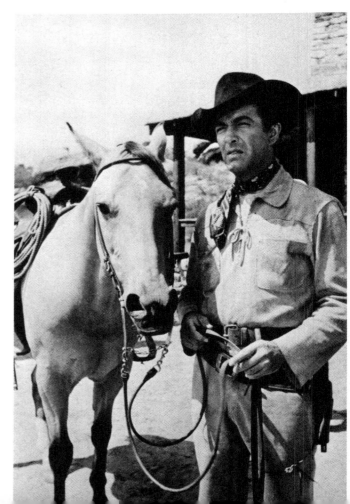

SPANGLER ARLINGTON BRUGH (Robert Taylor) on the set of *Ambush*—his thirty-sixth film for MGM in less than twenty-five years.

OPPOSITE: BARBARA STANWYCK out riding near her home in Hollywood in 1938, the year she made *Always Goodbye*.

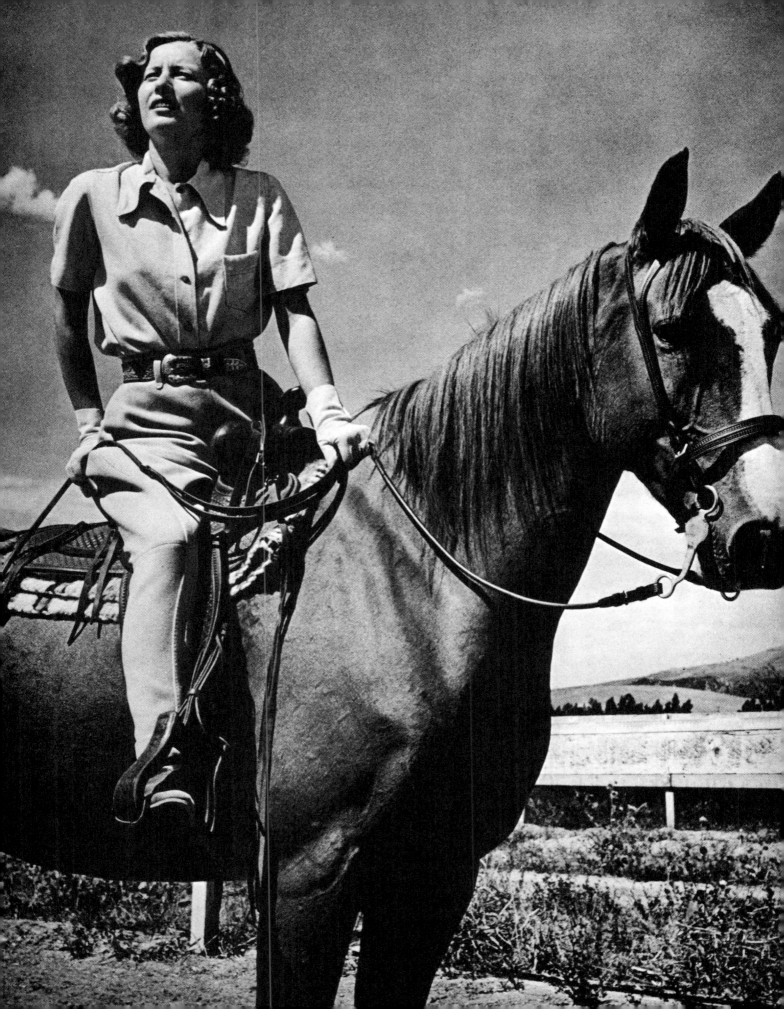

JOAN BLONDELL in an uncertain moment during a rehearsal of *The Naked Genius* (1943).

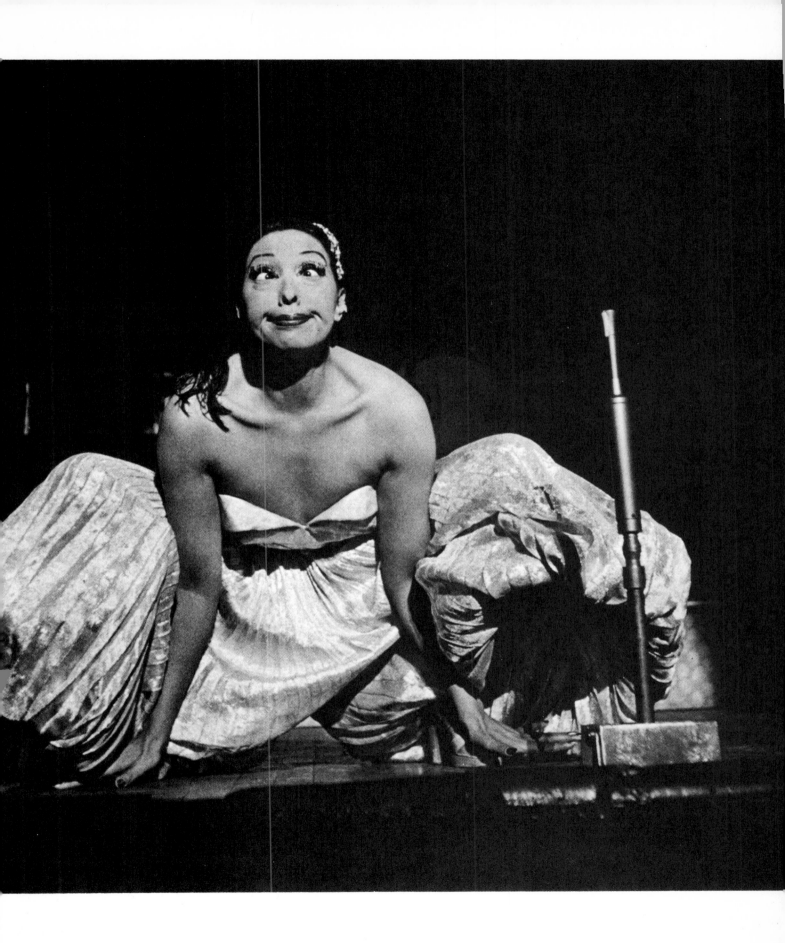

JOSEPHINE BAKER, the girl from St. Louis who electrified Paris in the twenties by singing Ave Maria in a girdle of bananas, trying out a lively new number.

LAURITZ MELCHIOR, girded for the role of Tristan—opposite Helen Traubel's Isolde—at the Metropolitan Opera House in 1944. It was the tenor's two hundredth performance in the Wagnerian role.

RIGHT: VICTOR MATURE, who caught the public eye as well as Gertrude Lawrence's as the glamour boy in Moss Hart's 1941 psychoanalytical musical extravaganza *Lady in the Dark*, shows how Randy Curtis kept trim. One of Mature's films that year: *I Wake Up Screaming.*

OPPOSITE: BURGESS MEREDITH, memorable as Mio in *Winterset*, in *Liliom*, and as the *Playboy of the Western World*, sharing the steam room of the *Queen Elizabeth* with motor tycoon SIR WILLIAM ROOTES.

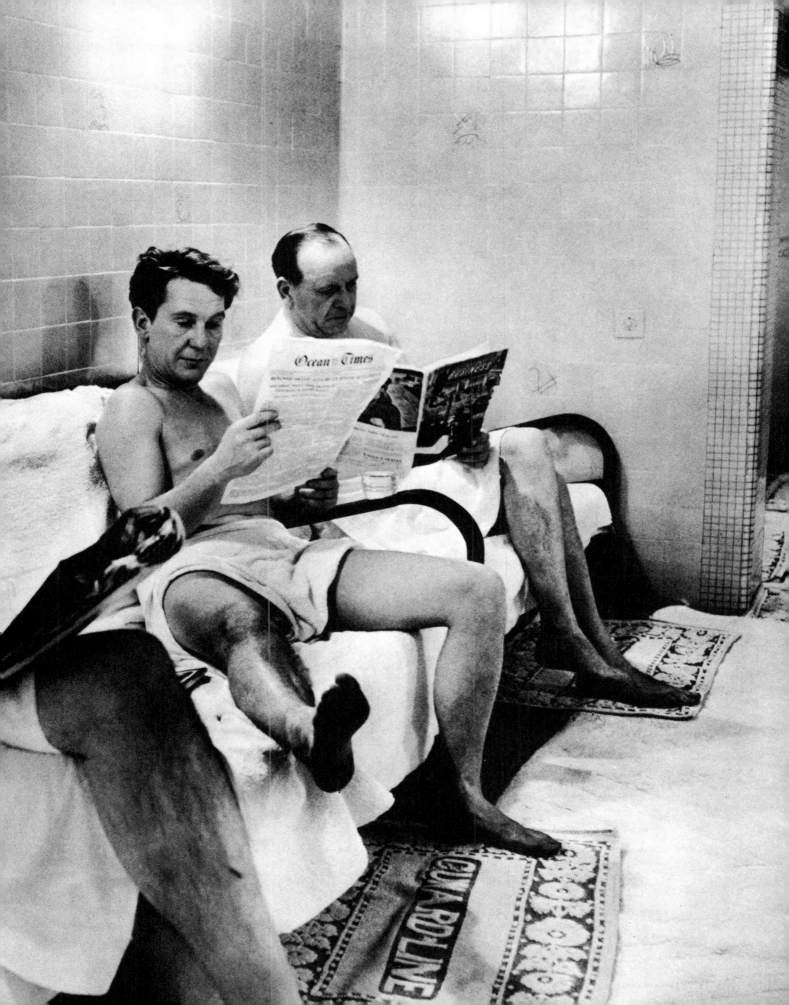

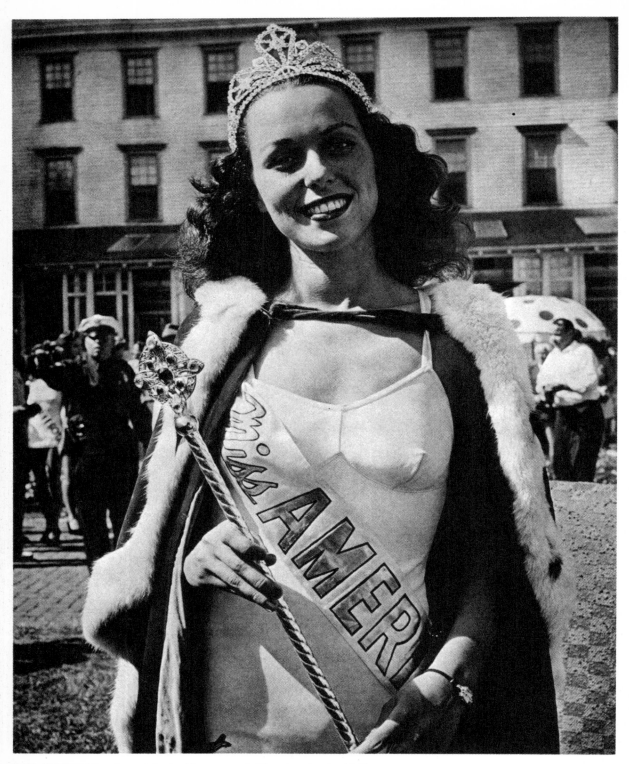

BESS MYERSON, whom Atlantic City crowned Miss America in 1945,
became New York City's queen of Consumer Affairs twenty-four years later.

MARILYN MAXWELL in MGM's *Key to the City*.

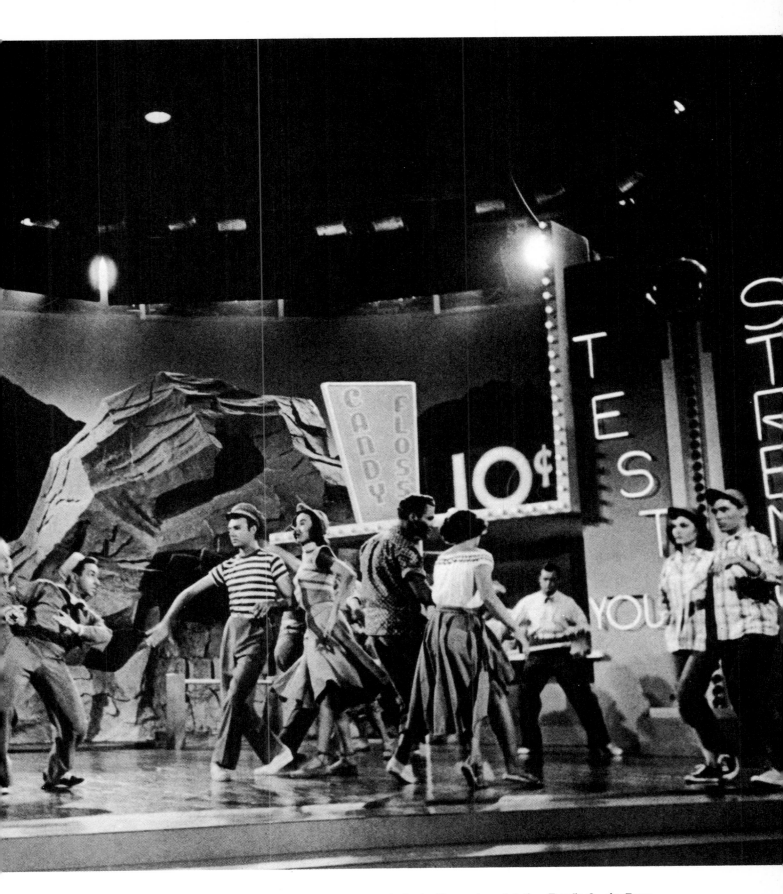

GENE KELLY and **VERA-ELLEN** dancing to the music of Leonard Bernstein in the film version of Arthur Freed's *On the Town*.

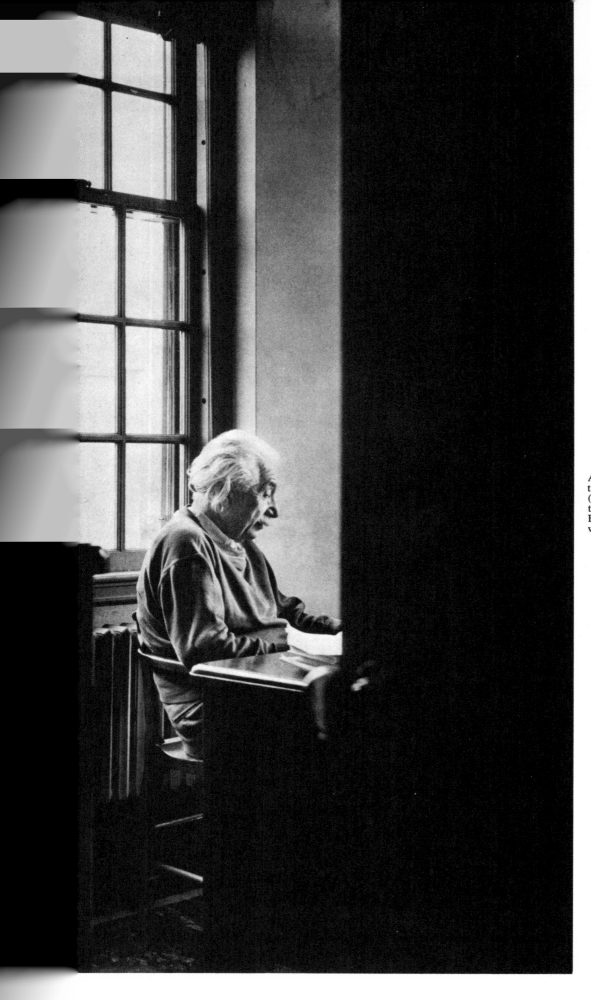

ALBERT EINSTEIN at The Institute for Advanced Study, Princeton (1947). Neighbors were fascinated that a man who could conceive of $E = mc^2$ could also enjoy evening walks and the duets of Mozart.

The Very Reverend MARTIN CYRIL D'ARCY, English Jesuit, author of *The Mind and Heart of Love,* through whom many artists and writers—Evelyn Waugh, Graham Greene, and Alec Guinness among them—were drawn to the Catholic church.

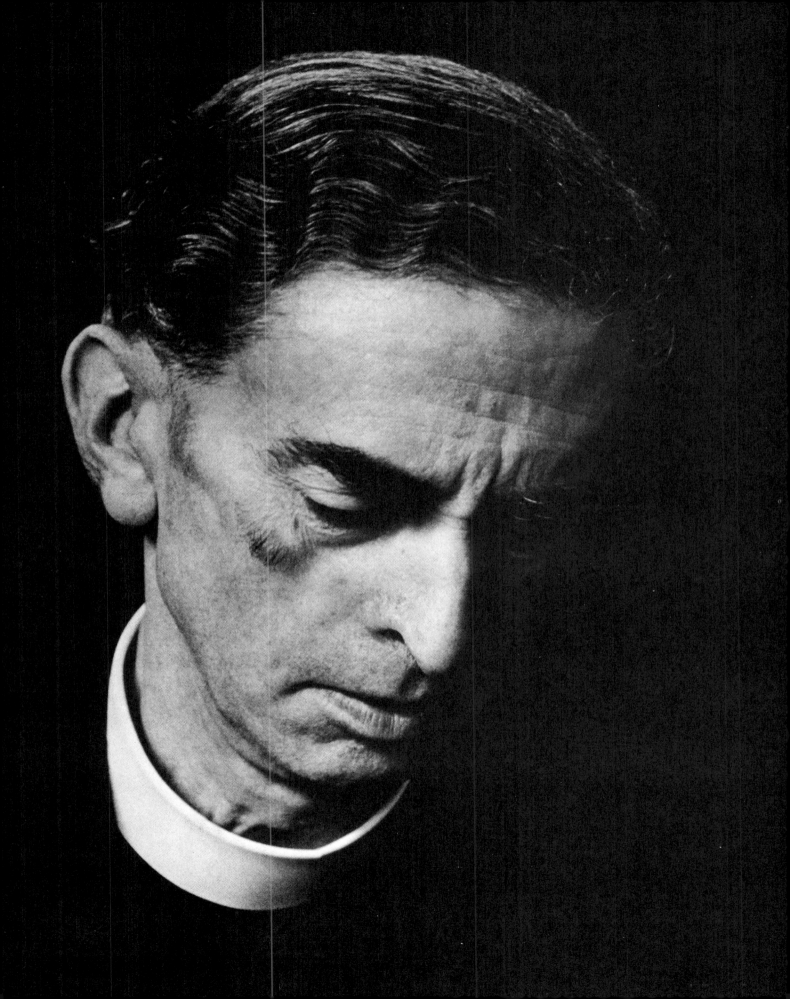

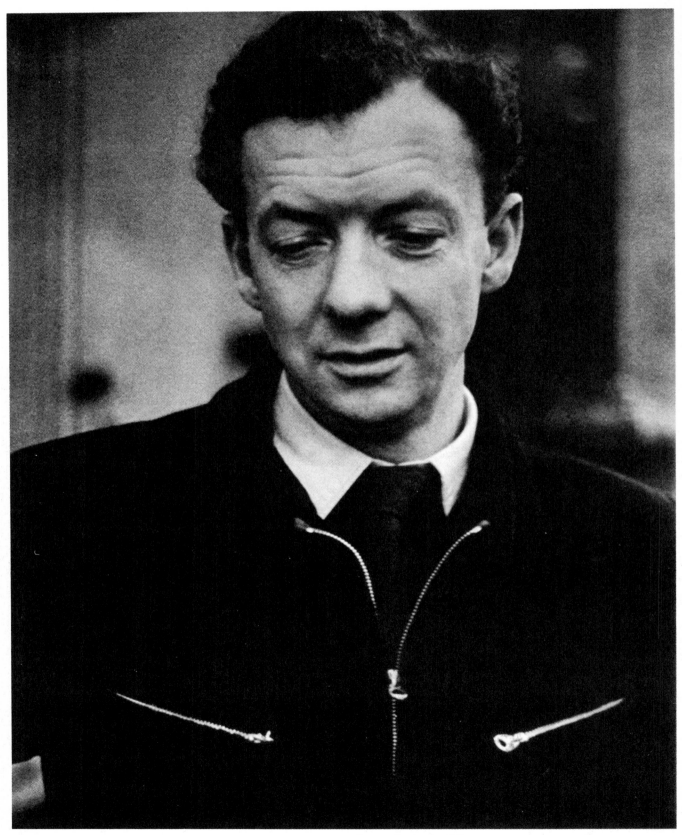

BENJAMIN BRITTEN during a rehearsal of his opera *Peter Grimes* at Covent Garden in 1951.

FRANZ LEHAR, ex-bandmaster and the creator of *The Merry Widow* (which premiered in Vienna in 1905), at home in Zurich. Between 1905 and 1947, the year this photograph was taken, Lehar had composed more than twenty-five light operettas.

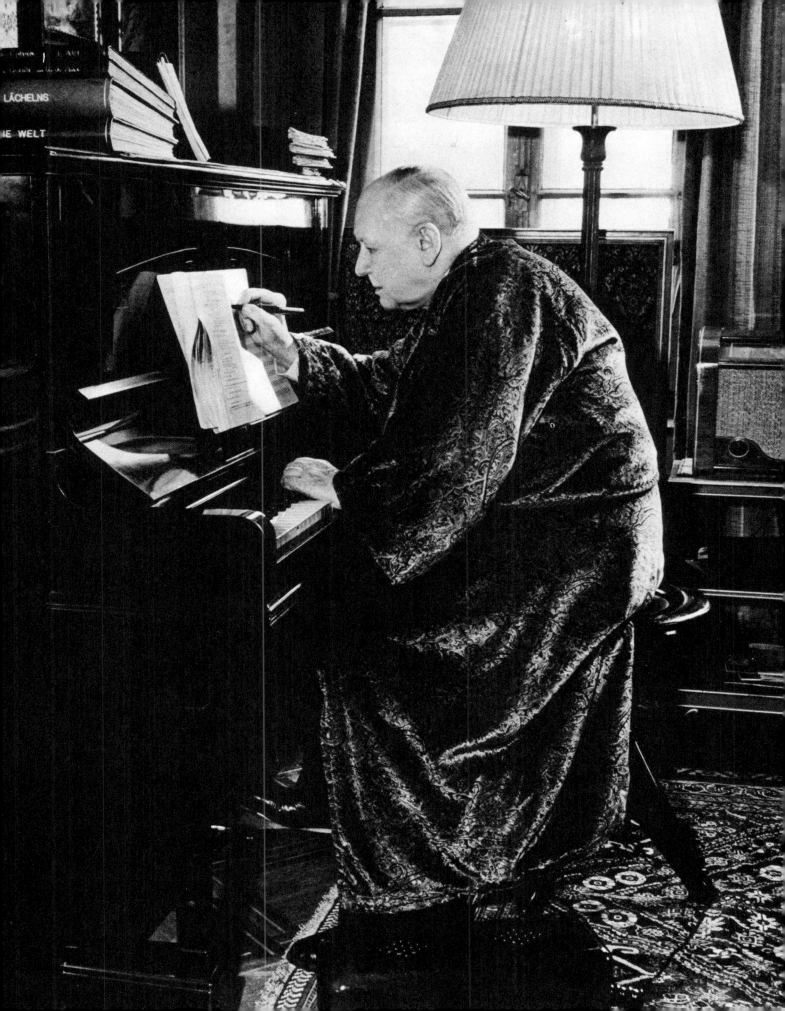

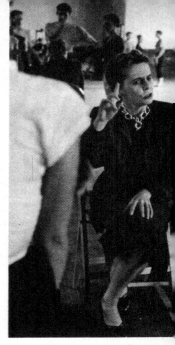

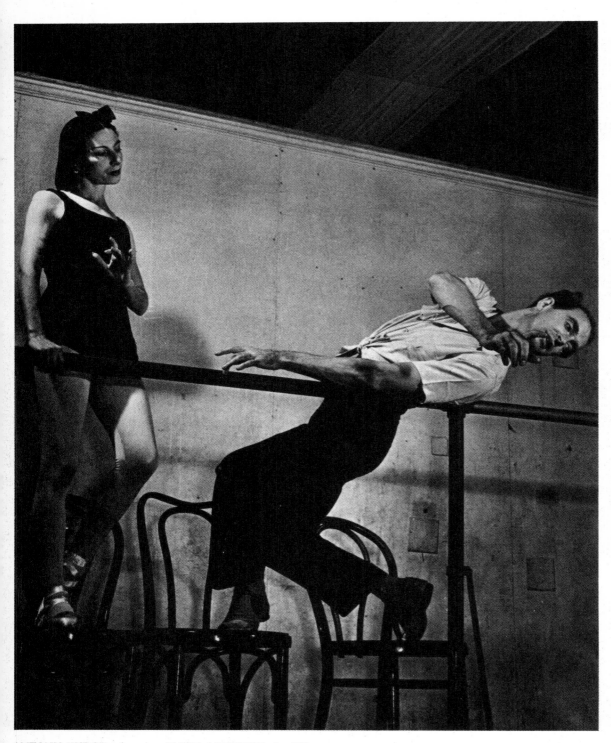

ANTONY TUDOR rehearsing ALICIA MARKOVA for *Pillar of Fire*, the ballet he choreographed to the music of Arnold Schönberg.

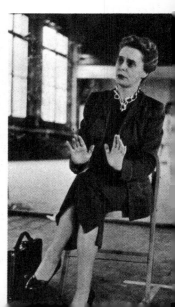

Dame NINETTE DE VALOIS, director of the Sadler's Wells Ballet (now the Royal Ballet), instructing members of the company in London (1951).

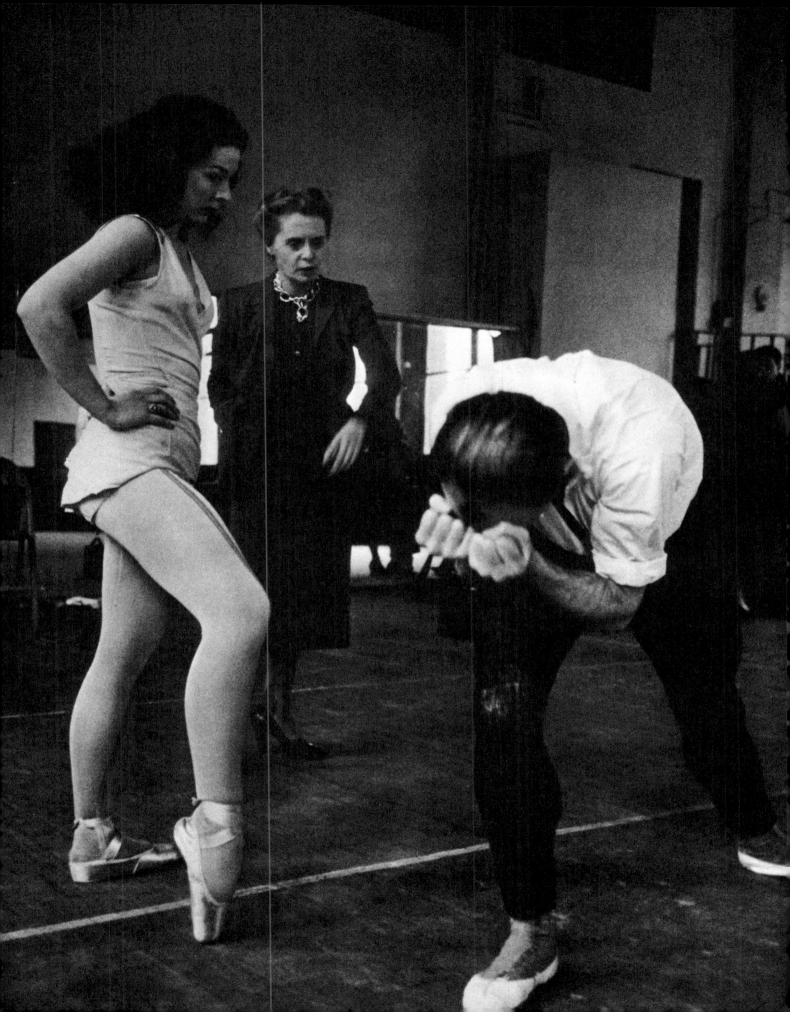

Light-footed GENE NELSON in the musical *Wabash Avenue* (1950). The film, directed by Henry Koster, also starred Betty Grable (page 116) and Victor Mature (page 102).

Singers STEVE LAWRENCE and EYDIE GORME doing a comic TV turn in 1958.

OPPOSITE: FRED ASTAIRE (Frederick Austerlitz), who teamed with sister Adele (later Lady Cavendish) in *Funny Face* and other musical comedies of the twenties, added to his dancing laurels in some thirty-five films. Here he is rehearsing the Jack and the Beanstalk number for *The Barkleys of Broadway* (1949).

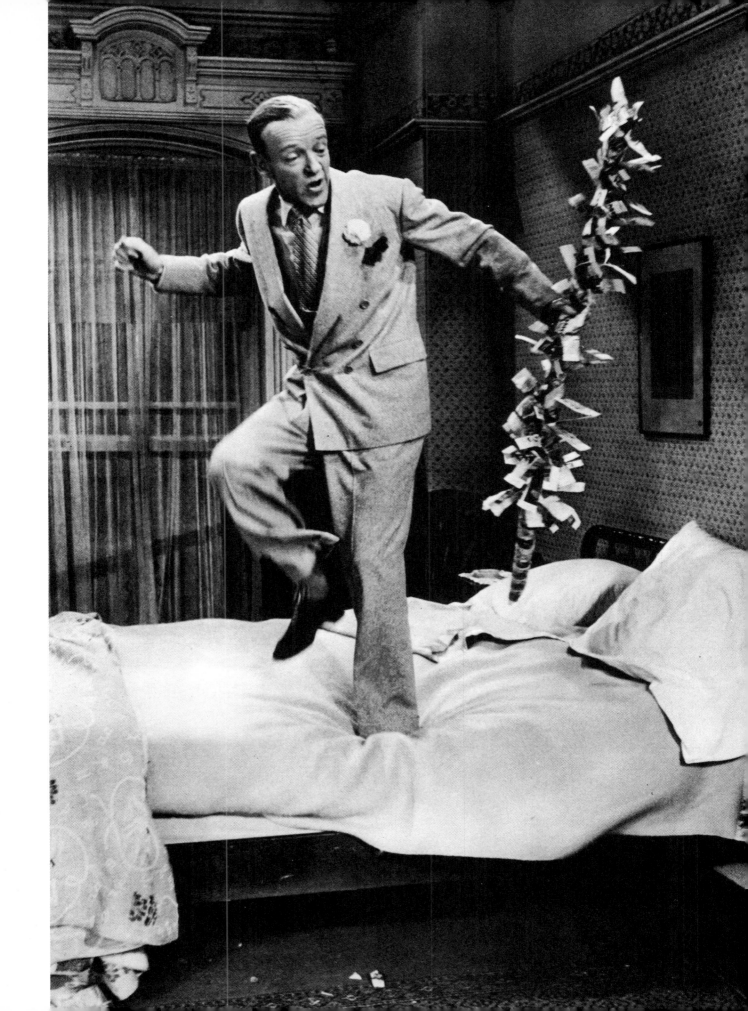

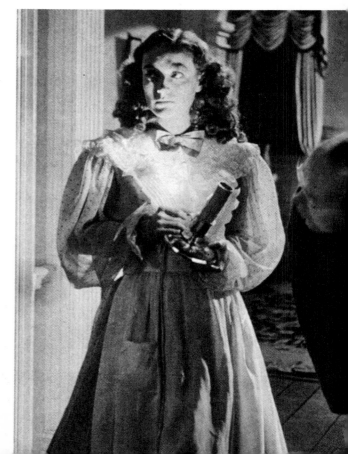

Hollywood in full dress, 1949:

TOP LEFT: DEBORAH KERR with MARK STEVENS in *Please Believe Me.*

FAR LEFT: "Pin-up Girl" BETTY GRA-BLE after a day's work in *Wabash Avenue.*

LEFT: Perennial favorite JOAN CRAW-FORD (Lucille Le Sueur), earlier, in *The Gorgeous Hussy* (1936).

ABOVE: ANN SOTHERN, LOUIS CAL-HERN, and JANE POWELL in *Nancy Goes to Rio.*

RIGHT: KIRK DOUGLAS as Rick Mar-tin in *Young Man with a Horn*, the film version of Dorothy Baker's novel loosely based on the life of Bix Beiderbecke.

MARION MARSHALL, CESAR ROMERO, and PAUL DOUGLAS in *Love That Brute*.

GENE TIERNEY with JOSE FERRER on the *Whirlpool* set.

The wistful, cat-loving JAMES MASON (London's *Daily Mail* voted him the most popular male film artist in 1946) in *East Side, West Side*.

LAUREN BACALL starring in *Young Man with a Horn* with Kirk Douglas (page 117).

BETTE DAVIS kicks off her shoe during an early rehearsal of *Two's Company*, the 1952 revue with Ogden Nash's lyrics and Vernon Duke's music. Her co-star: HIRAM SHERMAN.

OPPOSITE: LORETTA YOUNG in *Key to the City*, her twenty-seventh film in ten years (1949).

LUCILLE BALL and BOB HOPE in *Where Men Are Men* (1949).

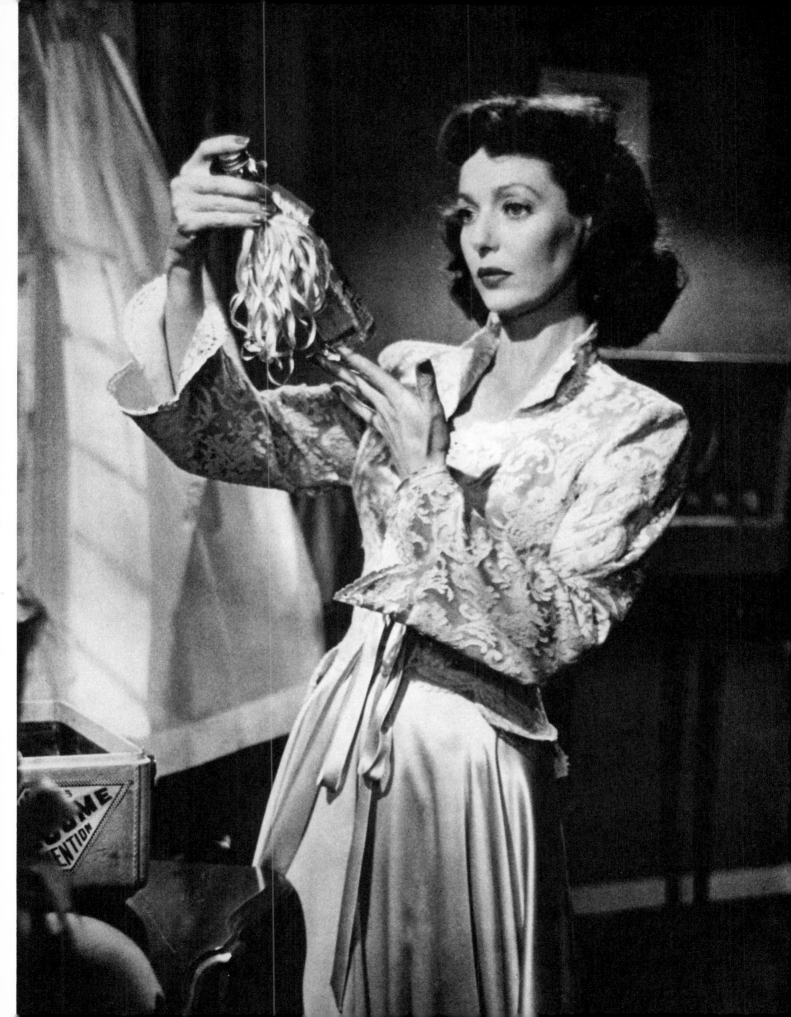

Cartoonist DAVID LOW, the creator of "Colonel Blimp," at his drawing board in London.

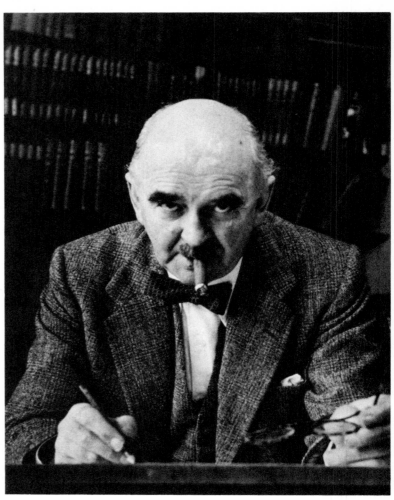

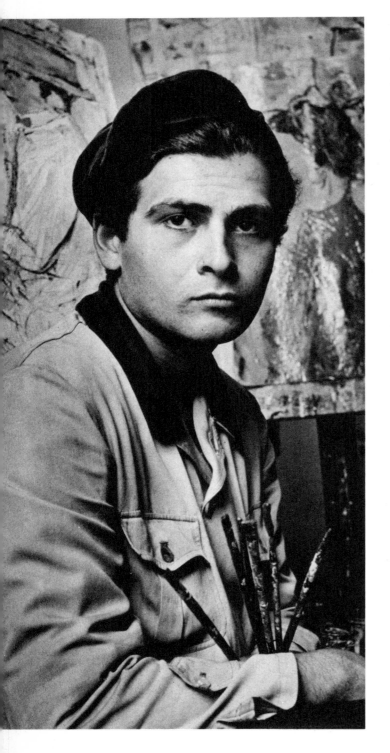

RENZO VESPIGNANI, twenty-one-year-old postwar Italian artist in his studio in Rome (1947).

A Mephistopheles-like AUGUSTUS JOHN, shortly after arriving at his Hampshire studio on a dark, rainy November afternoon. The Welsh portrait painter was finishing a likeness of Lady Phipps at the time (1951).

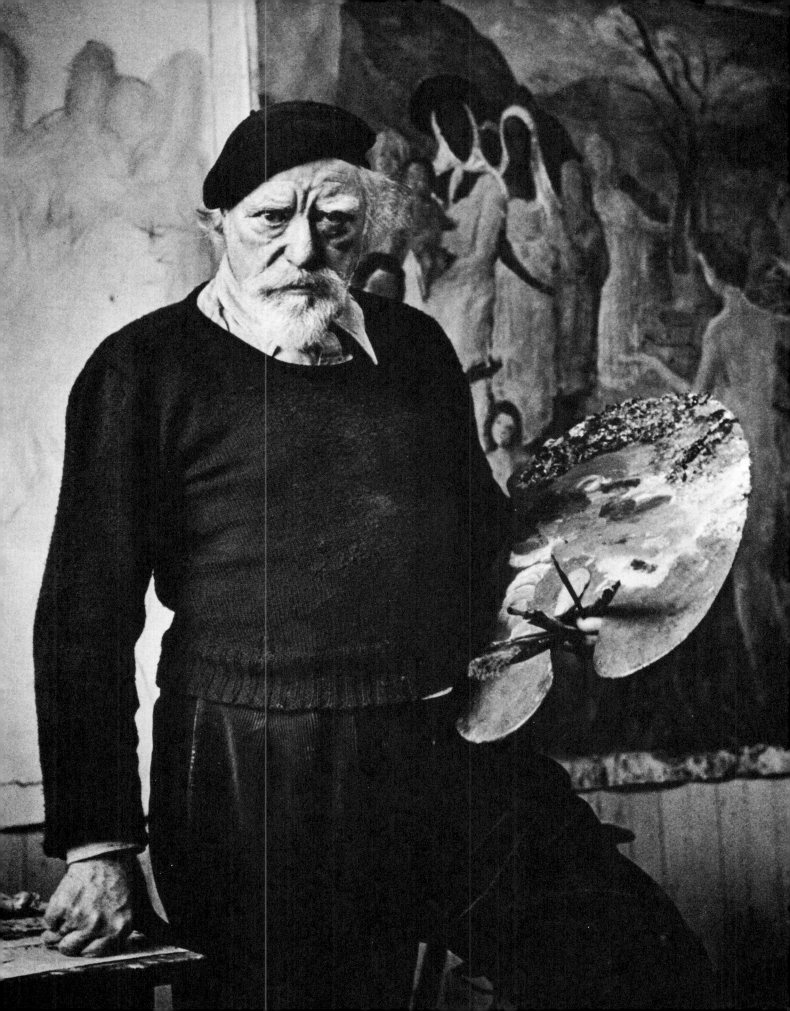

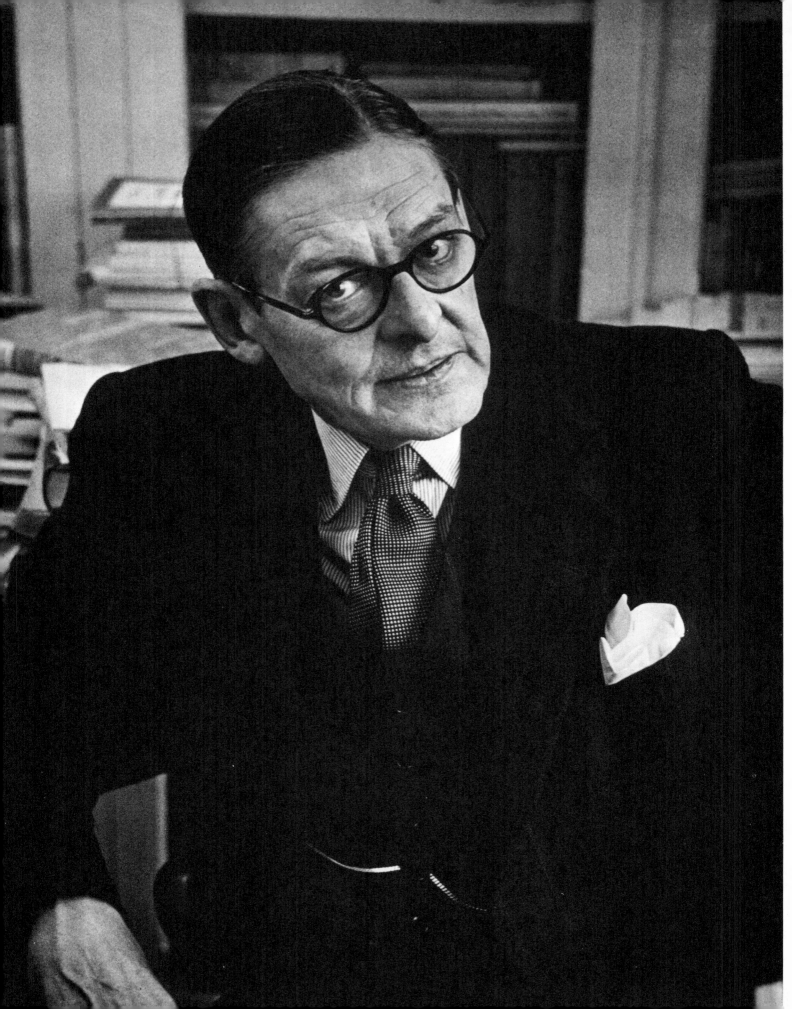

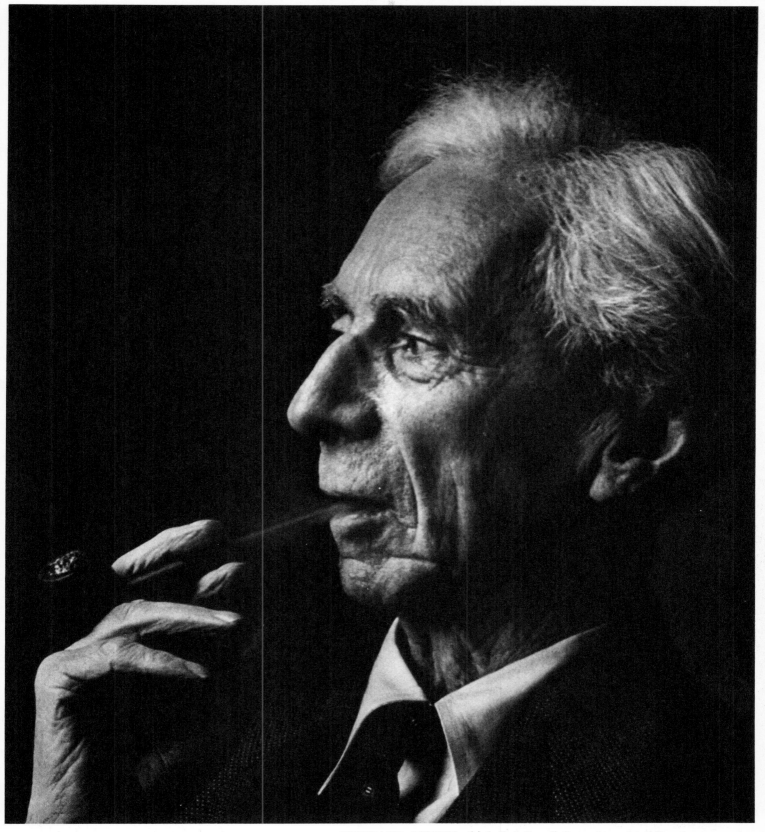

BERTRAND RUSSELL, third Earl Russell, the controversial philosopher, outspoken critic of war (he was jailed for his antiwar articles in 1918), social reformer (he caused an uproar over free love in 1933), at his house near London in 1951. Russell was a proud seventy-nine. Told he was one of the stillest of men to photograph, he replied, "The best occupation of a crocodile is to rest."

T. S. ELIOT in his office at Faber and Faber, the English publishers, of which he was a director. The photograph was taken while his play *The Cocktail Party* was repeating its Edinburgh success in New York where Alec Guinness (page 131) played the unidentified guest.

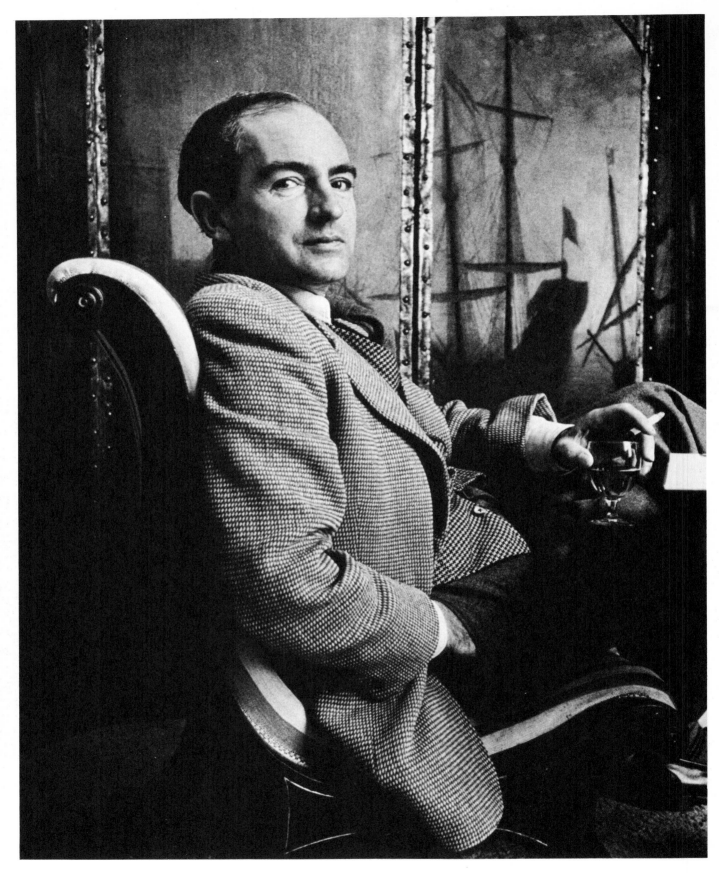

Poet-dramatist CHRISTOPHER FRY at home after his play *The Lady's Not for Burning* had ended a successful London revival in 1950 and had opened to encouraging reviews in New York. Fry's *Venus Observed* and his translation of the Anouilh play *Ring Around the Moon* were also produced in 1950.

THORNTON WILDER, winner of the Pulitzer prize for his novel *The Bridge of San Luis Rey* (1928) and for his play *Our Town* (1938), at Saratoga Springs in 1954. Mr. Wilder was at work on *The Matchmaker* (a revision of his 1938 play, *The Merchant of Yonkers*), which opened on Broadway the following year with Ruth Gordon in the lead role. *The Matchmaker* became the musical *Hello Dolly* in 1963.

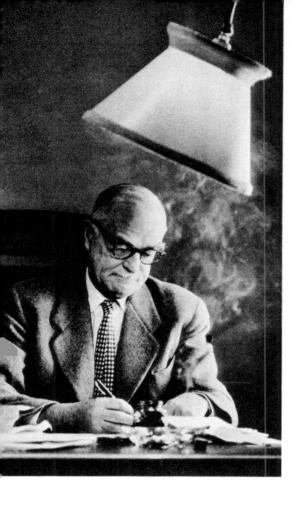

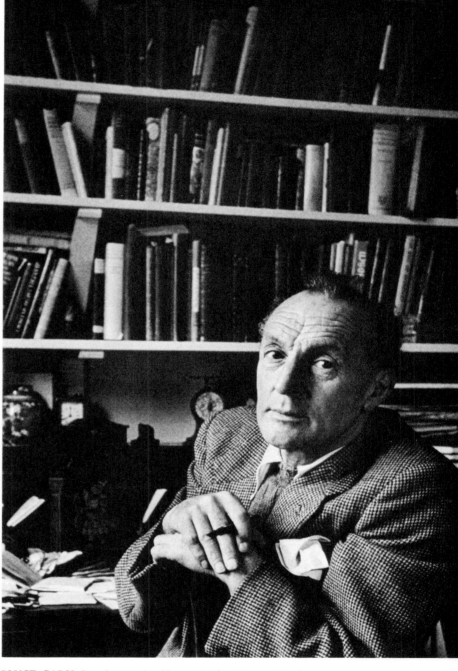

JOYCE CARY, best known for his novel *The Horse's Mouth*, in his beloved Oxford (1951).

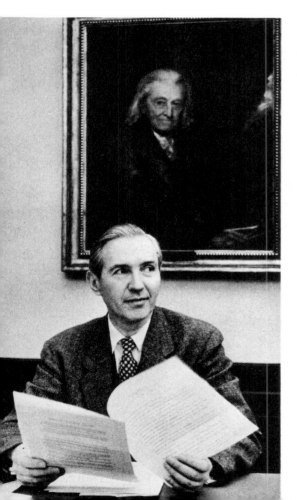

Historian and critic JACQUES BARZUN in 1956, a few months before he became dean of the Graduate Faculties at Columbia University.

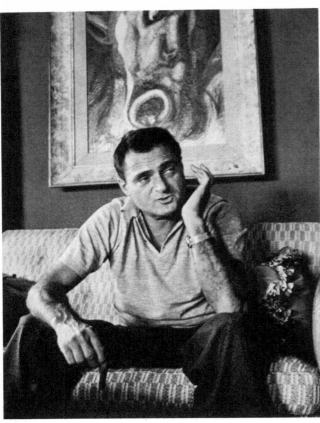

"The Live Wire" MICHAEL TODD, who produced *Around the World in Eighty Days* on film, in his apartment a few months before Elizabeth Taylor became Mrs. Todd.

ANTHONY ASQUITH, the great English film director, runs over a scene with EDITH EVANS.

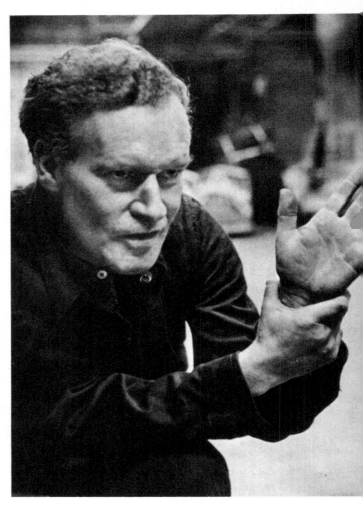

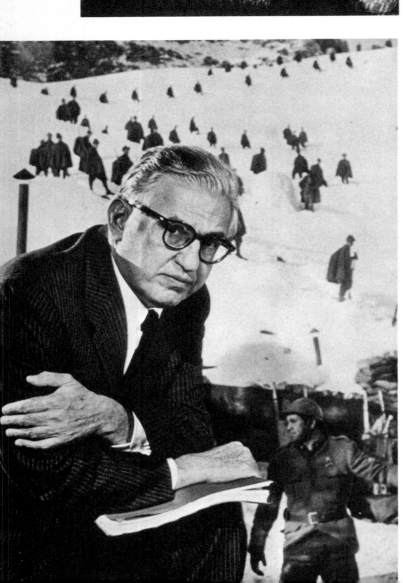

DAVID OLIVER SELZNICK, often referred to as "Mr. Movies," in front of a blowup from *A Farewell to Arms,* the 1957 film he produced based on the novel by Ernest Hemingway (page 132). Selznick's biggest money maker: *Gone with the Wind* (1939).

Dame EDITH EVANS, grand lady of the English theater, as Lady Bracknell (a part among well over a hundred she is noted for on stage) during the filming of Oscar Wilde's *The Importance of Being Earnest* in 1951.

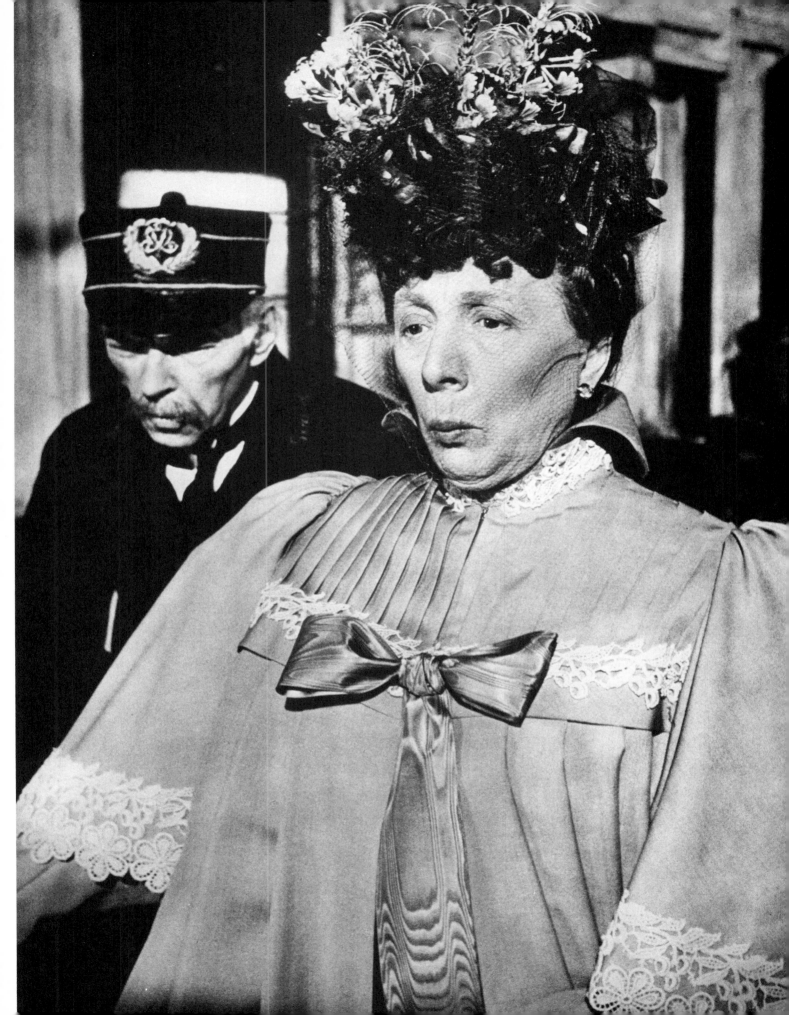

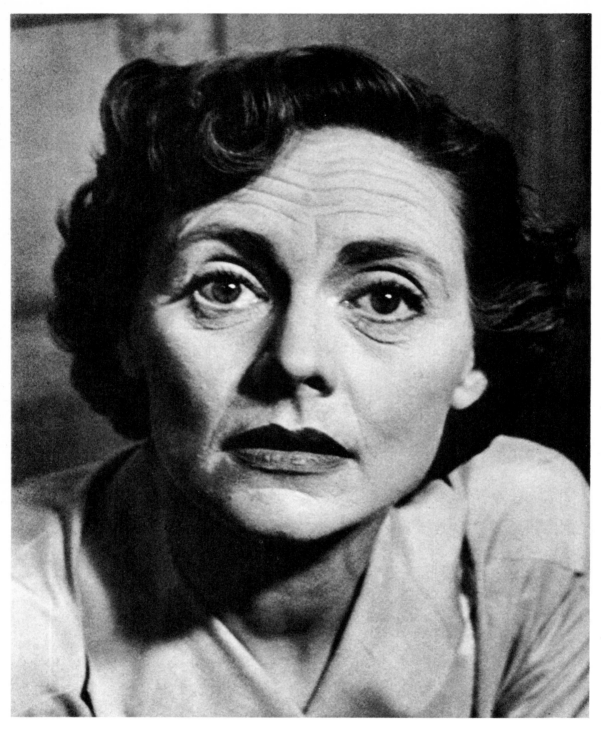

With over fifty stage roles to her credit, CELIA JOHNSON,
back in London after touring Italy with the Old Vic Company
in 1950, rehearsing for a film. Among her best known: *In Which
We Serve, Dear Octopus, This Happy Breed,* and *Brief Encounter.*

Equally at home in films as on stage (since 1934), ALEC
GUINNESS rehearses for *The Card* in London's chilly Ealing
studios. The actor enjoyed being photographed: "Thank you for
making it all so painless," Guinness said, after scarfing his neck
against the cold.

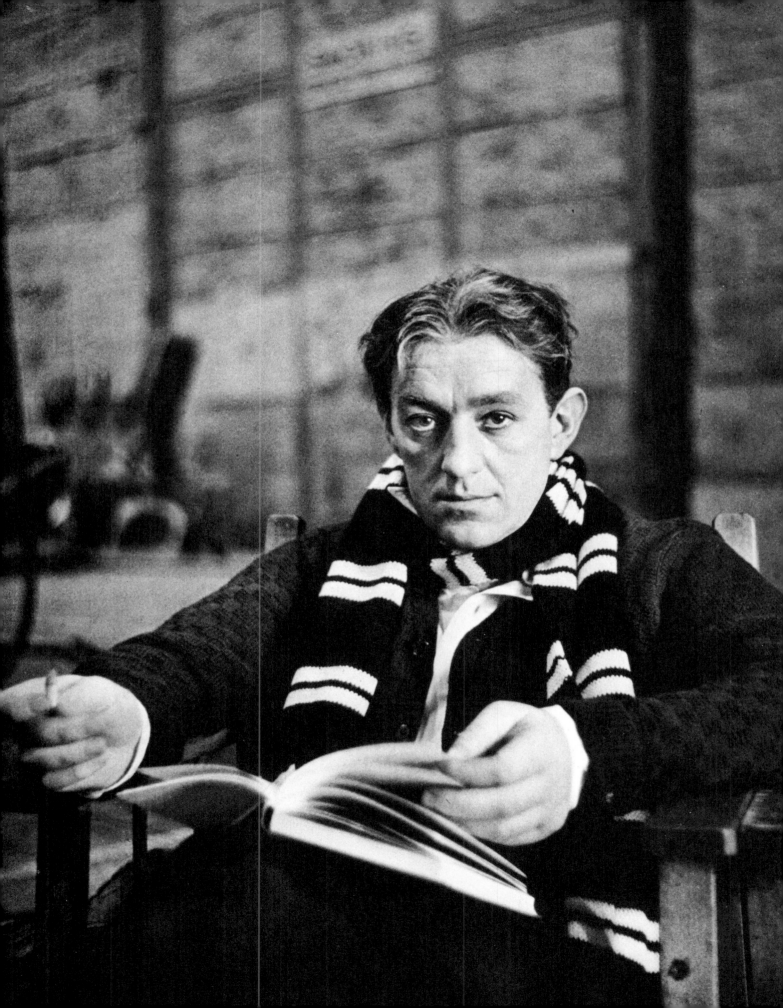

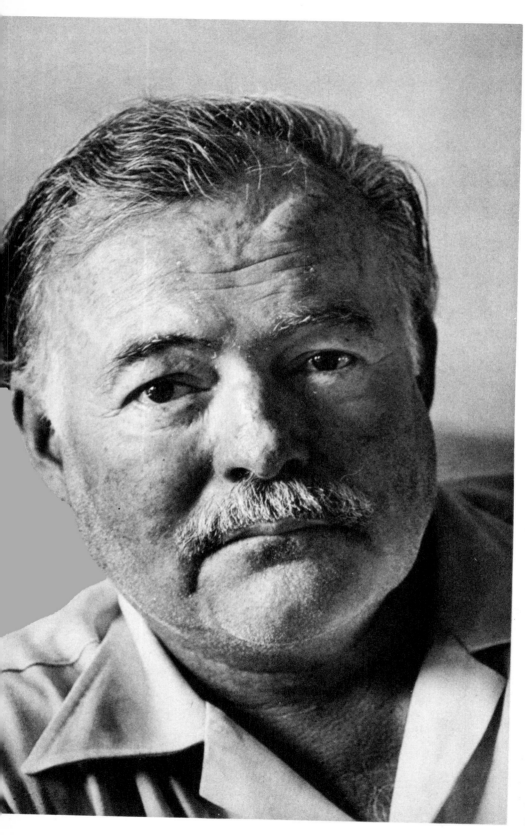

ERNEST HEMINGWAY in Cuba, the setting of *The Old Man and the Sea*. OPPOSITE: Santiago, the "old man" of the 1952 novella, in his shack near Cojimar. "Everything about him was old," wrote Hemingway, "except his eyes and they were the same color as the sea and were cheerful and undefeated." BELOW: Two informal photos of the American novelist—at his retreat, San Francisco de Paulo, and on his deep-sea fishing vessel near Morro Castle. Hemingway, whose most successful work was *For Whom the Bell Tolls*, received the Nobel Prize for Literature in 1954.

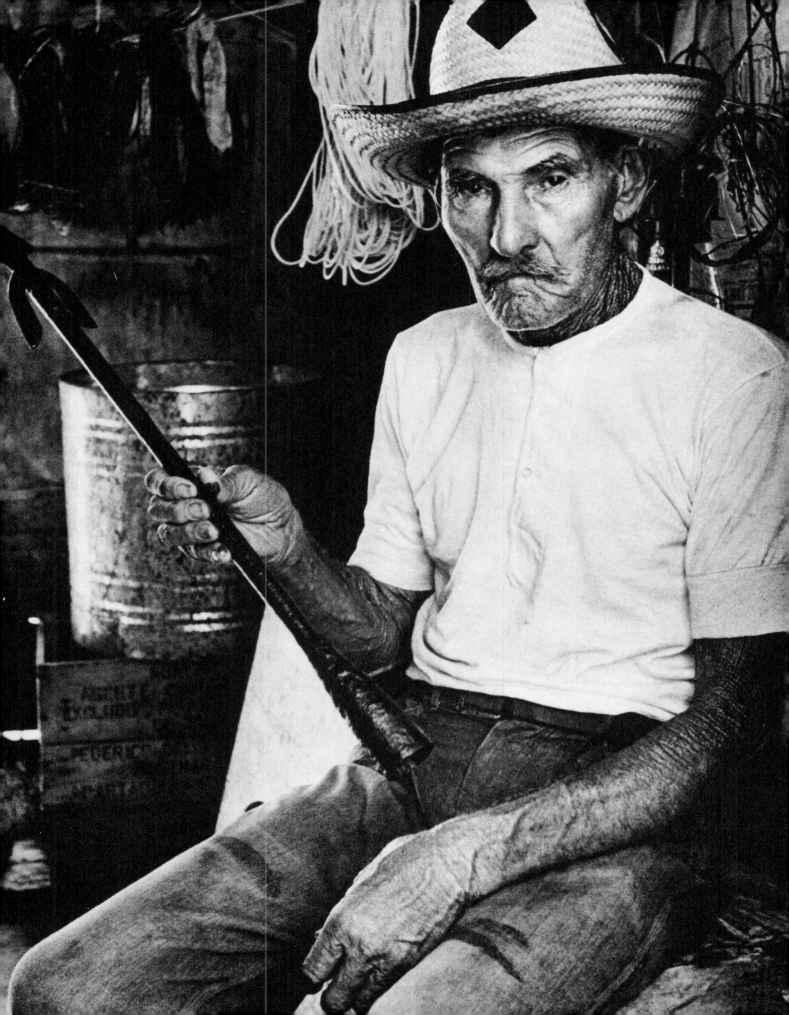

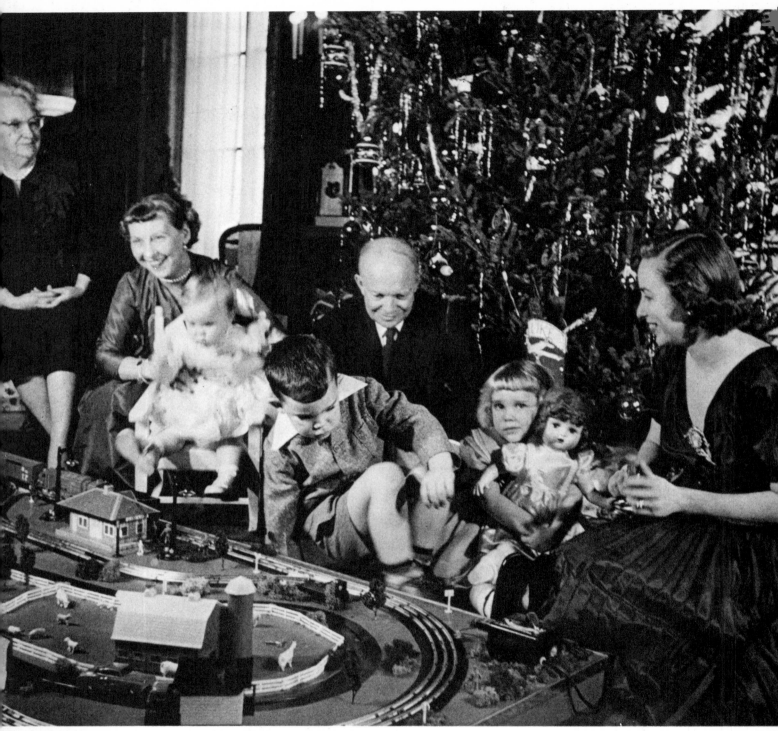

General DWIGHT D. EISENHOWER, President-elect, and Mrs. MAMIE EISENHOWER enjoy the family at Morningside Heights. It was Ike's last Christmas as president of Columbia University.

The DUKE and DUCHESS OF WINDSOR in 1952, sixteen years after the duke, then Edward VIII, had announced to the world that he was abdicating the throne of England to marry "the woman I love," the former Mrs. Wallis Warfield Simpson of Baltimore.

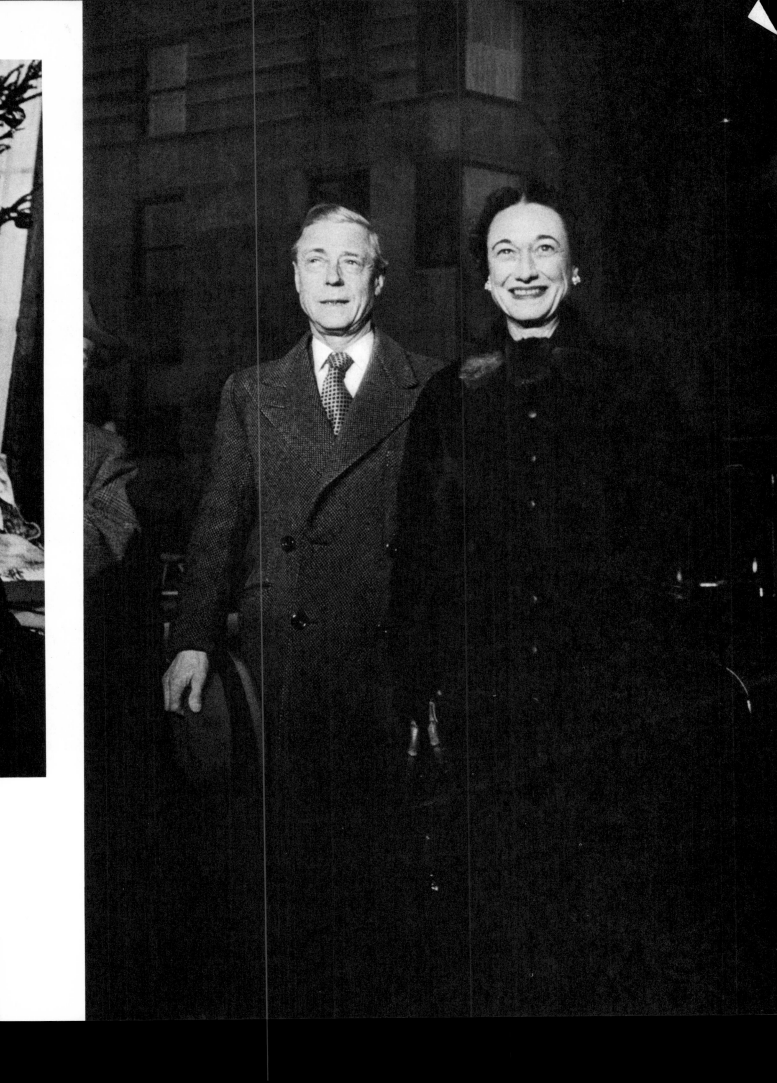

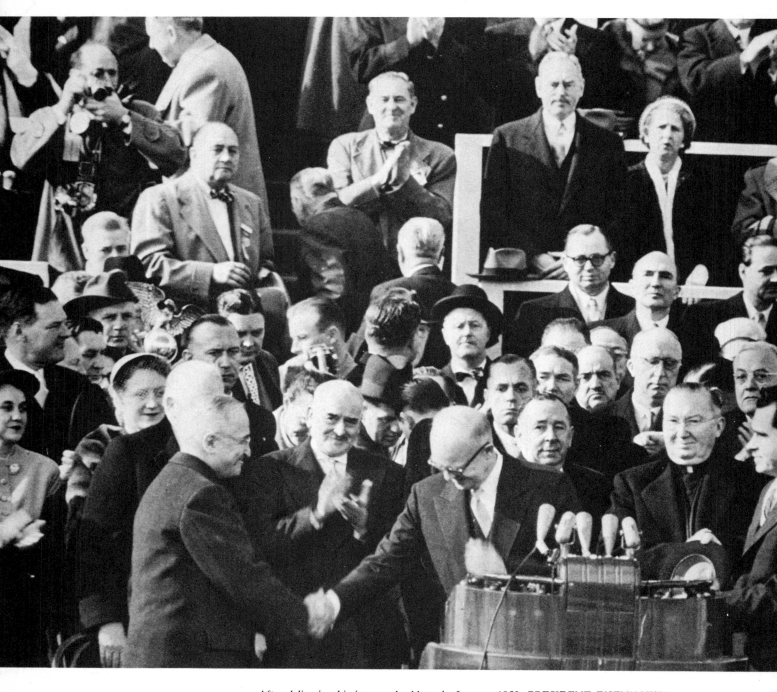

After delivering his inaugural address in January 1953, PRESIDENT EISENHOWER is congratulated by outgoing PRESIDENT TRUMAN. At far right, Vice-President RICHARD NIXON, and behind him, JOHN FOSTER DULLES. The head of former President HERBERT HOOVER frames the top of Mr. Truman's. To the left is HENRY CABOT LODGE. Among other notables: GENERAL BEDELL SMITH, Chief of Staff (back row, right), and DEAN ACHESON, Truman's Secretary of State.

OPPOSITE: GEORGE C. MARSHALL, former Chief of Staff of the U.S. Army and creator of the Marshall Plan. Truman appointed the five-star general U.S. Ambassador to China in 1945, Secretary of State in 1947, and Secretary of Defense in 1950, a post he held until 1951, when this photograph was taken.

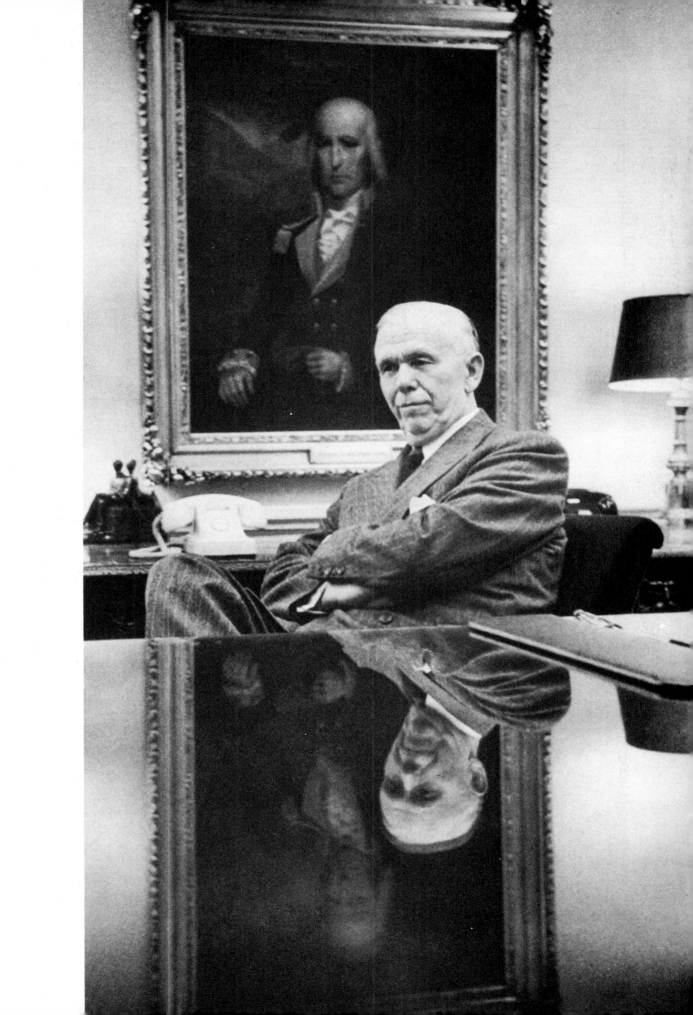

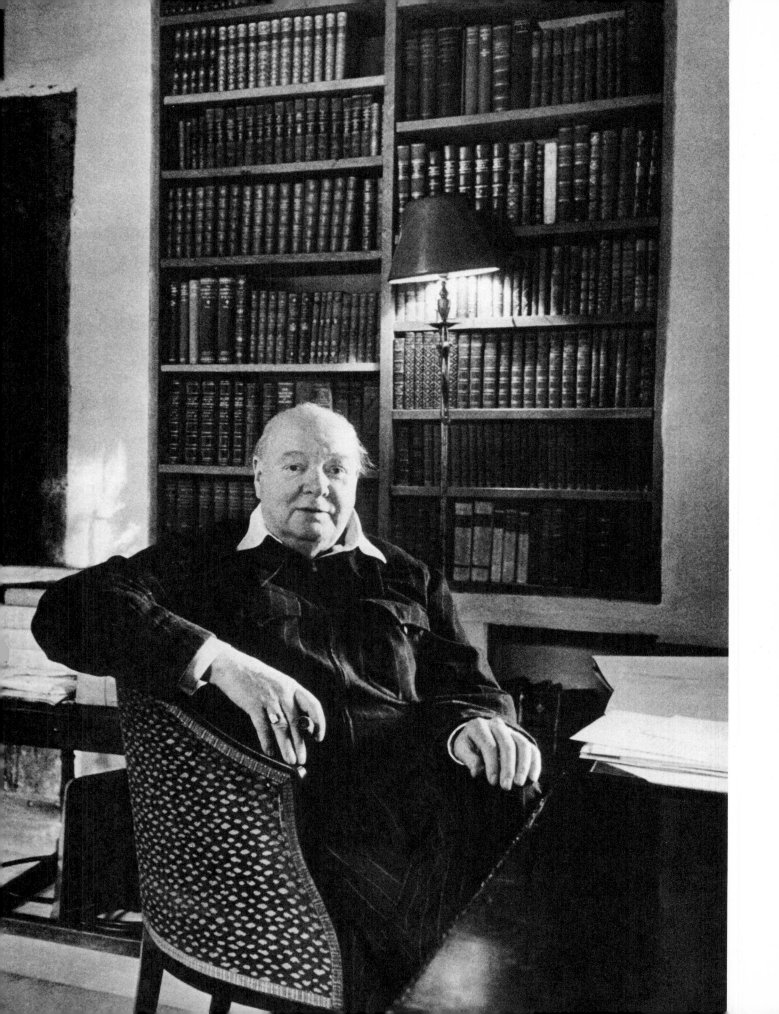

WINSTON CHURCHILL campaigning in Huddersfield. After six postwar years of Labour Party rule under Clement Attlee (page 193), England voted to return its war hero to power in 1951.

The great statesman in his library at Chartwell, Kent, shortly before he again took up the duties of Prime Minister.

WINSTON CHURCHILL in the New York apartment of financier and friend BERNARD BARUCH early in 1953. Facing the Prime Minister: JOHN FOSTER DULLES, U.S. Secretary of State; at his left: host BERNARD BARUCH; and far right: WINTHROP ALDRICH, U.S. Ambassador to the Court of St. James's.

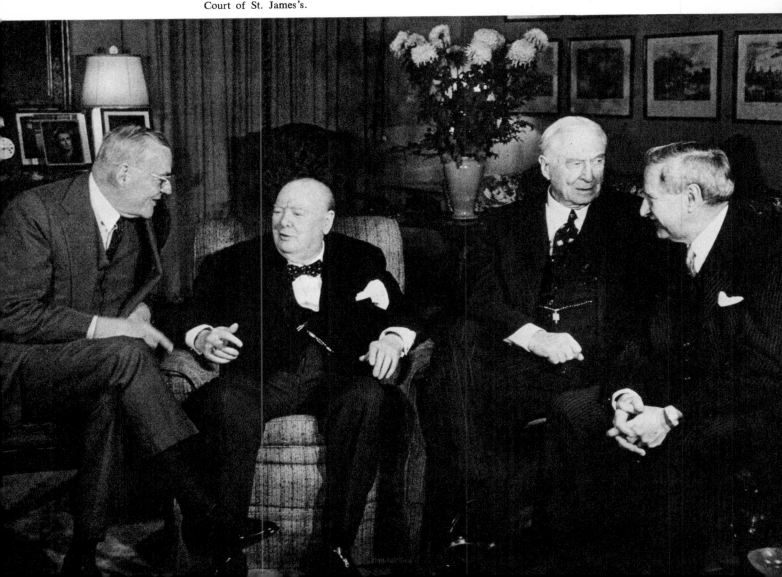

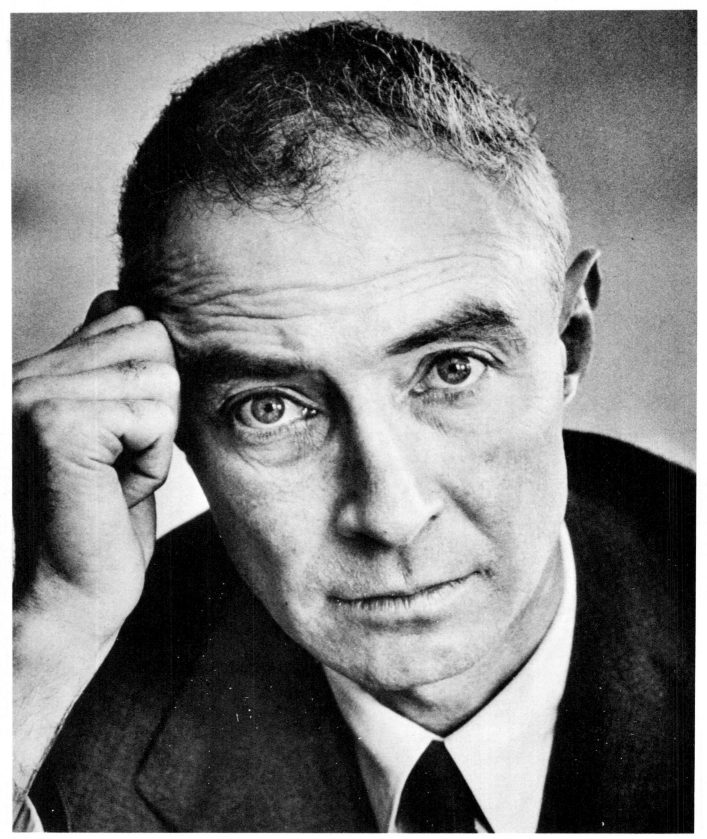

J. ROBERT OPPENHEIMER. In 1945 he was in charge of the Los Alamos, New Mexico, laboratories where the development of the atomic bomb resulted in the devastation of Hiroshima and Nagasaki. Four years later, an anxious Oppenheimer argued against the proposed crash program to build a hydrogen bomb, but President Truman (page 136), under pressure from opposing groups, finally gave the green light. The above photograph was taken in 1954 when Oppenheimer was director of The Institute for Advanced Study in Princeton.

CHARLES LAUGHTON, who made equally believable on film the Tudor king in Alexander Korda's *The Private Life of Henry the Eighth*, the artist in *Rembrandt*, and the sadistic Captain Bligh in *Mutiny on the Bounty*. In the early fifties, after becoming an American citizen, he held audiences rapt with readings from American classics.

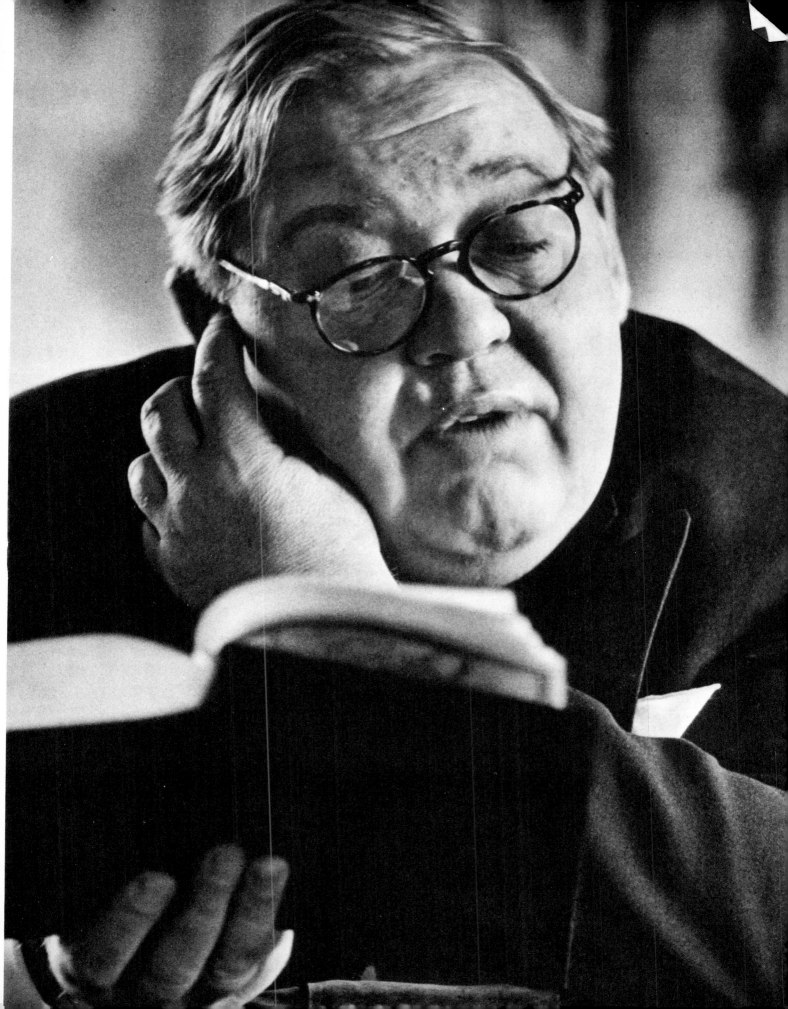

WHITNEY STRAIGHT, former chief executive of British European Airways, became deputy chairman of Rolls-Royce in 1956.

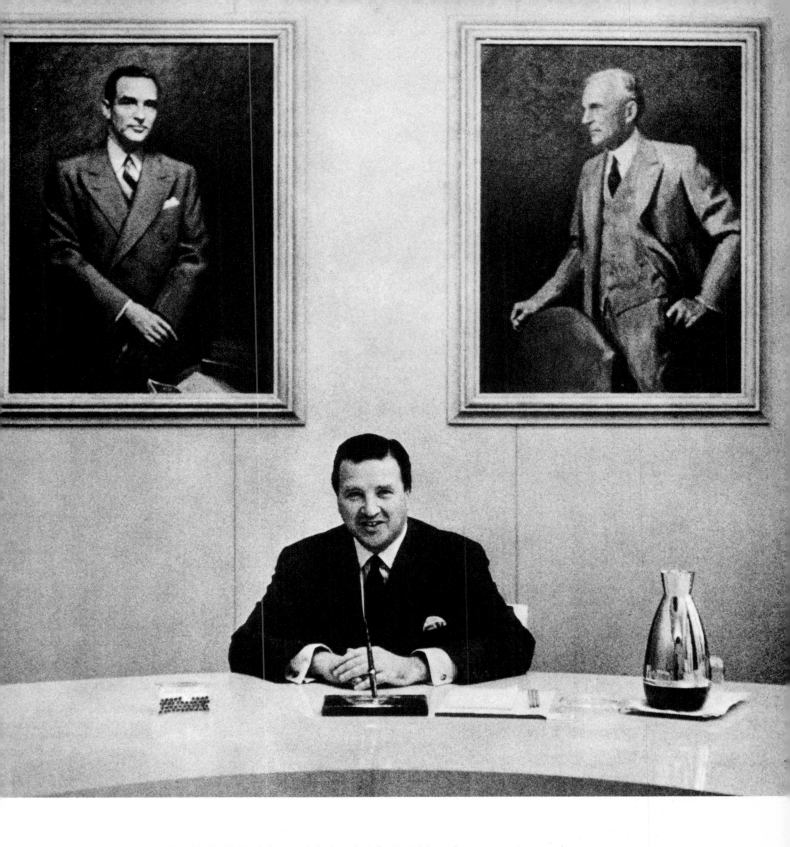

HENRY FORD II, chairman of the board of the Ford Motor Company, under portraits of father, Edsel, and grandfather, Henry, founder of the automobile dynasty. The photograph was taken in the board room in January 1956, shortly before the Ford stock was made public on Wall Street.

A smiling LORD BEAVERBROOK (William Maxwell Aitken),
owner of London's *Daily Express* and *Evening Standard* (1951).

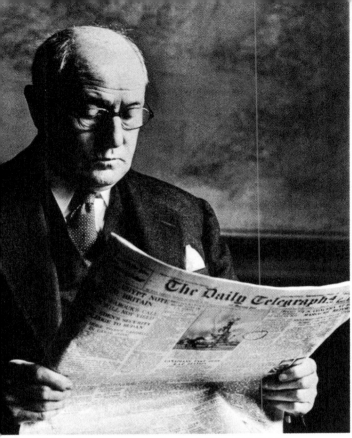

Taking the news more seriously: LORD CAMROSE (William Ewart Berry), editor-in-chief of the *Daily Telegraph*.

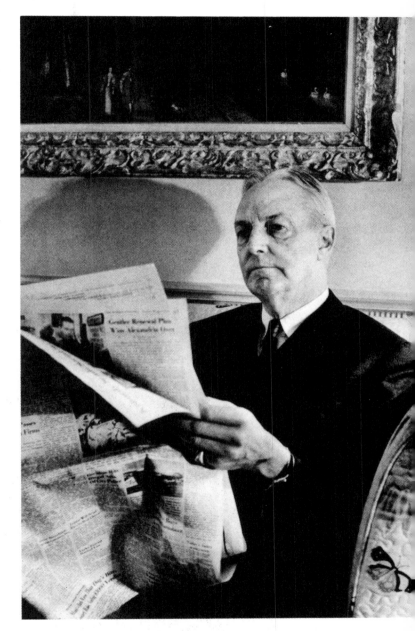

DAVID K. BRUCE, U.S. Ambassador to the Court of St. James's (under the Kennedy administration), catching up on the news in Washington in 1961.

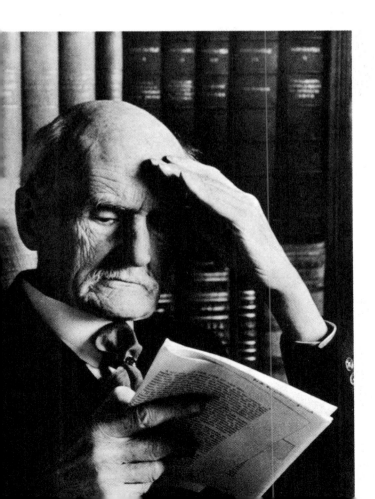

Classicist GILBERT MURRAY, translator of many Greek tragedies and prime mover for the revival of Greek drama on the English stage.

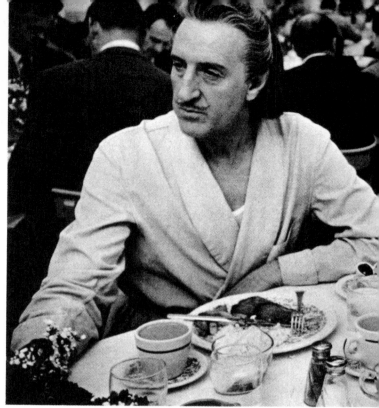

Time out for a "medium rare." BASIL RATHBONE with "Queen" ANGELA LANSBURY in Paramount's commissary. Both were starring with Danny Kaye (page 173) in *The Court Jester* (1954).

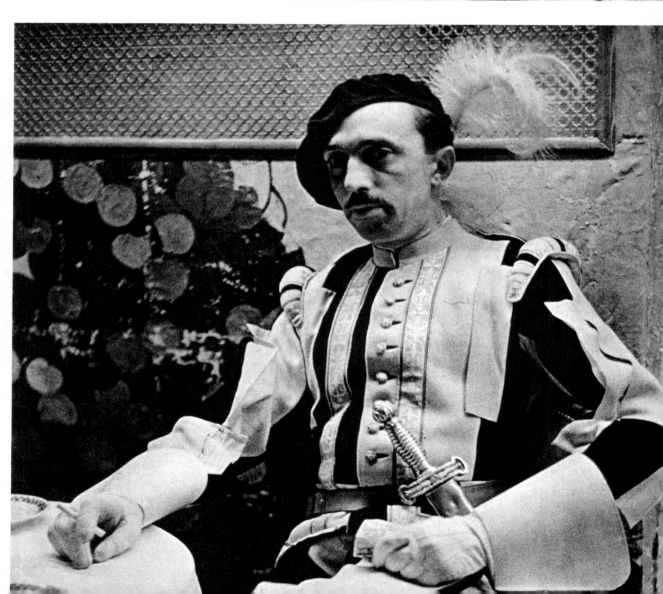

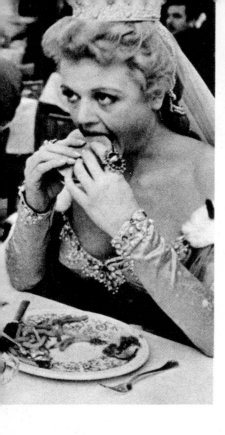

PRINCE RENÉ DE BOURBON as a Swiss Halberdier guard at a fancy dress party at St. Moritz's posh Palace Hotel.

MARGARET TRUMAN, daughter of the former President, treating a Martha Raye TV audience to an aria from *Rigoletto* in 1953.

Composer LEONARD BERNSTEIN (*West Side Story*) and wife, FELICIA MONTEALEGRE, in 1956. They were entertaining ALEXANDER and JAMIE with a lively duet—until both of *them* decided to join in. Two years later, Bernstein became the first American-born musical director of the New York Philharmonic.

IMOGENE COCA, teamed with Sid Caesar on a 1957 TV weekly, rehearsing a new number—to an impervious home audience.

TALLULAH BANKHEAD, American "darling" of London's stage through most of the twenties, won the part of her colorful Broadway career in Lillian Hellman's *The Little Foxes* in 1939. The photograph was taken in 1951, a few months after Miss Bankhead had concluded touring in a revival of Noël Coward's *Private Lives*.

The youngest member of the Elbert B. Little family with book and friends.

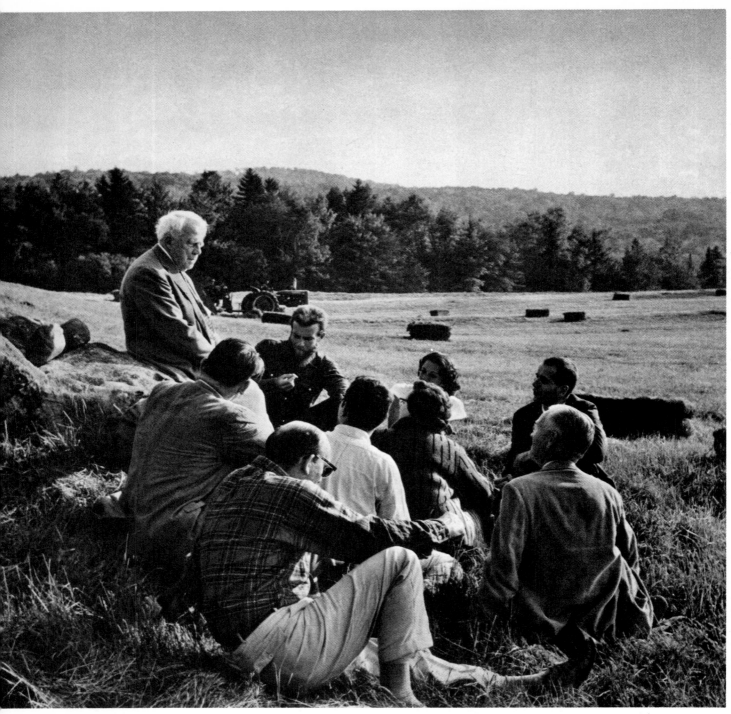

Poet ROBERT FROST lecturing in Breadloaf, Vermont.

A pensive MARILYN MONROE in Beverly Hills between filming *There's No Business Like Show Business* and *The Seven Year Itch* (1953). She was shortly to marry baseball hero Joe DiMaggio (OVERLEAF).

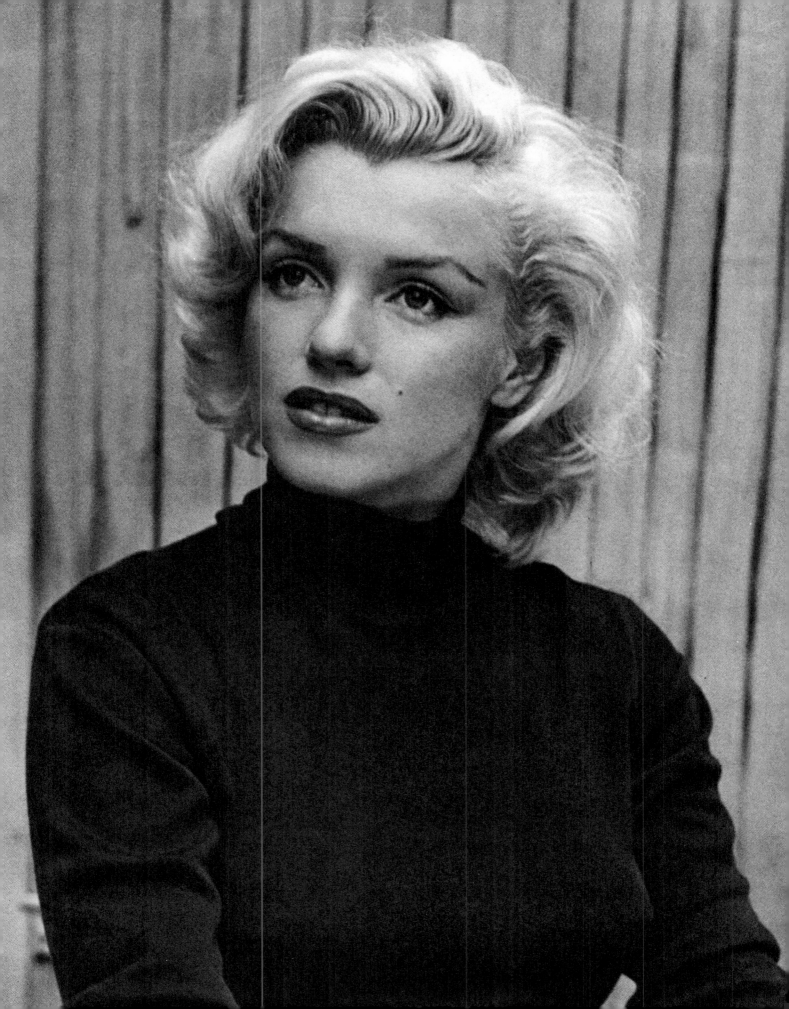

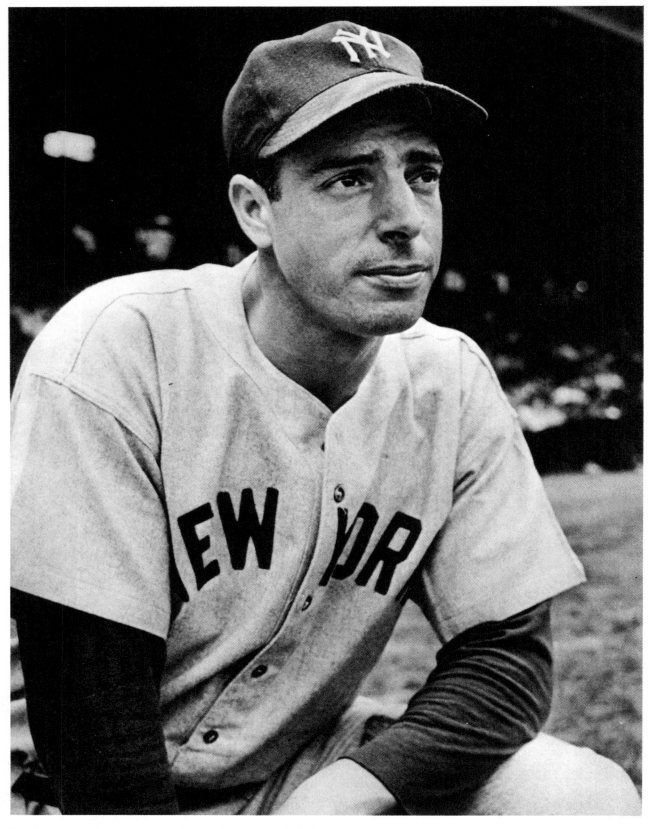

JOE DiMAGGIO, hard hitter and outfielder of the New York Yankees,
the year he was elected to the Baseball Hall of Fame (1955).

WILLIE MAYS, centerfielder for the New York (later, San Francisco) Giants,
in Chicago, 1954. Mays won the National League batting championship that year.

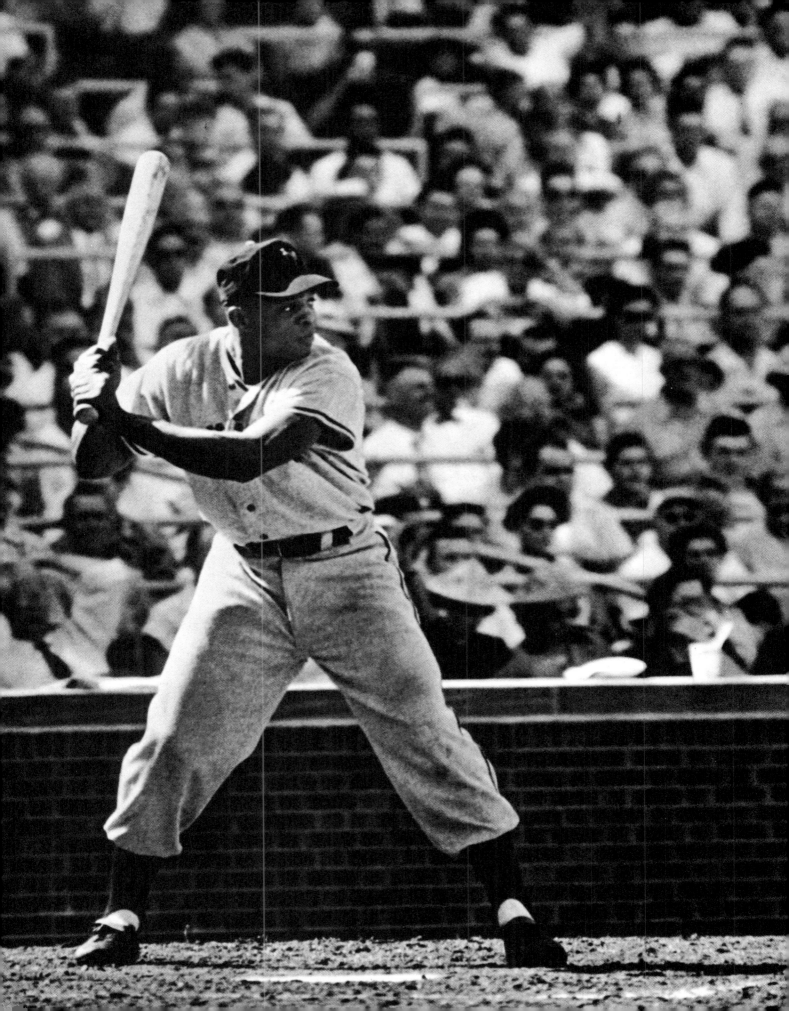

FRANK LLOYD WRIGHT—whose innovations ranged from the modern prairie-style houses he designed and built in the Midwest to the exotic Imperial Hotel in Tokyo and the spiraling Guggenheim Museum in New York—at home in North Spring Green, Wisconsin, 1956. "Art and Religion are the essences of being—cultivate them," the architect said. Three years later Wright died, aged ninety.

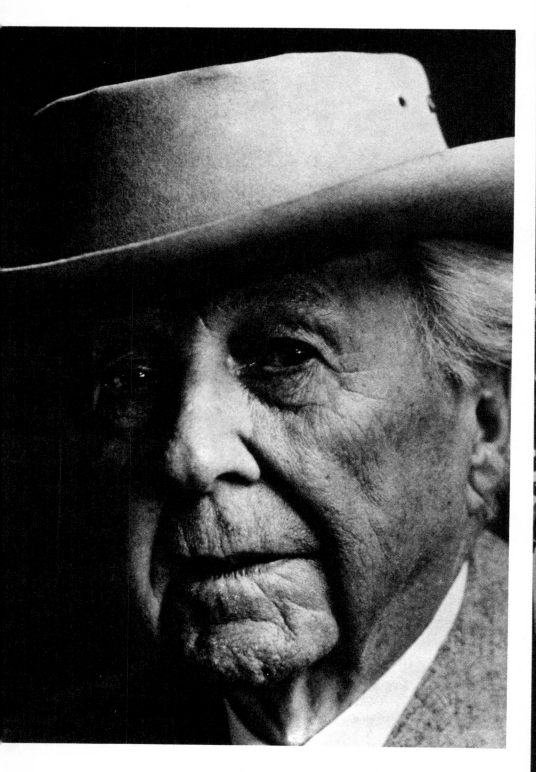
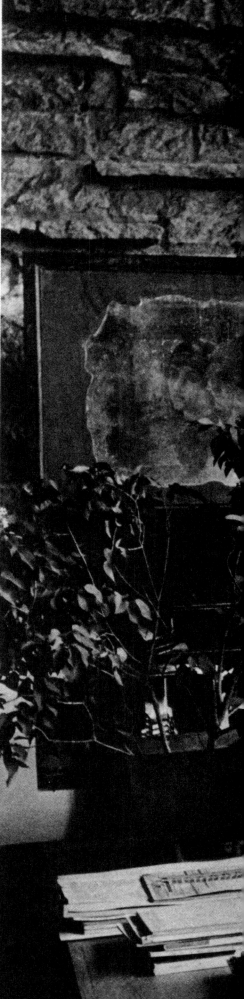

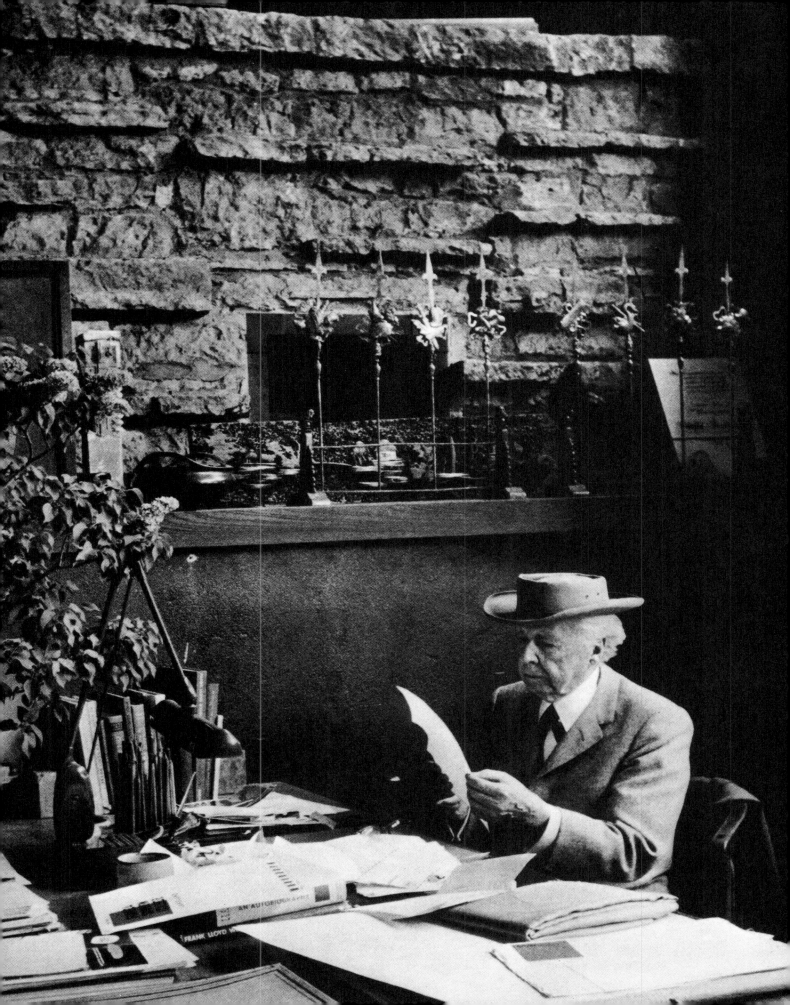

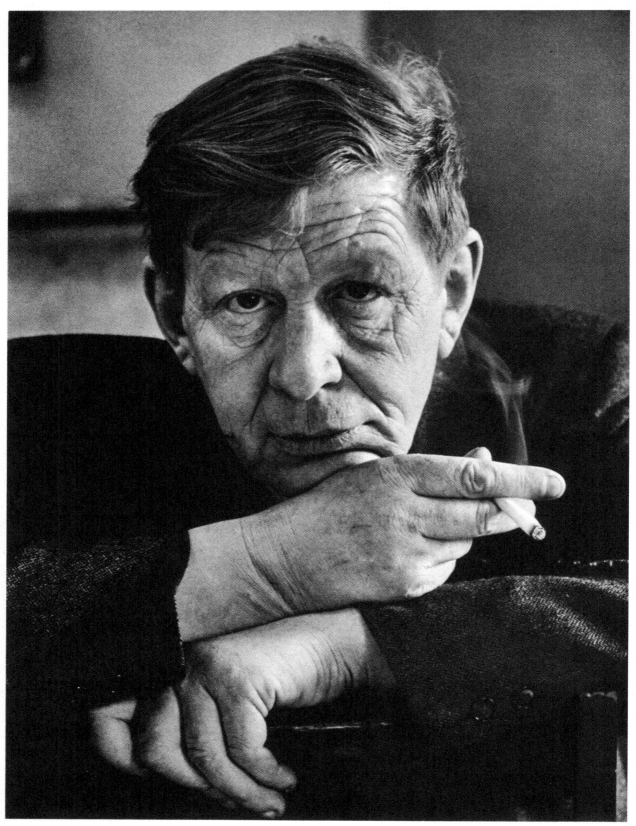

W. H. AUDEN in 1956. In the thirties, Auden was identified with British poets of Marxist leanings, and in recent years has been increasingly and notably occupied with philosophy and religion.

Dramatist TENNESSEE WILLIAMS (Mississippi-born Thomas Lanier Williams), who won both the Pulitzer Prize and the Drama Critics Circle Award for *A Streetcar Named Desire* in 1948, and again in 1955 for *Cat on a Hot Tin Roof,* sharing a breath of New York air with his "shy" bulldog (1956).

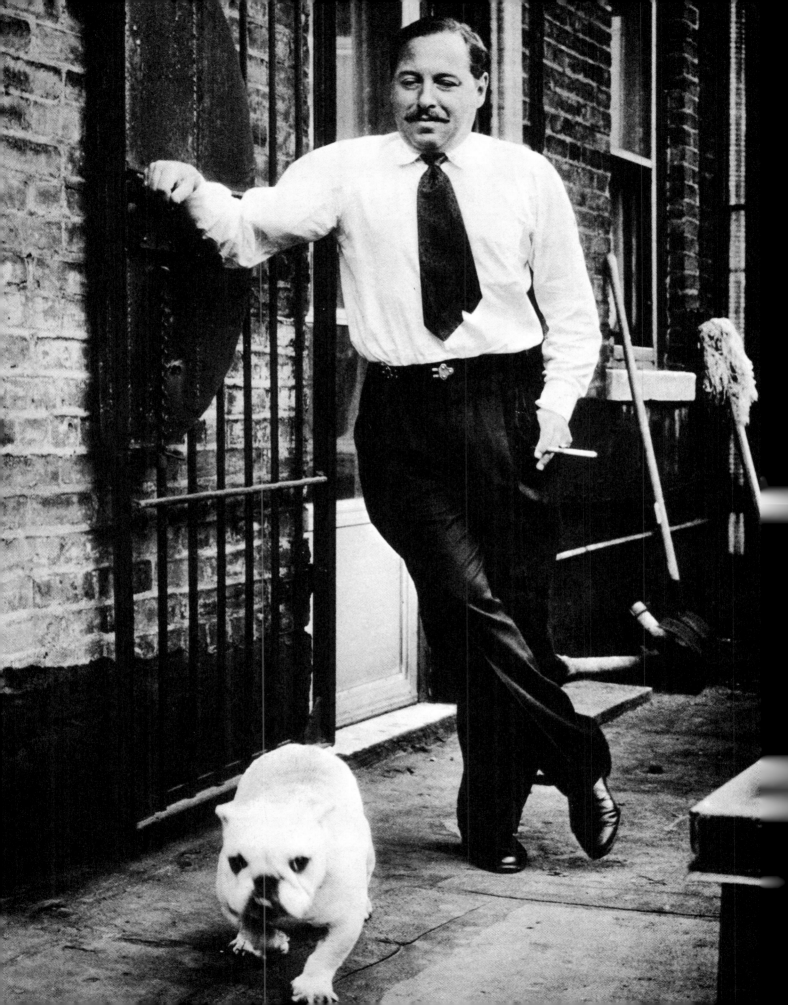

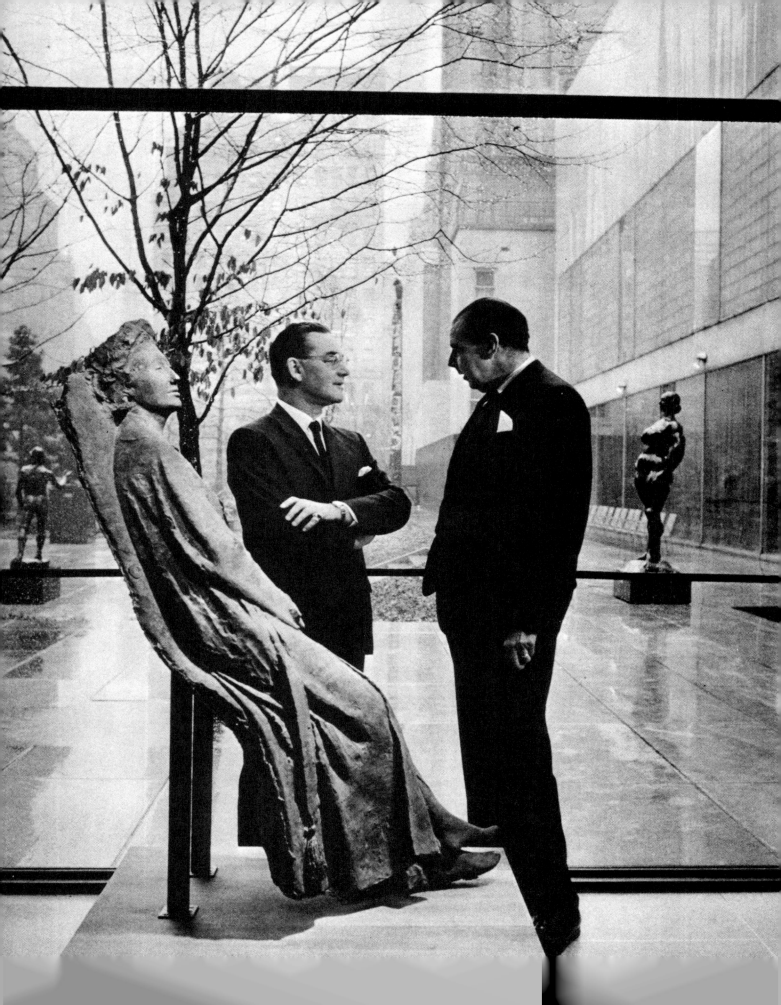

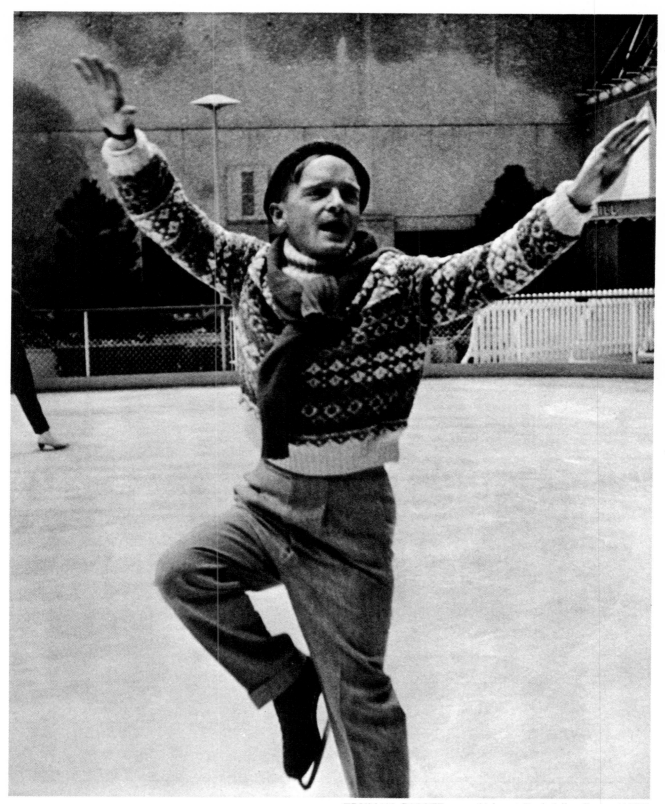

TRUMAN CAPOTE on cold ice at Rockefeller Center (1959).

Study in profiles: RENÉ D'HARNONCOURT, director of
New York's Museum of Modern Art, and Giacomo Manzu's
leaning sculpture face millionaire art patron and publisher JOHN
HAY WHITNEY in the museum (1955).

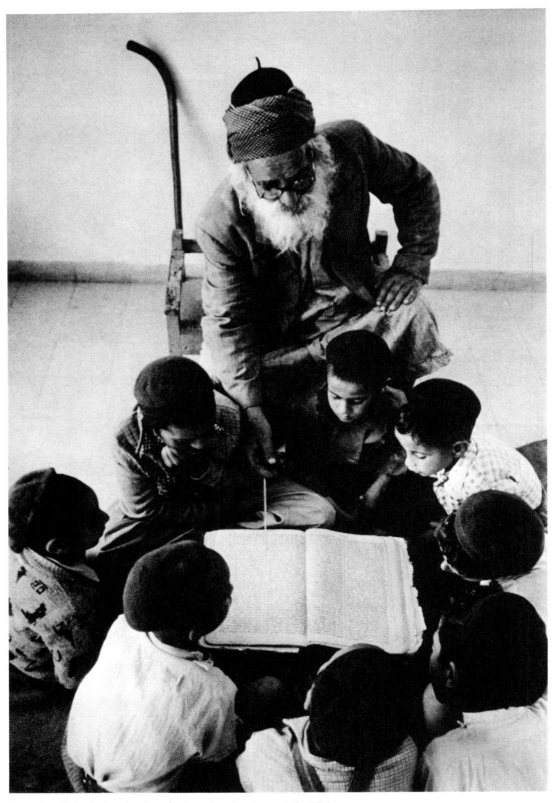

Yemenite scholar instructing boys in Jerusalem how to read the Bible.
As only one copy was available, some had to learn it upside down.

Rabbi in one of the small synagogues in Jerusalem's Mea Shearim.

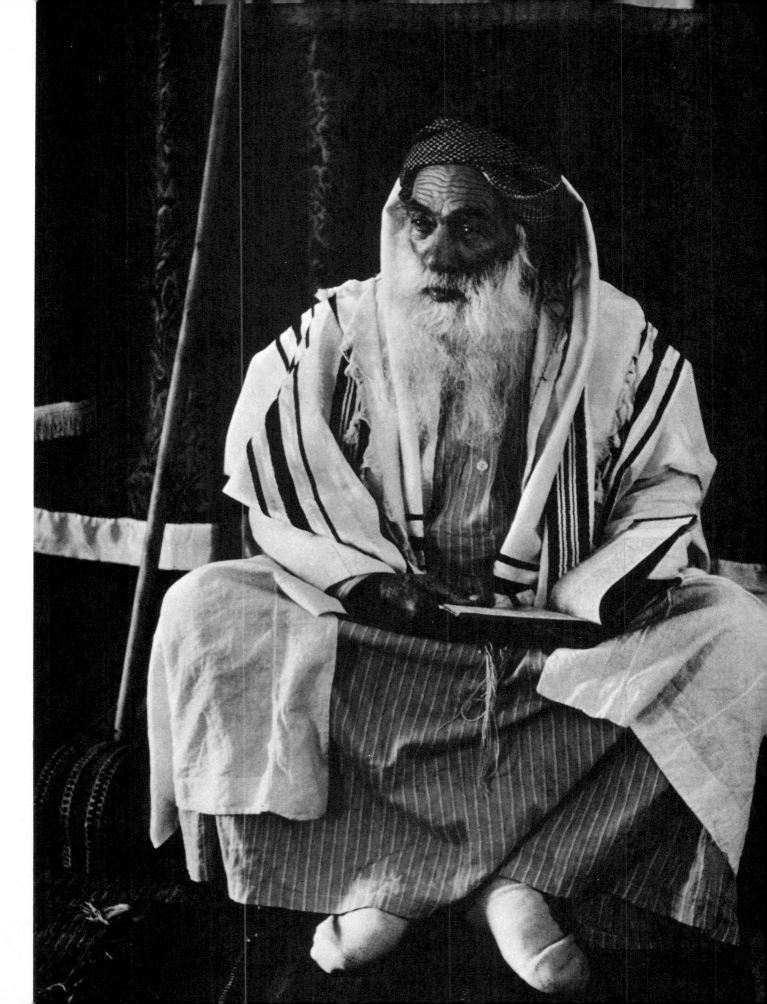

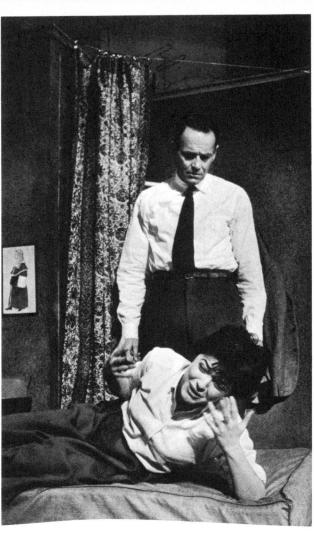

ANNE BANCROFT and HENRY FONDA during a rehearsal of William Gibson's play *Two for the Seesaw,* in 1958.

OPPOSITE: MARGARET LEIGHTON as Mrs. Shankland, one of the two memorable roles she played in Terence Rattigan's *Separate Tables* in 1956. At the other table: ERIC PORTMAN.

ETHEL WATERS and SYLVIA SIDNEY in one of the *Highlights of the Empire Theater* (1953).

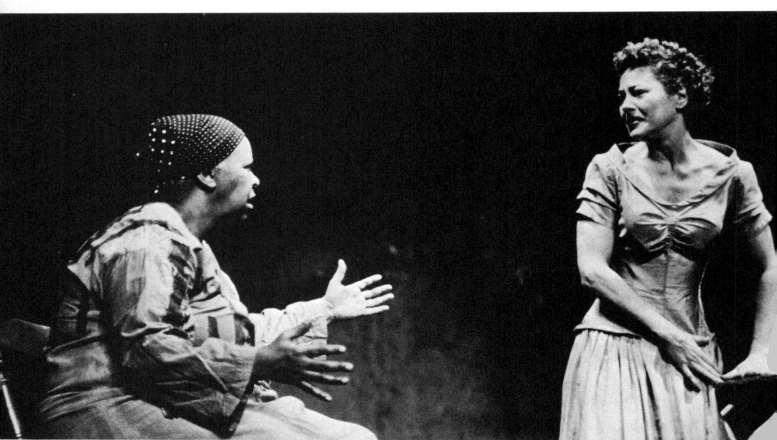

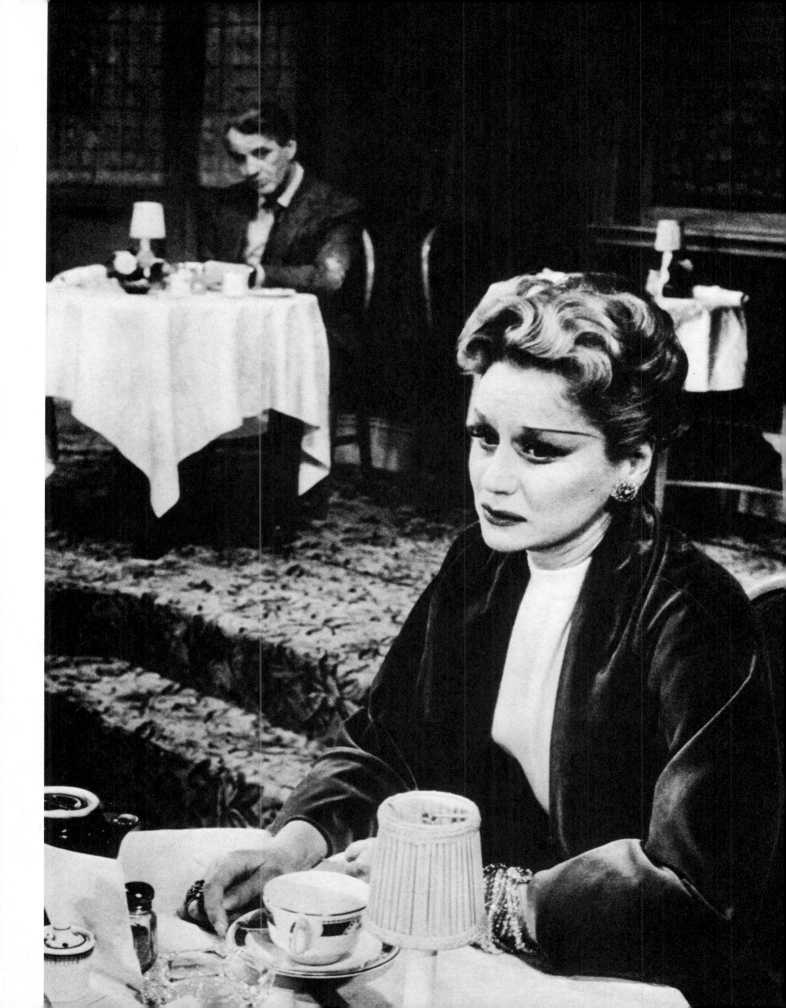

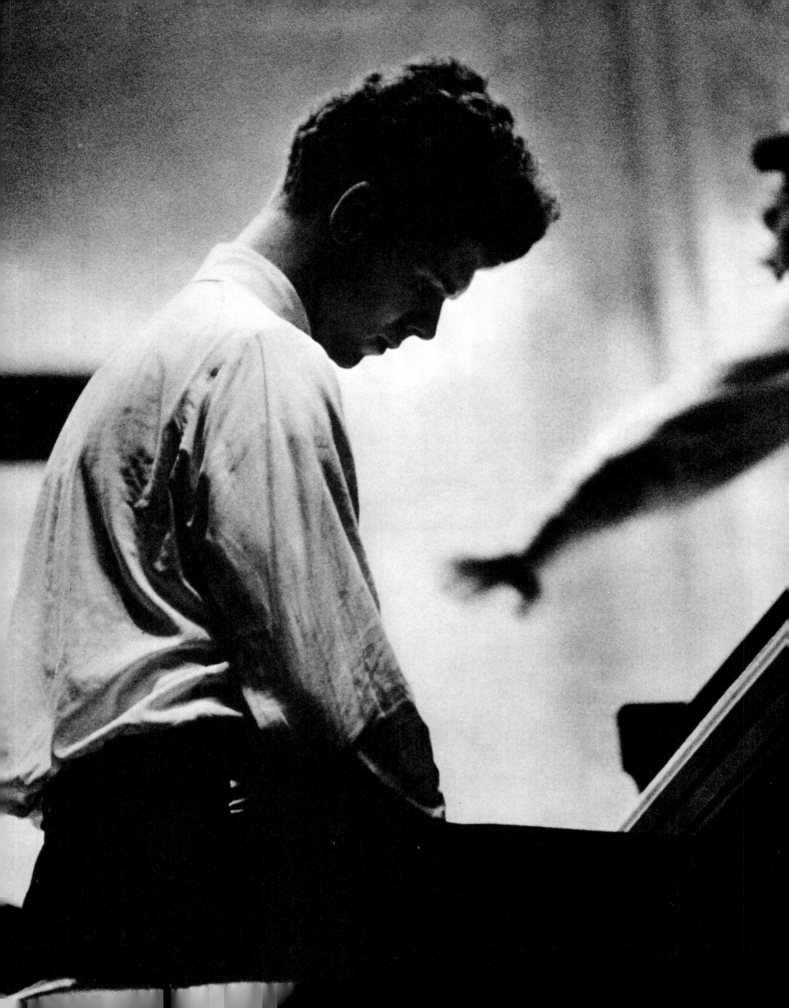

Russian-born GREGOR PIATIGOR-SKY, solo cellist since 1928, in his dressing room before a recital at Carnegie Hall (1960).

OPPOSITE: VAN CLIBURN at Carnegie Hall, shortly after winning the Tchaikovsky award in Moscow, rehearses Rachmaninoff's Piano Concerto No. 3 on the Steinway he had chosen out of the twenty pianos offered him. The owner of the outstretched arm is KYRIL KONDRASHIN, conductor of the Moscow Philharmonic Orchestra (1958).

Conductor LEOPOLD STOKOWSKI discussing a score with flutist WILLIAM KINCAID before a performance in 1960.

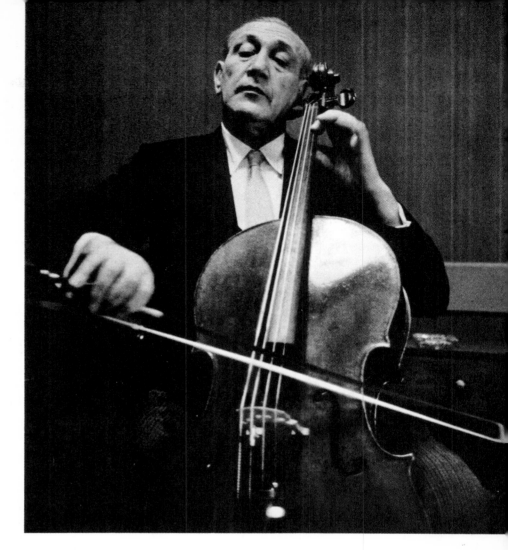

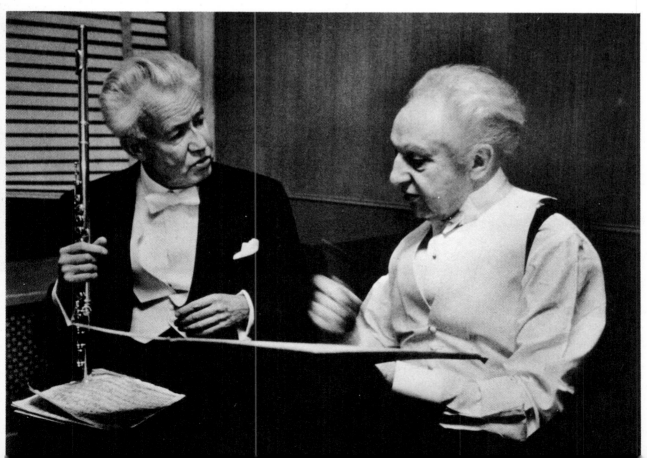

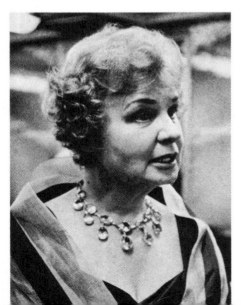

GALINA ULANOVA of the Bolshoi Ballet.

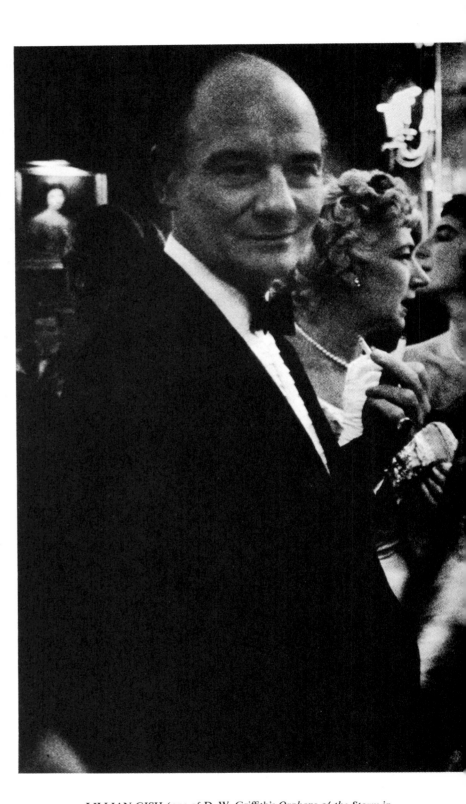

LEFT CENTER: LILLIAN GISH (one of D. W. Griffith's *Orphans of the Storm* in 1922) braving the rain in Shubert Alley in 1955. LEFT: SHIRLEY BOOTH (in *By the Beautiful Sea* in 1954 and *The Desk Set* a year later) at a charity function.

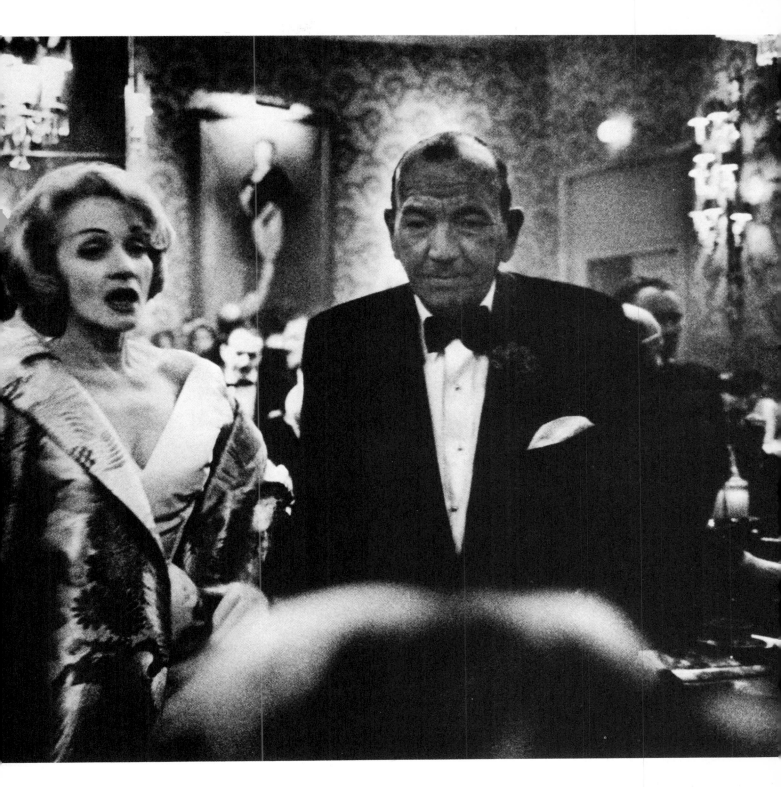

At the old "Met" between acts of the Bolshoi Ballet's *Romeo and Juliet:*
JOHN GIELGUD, probably the century's greatest *Hamlet,* with the legendary
MARLENE DIETRICH and equally legendary NOEL COWARD (1959).

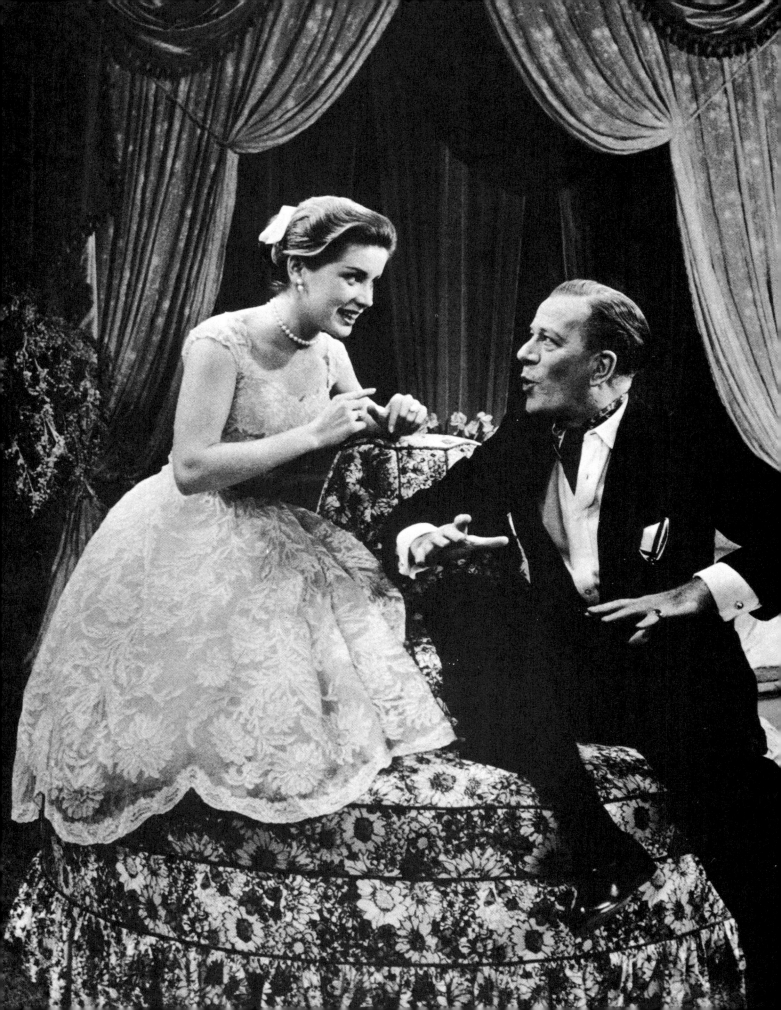

CYRIL RITCHARD, DOLORES HART, and (RIGHT) CHARLES RUGGLES—as his usual self—in the 1958 Samuel A. Taylor comedy *The Pleasure of His Company,* which also starred Cornelia Otis Skinner.

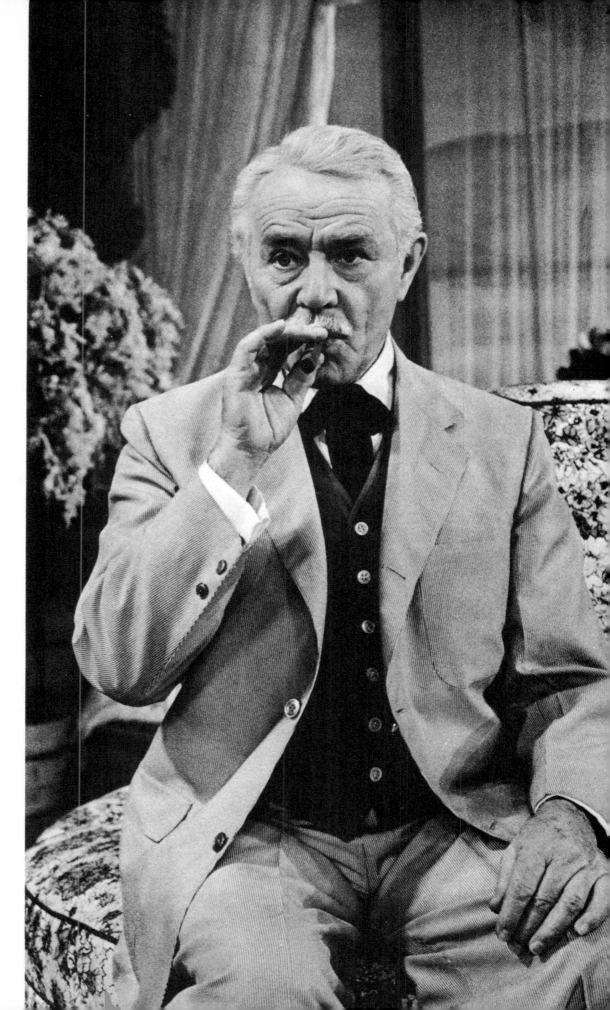

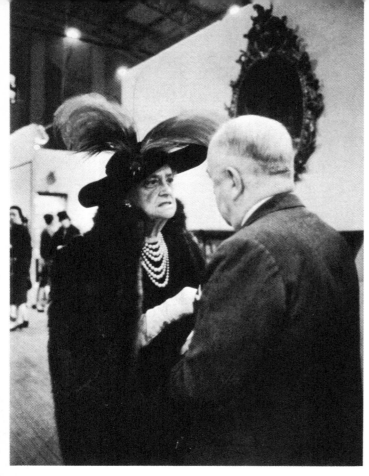

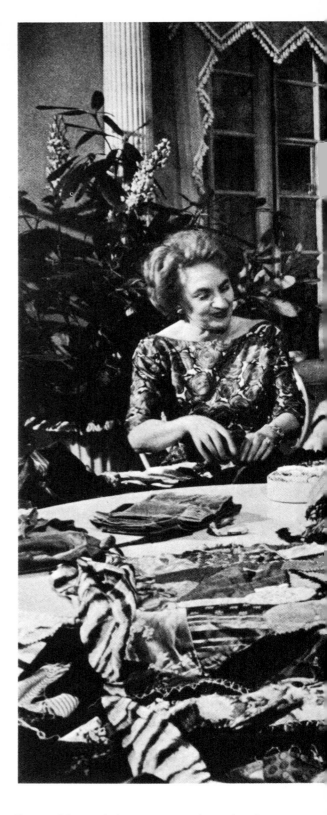

Lovers of lace and plumage at an antiques show in New York: TOP: Mrs. KATHERINE MURPHY, collector of Americana; and, BOTTOM: Decorator ROSE CUMMING. Few bargains were in sight.

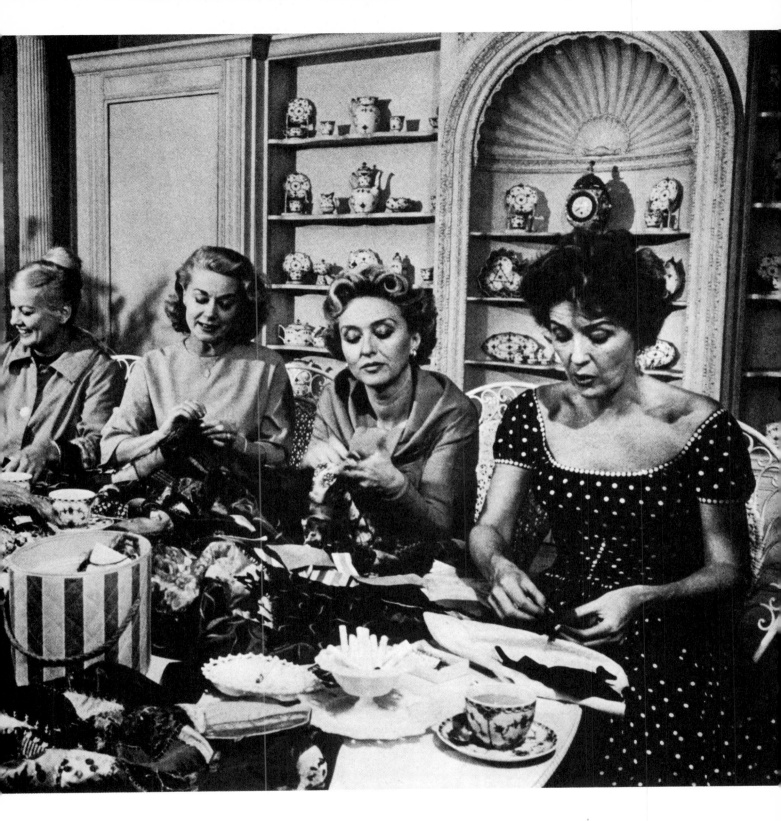

At a quilting party (1959). Better known on stage and screen than as quilters, the five busy ladies are HERMIONE GINGOLD, FAYE EMERSON, JUNE HAVOC, CELESTE HOLM, and, nearest the camera, hostess GYPSY ROSE LEE.

DAVE GUARD, NICK REYNOLDS, and BOB SHANE—the KINGSTON TRIO—reviving *Lizzie Borden* in their lively song at a pop concert in 1959.

Sixteen-year-old FABIAN (Fabian Forte) exciting a teenage audience with *Turn Me Loose* in 1959.

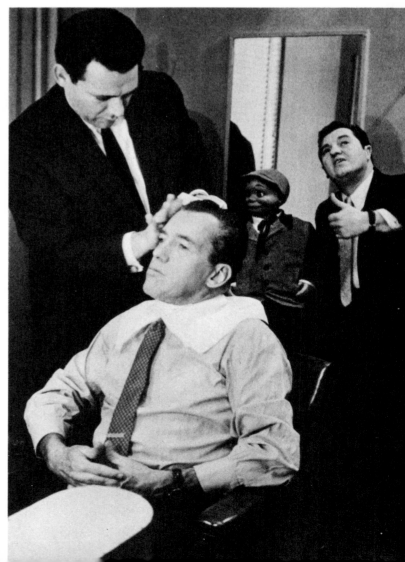

Making ED SULLIVAN up for the cameras before one of his hourly Sunday night television shows in 1959.

Comedian DANNY KAYE (David Kuminsky) in *On the Riviera* (1951). RIGHT: BOB HOPE emceeing at *Life*'s twenty-fifth birthday party at the Ziegfeld Theater in 1961.

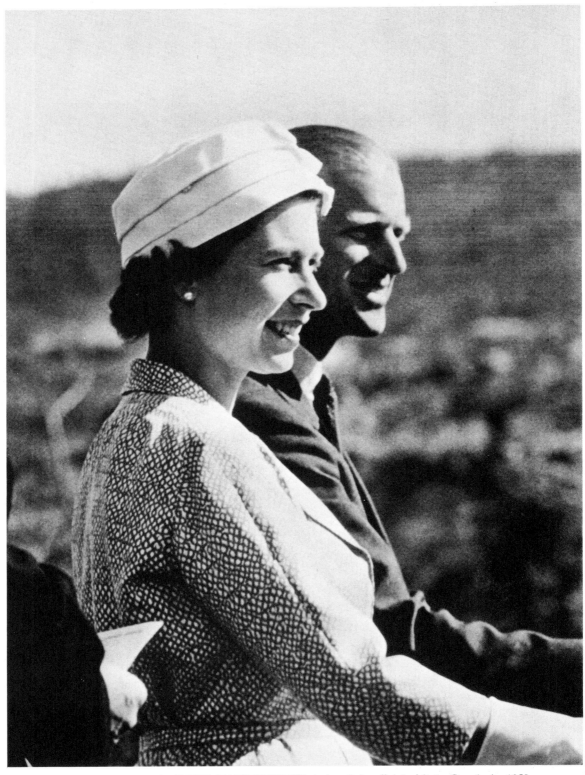

QUEEN ELIZABETH II and the DUKE OF EDINBURGH during their official visit to Canada in 1959.

The couple receives a royal welcome in Montreal.

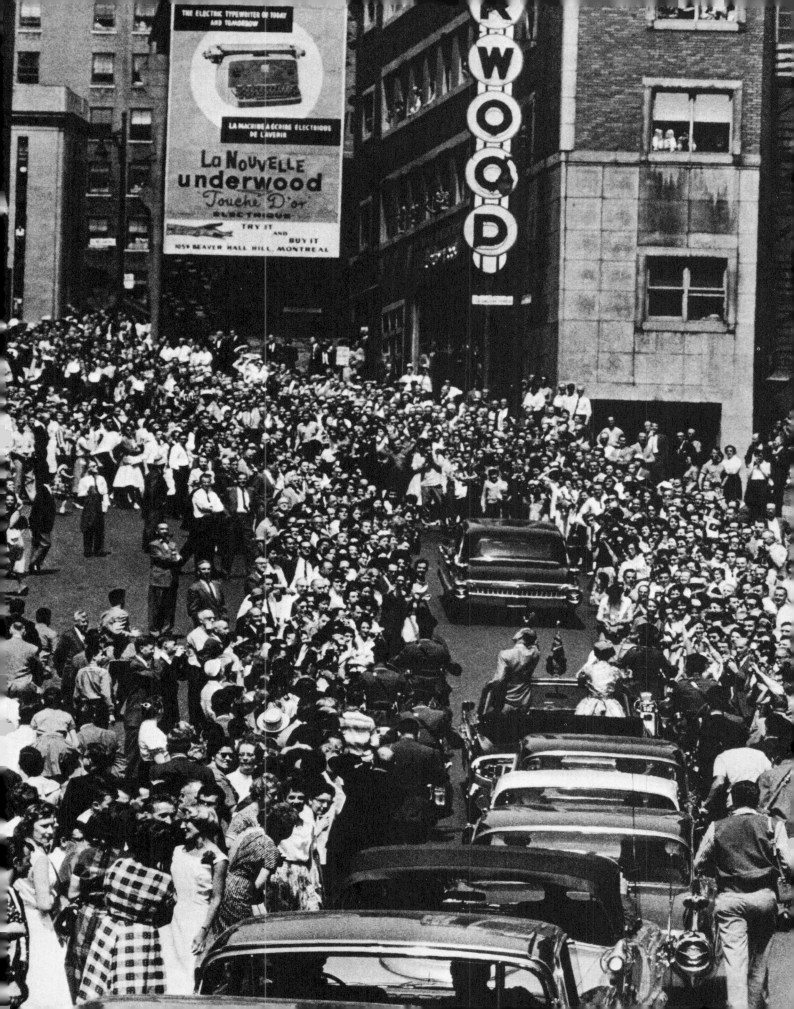

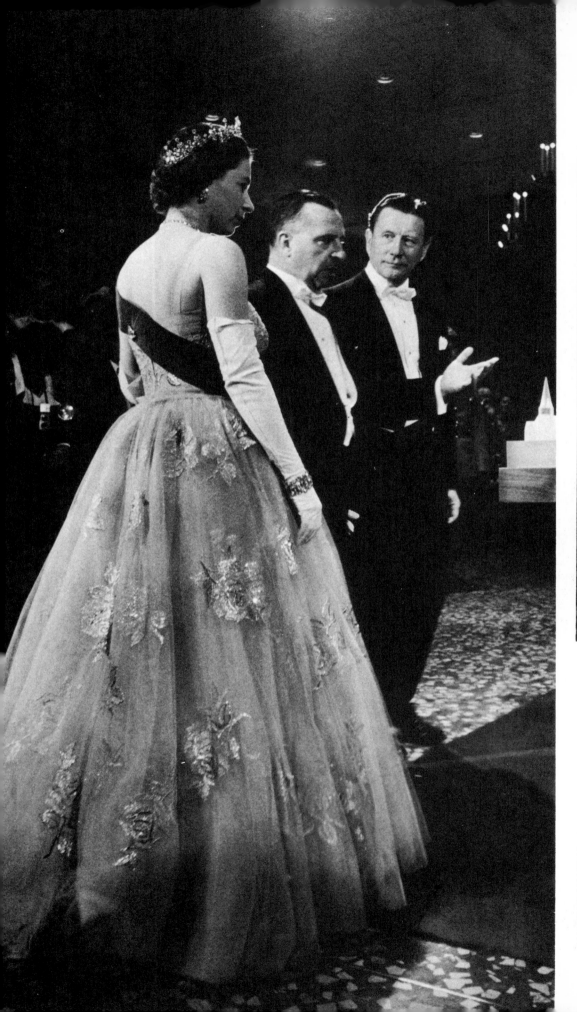

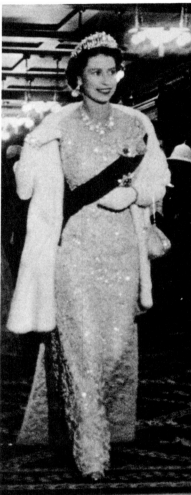

In Quebec, QUEEN ELIZABETH arriving at the Château Frontenac and (left) viewing an exhibition model in the vestibule of the hotel.

Eight years earlier (while George VI was still King of England), QUEEN ELIZABETH, now Queen Mother, at a reception in London following a command performance of *Where No Vultures Fly*, the film about a wildlife expedition near Kilimanjaro. Waiting in line: ZACHARY SCOTT, LIZABETH SCOTT, JANE RUSSELL, and the irrepressible Dame MARGARET RUTHERFORD .

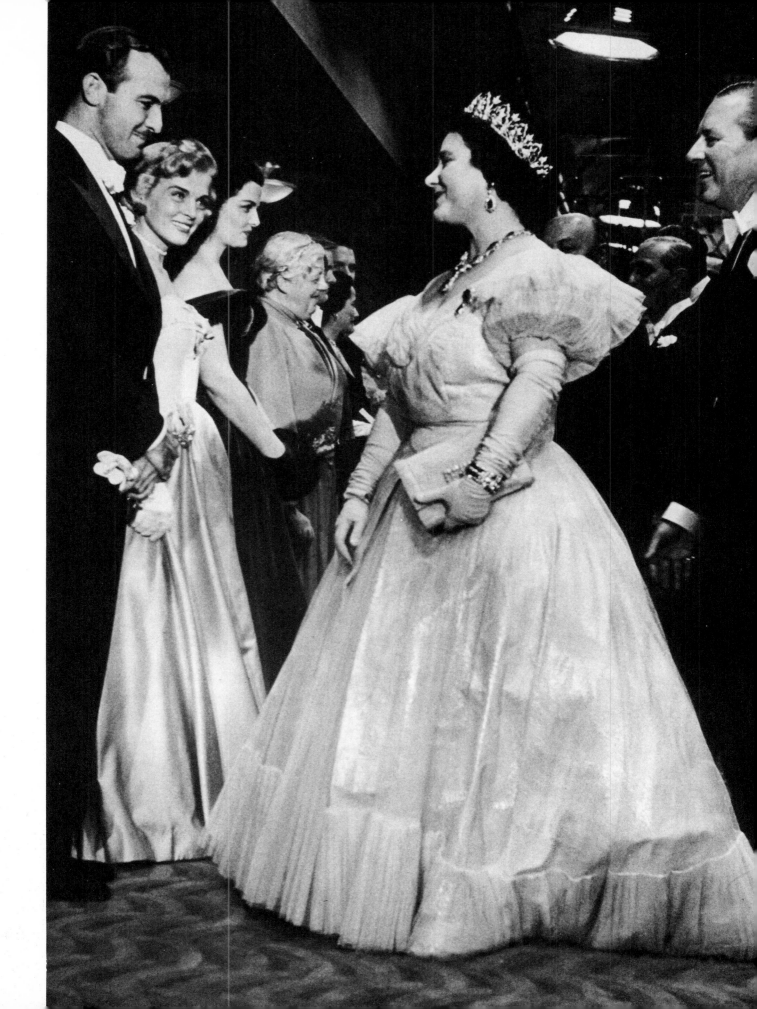

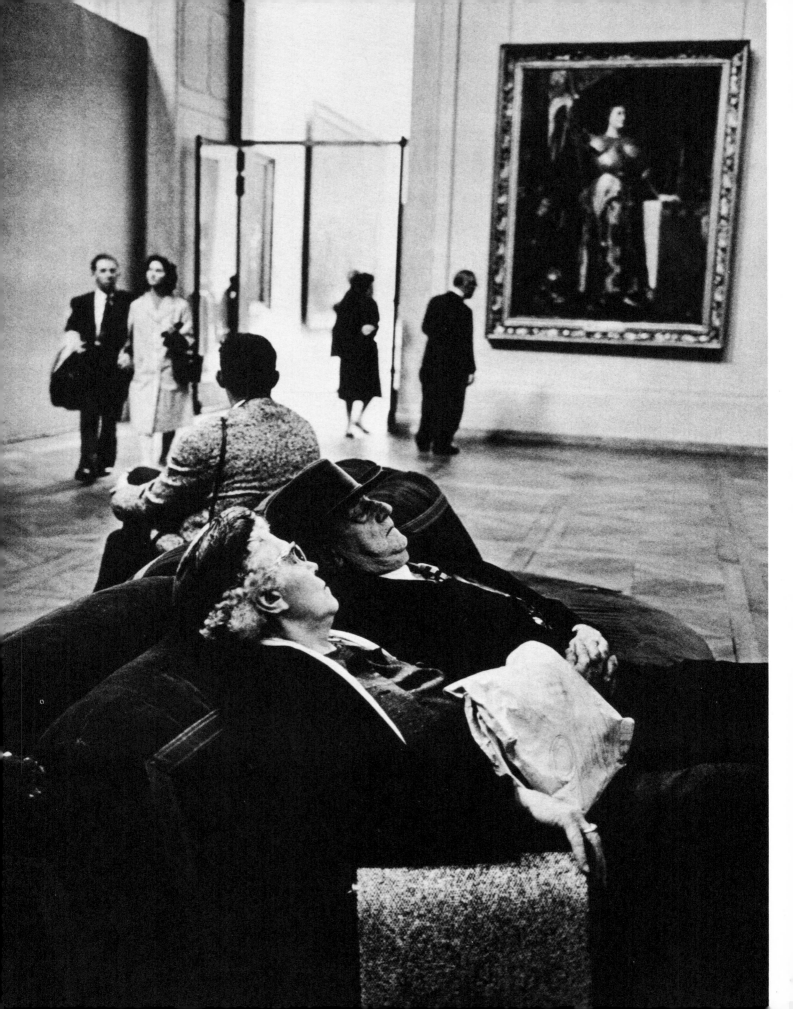

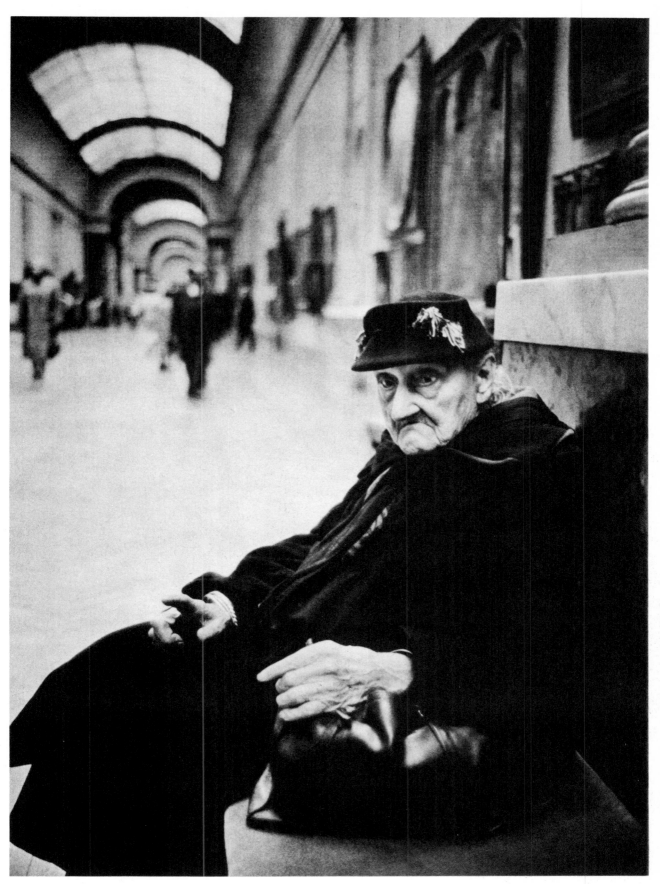

In the Louvre. Two American tourists call it quits, while
an aged Parisienne ponders the famous Mona Lisa smile.

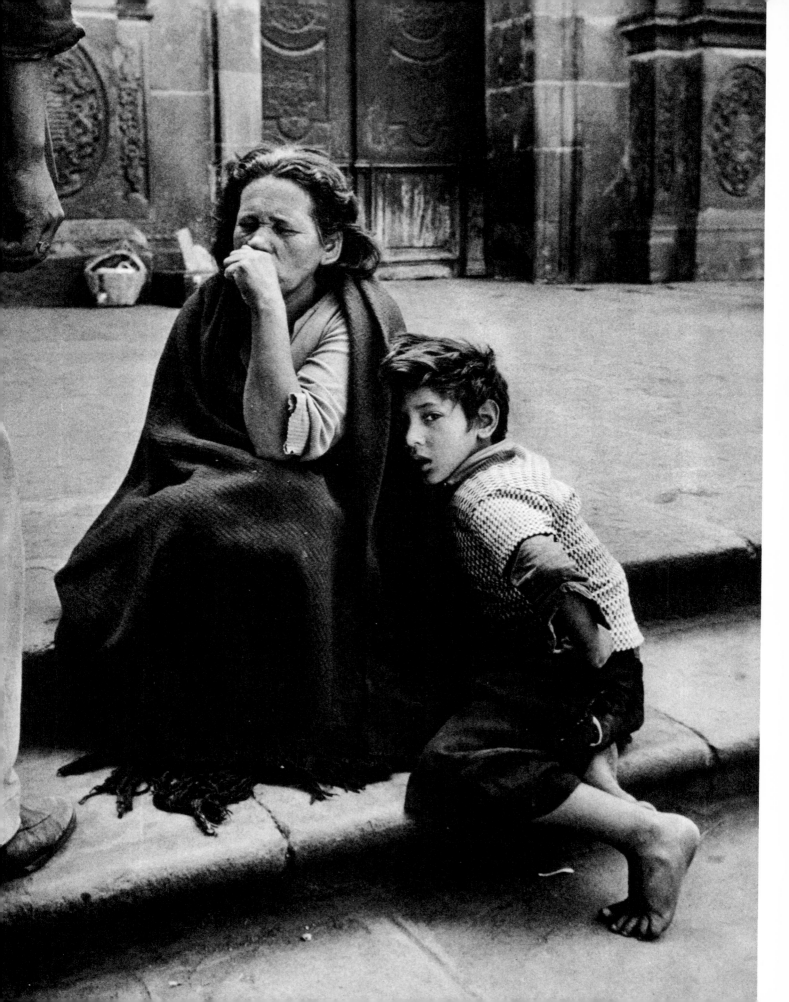

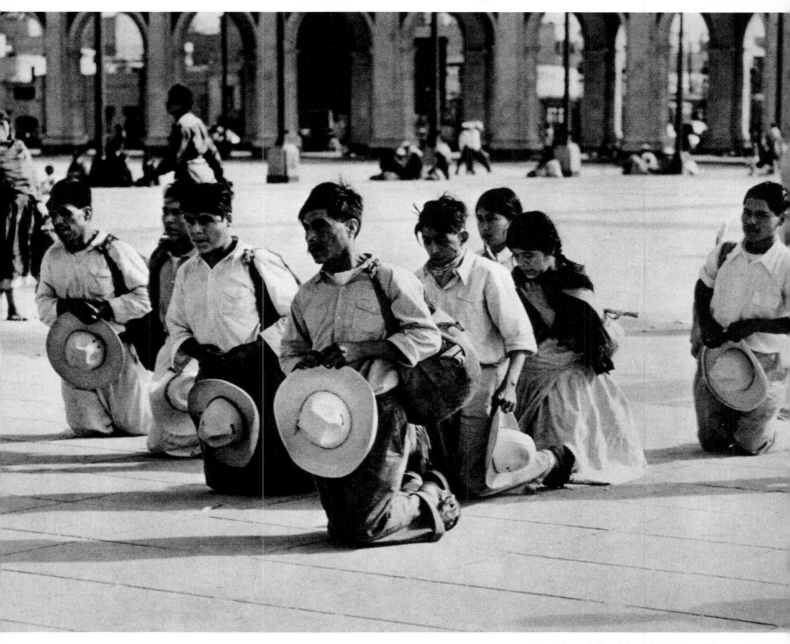

The faithful. A pilgrimage to the shrine of Guadalupe in Mexico City.

The poor. In Quito, Ecuador.

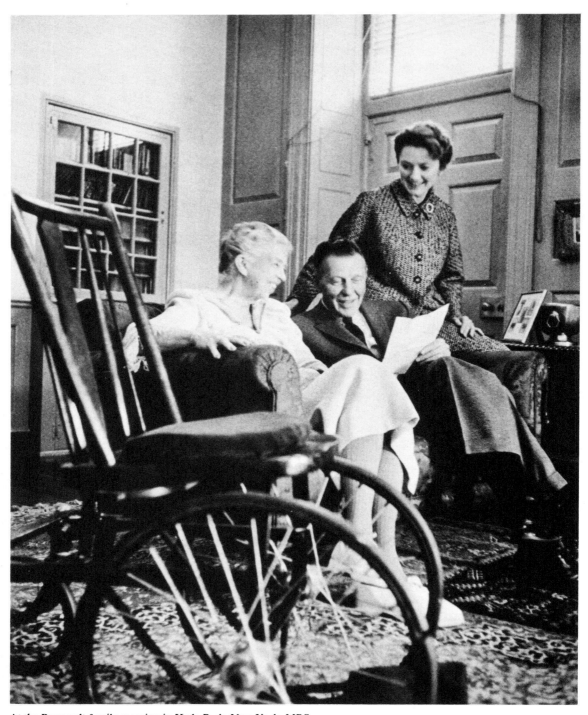

At the Roosevelt family mansion in Hyde Park, New York, MRS. ELEANOR ROOSEVELT talks with RALPH BELLAMY and MARY FICKETT before the two actors went into rehearsal for *Sunrise at Campobello*, the Dore Schary play based on the life of her late husband (1958).

ELEANOR ROOSEVELT with guests of honor NINA and NIKITA S. KHRUSHCHEV at Hyde Park in 1959. Between Mrs. Roosevelt and Mr. Khrushchev: VIKTOR M. SUKHODRIEV, the Kremlin's official interpreter; behind Khrushchev: FRANKLIN D. ROOSEVELT, JR., and to his left, HENRY CABOT LODGE, Senator from Massachusetts, who was Nixon's running mate in the 1960 Presidential election.

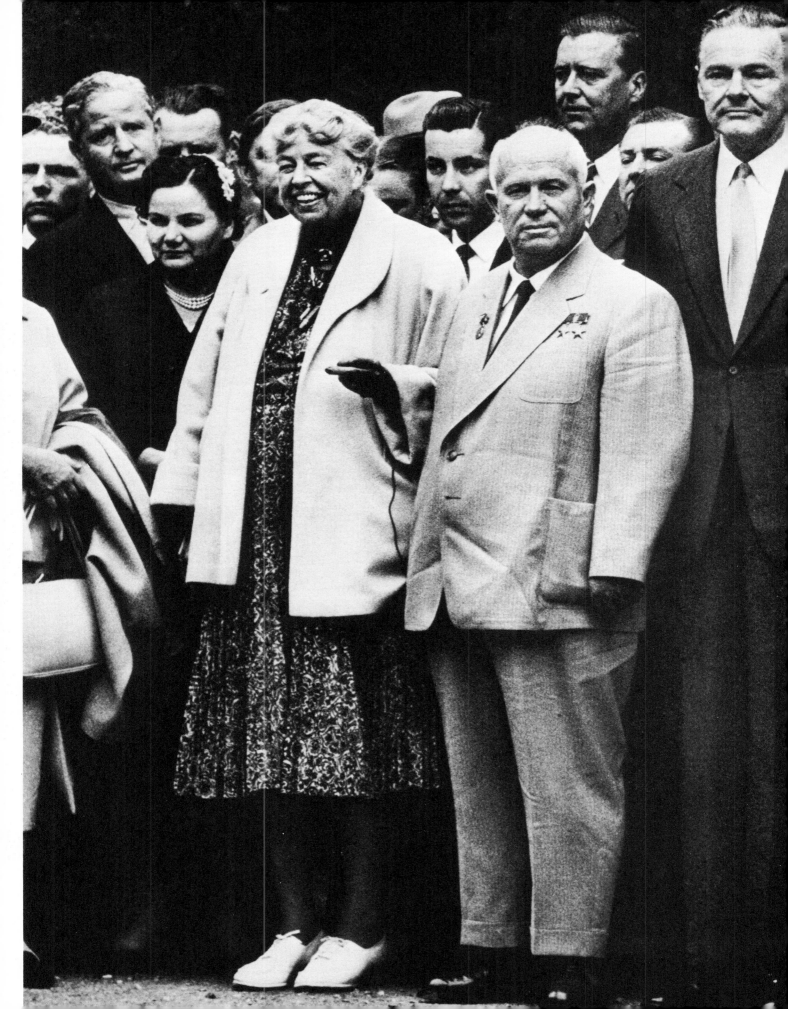

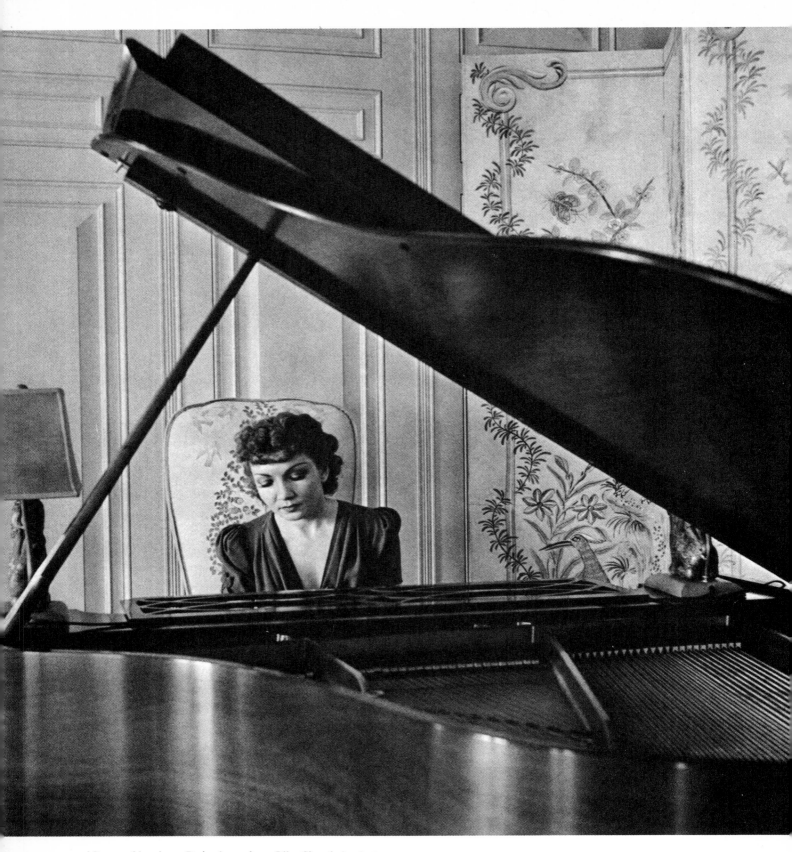

After working in a Paris dress shop, Lily Chauchoin, better known as CLAUDETTE COLBERT, crossed the Atlantic to become one of Hollywood's busiest and highest paid stars. Her two great hobbies: the piano and painting.

JACQUELINE KENNEDY with poet CARL SANDBURG before being interviewed by Dave Garroway on the "Today" show in 1960.

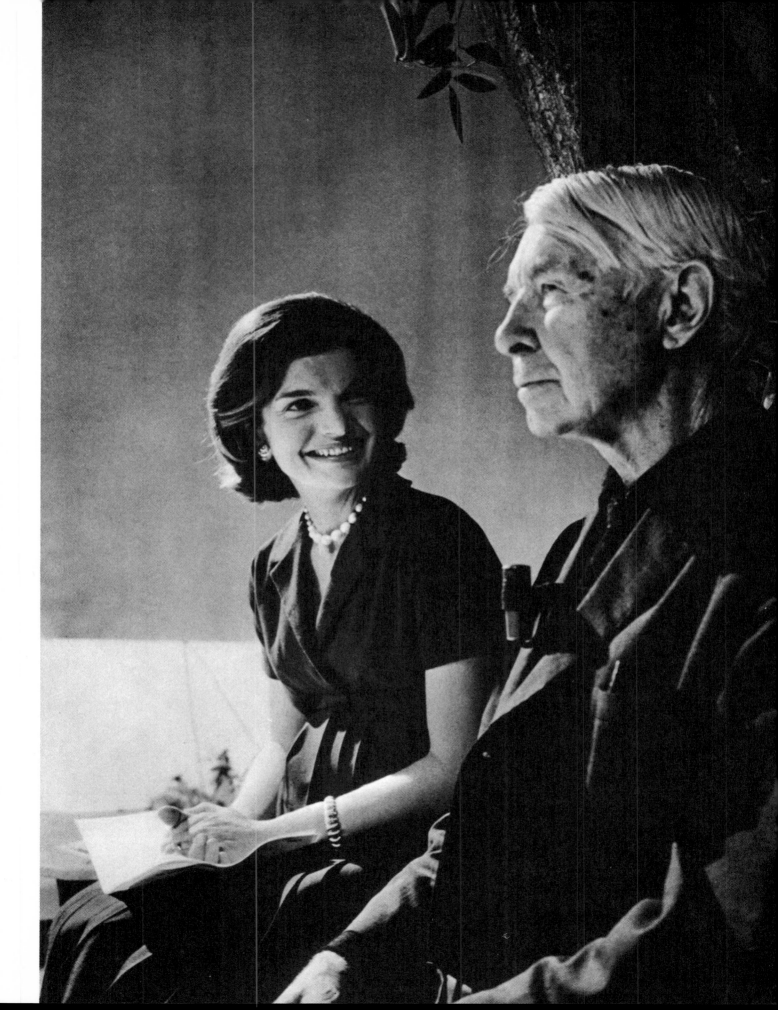

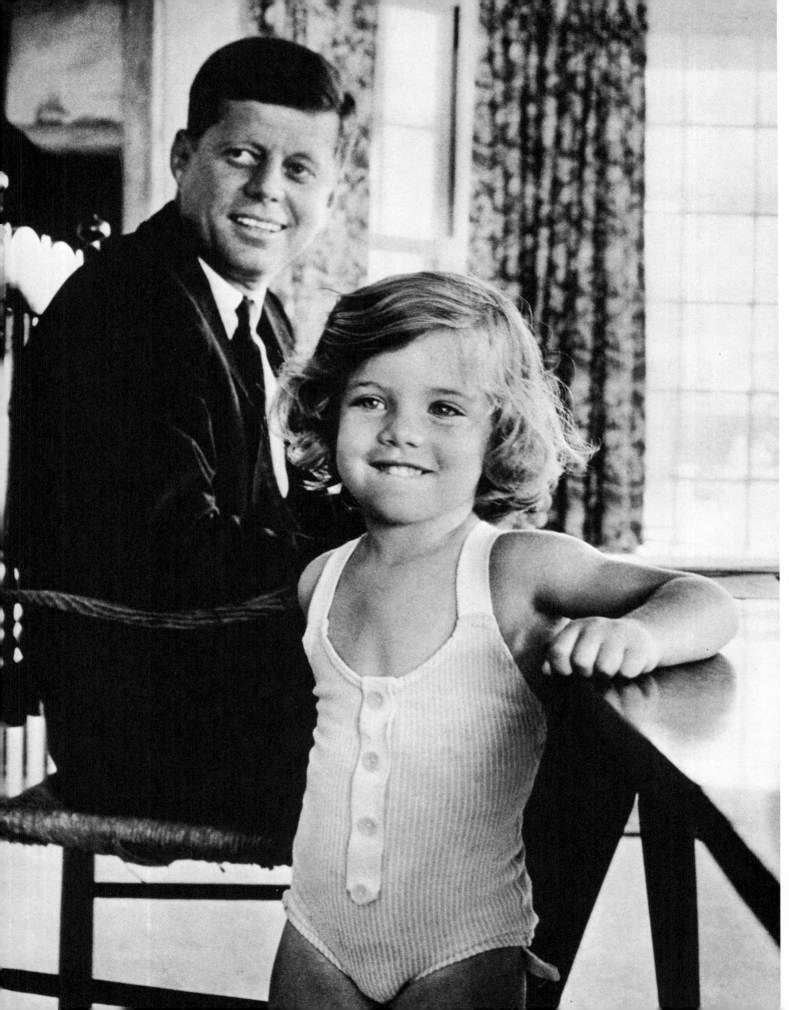

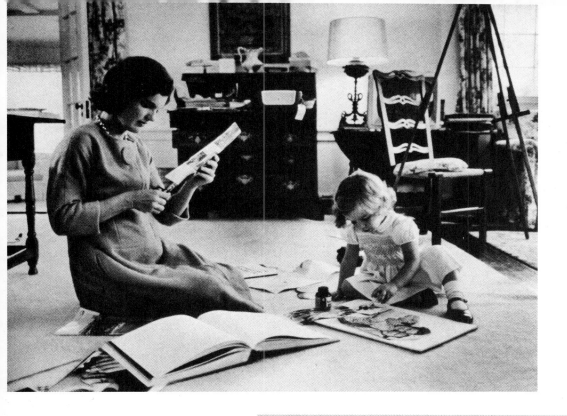

Family life in Hyannisport: JOHN, JACKIE, and CAROLINE KENNEDY.

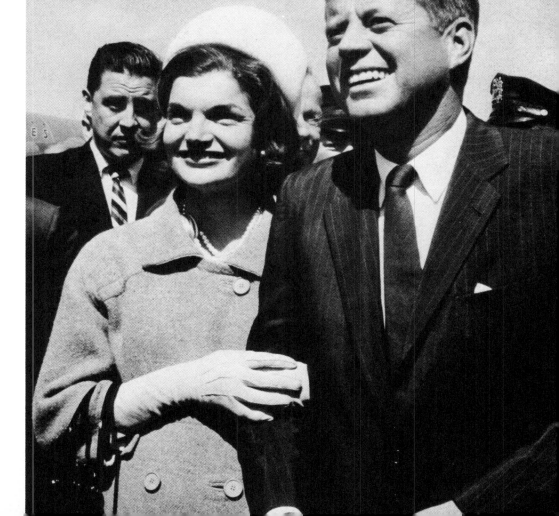

The famous KENNEDY smiles—at La Guardia's Marine Air Terminal in 1960. Senator Kennedy, still campaigning for the Presidency, was to defeat Republican contenders Richard Nixon (page 253) and Henry Cabot Lodge (page 183) in the November elections.

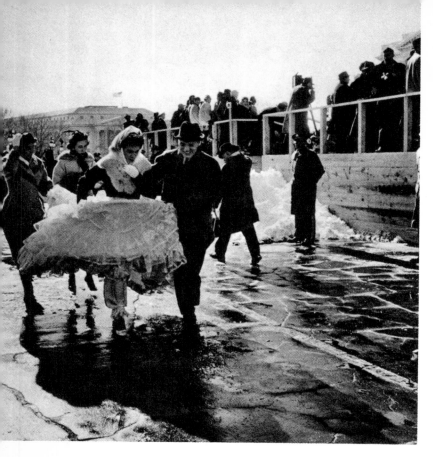

On the cold day of January 20, 1961, guests arrive at the Capitol
in Washington to watch John F. Kennedy's inauguration.

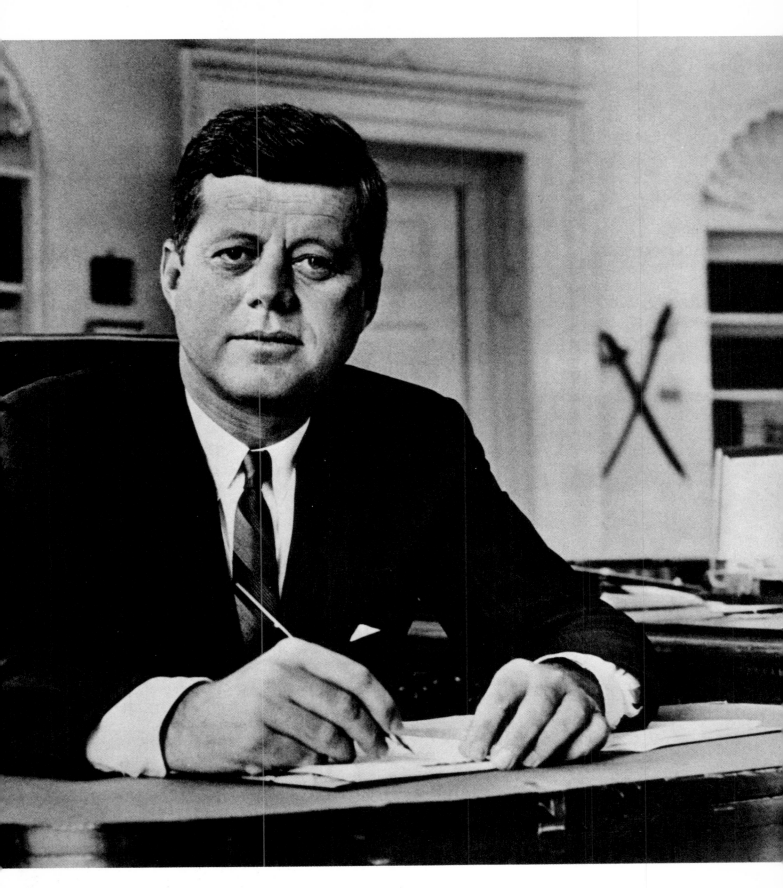

President JOHN F. KENNEDY in the White House, June 1962.

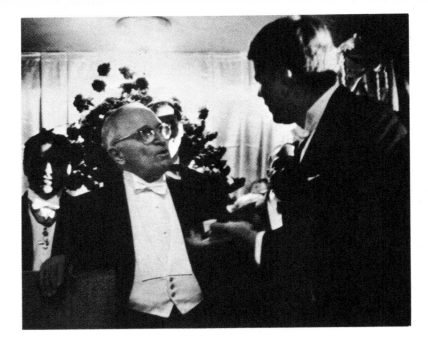

Within five years fellow Americans, and most of a stunned world, mourned the death by violence of President JOHN F. KENNEDY in Dallas, Texas, 1963 (ABOVE, with HARRY TRUMAN, 1961); spiritual and civil rights leader MARTIN LUTHER KING in Memphis, Tennessee, 1968 (BELOW, in his office in Birmingham, Alabama, 1960); and, ROBERT KENNEDY, Presidential contender, in Los Angeles, California, 1968 (OPPOSITE, with his wife, ETHEL KENNEDY, during his brother's inaugural parade in 1961).

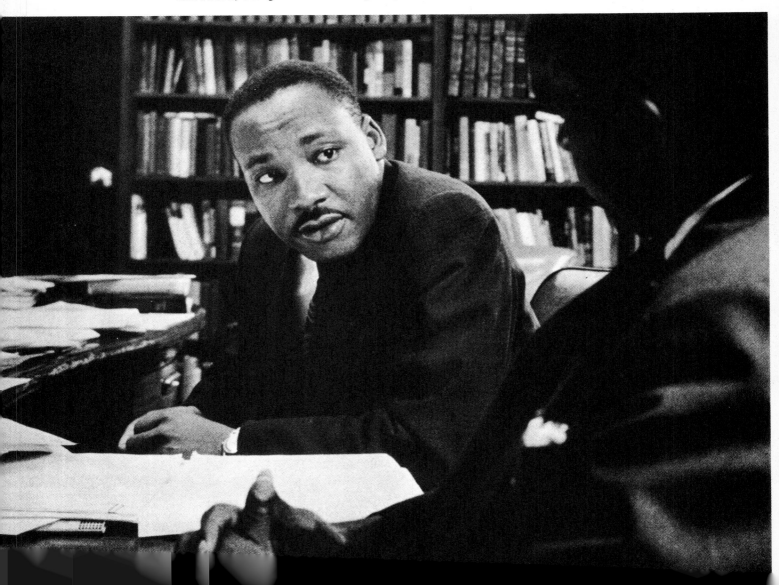

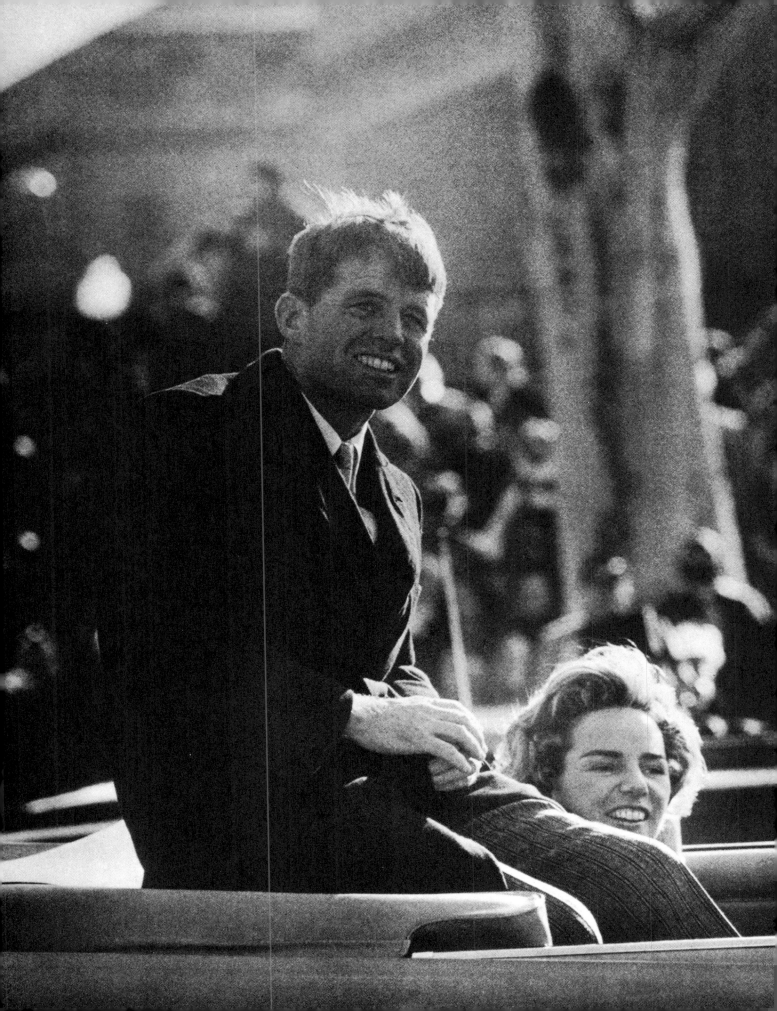

A sleepy KENNETH KAUNDA, leader of the United National Independence party of Northern Rhodesia (later President of Zambia), saw little of Atlanta from the air (1960).

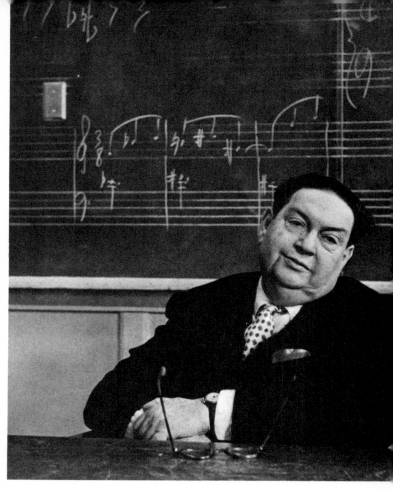

Composer DARIUS MILHAUD wearying toward the end of a music class at the University of Iowa.

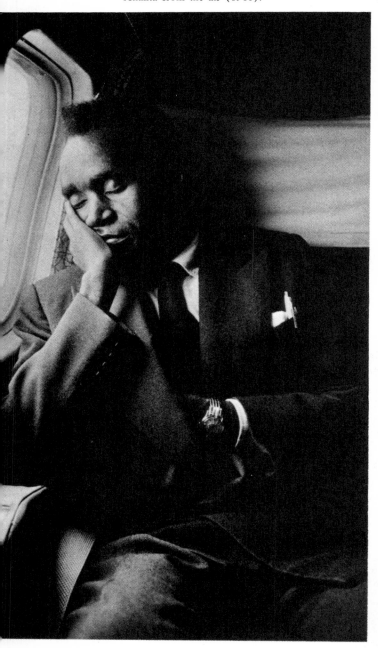

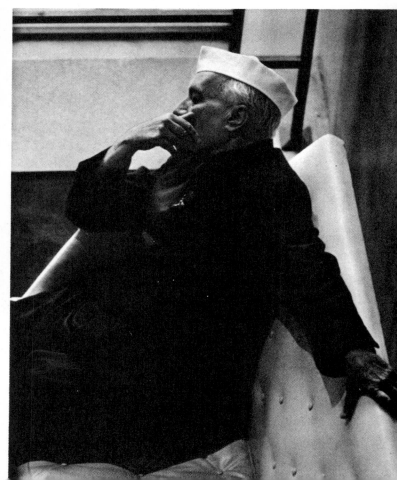

JAWAHARLAL NEHRU, Prime Minister of India, after an exhausting session at the U.N.

OPPOSITE: CLEMENT ATTLEE dozing at a Labour Party meeting in London (1951).

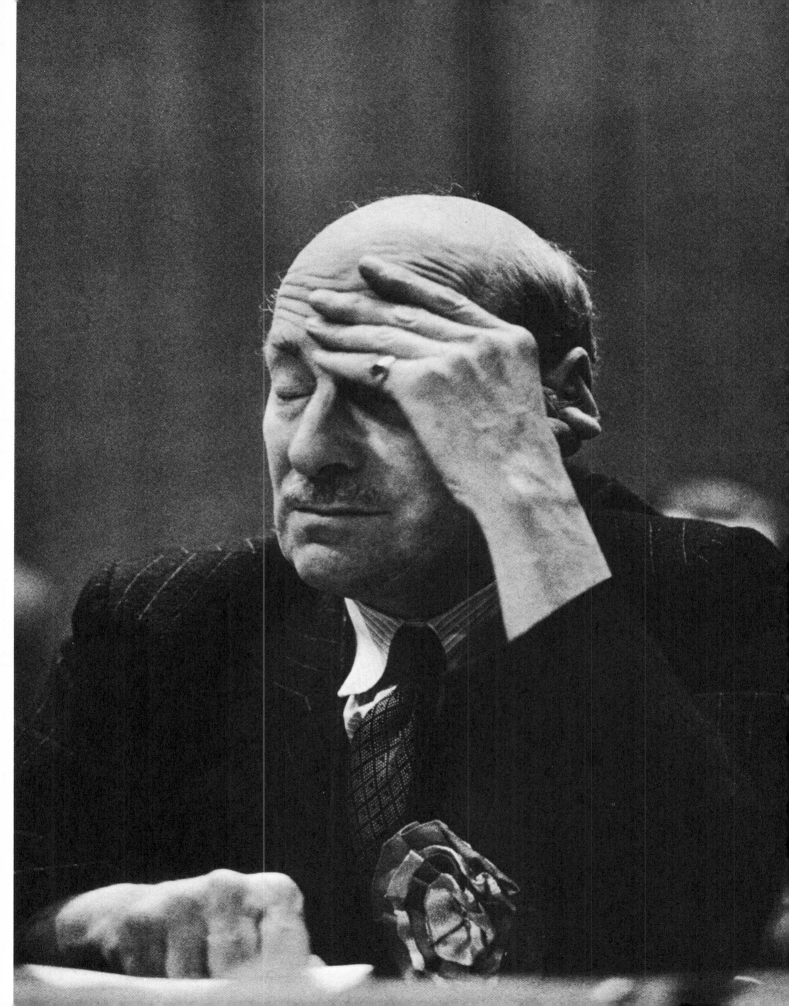

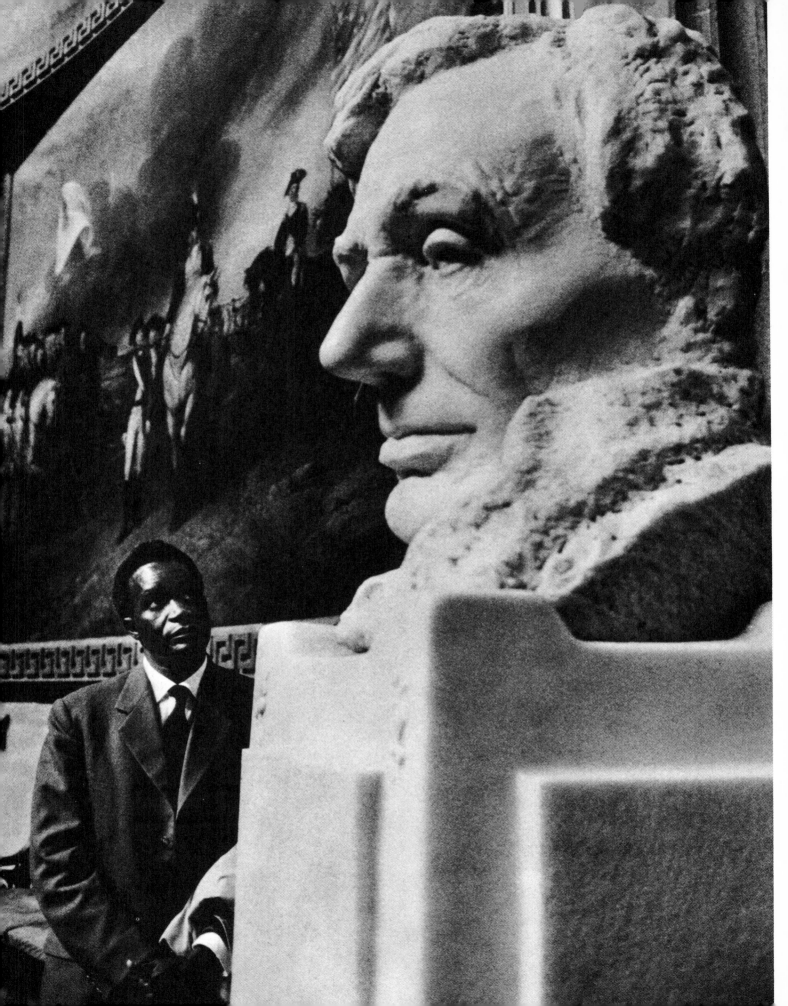

Prisoner JOMO KENYATTA (the "Burning Spear"), spiritual leader of the Mau Mau rebellion, outside the Nakuru courthouse, Kenya, prior to being sentenced to seven years in prison by the British. RIGHT: Thirteen years later, a triumphant President Kenyatta, replete with leopard-skin coat and whisk, strolling through the Palace Gardens in Nairobi, 1966.

OPPOSITE: In Washington, KENNETH KAUNDA contemplating the head of Abraham Lincoln in the Capitol.

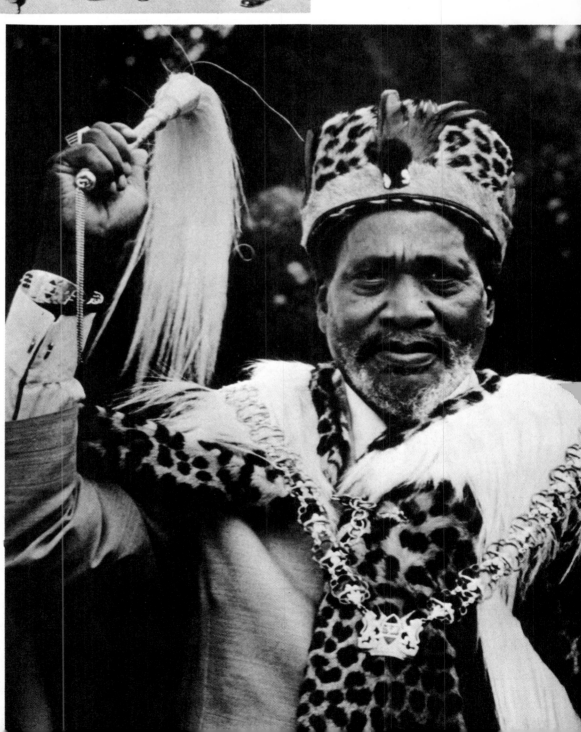

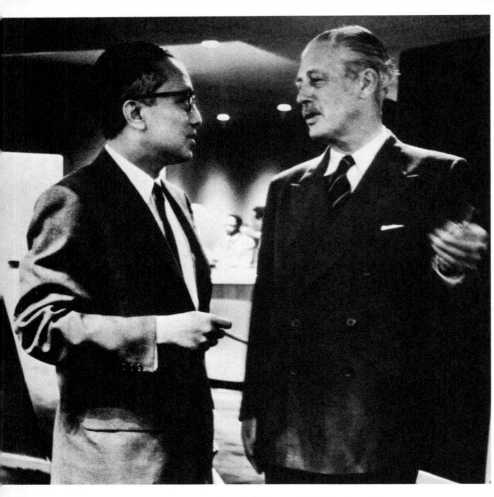

HAROLD MACMILLAN, Prime Minister of England, talking to U THANT, Secretary General of the U.N., in 1960.

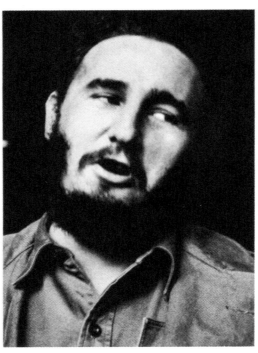

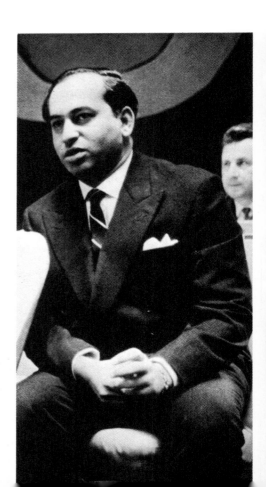

RALPH BUNCHE, U.N. Undersecretary for Special Political Affairs (he had been awarded the Nobel Peace Prize in 1950 for his work with the U.N. in bringing peace to Palestine), and, at RIGHT, FIDEL CASTRO arguing a point for Cuba.

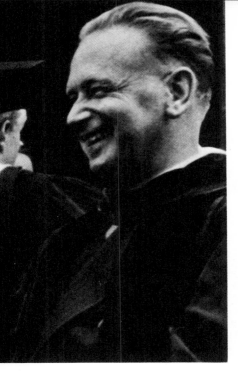

DAG HAMMARSKJOLD, Swedish statesman and Secretary General of the U.N. until his death in a plane crash over Rhodesia in 1961. Posthumously, he was awarded the 1961 Nobel Peace Prize. BELOW: GOLDA MEIR, who became Prime Minister of Israel in 1969.

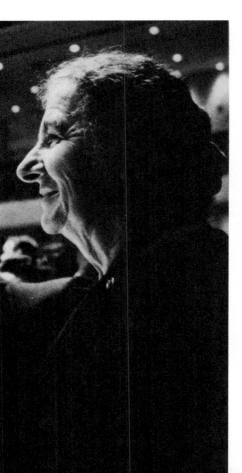

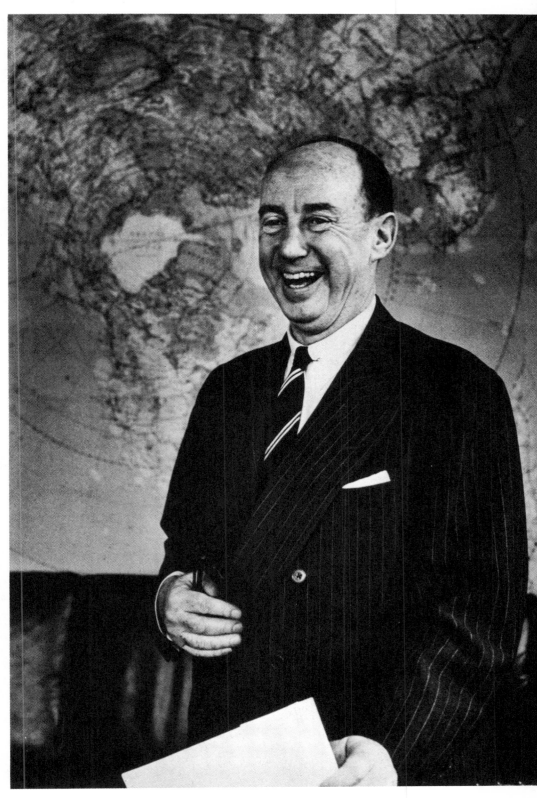

ADLAI STEVENSON (Presidential contender in 1952 and unsuccessfully again in 1956) wreathed in smiles after his appointment as U.S. Ambassador to the United Nations in 1961.

BELOW: DAVID ROCKEFELLER, Chase Manhattan's chief executive, with the EARL OF HOME attending the 1961 Harvard University commencement exercises. RIGHT: NELSON ALDRICH ROCKEFELLER in 1960, at home in Pocantico Hills, and (OPPOSITE) cruising off Seal Harbor, Maine, in 1958, the year he was elected Governor of New York. BELOW RIGHT: LAURANCE ROCKEFELLER, recipient of numerous environmental awards, at Caneel Bay in the Virgin Islands.

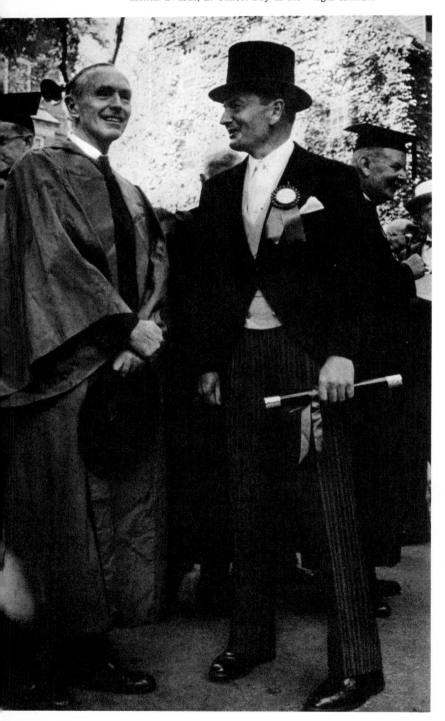

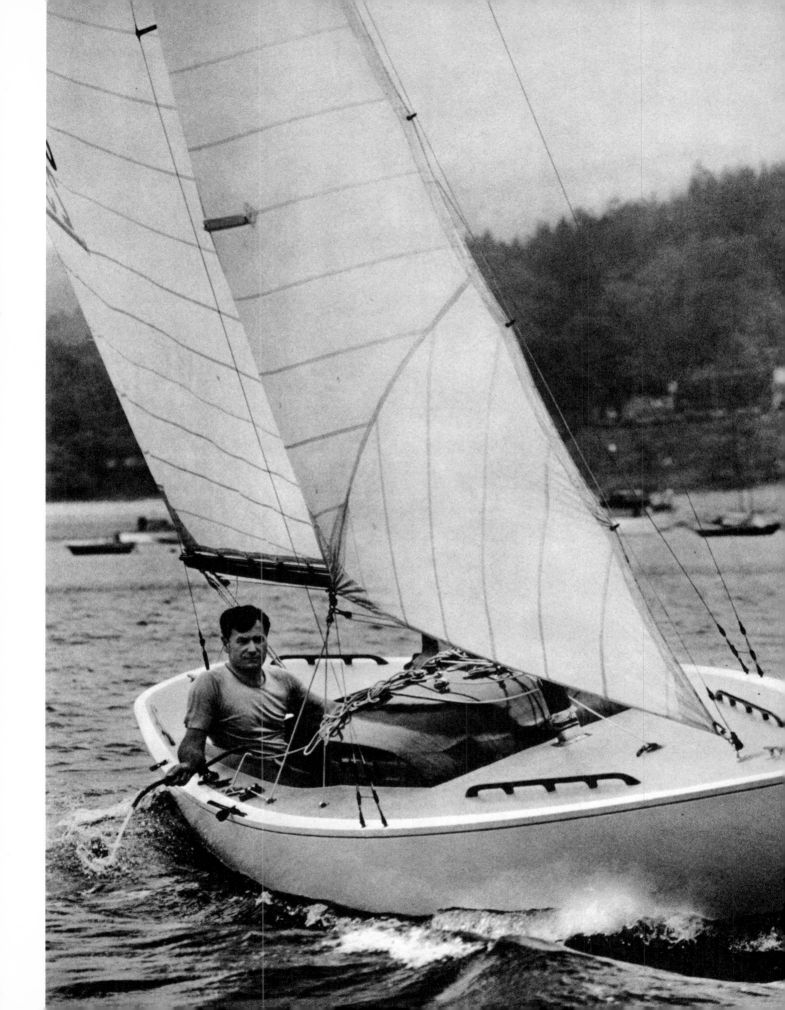

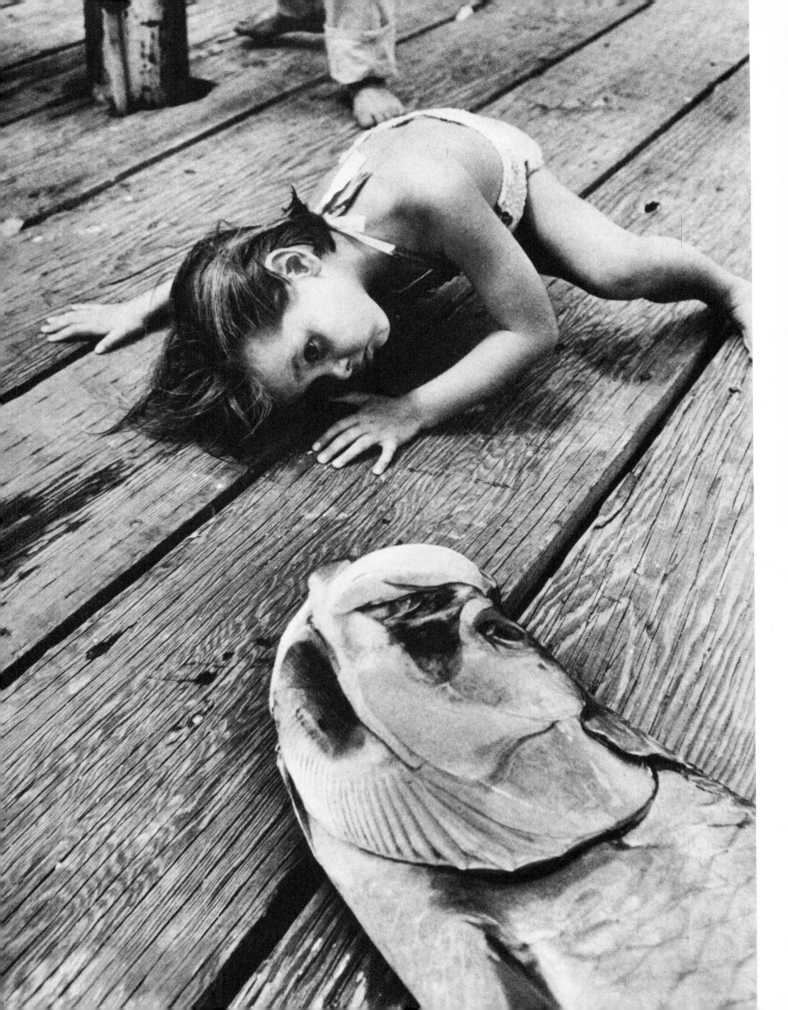

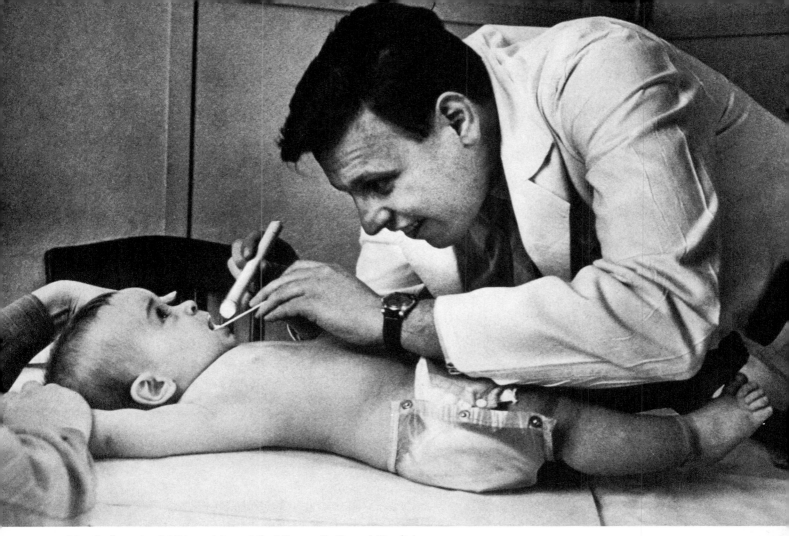

After finally saying "ah" to an intern at the Minneapolis General Hospital.

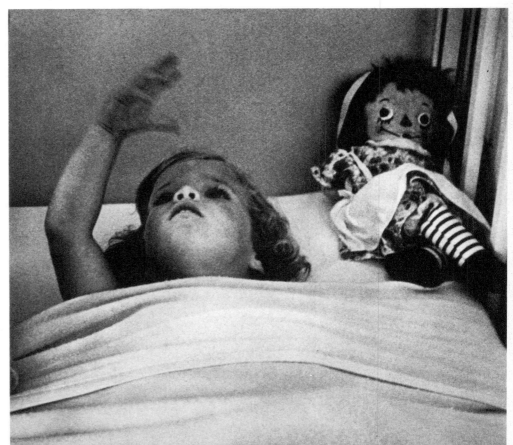

Bedtime for CAROLINE KENNEDY.

Wondering what Jonah *might* have
felt like.

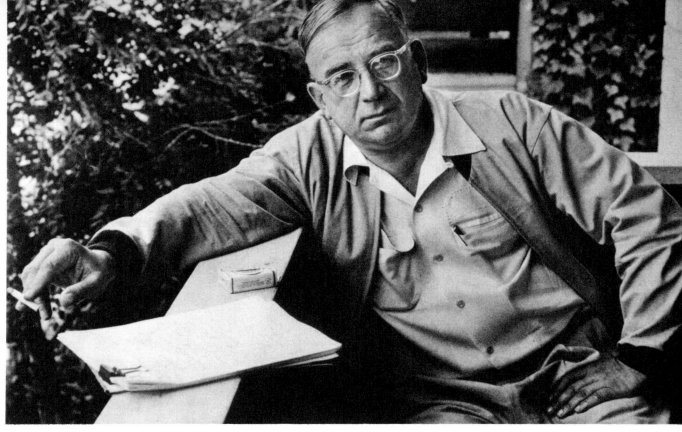

GEORGE GAMOW, Russian-born physicist and author of *Birth and Death of the Sun* and *The Creation of the Universe*. The recurring theme in his various works: the application of nuclear physics to stellar evolution.

REINHOLD NIEBUHR, Protestant theologian, shortly before he retired as professor of Applied Christianity at the Union Theological Seminary, New York.

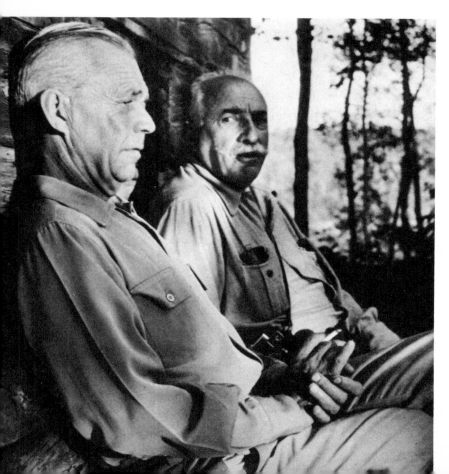

LEFT: Publisher (and gourmet) ALFRED A. KNOPF with distinguished author SIGURD OLSON at the naturalist's lakeside cabin in Ely, Minnesota (1961). OPPOSITE: RACHEL CARSON, author of *The Sea Around Us* (1951), at home in Silver Spring, Maryland, in 1962 after her last book, *Silent Spring,* had become the subject of heated political debates. In warning of the danger of unrestricted use of insecticides, Miss Carson stimulated public awareness of present-day environmental problems. Two years later she died, aged fifty-seven.

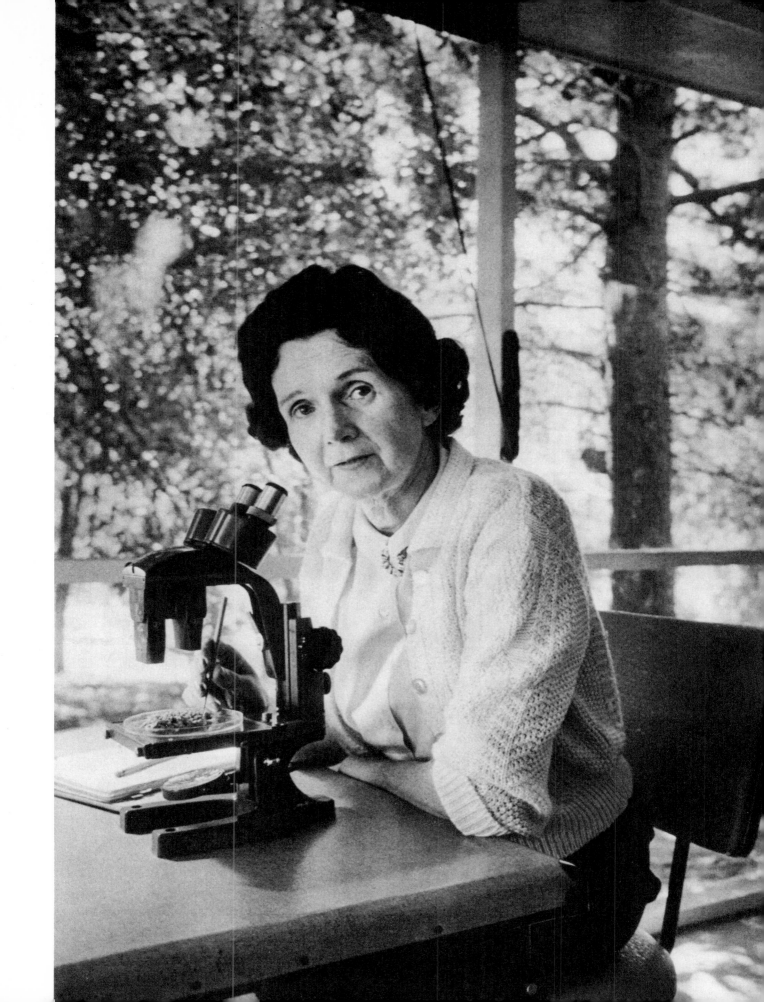

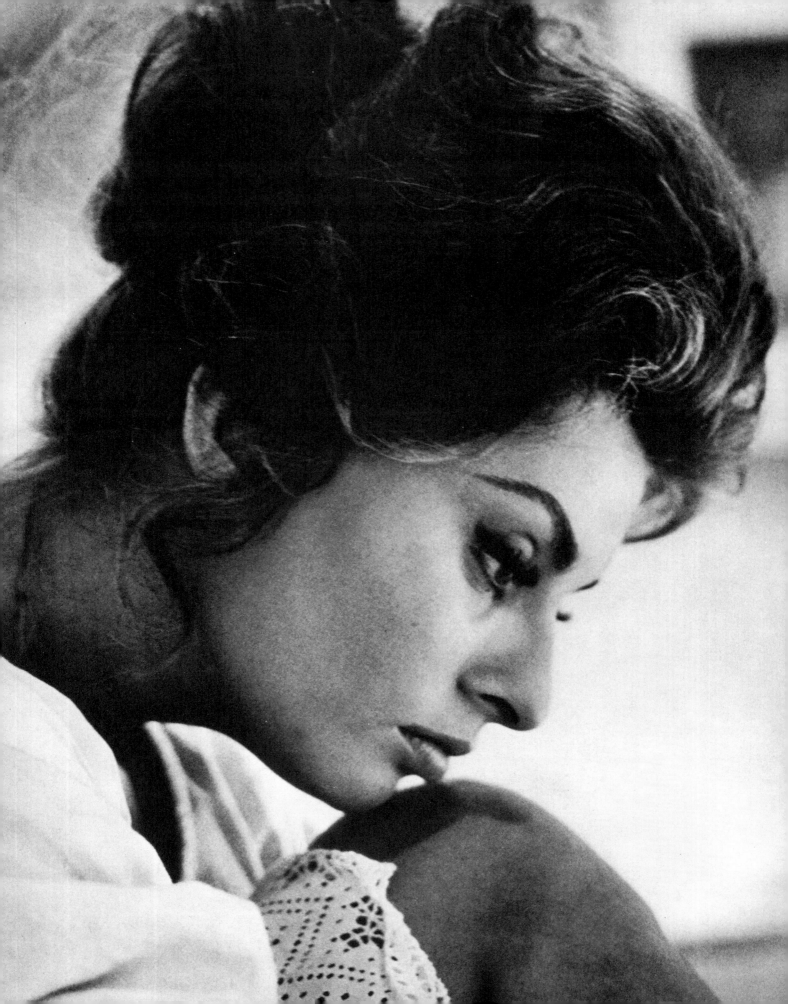

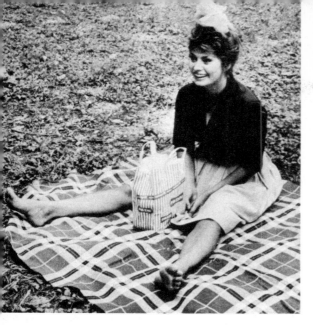

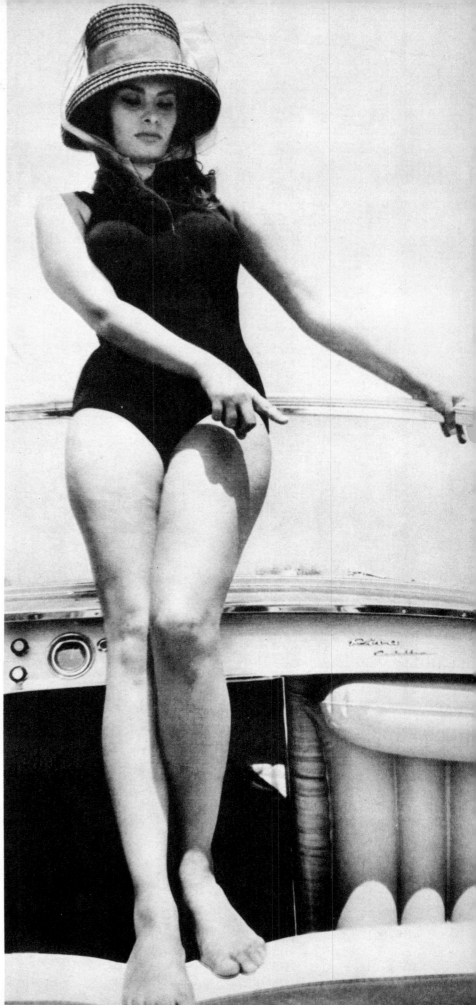

Italy's *bellezza*—SOPHIA LOREN. OP-POSITE: A quiet moment in *Madame Sans Gêne*, the 1963 film in which she starred opposite Robert Hossein. BELOW: During the filming. ABOVE: In Caserta, near Naples. RIGHT: In producer-husband Carlo Ponti's speedboat off the coast of Ischia. OVERLEAF: With MARCELLO MAS-TROIANNI in *Marriage Italian Style*.

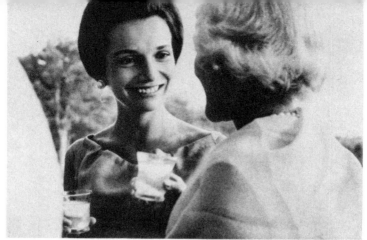

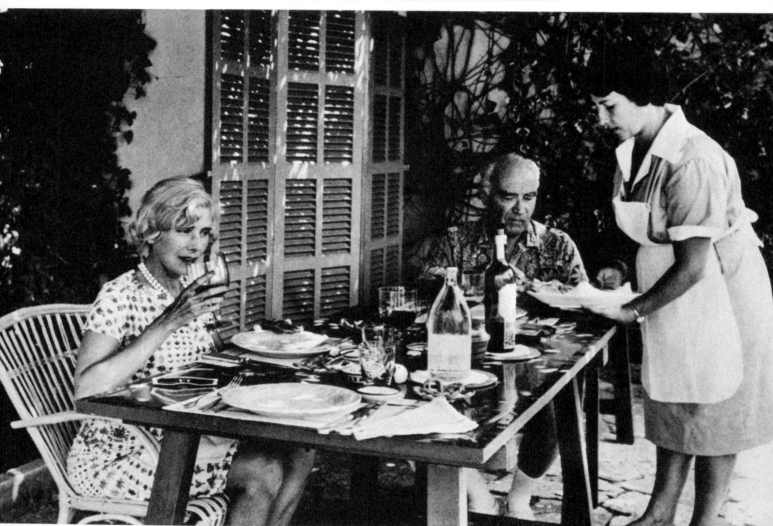

CLARE BOOTHE LUCE, writer (first for *Vogue*), playwright (*The Women*), and first American woman ambassador to a major country (Italy), chatting (TOP) with PRINCESS LEE RADZIWILL (Jackie Kennedy Onassis' sister); lunching (ABOVE) with husband, HENRY R. LUCE, founder of Time-Life, and (OPPOSITE) enjoying the sun with J. IOVANOVICH aboard the shipping tycoon's yacht. Majorca, 1962.

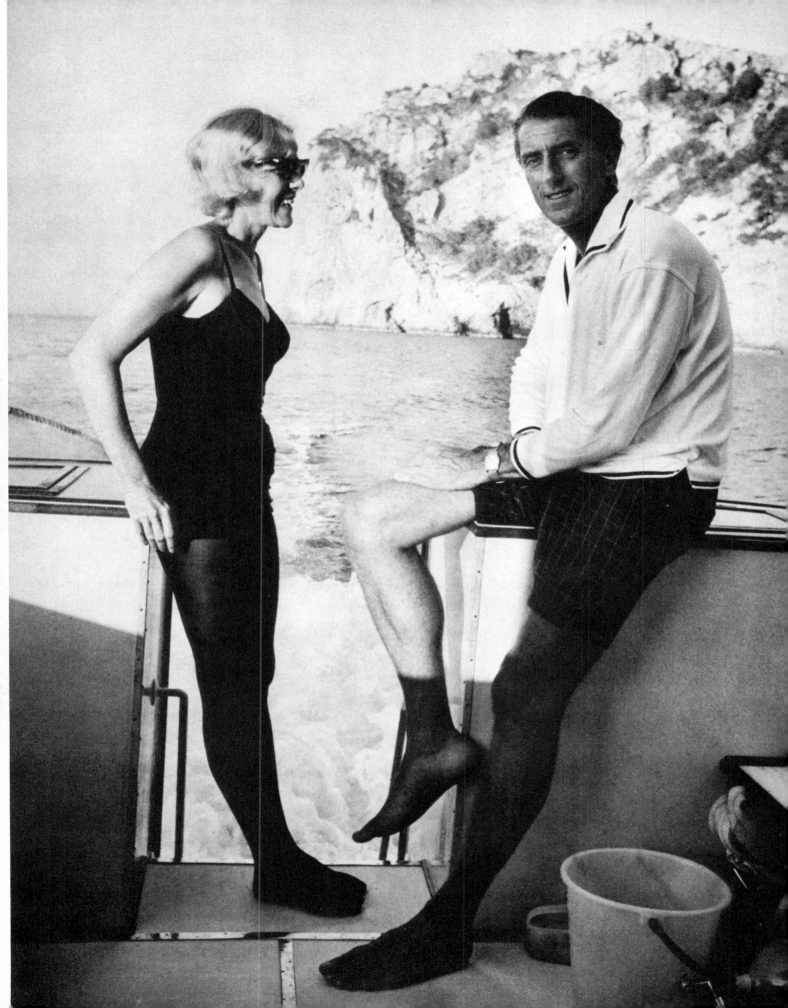

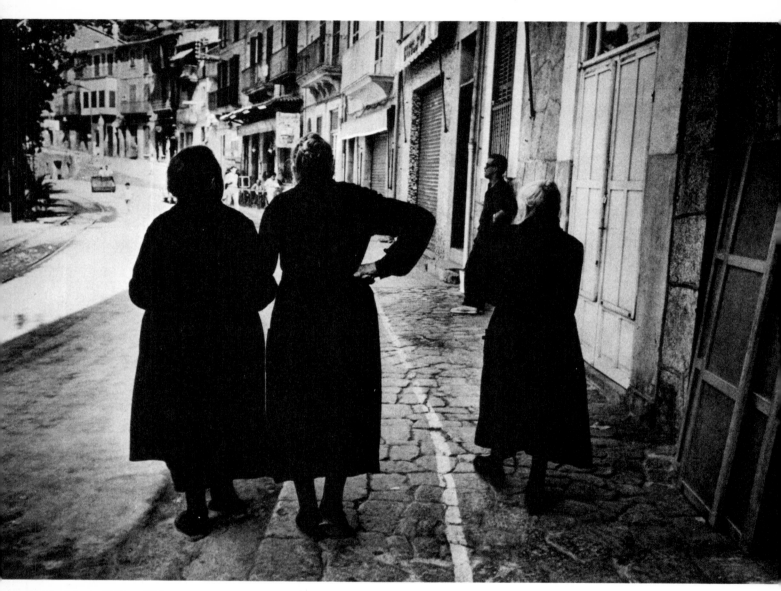

Street scene in Sollero, Majorca.

ROBERT GRAVES, English poet, critic, and novelist (*Goodbye to All That* and *I, Claudius*), preparing a light lunch in his house in Deya, Majorca (1962).

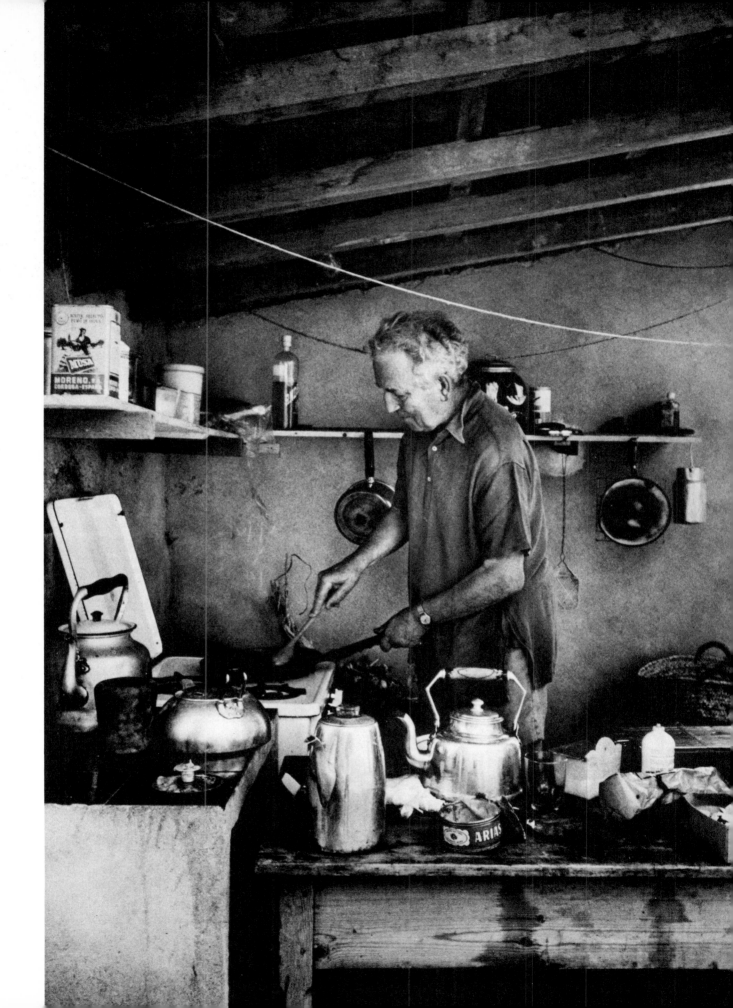

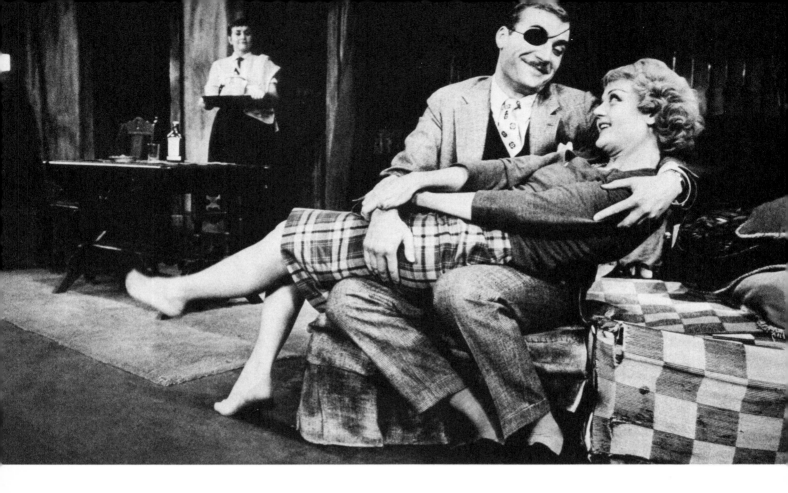

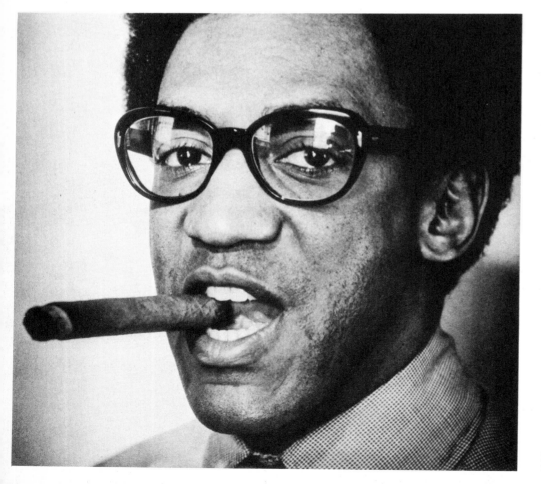

ANGELA LANSBURY (later *Mame* in the Patrick Dennis musical) supported by NIGEL DAVENPORT in *A Taste of Honey,* the play by the nineteen-year-old theater usher Shelagh Delaney, which London and New York audiences saw at the end of the fifties. Looking on: Sir Laurence Olivier's wife, JOAN PLOW-RIGHT.

BILL COSBY, JR., the one-time bartender whose talent for twisting everyday incidents into absurdities landed him the role as the comic Alex Scott in the television series *I Spy* in 1965.

OPPOSITE: BING (Harry Lillis) CROSBY, the original voice of *I'm Dreaming of a White Christmas* (*Holiday Inn,* 1942), relaxing in San Francisco in 1956. Since *The King of Jazz* (1930), Mr. Crosby has crooned his way through seventy-odd films.

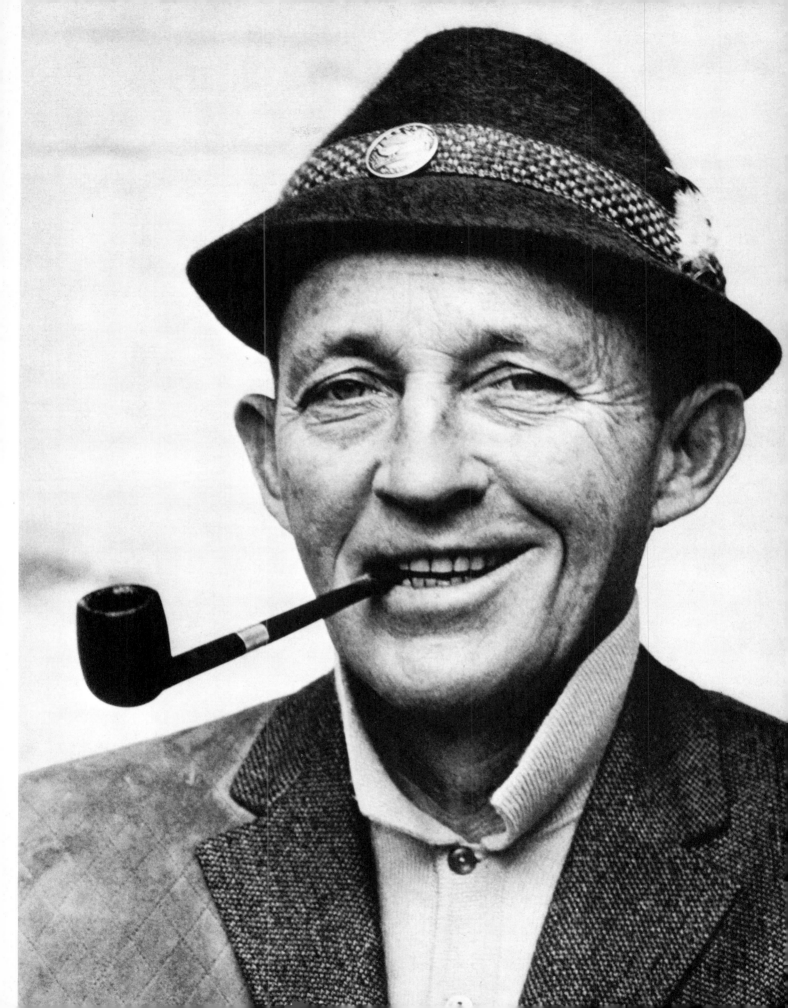

LEONTYNE PRICE during her debut at the Metropolitan Opera in Verdi's *Il Trovatore*, January 1961.

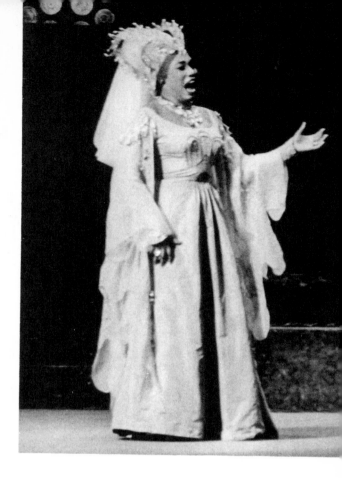

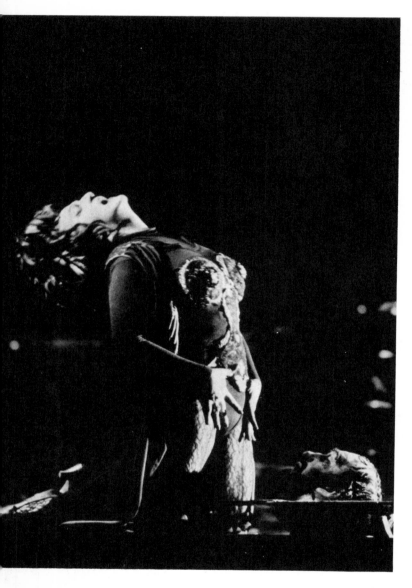

"Salomé" BIRGIT NILSSON—with the prized head of John the Baptist—in the Richard Strauss opera.

BEVERLY SILLS in the opera the soprano has all but made her own, *Maria Stuarda* by Gaetano Donizetti.

OPPOSITE: JOAN SUTHERLAND in the mad scene of Donizetti's *Lucia di Lammermoor*.

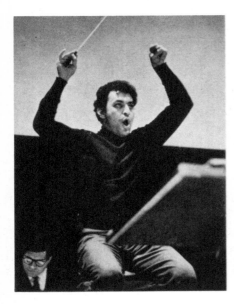 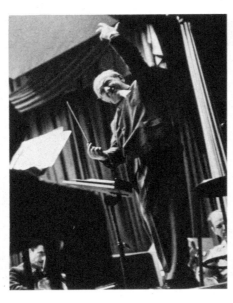 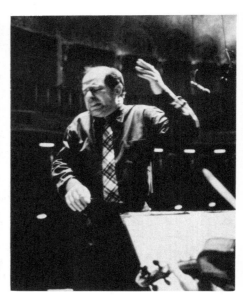

At rehearsal, LEFT TO RIGHT: Conductors ZUBIN MEHTA (Los Angeles Philharmonic), FRITZ REINER (late of the Chicago Symphony Orchestra), and PIERRE BOULEZ (New York Philharmonic). BELOW: THOMAS SCHIPPERS conducting Tchaikovsky's *Queen of Spades* at the Metropolitan Opera House.

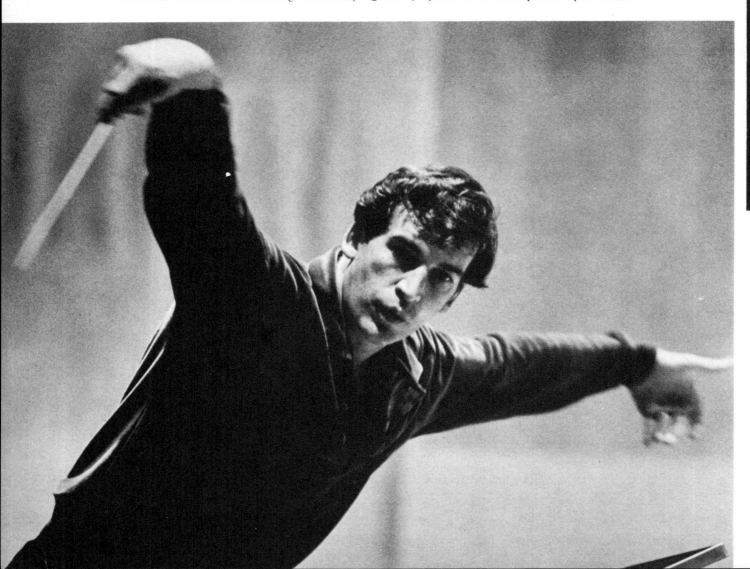

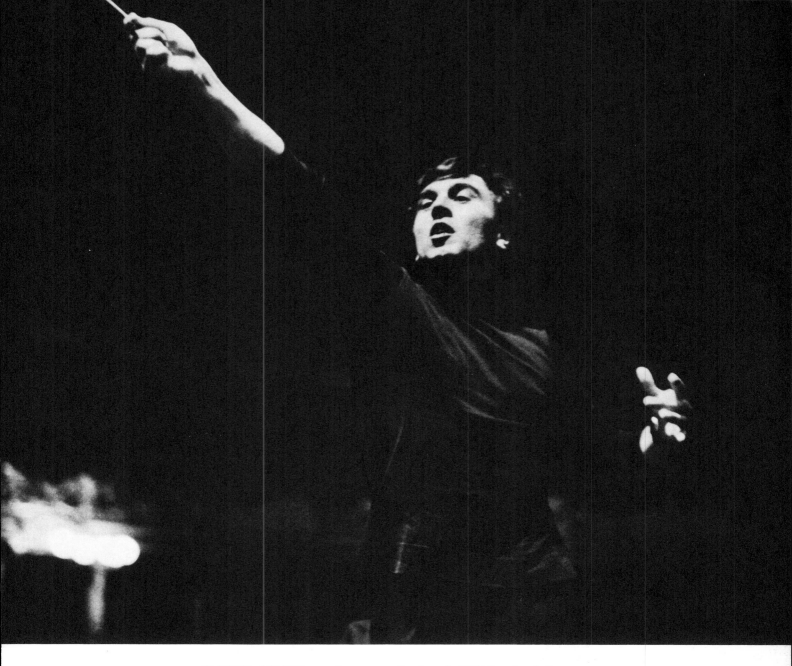

CLAUDIO ABBADO warming up over Beethoven's "Fifth" at La Scala.
BELOW, LEFT TO RIGHT: COLIN DAVIS at London's BBC studio; GEORGE
PRETRE and CHARLES MÜNCH, both equally expressive in Boston.

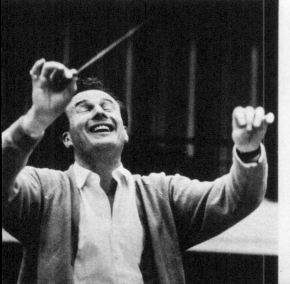
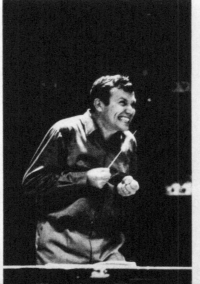
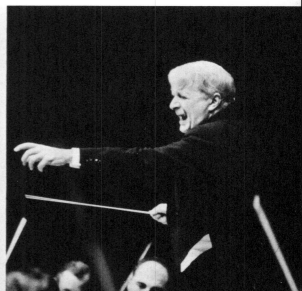

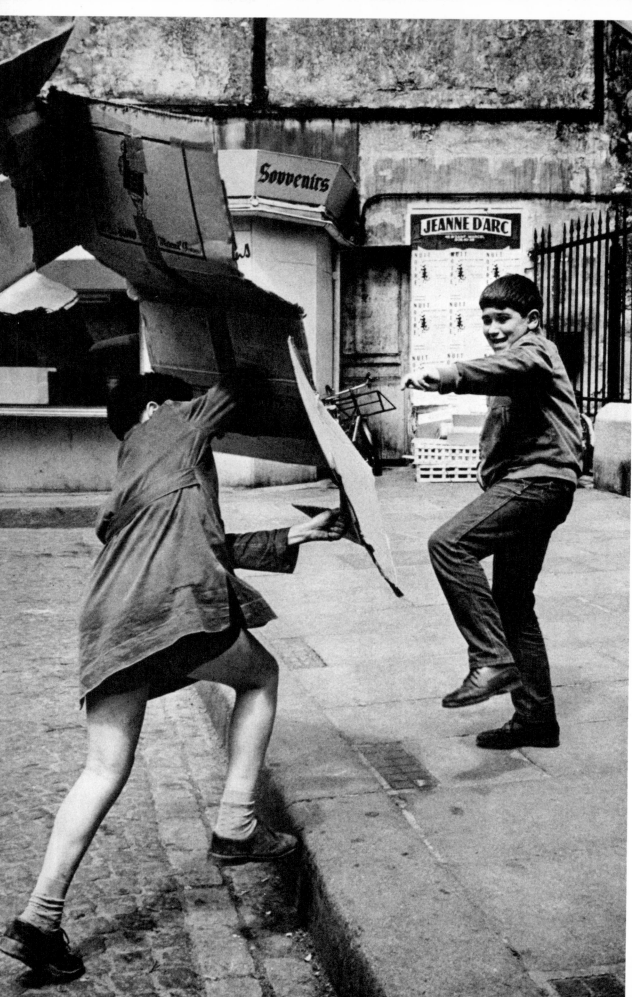

Boys.

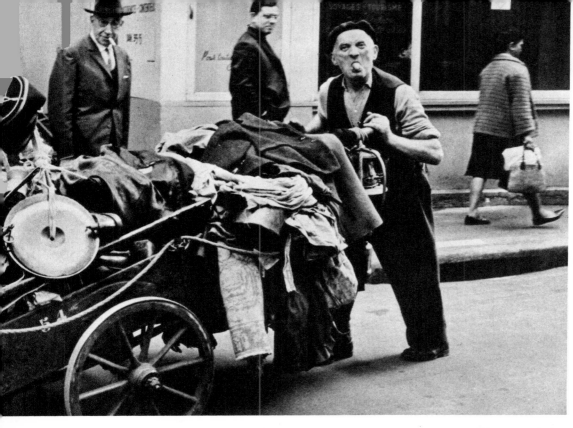

Some people don't like
to be photographed.

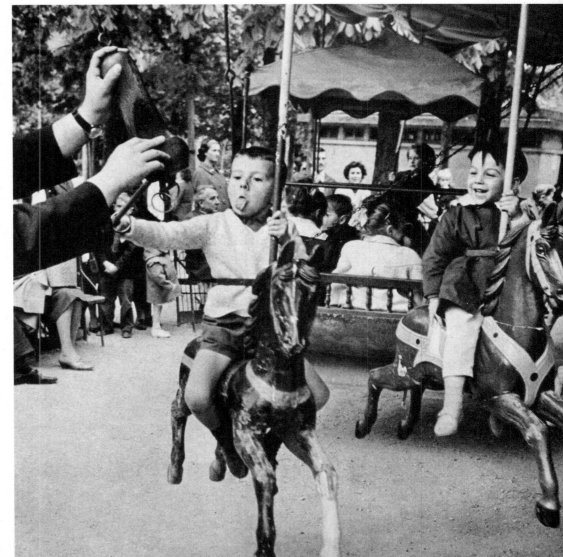

"Hooking the ring" means another *free* ride.

OVERLEAF: Watching a puppet show
in the Luxembourg Gardens, Paris.

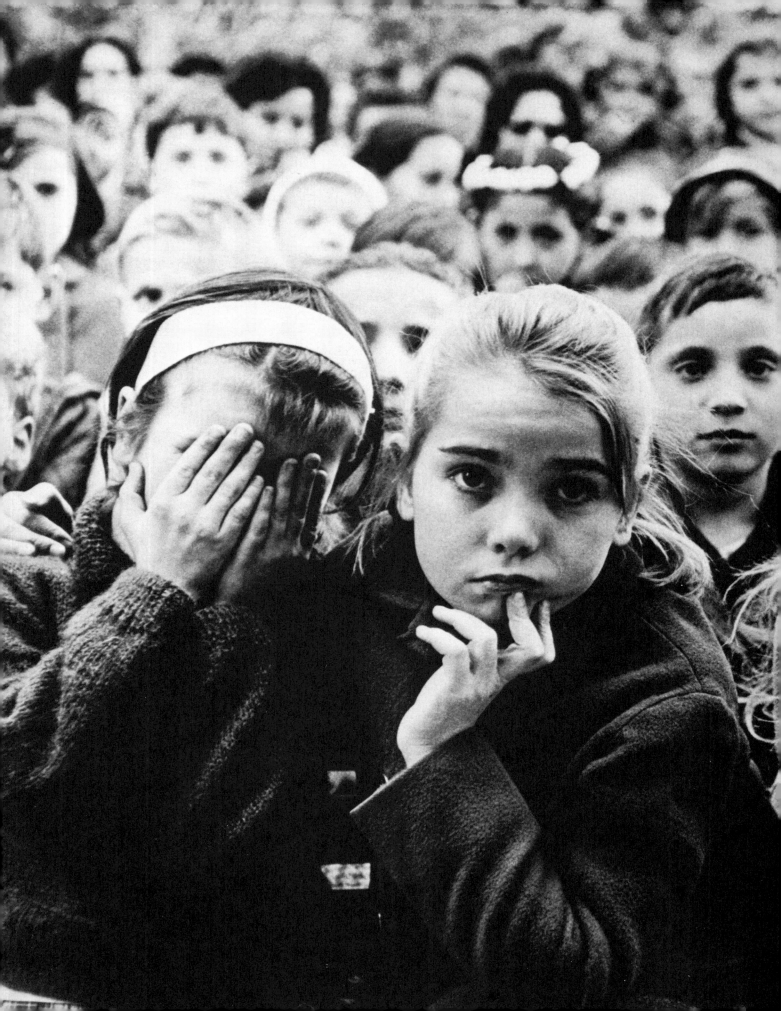

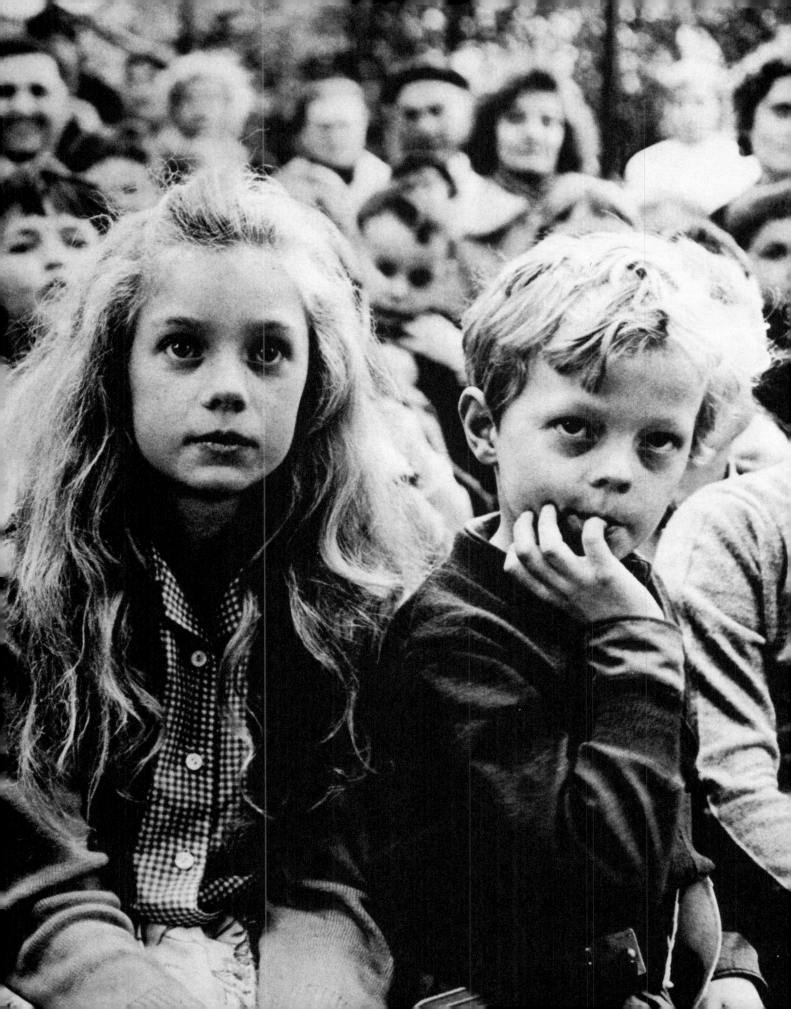

Sunday.

Along the Champs Elysées.

April in Paris.

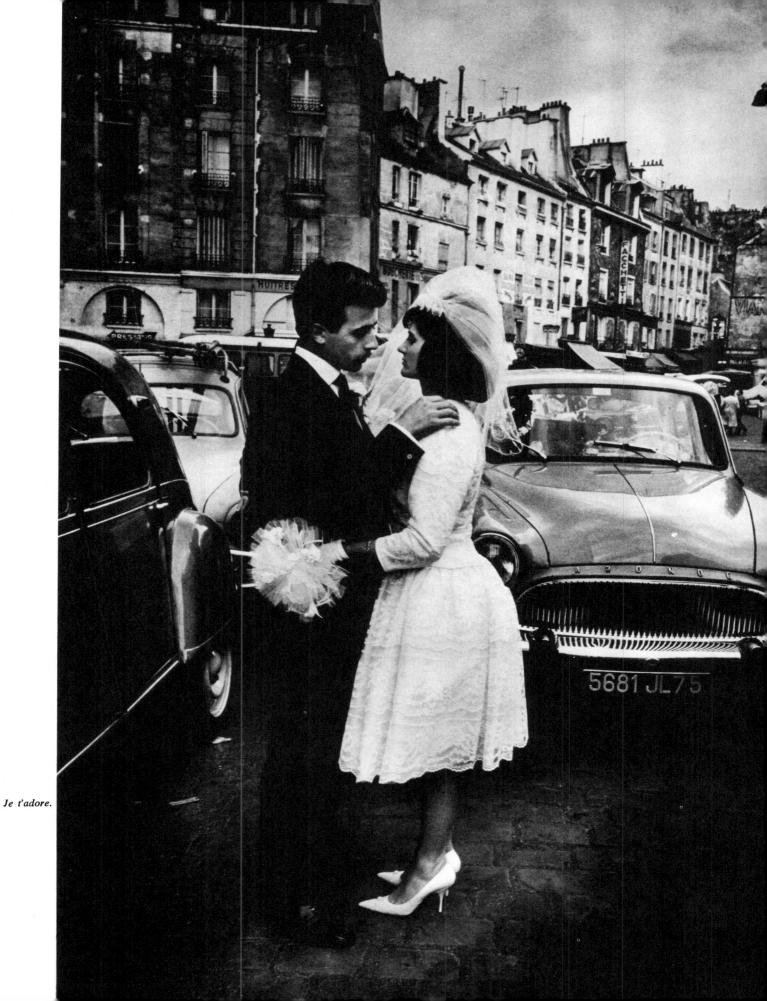

Je t'adore.

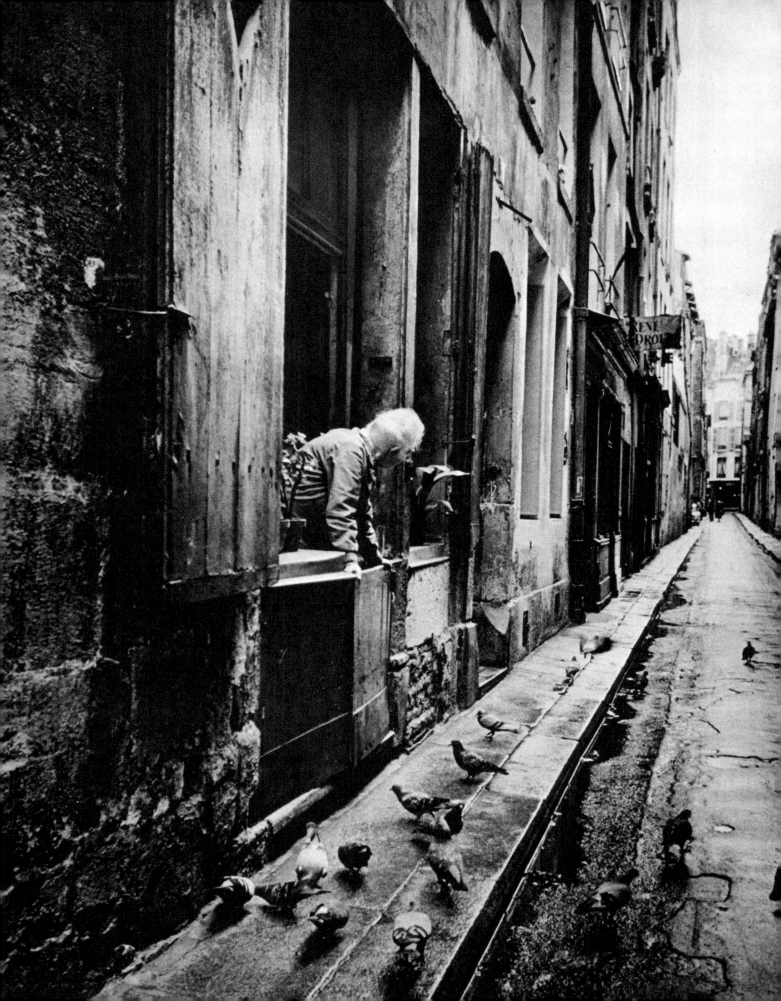

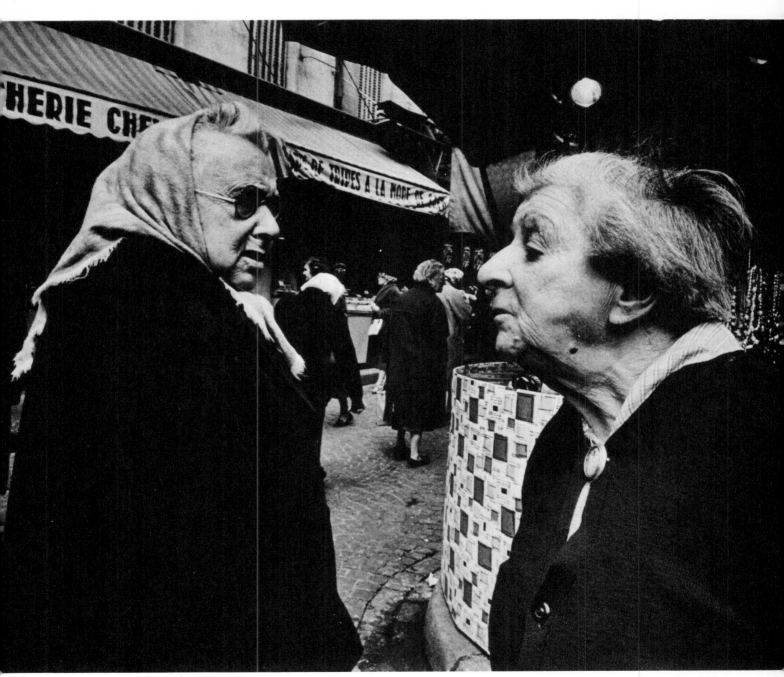

Contretemps—over the price, and age, of a chicken.

Autumn in Paris.

In the Washington mansion of MARJORIE MERRIWEATHER POST—heiress of a fortune that grew and grew with Postum—the row of VIP's on the living-room piano are: Mr. and Mrs. John F. Kennedy; King Frederick IX; Edward, Prince of Wales (the Dorothy Wilding photograph was his and the Duchess of Windsor's favorite); King Gustaf V; Dwight D. Eisenhower; Queen Elizabeth II; King Olaf; and (in the foreground) George VI with Queen Elizabeth. RIGHT: Mrs. Post with pampered pet SCAMPI in an antiquity "rescued" from the Belgian royal family. Mrs. Post was first married to Joseph E. Davies, once a U.S. ambassador to the U.S.S.R.

People with dogs . . .

and with other people's dogs.

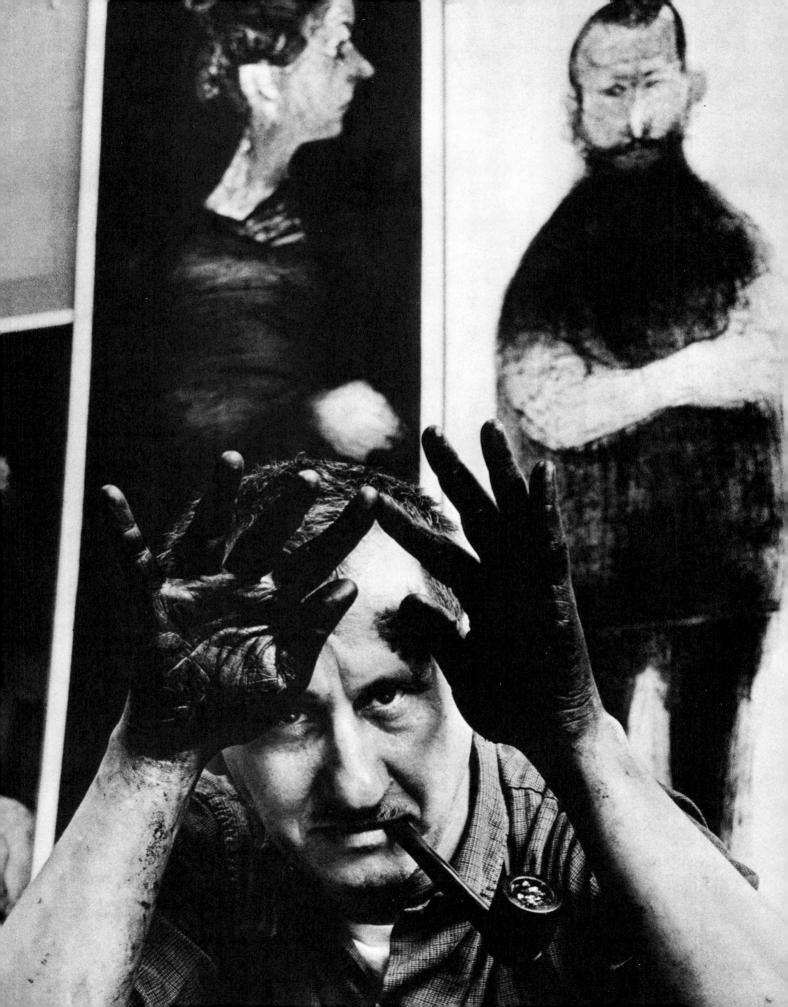

THOMAS HART BENTON, a leader of the burgeoning American art scene in the thirties, with a portrait of his later self (1970). "It was," said Benton, "one of the most difficult tasks in my life."

ANDREW WYETH at Cushing, his favorite retreat in Maine—the state where Winslow Homer, John Marin, and other great artists have lived or summered. The successful Mr. Wyeth winters at Chadds Ford near Philadelphia.

OPPOSITE: Chilean engraver MAURICIO LASAN-SKI proving that an artist's hands are as important as his eyes. In the background, some of Lasanski's life-size works at the University of Iowa.

MIA FARROW (formerly Mrs. Frank Sinatra, now Mrs. André Previn) during the filming of *A Dandy in Aspic*. Berlin, 1967.

JAMES WYETH, third generation in a family of artists. His father—Andrew Wyeth (page 233); his grandfather—N. C. Wyeth, whose Scribner's Illustrated Classics (*Robinson Crusoe, The Last of the Mohicans,* and *The Yearling,* among others) are still in print.

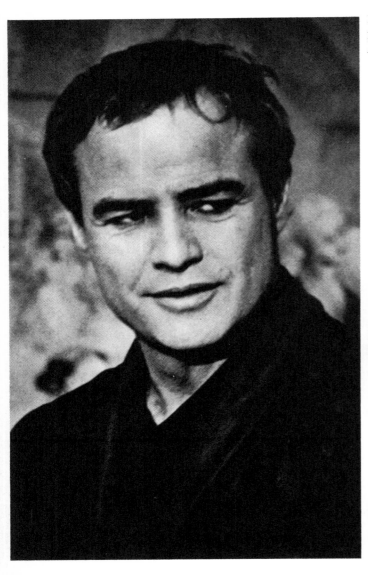

MARLON BRANDO in *A Countess from Hong Kong* (1967), his nineteenth film since re-creating the part that won him stage fame in *A Streetcar Named Desire* (1951).

CHARLES CHAPLIN, director of *A Countess from Hong Kong* (his first film since 1956) with "Countess" SOPHIA LOREN; and (BELOW) enjoying a joke with BRANDO.

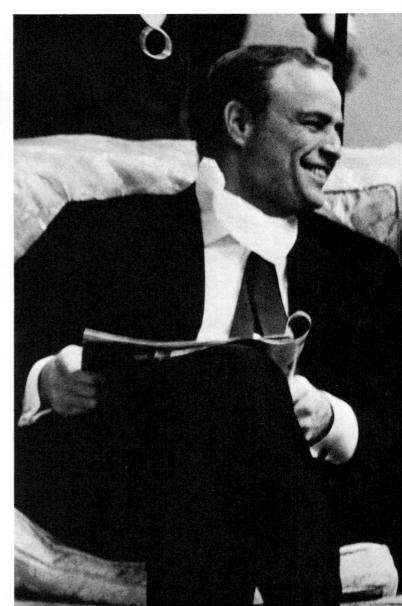

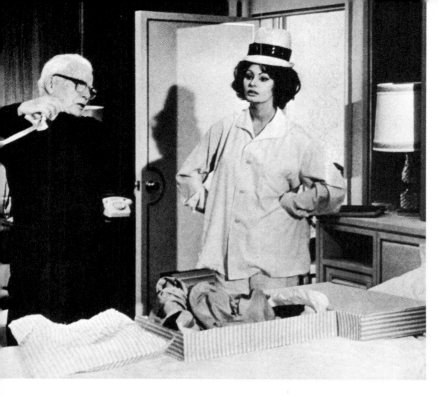

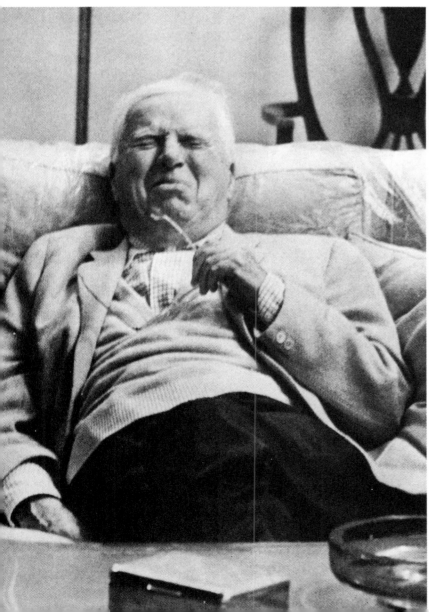

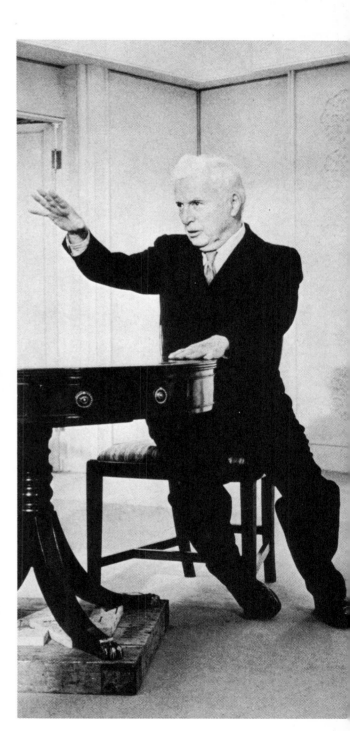

In the serious role of director.

ROBERT EVANS, once proprietor of a sporting goods shop, was discovered by Hollywood's Norma Shearer (Mrs. Irving Thalberg), then gave up acting to become Paramount's executive vice-president. He is responsible for *Love Story* (in which his then wife-to-be, Ali MacGraw, starred), *Funny Girl*, and other big money makers. BELOW: EVANS on the set of a Western, and (RIGHT, TOP TO BOTTOM) with "Sheriff" JOHN WAYNE; with JULIE ANDREWS (whose Eliza in *My Fair Lady* led her to Hollywood); and with "Funny Girl" BARBRA STREISAND.

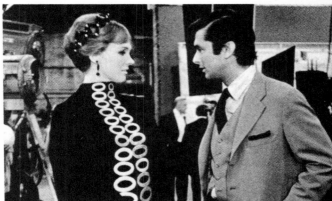

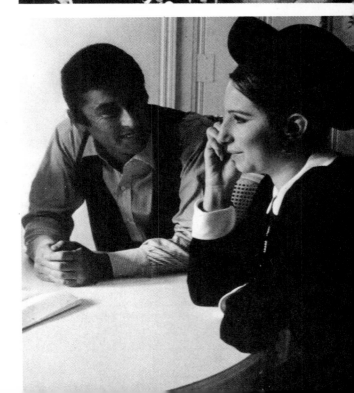

WALTER GROPIUS, protagonist of functional architecture and head of Germany's famed Bauhaus during most of the twenties. After working in London during the mid-thirties, Gropius' successful American career led him to teach at Harvard.

BELOW: MARCEL BREUER in 1972. The Hungarian-born architect was also active in the Bauhaus group and from 1937 to 1942 was associated with Walter Gropius (right) in the U.S. Among the architect's later achievements: New York's Whitney Museum of American Art (1966).

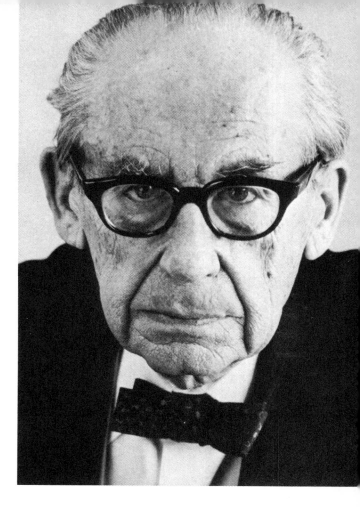

RIGHT: LOUIS KAHN, another of our century's most distinguished architects, photographed in Philadelphia, where he has taught at the University of Pennsylvania since the late fifties. Among Kahn's works: the Salk Institute in La Jolla, California, and the Kimbell Art Museum in Fort Worth, Texas. Among his sayings: "All of knowledge has only to deal with how we were made. You discover your own structure by making other structures."

OPPOSITE: DR. EDWIN H. LAND, pioneering genius in science and inventor of the Polaroid Land camera, with his latest innovation, the SX70.

GJON MILI (AT LEFT), introducer of multiple strobe lighting, past master of action photography—notably of dancers—is the author of *Picasso: Third Dimension;* (CENTER) CARL MYDANS, one-time *Life* photographer and author of *More Than Meets the Eye* and *The Violent Peace;* and DMITRI KESSEL (RIGHT) who joined *Life* in 1937. A collection of Kessel's great photographs of art and architectural treasures appeared in *Splendours of Christendom.*

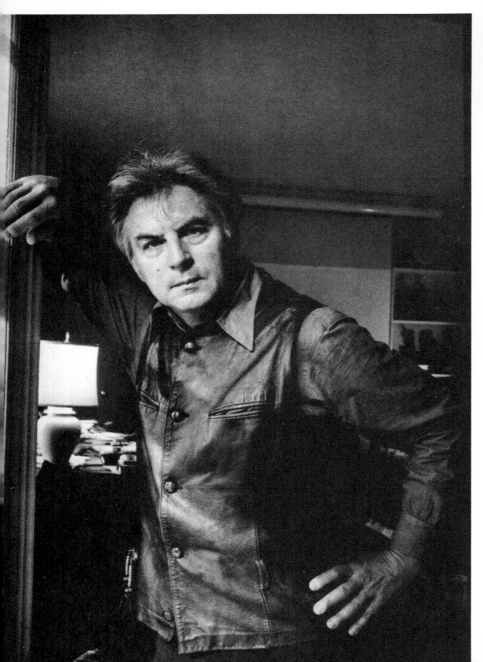

Vienna-born ERNST HAAS, master color photographer and winner of many awards, in his New York studio (1973). His book, *The Creation,* published in 1971, has been acclaimed as the most challengingly original and beautiful photo book yet.

RIGHT: Californian ANSEL ADAMS, teacher, lecturer and one of the most creative exponents of landscape and nature photography, is also an authority on the preservation of natural resources.

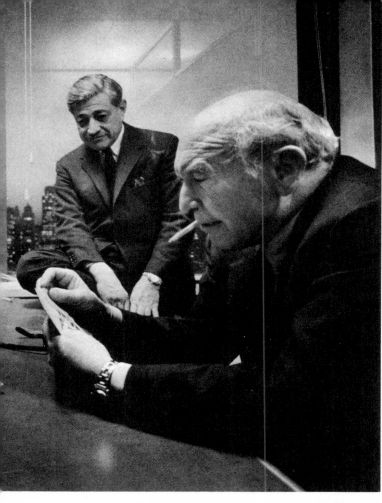

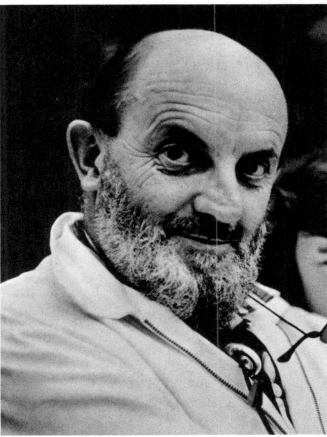

GORDON PARKS, whose genius runs to poetry and prose as well as photography. His books include *A Poet and His Camera*, *A Choice of Weapons*, *Whispers of Intimate Things*, *Shaft*, and *The Learning Tree*, the last two made into films directed by him.

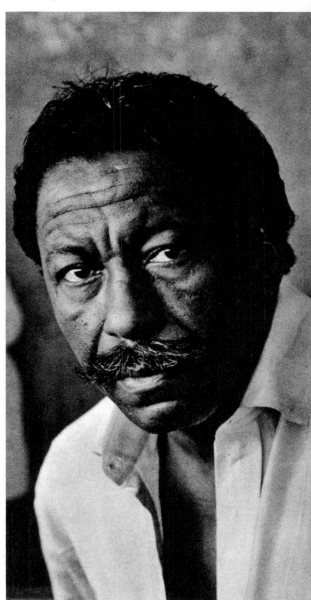

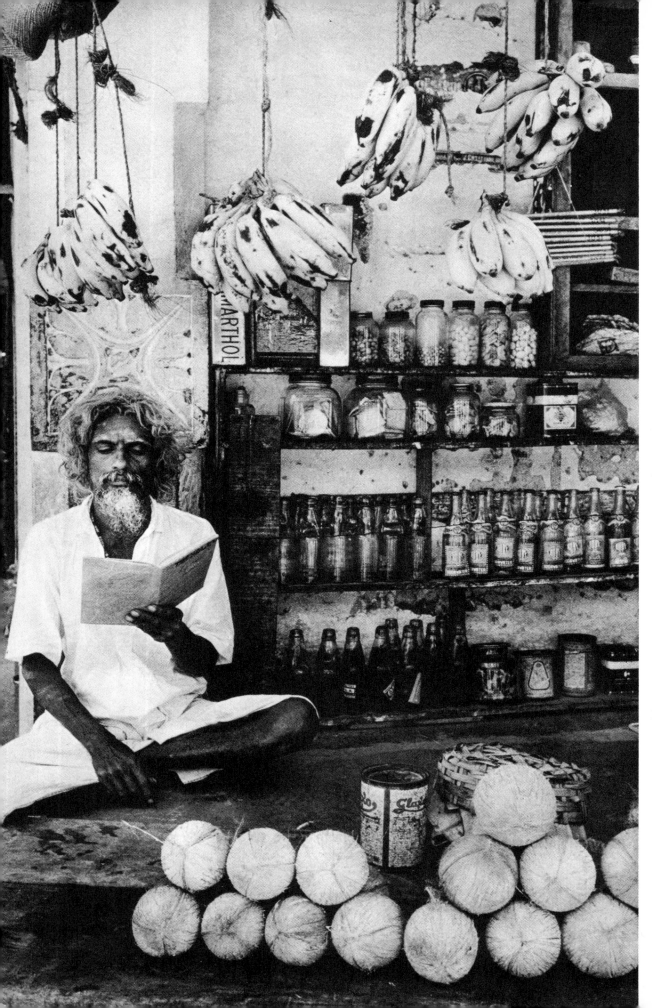

In Mahabalipuram,
India.

DUNCAN GREEN-
LESS, author of the
World Gospel series,
at the Theosophical
Society headquarters,
Madras.

OVERLEAF: Street in
old Delhi.

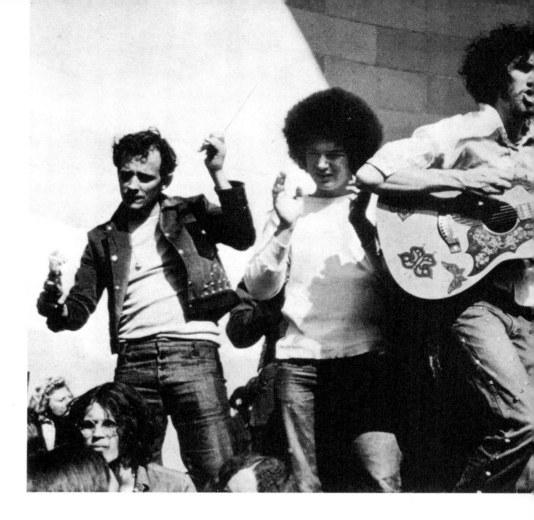

Hippie in Berkeley.

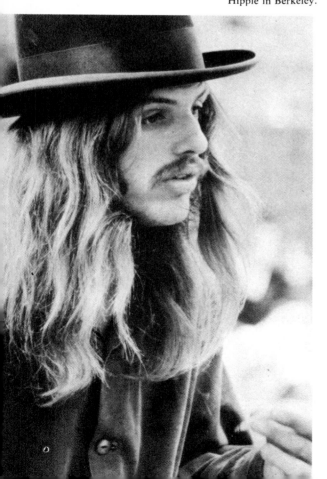

Hippies in New York.

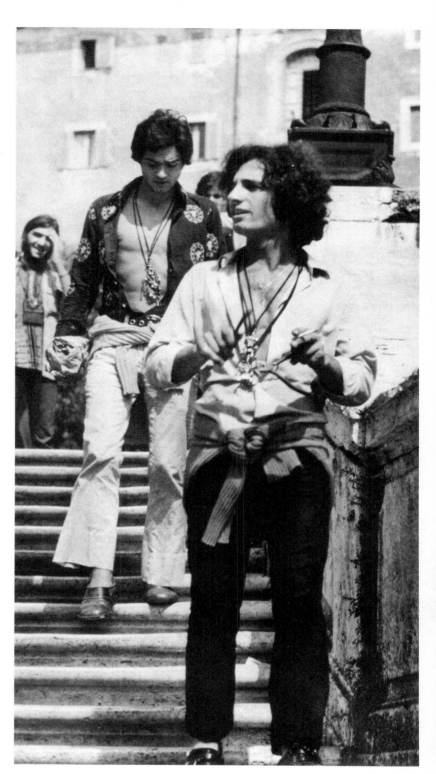

Hippies on the Spanish Steps, Rome.

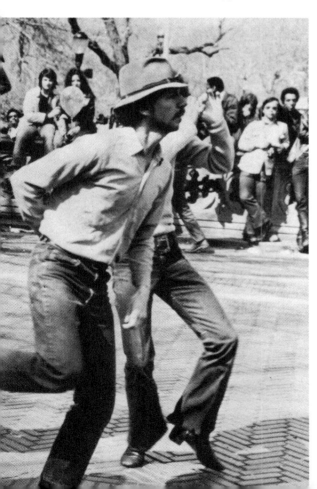

Two members of the "pop" Ars Nova group.

Hippie
in California.

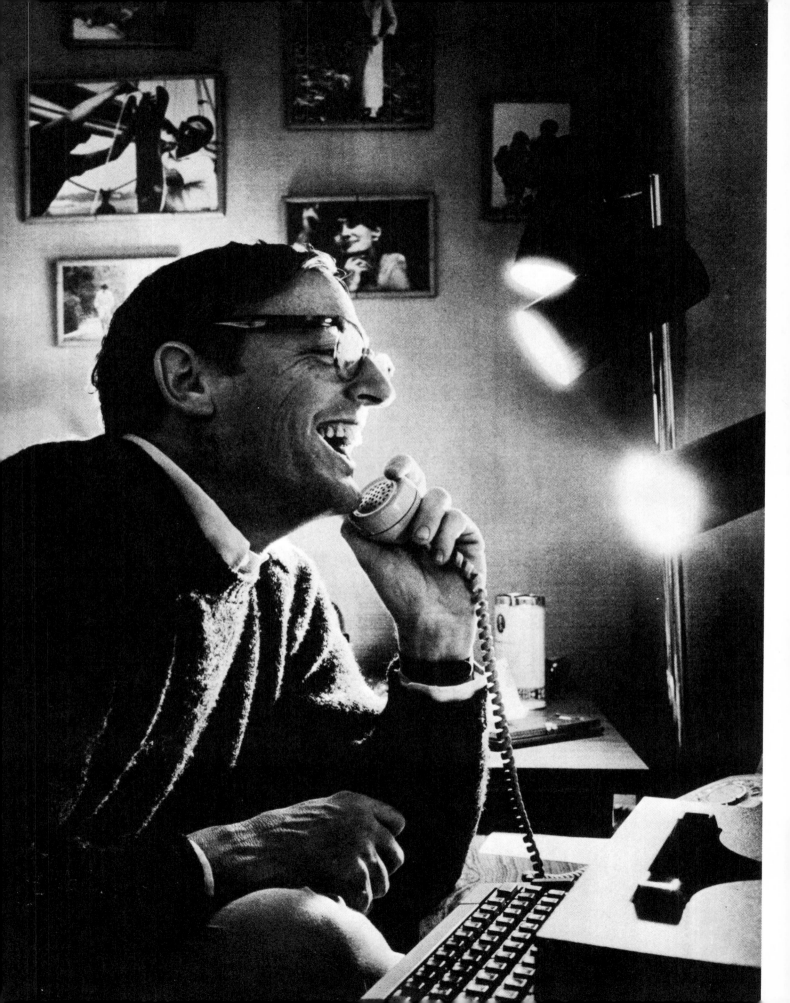

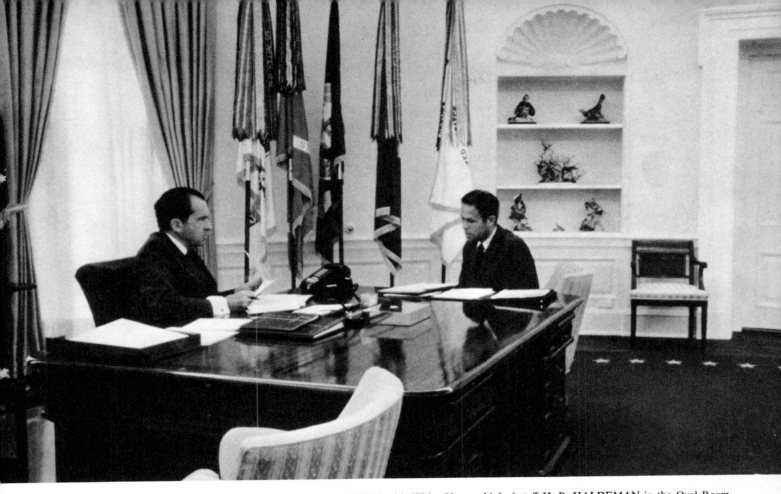

President RICHARD MILHOUS NIXON with White House chief of staff H. R. HALDEMAN in the Oval Room of the White House. BELOW LEFT: HENRY KISSINGER, President Nixon's globe-trotting national security adviser, and (RIGHT) SPIRO AGNEW, Vice-President, after inquiring if he was being photographed by a member of the "silent majority." (1970)

OPPOSITE: WILLIAM F. BUCKLEY, right-wing columnist, speaker, and editor-in-chief of the *National Review,* exchanging witticisms on the phone with associate James Burnham.

At *Playboy*'s 1971 International Writers Convocation

DAVID HALBERSTAM, Pulitzer Prize-winning former correspondent for *The New York Times* and contributing editor to *Harper's*, who has made a specialty of U.S. foreign policy and political reporting. His books include: *The Unfinished Odyssey of Robert Kennedy, The Making of a Quagmire*, and *The Best and the Brightest*. SECOND FROM LEFT: TOM WICKER, associate editor of *The New York Times*, who is based in Washington where he writes on national political affairs. BELOW: JOHN KENNETH GALBRAITH, economist, essayist, critic, and Harvard professor who was ambassador to India during the Kennedy administration.

ART BUCHWALD, one of America's most popular humorists.

CLEMENT FREUD (grandson of Sigmund Freud) *gourmet extraordinaire* and T.V. personality.

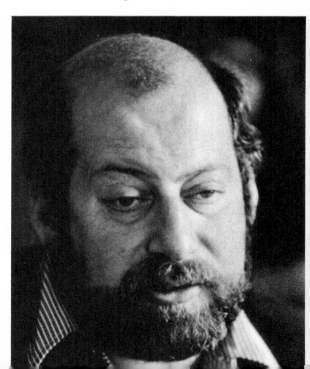

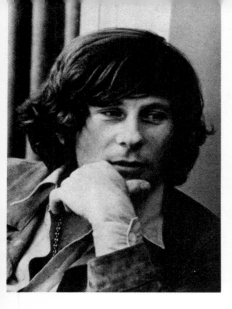
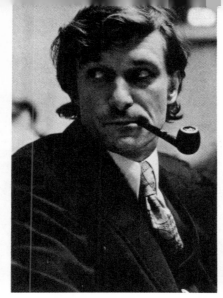
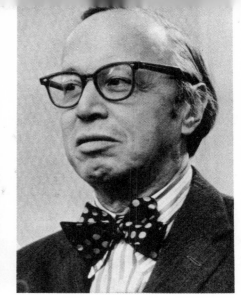

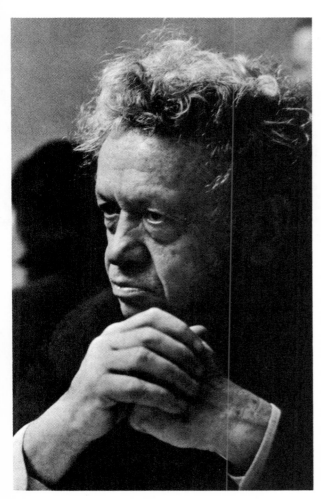

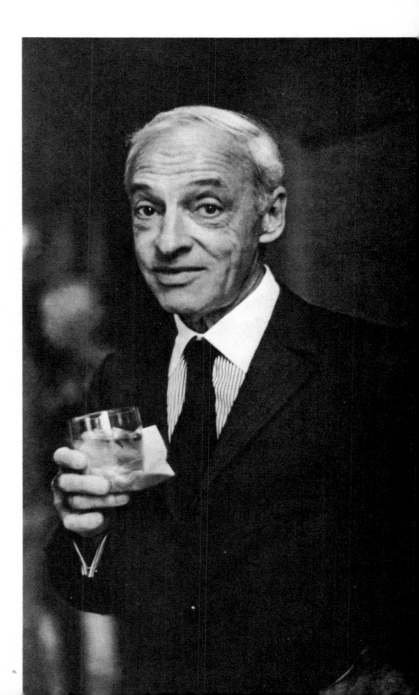

TOP ROW, LEFT TO RIGHT: ROMAN POLANSKI, the creative and colorful young Polish director of the films *Knife in the Water, Repulsion, Macbeth,* and others; HUGH M. HEFNER, editor and publisher of *Playboy;* and, ARTHUR SCHLESINGER, JR., presidential adviser during the Kennedy administration, noted historian, and author of *The Age of Jackson* and *A Thousand Days: John F. Kennedy in the White House.* ABOVE: Russian-born MAX LERNER, author and political columnist for *The New York Post* and syndicated newspapers. He is also a professor of American Studies at Brandeis University. RIGHT: SAUL BELLOW, best-selling author of *The Adventures of Augie March* (a 1954 National Book Award winner), *Seize the Day, Henderson the Rain King, Herzog,* and, more recently, *Mr. Sammler's Planet.*

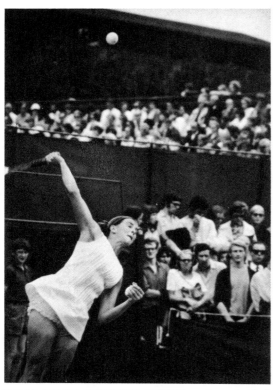

U.S.A.'s **MARY ANN EISEL CURTIS** serving a fast ball to Australia's Kerry Melville at Wimbledon, 1971.

BILLIE JEAN KING—in 1968 the first American woman in twenty-eight years to win all the major tennis competitions in England and the United States.

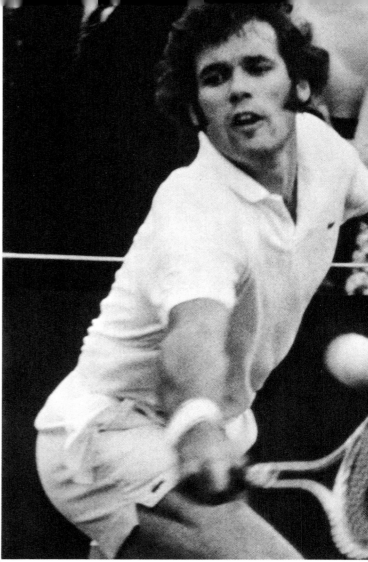

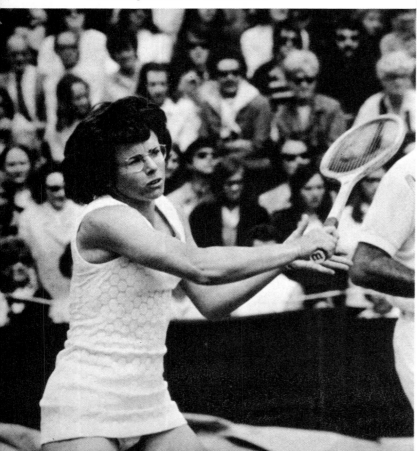

CLARK EDWARD GRAEBNER. With three fellow Americans, he won the Davis Cup for the U.S. in 1968. BELOW: Australia's MARGARET COURT, the second woman to win the Grand Slam, also took the South American trophy in 1970.

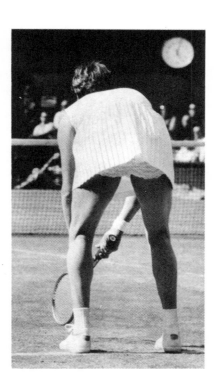

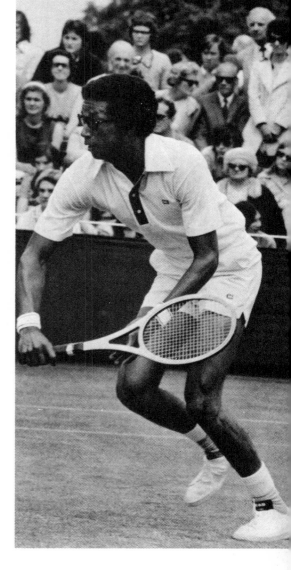

RIGHT: Hard-hitting ARTHUR ASHE, whose laurels have included winning the first U.S. Open Championship at Forest Hills in 1968.

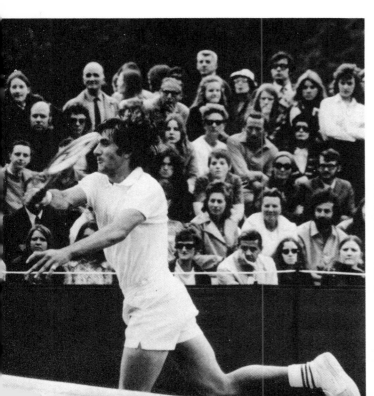

FAR LEFT: EVONNE GOOLAGONG, who stole the show—with Women's Singles title from fellow countryman Margaret Court—at Wimbledon in 1971. Said a good-humored Mrs. Court following the theft: "I think, at last, I have found an Australian to take my place."

ILIE NASTASE. After defeating Arthur Ashe in the 1972 U.S. Open Championship, the Rumanian was scolded by Ashe for a shortness of manners on court.

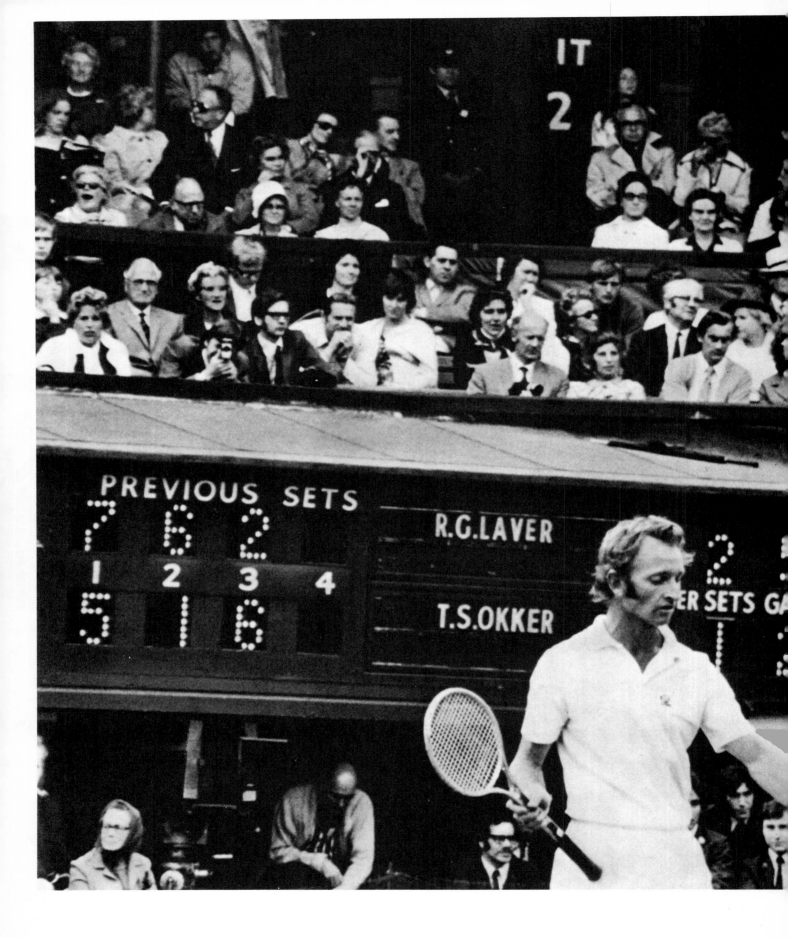

ROD LAVER on Wimbledon's Center Court in 1971. The red-headed left-hander was the un-
defeated star of all major competitions in Australia, France, England, and the U.S.A. in 1968.

KATHY EISENSTAEDT, to whose memory this book is lovingly dedicated.

INDEX